清华美术

卷18

主编：张　敢

美国艺术史与展览

清华大学出版社
北　京

图书在版编目（CIP）数据

清华美术．卷18，美国艺术史与展览/张敢主编．—北京：清华大学出版社，2021.9
ISBN 978-7-302-49453-9

Ⅰ.①清…　Ⅱ.①张…　Ⅲ.①美术评论-世界②艺术史-美国　Ⅳ.①J051②J71.209
中国版本图书馆CIP数据核字（2018）第021851号

责任编辑：纪海虹
装帧设计：赵　健
责任校对：宋玉莲
责任印制：杨　艳

出版发行：清华大学出版社
　　　　　网　　址：http://www.tup.com.cn,　　　　http://www.wqbook.com
　　　　　地　　址：北京清华大学学研大厦A座　　　　邮　　编：100084
　　　　　社 总 机：010-62770175　　　　　　　　　　邮　　购：010-62786544
　　　　　投稿与读者服务：010-62776969，c-service@tup.tsinghua.edu.cn
　　　　　质量反馈：010-62772015，zhiliang@tup.tsinghua.edu.cn
印 刷 者：小森印刷（北京）有限公司
经　　销：全国新华书店
开　　本：210mm×285mm　　印　　张：8.75　　　　字　　数：296千字
版　　次：2021年9月第1版　　　　　　　　　　　　印　　次：2021年9月第1次印刷
定　　价：88.00元

产品编号：061650-01

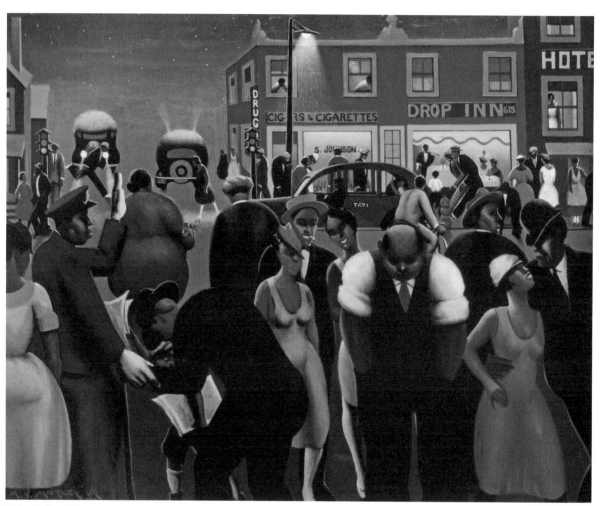

阿奇巴尔德·莫特利,《黑带》,1934 年,布面油画,33×40.5 英寸(83.8×102.9 厘米),汉普顿大学美术馆,弗吉尼亚州汉普顿。
Archibald J. Motley Jr., *Black Belt*, 1934, oil on canvas, 33×40.5in.(83.8×102.9cm). Hampton University Museum, Hampton, Virginia.

卷首语

展览是现代艺术史的重要组成部分。一方面，展览是作品面向公众的契机，是一派艺术风格、一种艺术主张进入历史叙事的节点，现代艺术史风格流派前仆后继，以展览来讲史容易掐住表层的流变脉络与深层的图像逻辑；另一方面，展览是现代艺术公共领域的核心，是艺术家、批评家、艺术商、收藏家，以及后来的策展人等各方角色登台亮相的共同舞台，作品生产与传播背后错综的社会因素也投射在展览之中。因此，对如今越来越重视艺术的社会理解的历史叙事而言，展览至关重要。

本卷的主题是"美国艺术史与展览——19 世纪至今美国艺术在本土与海外的呈现"，内容来自在清华美院举办的同名研讨会。从主题来看，研讨会是要从展览机制来透析美国艺术的身份及历史叙事的立场，考察美国艺术的策展方略。以展览为透镜也可以清晰地梳理出一条美国艺术的发展史。

现代意义上最早的艺术展览是法国的官方沙龙展，在路易十四治下，沙龙展的目的是要彰显皇家的赫赫威仪，是皇权形象的一部分。大革命之后，展览逐渐开放，学院外、非本国的艺术家也可以参加。在此情况下，美国人约翰·范德林（John Vanderlyn）在 1800 年得以参展。在美国政要的资助下，他是第一个留法学习，参加沙龙，并获奖的美国艺术家，尽管回国后他继续创作新古典主义历史画的抱负并没有条件实现。美国南北战争之后，大量年轻的美国人漂洋过海留法学画，沙龙展是他们职业生涯的目标。到了 19 世纪 80 年代，几乎每年都有超过 100 位美国艺术家入选沙龙，他们的作品跟法国导师的十分相像，混在数千件里，分辨不出哪些属于美国的艺术。

现代展览发端的另一个系统是世界博览会。除了 1851 年英国水晶宫的那一届，世博会上都有重要的艺术展示，每个国家都会成立专门的组委会，认真地挑选作品，以显示各自的文化实力。1855 年，巴黎世博会上美国人乔治·希利（George Peter Alexander Healy）展出了一幅历史画《富兰克林面见路易十六》，画中，美国政治家把一份新国家的方案放到一个岌岌可危的旧王朝面前，显示了美国的雄心。1867 年的巴黎世博会上，美国人送来了哈德逊河画派，还把自己的展区做成木屋和教室的样子，希望描绘本土风光的本土画派能显示出本土的文化形象，同时也能刺激欧陆人来新大陆旅游与安居，然而，法国批评界却极看不起这批作品。对此，美国国内的舆论进行了反省，在后两次巴黎的世博会上美国人都只保险地送出一些旅欧画家的人物画来展出。直到 1893 年与 1900 年的这两届，美国人才重新燃起了超越旧世界的豪情。

在世博会上艺术的展示毕竟是次要的，但它却催生了独立的国际艺术展。在 19 世纪后半叶，欧洲各国的大城市竞相举办大型展览，提升或争夺文化资本，也希望为本地艺术家打开更大的市场。第一个政府资助的国际艺术展是 1869 年在慕尼黑玻璃宫的展览，很快，这些展览的活跃程度就超越了国家沙龙。到 19 世纪末，一些重要的展览都形成了自己的节奏与惯例，其中影响最为深远的就是 1895 年发端的威尼斯双年展。

1913 年，美国一批前卫艺术家也希望为自己办一次展览，结果却在欧洲国际展览模式与大量新作品的刺激下，不断扩大规模，办成了一个国际展览。欧洲作品的数量虽不及美国一半，却成功喧宾夺主，在美国打开了新艺术展示与收藏的渠道，那就是著名的"军械库"展览。此后 5 年内，大大小小近 200 个新艺术展览在纽约各处开幕。展览也引起了新一轮欧洲与本土之争，现代艺术的重要推手阿尔弗雷德·施蒂格利茨（Alfred Stieglitz）逐渐投身到本土艺术的发展事业中。

"二战"后的美国迎来了为自己的文化正名的时机。在政府和博物馆的推动下，抽象表现主义在欧洲各大展览上亮相，并组成"新美国绘画"展，在欧洲各地巡回，为美国的当代艺术与文化赢得了国际声誉。1964 年的威尼斯双年展上，尽管遭到欧洲人的质疑，罗伯特·劳申伯格（Robert Rauschenberg）终于捧得大奖。由此可见，"二

战"之后的美国非常迫切地想在国际展览上发出自己的声音，这种国家竞争的思维延续了很长一段时间。

20世纪60年代后期在艺术展览史上是一个分水岭。由于全球艺术资讯的发达，人们不再需要定期前往大型双年展来了解艺术动态。这时候，双年展需要对当代艺术动向做更深入的阐释，以国别为框架的传统展览模式逐渐让位给以主题为秩序的展览模式。随之而来也产生了一系列变化，比如，具备专业能力的职业策展人的崛起，先方案后作品的策展与创作方式渐为流行，展览作为整体文化产品甚至凌驾在作品之上等。

主题展览的流行并不意味着国别界限的消融，相反，全球化背景下的多元文化身份与交流成了20世纪80年代以来展览的一大重要主题。非西方中心城市，如哈瓦那（1984年）、伊斯坦布尔（1987年）也纷纷办起了双年展，它们的活跃程度甚至超过了老牌的双年展。而在此之前，除了圣保罗双年展，大型展览基本都在欧美国家举办。面对非西方国家当代艺术的兴起与繁荣，西方的展览也日趋倡导多元文化论。1990年，纽约的当代艺术新博物馆、哈莱姆美术馆和西班牙裔当代艺术博物馆合作推出了展览《十年展：80年代的身份框架》，从民族、人种、性别等多文化角度展现了不一样的20世纪80年

代艺术实践。3年后，惠特尼美国艺术博物馆双年展上更加明确了这种文化指向，使许多原来边缘的创作都走进了中心舞台。

我们今天讨论"美国艺术史与展览"的话题，至少包括两个层面：一是展览中的艺术历史，考察的是展览机构与策展人的史观；二是历史上的展览与艺术，考察历史演进中展览的作为。与有着悠久历史的中国和欧洲各国相比，美国的艺术史显得非常短暂。然而，美国却在第二次世界大战之后，一跃成为西方艺术世界的中心。这既与美国艺术家一直希望创造具有美国特色的艺术的抱负有关，也与他们对本国艺术千方百计、不遗余力地推广有关。今天，中国艺术家肩负着中华文化伟大复兴的使命，同时也肩负着树立文化自信的责任。中国艺术如何发展？如何"走出去"？美国艺术家、策展人和理论家的探索，对我们而言无疑有着重要的借鉴意义和价值。本卷收录了美国学者撰写的9篇文章，各有侧重，在此不再赘述，大家读内文便知。

张敢
2021年6月25日于双清苑

目 录

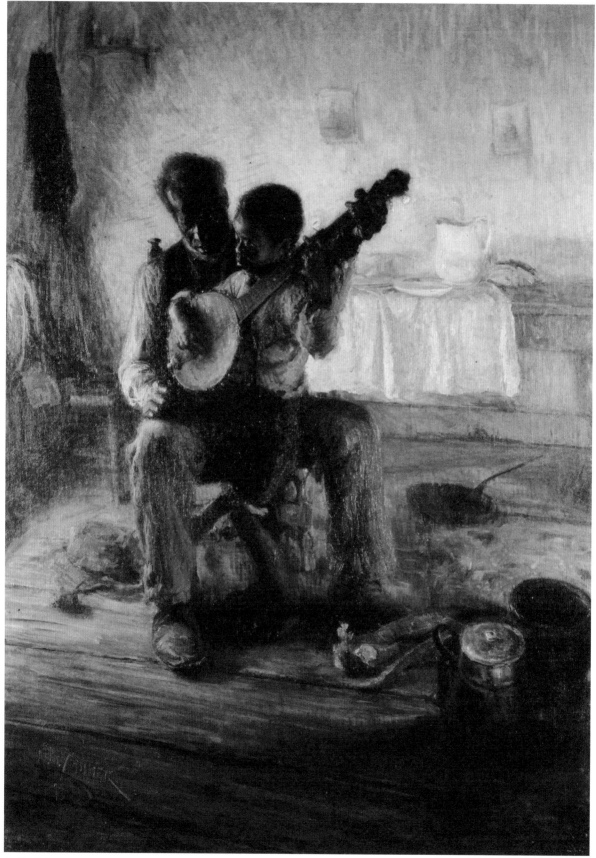

亨利·奥萨瓦·坦纳，《班卓琴课》，1893 年，布面油画，49×35.5 英寸（124.5×90.2 厘米），汉普顿大学美术馆，弗吉尼亚州汉普顿。
Henry Ossawa Tanner, *The Banjo Lesson*, 1893, oil on canvas, 49 × 35.5in. (124.5 × 90.2cm) . Hampton University Museum, Hampton, Virginia.

美国艺术的容颜变迁
The Changing Face of American Art

芭芭拉·哈斯克尔　李云 * 译
Barbara Haskell　Translator: Li Yun

会议以"展览中的美国艺术"为题,就一定要问"什么是美国艺术?"是简单的美国公民的艺术,还是美国人、美国历史、美国地理中某些本质特征的反映?问题的核心是国家身份,美国在历史上从未停止过对国家身份的争论。美国相对年轻,人们的先祖不一,出身不同,就要有共性将大家维系起来,艺术就起到了这个作用。美国的艺术在孤立主义与世界主义之间不断摇摆,从而推动了国家自我意识的形成。本文所要讲述的,就是这种来回摇摆所形成的张力图景,及其在本土展览与国际展览中的体现。

1776 年,美国独立。起初的几十年里,美国人并不在意艺术的审美独立。当时,英国在多数美国人心中就相当于"家",紧随英国的艺术风格是理所应当的。美国艺术家创作的历史画作、权贵肖像都完全遵循欧洲先例,只有描摹对象是美国的。1828 年,平民主义者安德鲁·杰克逊(Andrew Jackson)当选为总统,伴随着国家经济的繁荣,兴起了一个强大的中产阶级,他们需要的是表现普通生活、日常经验的艺术。随着艺术赞助从精英贵族转向中产阶级,风俗画中,以寻常的"美国"生活来体现可辨的"美国"样式就成了惯例。"画画要心怀大众——一定要为多数人,而不是为少数人而作,"[1]费城画家威廉·西德尼·芒特(William Sidney Mount)这么说过。从芒特、乔治·凯莱布·宾厄姆(George Caleb Bingham,图 1)、伊斯门·约翰逊(Eastman Johnson)到乔治·卡特林(George Catlin),他们笔下的美国种族包容、和谐民主,不排斥黑人与印第安人,这引起了争议。在当时的现实中,黑奴状况还未改善,印第安人则不断遭逐,艺术家描绘的美国实际上理想多过真实。但在画里的理想看起来都是真的,他们为这个年轻的国度构想出了一块自由、民主的领地。在当时,初建的艺术学院都会有对公众开放的年度展览,他们因此有了投缘的观众。这些学院中,1807 年成立的宾夕法

The topic of this conference—"American Art in Exhibition"—is inextricably linked to the question of "What *is* American art?" Is it simply art made by citizens of the United States, or does it reflect something essential about the character of the nation's people, its history, and its geography? At the core of this question is the issue of national identity, which has been an ongoing source of debate throughout American history. As a relatively young country, with a population lacking common ancestors and backgrounds, we have sought to find common denominators that bind us together. Art has played a role in this. In helping to shape the country's sense of itself, art in the United States has swung between aesthetic insularity and cosmopolitanism. The broad arc of those swings and how they have been reflected in national and international exhibitions is the subject of this talk.

The idea of an aesthetically independent art did not occur to Americans in the early decades after Independence in 1776. At a time when England, for most of the country's population, was still a synonym for "home", reliance on it for artistic styles was assumed. Our art was national in subject matter only; the history paintings and portraits of prominent people that American artists produced were completely dependent on European precedents. The 1828 election of populist Andrew Jackson as president, coupled with the country's growing financial prosperity, changed that by giving rise to a strong middle class demanding a subject matter that addressed the lives and everyday experiences of common people. Genre scenes depicting recogni-zably "American" types in familiar, everyday "American" situations became the norm, as patronage shifted from the elite to the middle class. "Paint pictures that will take with the public—never paint for the few, but the many," Philadelphia painter William Sidney Mount said.1 Artists from Mount to George Caleb Bingham (Fig.1), Eastman Johnson,

* 李云 浙江工业大学副教授(Li Yun Associate Professor,Zhejiang University of Technology)

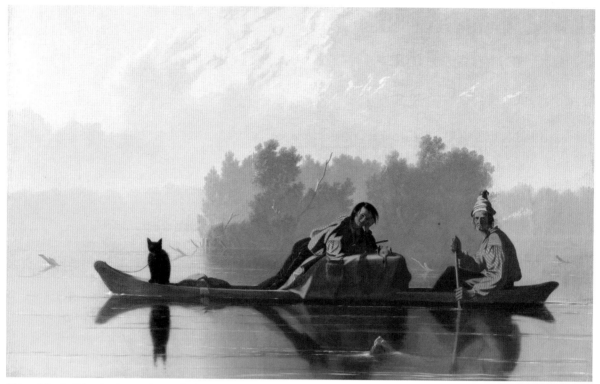

图1　乔治·凯莱布·宾厄姆，《顺河而下的皮毛商人》，1845 年，布面油画，29×36¹/₂ 英寸（73.7×92.7 厘米），大都会艺术博物馆，纽约。图像版权 © 大都会艺术博物馆。图像来源：艺术资源，纽约。

Fig.1　George Caleb Bingham, *Fur Traders Descending the Missouri*（*French-Trader–Half Breed Son*），1845. Oil on canvas, 29×36¹/₂in.（73.7×92.7 cm）. The Metropolitan Museum of Art, New York. Image copyright © The Metropolitan Museum of Art. Image Source: Art Resource, NY.

尼亚艺术学院与 1825 年成立的纽约设计学院最为重要。19 世纪早期，艺术的民主化是由各种艺术联盟培植起来的，联盟为成员们提供工作，给他们版画原作，若能中奖，则可一睹油画原作。当时，纽约的美国艺术联盟影响力最大，也最为成功，1849 年鼎盛时，成员可达 19000 人。

在欧洲人眼里，那些美国日常生活的图画并不有趣。因而，美国风俗画很少在国际沙龙或是伦敦、巴黎的年度博览会上亮相。唯有卡特林画的印第安人是个例外（图2），无论在美国，还是在欧洲的各大都城，都有一批青睐他的观众，他们在画中看到了不同于欧洲国家的身份证明。卡特林也善于出风头，称自己的展览为"印第安画廊"，其中有标榜印第安人及其文化的绘画，还有印第安人的服装、烟管、武器、篮子、帐篷等工艺品，再以"沙龙风格"助力宣传。他在部落里待过，这些东西都是那时搜罗来的。他还做讲座，讲述狂野西部，让展览更为生动。"画廊"在美国巡回了两年，之后卡特林把它带到了国外，随行的还有一批印第安人，他们可以表演狩猎、剥皮、舞蹈与传统仪式。在欧洲，卡特林一待就是 31 年，为欧洲观众带去了法国诗人夏尔·波德莱尔所说的"酋长们高傲、自由的品格，既谦恭又骁勇。"[2]

到了 19 世纪中期，美国艺术家有了另一个主题来表达这个新生国家的身份意识：广袤、未开发的荒野，

and George Catlin depicted America as a harmonious and racially inclusive democracy in which African Americans and Native Americans had a place, albeit contested. Given the realities of slavery and the forced relocation of Native Americans during these decades, the country these artists described was more ideal than real. But in painting it as if it were real, they codified the special place that freedom and democracy had in the young nation. Their message found a ready audience among the public who frequented the annual exhibitions held at the nation's newly established art academies, the most important being the Pennsylvania Academy of Art, founded in 1807, and the New York Academy of Design, founded in 1825. Art's democratization in the early nineteenth century was fostered by art unions, which commissioned and distributed original engravings to their members and made original paintings available in lotteries. The American Art-Union in New York was the most influential and successful. At its height, in 1849, it had almost 19,000 subscribers.

From a European perspective, depictions of American daily life were of little interest, with the result that American genre pictures were rarely included in the international salons and expositions held annually in Paris and London. The exception was Catlin's depictions of Native Americans

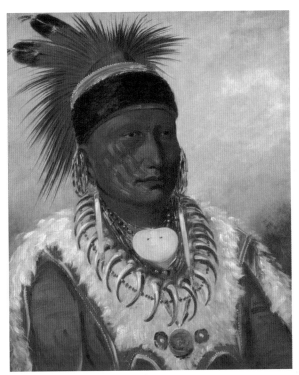

图 2　乔治・卡特林，《白云，爱荷华的酋长》，1844 年 /1845 年，布面油画，27¹⁵/₁₆×22¹³/₁₆ 英寸（71×58 厘米），国家美术馆，华盛顿，保罗・梅隆藏品，1965.16.347。

Fig.2　George Catlin, *The White Cloud, Head Chief of the Iowas*, 1844/45. Oil on canvas, 27^{15}/$_{16}$×22^{13}/$_{16}$in. （71×58cm）. National Gallery of Art, Washington, D.C.; Paul Mellon Collection 1965.16.347.

由东至西，从壮美的哈德逊河河谷一直到落基山脉和约塞米蒂。在近若神圣的光线里，美国那美得令人屏息的自然风光被绘成了一幅幅全景图，托马斯・科尔（Thomas Cole）、弗里德里克・丘奇（Frederic Church，图 3）、艾伯特・比兹塔特（Albert Bierstadt）让我们觉得伊甸园式的天堂是神恩的启示，蕴含着上帝对新生美国承诺的祝福。这种解释与美国"天定命运"的信念互相呼应，在宗教上合法化了国家向西部的拓殖。这些作品尺幅巨大，刻画精微，一度被称作"伟大图像"，深受大众喜爱，艺术家也顺势以一种戏剧化的方式来陈列和宣传作品。他们专门模仿当时的移动全景画，那是某种电影雏形，在黑屋子里展示，控制好灯光，以增强画面光线效果，以此招揽了大批观众。排队买票的人数以千计，以求一睹这些既宏大又精微的美国田园风景。在风格上，这些描绘美国西部与哈德逊河河谷的画作类似于杜塞尔多夫艺术学院的德国画派。因而在欧洲，它们也顺理成章地获致青睐，成了第一个在国外得到认可的美国画派，在伦敦皇家艺术学院年度展览上，在巴黎沙龙里，在 1851 年诞生后的世界博览会上，都有它们的身影。例如，1867 年巴黎的世博会上就有 87 幅美国绘画展出，弗里德里克・丘奇还斩获了一枚奖章。

（Fig.2）, which found a receptive audience not only in the United States but also in capital cities around Europe, where they were seen as testaments to a national identity distinct from Europe. Catlin was a showman. His "Indian Gallery", as he called it, consisted of paintings honoring Native Americans and their culture, hung "salon style" alongside Native American costumes, pipes, weapons, baskets, teepees, and other artifacts he had collected from the tribes he had lived among, all of which he augmented with lectures he gave on the Wild West. After two years of showing his "gallery" across the United States, he took it abroad, bringing with him a retinue of Native American people who enacted hunts, scalpings, dances, and traditional ceremonies. Catlin remained in Europe for thirty-one years, introducing European audiences to what the French poet Charles Baudelaire referred to as "the proud, and free character of these chiefs, both their nobility and manliness."[2]

By the mid-nineteenth century, American artists had found another subject through which to express the country's nascent sense of its national identity: its vast, untouched wilderness, starting with the splendor of the Hudson River Valley in the east and moving to the Rocky Mountains and Yosemite in the west. The seemingly divine light that infused the panoramic depictions of America's breathtaking natural beauty by artists such as Thomas Cole, Frederic Church （Fig.3）, and Albert Bierstadt suggested divine favor, signaling an Edenic paradise that, implicitly, had been granted by God for the benefit of the new nation. Such an interpretation resonated with a country that had come to believe in "Manifest Destiny", the idea that the nation's westward expansion was divinely sanctioned. Large in scale and meticulously rendered, these "Great Pictures", as they were called, had wide popular appeal, which the artists exploited by presenting and promoting them as theatrical experiences. Consciously emulating the contemporaneous pre-cinematic moving panoramas that were then attracting large audiences, the artists exhibited their works in darkened rooms under controlled lighting conditions to enhance optical impact. Thousands of people lined up to pay admission to see these oversized, minutely detailed views of American pastoral landscapes. Stylistically, these paintings of the American West and the Hudson River Valley resembled those of the German school of painting associated with the Dusseldorf Art Academy. Not surprisingly, they found favor in Europe, making them the first school of American painting to be recognized abroad by inclusion in the annual exhibitions at the Royal Academy in London, the Paris Salon and, after their inception in 1851, at World's Fairs. The 1867 Exposition Universelle in Paris, for example, in which Frederic Church won a fine arts medal, included eighty-seven American

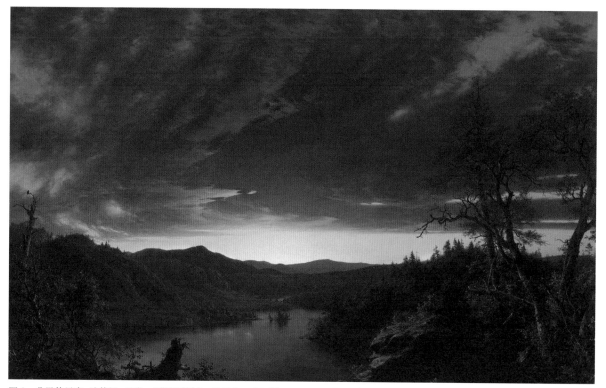

图3　弗里德里克·埃德温·丘奇，《荒原黄昏》，1860 年，布面油画，40×64 英寸（101.6×162.6 厘米），克利夫兰艺术博物馆，威廉·H. 马拉特夫妇基金捐助，1965.233。摄影 © 克利夫兰艺术博物馆。

Fig.3　Frederic Edwin Church, *Twilight in the Wilderness*, 1860. Oil on canvas, 40×64in.（101.6×162.6cm）. The Cleveland Museum of Art, Mr. and Mrs. William H. Marlatt Fund 1965.233. Photography © The Cleveland Museum of Art.

　　内战之后，一切都不同了，四年的残酷战争（1861年—1865 年）给这个诞生尚不足百年的国家带来了巨大转变。一方面，随着国家稳固，奴隶制问题的解决，美国转型为一个工业强国，它的经济发展迅猛，制造业产量可以与英国、法国、德国三者的总数相较高下。另一方面，战争也在美国人心理上造成了灾难性的创伤，伤亡不计其数，痛楚难以言说，上一代艺术家风俗画中的纯洁理想、风景画里的昭著神性就显得不合时宜了。美国艺术家于是将目光投向了国外，在欧洲风雅场上寻找文化庇护。1876 年，艺术不再执着于国家身份的表达。艺术家迫切地抹去乡音，模仿他人。在费城美国独立百年博览会上，有一批评家对展出的艺术作品评述道："（1876 年之前）我们还有所谓的……美国画派；而如今美国画派已近乎消亡……我们开始跟别人一样地作画。"[3] 到了 1889 年巴黎世博会召开时，旅居法国首都的美国艺术家数量之多，竟可在本土艺术家之外单辟一画廊展陈作品。而不论在美国内外，均少有艺术家描绘全然的美国题材。尊奉欧洲典范的美国艺术家则得到了嘉奖：当年有 57 位美国画家抱得大奖，24 位得到提名。当时，威廉·梅里特·蔡斯（William Merritt Chase）转变风格，吸收法国印象派的画法，斩获了一枚银奖。有评论者称，美国艺术已经 "与法国、英国、瑞士、斯堪

paintings.

　　Everything changed after the Civil War, a brutal four-year conflict（1861–1865）that was of immense consequence for the country, itself not even a century old. On the one hand, with the question of slavery settled and unification certain, the United States transformed itself into an industrial power, growing an economy whose manufacturing output equaled that of Great Britain, France, and Germany combined. Yet, the war had taken a devastating toll on the American psyche, having produced unspeakable injuries and mass numbers of casualties that seemed at decided odds with the innocent, idealistic genre scenes and divinely infused landscapes of earlier generations of artists. In response, American artists looked abroad, seeking cultural refuge in the refinements of Europe. By 1876, art as an expression of national identity had faded. In their desire to shed their provincialism, American artists became imitative. As one critic observed about the art exhibited in the Philadelphia Centennial, "（before 1876）we had what was called...an American school of painting; and now the American school of painting seems almost to have disappeared... We are beginning to paint as other people paint."[3] By the time the 1889 Parisian Exposition Universelle opened, there were so many American expatriate artists residing in the

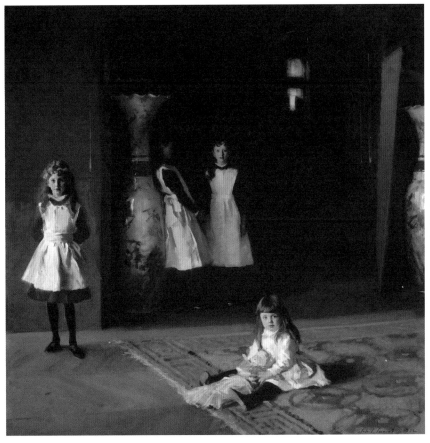

图4 约翰·辛格·萨金特,《爱德华·达雷·波伊特的女儿们》,1882年,布面油画,$87^3/_8 \times 87^5/_8$英寸(221.9×222.6厘米),波士顿美术馆,玛丽·路易莎·波伊特、茱莉亚·欧弗林·波伊特、简·休巴德·波伊特和佛罗伦斯·D.波伊特为纪念父亲爱德华·达雷·波伊特捐赠,19.124。摄影© 波士顿美术馆,2014年。

Fig.4　John Singer Sargent, *The Daughters of Edward Darley Boit*, 1882. Oil on canvas, $87^3/_8 \times 87^5/_8$in.(221.9×222.6cm). Museum of Fine Arts, Boston; gift of Mary Louisa Boit, Julia Overing Boit, Jane Hubbard Boit, and Florence D. Boit in memory of their father, Edward Darley Boit, 19.124. Photograph © 2014 Museum of Fine Arts, Boston.

的纳维亚及其他国家艺术家,那些大部分训练得自巴黎画室的艺术家没有什么差别了。"[4] 小说家亨利·詹姆斯(Henry James)的笔调也类似,他写道:"今天,要找'美国艺术',几乎只能去巴黎。终在巴黎之外找到了它,里面还是有很多巴黎的调调,这是一个简单事实。"[5] 因而,19世纪晚期三位美国艺术巨匠——约翰·辛格·萨金特(John Singer Sargent,图4)、玛丽·卡萨特(Mary Cassatt)和詹姆斯·麦克尼尔·惠斯勒(James McNeill Whistler)都是旅欧画家。在美国本土,有法国印迹的艺术家也得权得势,掌控了纽约国家学院(译者注:前身是1825年成立的纽约设计学院)的年度展览,那是美国审美品位的首要标杆,把守着通往商业画廊的大门。19世纪90年代,这些画廊纷纷在纽约成立,其中有:杜兰特-吕埃尔、蒙特罗斯、麦克贝斯、金普勒和维尔当斯坦等。

截至1900年,法国的风格与题材已盛行25年,美国科技工业实力的崛起,全球化与帝国主义眼界的养成,使得这种卑躬之态变得摇摆不定了。美西战争的胜利(1898年),对古巴、波多黎各、关岛、夏威夷和菲律宾等地的吞并都是美国国力增强的证明。1901年,西奥多·罗斯福当选总统之后,美国在世界事务中日渐活跃。罗斯福调停了日俄战争(1904—1905年),维护了

French capital that their works had to be shown in a separate gallery from that of American artists who were still living in the United States. Few artists of either group depicted overtly American subjects. The embrace by American artists of European models was rewarded: fifty-seven of the exposition's awards that year and twenty-four honorable mentions were given to American painters. William Merritt Chase, who had altered his style to incorporate elements of French Impressionism, won the silver medal. American art, as one commentator wrote, had become "virtually indistinguishable from that... of the hundreds of French, English, Swiss, Scandinavians and other nationals who had learned most of their lessons in Parisian studios."[4] Novelist Henry James echoed a similar sentiment, noting that "it is a very simple truth, that when to-day we look for 'American art' we find it mainly in Paris. When we find it outside of Paris, we at least find a great deal of Paris in it."[5] Fittingly, three of the giants of late nineteenth-century American art—John Singer Sargent (Fig.4), Mary Cassatt, and James McNeill Whistler—were expatriates. French-influenced artists who remained in the United States entered positions of power, controlling the annual shows at New York's National Academy, which had become the nation's primary arbiter of aesthetic taste, and serving as gatekeepers to the commercial galleries that

开凿和运营巴拿马运河的权力，将之纳为美国属地，并派出一支16艘军舰的小型编队巡回全球，张扬国家武力（1907—1909年）。美国在国际舞台上成为一支主要力量，这又激起了对美国本土题材与风格的需求。温斯洛·霍默（Winslow Homer）和托马斯·伊肯斯（Thomas Eakins）在当年备受拥戴，不逊于政界先人，适逢19世纪90年代美国各大城市纷纷建立百科式的博物馆，他们的作品赫然在列。为彰显国家的强势，1900年巴黎世博会的美国艺术展区由美国国务院亲自督办。目标就是要宣扬"美国艺术生产大国的新地位"，不受"外国规束"[6]。为确保作品含有美国独特的题材，国务院下令，美国展品中至少有70%需是本土出产。1909年，美国国会也如法炮制地通过一项法案，对20年内所做的非美国艺术征收15%的进口关税，以激励对当代美国艺术的赞助。

艺术家中，有一批向欧洲寻求灵感，另一批人则时不我待地打造独立自觉的美国艺术，两者的摩擦难以避免。1908年2月，冲突到了一个高潮，罗伯特·亨利（Robert Henri）及其同道共8人（图5）在麦克贝斯画廊举办了一个"非法沙龙"，以对抗国家学院，后者在其年度展览上拒绝了他们的作品。[7]亨利意识到美国民族主义的思潮日渐蓬勃，故而在展览中植入了这一主题，

opened in New York in the 1890s: Durand-Ruel, Montross, Macbeth, and E. Gimple and Wildenstein.

By 1900, the subservience to French styles and subjects that had prevailed for twenty-five years began to falter in the face of American technological and industrial power and the nation's growing global and imperialist outlook, evidenced by its victory in the Spanish-American War（1898）and its annexation of Cuba, Puerto Rico, Guam, Hawaii, and the Philippines. Once Theodore Roosevelt became president in 1901, America gained even more prominence in world affairs, as Roosevelt mediated peace in the Russo-Japanese War（1904–1905）, secured rights to build and operate the Panama Canal as an American protectorate, and sent a flotilla of sixteen American naval warships on a circumnavigation of the globe to assert the country's military strength（1907–1909）. As America became a more dominant force on the international stage, calls for indigenous American subjects and styles returned. Winslow Homer and Thomas Eakins found themselves honored as revered elder statesmen, their work featured in the encyclopedic museums that had sprung up in the nation's major cities in the 1890s. In an attempt to underscore America's ascendance, the U.S. State Department assumed administration of the American art

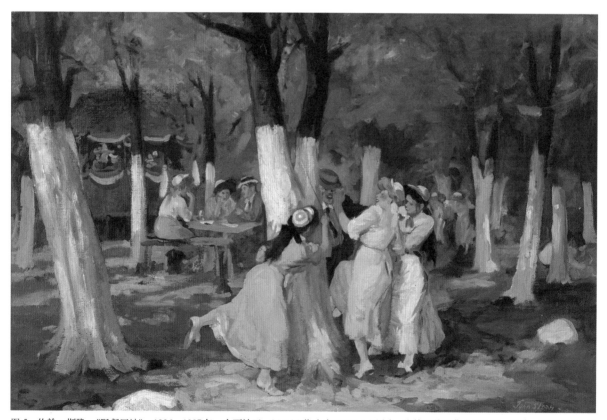

图5　约翰·斯隆，《野餐园地》，1906—1907年，布面油画，24×36英寸（61×91.4厘米），惠特尼美国艺术博物馆，纽约，购买 41.34. © 特拉华美术馆、艺术家版权协会（ARS），纽约。

Fig.5　John Sloan, *The Picnic Grounds*, 1906-07. Oil on canvas, 24×36in.（61×91.4cm）. Whitney Museum of American Art, New York; purchase 41.34. © 2013 Delaware Art Museum / Artists Rights Society（ARS）, New York.

以谴责学院对真正美国艺术家的抑制。这张民族牌很起作用,开幕当天,每小时里有300余人涌入麦克贝斯画廊。评论家纷纷拥护展览的民族主义纲领,并将参展者称为"独立、本土的美国艺术的十字军战士"[8]。亨利在美国绘画历程中扮演了重要角色,他倡导艺术需表达"国家本土的伟大观念",激励艺术同道抛弃欧洲中心的主题,替之以一种新的城市题材,取材美国的兴旺城市与大众文娱,表现不同人种的街区生活与休闲娱乐,不落俗套。[9]然而,在观念与题材之外,他和那些后来以"垃圾箱"得名的艺术家同道却深深受惠于欧洲先驱们的风格。这也是确凿事实,当时有批评家就认为,1908年的这次展览是"这些年来纽约所见最异国化、最法式的绘画展览,跟着20年前风行法国的艺术蹒跚学步,当然称不上是'革命'"[10]。退而言之,民族主义的基调,生动而民主的题材,使得垃圾箱画家在1908年仍算得上是时代之先锋。

先锋的帽子他们一直戴到了1913年2月,直到纽约军械库展览的开幕。展览发起人中不少是亨利的追随者,因而初衷即是要彰显美国的成就。结果却恰恰相反,军械库展览成了从法国新古典主义、浪漫主义至野兽派与立体主义的一场现代艺术历程博览。在附发的展览目录上清晰地写着,任何艺术家的创作,若未有新近欧洲风格的"标识"就"落后"[11]了。以此标准衡量,美国艺术非但褊狭一方,而且低人一等。威廉·格拉肯斯(William Glackens)代表美国艺术展出,在他看来,展览暴露出"我们无一是创新者,任何有价值的东西都得自于法国艺术的影响。"[12]展览组委会创始人之一杰尔姆·迈尔斯(Jerome Myers)也有同样的感受,他扼腕道:"我们的国家比以往任何时候都更像是殖民地;我们也比以往任何时候更像乡巴佬。"[13]展览上多数美国艺术是写实的,画家奥斯卡·布鲁姆纳(Oscar Bluemner,图6)后来回顾说,即使那一小部分抽象艺术,也落后了欧洲数十年。[14]

美国艺术给人的印象就是模仿者,"取道欧洲"而非独辟蹊径,国家表达的自立复兴于是愈见迫切。[15]军械库展览三年之后,作家詹姆斯·奥本海姆(James Oppenheim)、瓦尔多·弗兰克(Waldo Frank)和凡·怀克·布鲁克斯(Van Wyck Brooks)合办了文学杂志《七艺》,以支持美国新的视觉艺术,鼓励文学的脱欧独立。《土地》的民族主义号召则更响亮,这本杂志由纽约画廊主罗伯特·科迪(Robert Coady)创办,从1916年12月一直发行到1917年7月。科迪对美国艺术受到欧洲现代艺术的影响直言不讳,他所宣扬的是"独立于欧洲各大'主义'之外的"[16]美国艺术。阿尔弗雷德·施蒂格利茨(Alfred Stieglitz)既是摄影家又是画廊主,在军械库展览之前,他本是欧洲抽象艺术在美国的主要拥护者,遂也将重心转到了审美独立上。1915年,施蒂格

section of the 1900 Exposition Universelle in Paris. The department's stated goal was to assert "a new position for the United States as an art-producing nation" without "foreign trammels."[6] To ensure the inclusion of specifically American subjects in the exposition, the department stipulated that at least seventy percent of the works representing America be made in the United States. In 1909, Congress followed suit, passing a fifteen percent tariff on imported art created within the past twenty years by non-Americans to encourage patronage of contemporary American art.

Friction between artists who looked to Europe for inspiration and those who felt it was time to forge an independent, self-consciously American art was inevitable. It came to a head in February 1908, when Robert Henri and seven fellow artists (Fig.5) opened an "outlaw salon" at the Macbeth Galleries in revolt against the National Academy, which had rejected their art from its annual exhibition.[7] Cognizant of the rising tide of nationalism in the country, Henri injected the issue into the exhibition by accusing the academy of impeding artists who were truly *American*. Playing the national card worked; on opening day, more than 300 viewers per hour crowded into Macbeth's gallery. Commentators embraced the exhibition's nationalist agenda, calling its participants "crusaders for an independent, indigenous American art."[8] Henri played an important role in American painting by advocating for an art that embodied what he called "the great ideas native to the country" and urging his fellow practitioners to replace Eurocentric themes with a new urban subject matter drawn from popular entertainments and unfashionable, ethnic neighborhoods in America's burgeoning cities and popular entertainments.[9] But apart from ideology and subject matter, he and his fellow "Ashcan" artists, as they came to be called, were deeply indebted to European stylistic precedents. Indeed, one critic called their 1908 exhibition "the most foreign, the most Frenchified show of paintings that we have seen in New York in years. Surely it is not 'revolutionary' to follow in the footsteps of the men who were the rage of artistic Paris twenty years ago."[10] Still, the nationalist rhetoric and vibrantly democratic subject matter of the Ashcan painters were enough to position them in 1908 as the era's avant-garde.

They held that title until February 1913, when the Armory Show opened in New York. Initiated by many of the artists in Henri's circle, the show's original aim had been to showcase American achievements. Instead, it became an exposition of the progression of modern art of primarily French origin from Neo-Classicism and Romanticism to Fauvism and Cubism. The message of the exhibition, as explicitly stated in the accompanying catalogue, was that any artist whose work did not "show signs" of the latest

图 6 奥斯卡·布鲁姆纳,《今年的最后一天》,约 1929 年,木板油画,14×10 英寸(35.6×25.4 厘米)。惠特尼美国艺术博物馆,纽约,茱莉亚娜·福斯捐助,31.115。

Fig.6 Oscar Bluemner, *Last Evening of the Year*, c. 1929. Oil on composition board, 14×10in.(35.6×25.4cm). Whitney Museum of American Art, New York; gift of Juliana Force 31.115.

利茨宣布他的"291"画廊不再展出欧洲作品。1917 年,"291"画廊息业,随后他的几个画廊——亲密画廊和"一个美国地方"——都只为美国艺术服务,在他看来那是"今日美国的必要部件"[17]。

20 世纪 20 年代,美国的工业、金融实力称雄世界,在国际舞台上的地位也愈显重要,创作自立的国家艺术看似是可行之举。第一次世界大战对欧洲人而言是一场浩劫,他们也经历到了美国人内战时的心理创伤。有批评家说,现在的美国人感到自己的国家"不比天杀的欧洲差",另有批评家也回应道:"我们刚刚继承了凌驾世界的傲然地位。"[18] 施蒂格利茨身边的艺术家在世纪初的那些年里汲取了欧洲抽象的养料,如摄影家保罗·斯特兰德所说,那时都将目光转到了"美国而不是其他任何地方"[19] 的题材上。对于布鲁姆纳、阿瑟·多弗(Arthur Dove)、约翰·马林(John Marin)、马斯登·哈特利(Marsden Hartley)、乔治娅·奥基弗(Georgia O'Keeffe)等人而言,自然是灵感的源泉。另一些人,比如查尔斯·德慕斯(Charles Demuth,图 7)、查尔斯·席勒(Charles

European styles had "fallen behind."[11] Judged by this criterion, American art was insular and inferior. To William Glackens, who had selected the show's American portion, the exhibition revealed that "we have no innovators here. Everything worthwhile in our art is due to the influence of French art."[12] The sentiment was echoed by Jerome Myers, a founding member of the show's organizing committee, who lamented that "more than ever before, our great country had become a colony; more than ever before, we had become provincials."[13] While most American art in the exhibition was realist, the small amount of American abstract art that was included was decades behind European developments, as painter Oscar Bluemner(Fig.6)noted in his review of the show.[14]

The impression that American art was imitative, that it was "sponging on Europe for direction" rather than developing its own path, gave urgency to renewed calls for an autonomous national expression.[15] Three years after the Armory Show, writers James Oppenheim, Waldo Frank, and Van Wyck Brooks launched *Seven Arts*, a literary journal advocating a new American visual art and literature independent of Europe. The nationalist agenda found an even stronger voice in *The Soil*, which New York gallerist Robert Coady published from December 1916 to July 1917. An outspoken critic of the influence of European modern art on American practitioners, Coady promoted an American art "free from all the 'isms' that came from Europe."[16] Photographer and gallerist Alfred Stieglitz, who had been the primary American champion of European abstraction before the Armory Show, put his weight behind aesthetic independence, announcing in 1915 that his "291" gallery would no longer exhibit work by Europeans. After "291" closed in 1917, he devoted his subsequent galleries—The Intimate Gallery and An American Place—solely to Americans whose art addressed what he called "an integral part of America today."[17]

In the 1920s, as America assumed an even greater position of importance on the international stage as the world's leading industrial and financial power, the creation of an autonomous national art seemed attainable. World War I had wreaked havoc in Europe, causing devastation of the sort that had traumatized Americans during the Civil War; now, as one critic put it, Americans felt that their country "is just as God-damned good as Europe," a sentiment echoed by another critic, who announced that "we have just fallen heir to the proud position of world supremacy."[18] Artists in Stieglitz's circle who had assimilated the lessons of European abstraction in the early years of the century turned their attention to subjects that mirrored "America and nowhere else," as photographer Paul Strand put it.[19] For those like

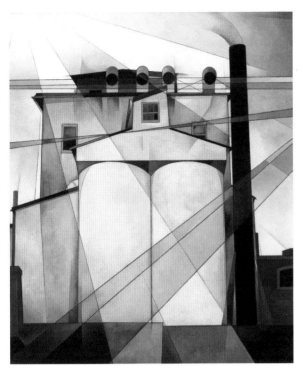

图7 查尔斯·德慕斯，《我的埃及》，1927 年，油彩、白粉、石墨、木板，35¹⁵/₁₆×30 英寸（91.3×76.2 厘米），惠特尼美国艺术博物馆，纽约，用格特鲁德·范德比尔特·惠特尼提供的捐助购买，31.172。
Fig.7 Charles Demuth, *My Egypt*, 1927. Oil, fabricated chalk, and graphite pencil on composition board, 35¹⁵/₁₆×30in. （91.3×76.2cm）. Whitney Museum of American Art, New York; purchase, with funds from Gertrude Vanderbilt Whitney 31.172.

Bluemner, Arthur Dove, John Marin, Marsden Hartley, and Georgia O'Keeffe, nature became the source of inspiration. Others, such as Charles Demuth （Fig.7）, Charles Sheeler, and Joseph Stella, looked to the monumental symbols of modern industrialization and technology.

The stock market crash in 1929 and the ensuing Depression rekindled the country's isolationism and reinstated genre scenes of everyday life as the style most appropriate to documenting the American cultural landscape. The Regionalism of Thomas Hart Benton, John Steuart Curry, and Grant Wood （Fig.8）, the American Scene paintings of artists like Reginald Marsh （Fig.9）, and the 1,100 government-sponsored murals that were commissioned for public buildings across America gave comforting, idealistic evidence of the enduring aspects of the American way of life in the face of economic catastrophe. Visual reminders of a more innocent and uncomplicated time, they answered the need for continuity and faith in America.

The pressure on artists during the Depression to aesthetically demonstrate their national credentials was intense, with debates raging between realists and abstractionists over what subjects could legitimately be called "American" and whether abstraction was or was not "foreign." The arguments heated up in 1934 after *Time* magazine identified Regionalism as *the* authentic American art movement, one that was replacing incomprehensible, foreign-based art styles. The implication was that genuine American art depicted American subjects in a style that was independent of European influence and democratically accessible. Institutionally, the debate played out in the two museums that were founded in New York City in 1929 and 1931, respectively: the Museum of Modern Art and the Whitney Museum of American Art. Although committed to the diversity and inclusiveness it felt was inherently American, the Whitney favored realism, while the Modern, rooted in the ideology of artistic progress, privileged abstraction.

With the outbreak of World War Ⅱ in Europe, whatever animosity existed over the definition of what constituted authentic American art was supplanted by the appropriation of it by the U.S. government as a marketing tool to counter Nazi propaganda. The State Department contracted with public and private-sector institutions such as the American Federation of the Arts, the Council for Inter-American Cooperation, and the National Gallery of Art to organize traveling exhibitions for distribution to Latin America and Europe of art that portrayed American life and society as harmonious and optimistic. After the war, the department appointed J. LeRoy Davidson, a former director of the Walker Art Center, to take direct charge of these programs. Conscious that European intellectuals viewed America as a cultural

Sheeler）、约瑟夫·斯泰拉（Joseph Stella）等人，关注的则是现代工业和技术等里程碑式的符号象征。

1929 年，股市崩盘，大萧条随后袭来，美国的孤立主义重新燃起，日常生活风俗情景是记录美国文化图景最恰当的方式，又重获青睐。托马斯·哈特·本顿（Thomas Hart Benton）、约翰·斯图尔特·库里（John Steuart Curry）和格兰特·伍德（Grant Wood，图 8）的乡土主义，雷金纳德·马什（Reginald Marsh，图 9）的美国情景绘画，还有在经济灾难面前，为表明美国生活方式这一理想并未消失并抚慰大众，政府在全国各地的公共建筑上出资营建了 1100 幅壁画，它们是一个更简单、更纯真年代的视觉信标，回应了不愿变化的祈求，回应了对美国的信念。

艺术家在大萧条期间的压力很大，需设法在审美上显出自己的国家身份，当时就有争论，现实主义与抽象艺术，到底谁可以正当地自称"美国"；抽象艺术到底是或不是从"他国"舶来的？论辩的升温是在 1934 年，《时代》杂志将乡土主义定为唯一正统的美国艺术运动，认为它正在取缔晦涩、外源的艺术风格。言下之意，真正的美国艺术应是以独立于欧洲，且是人人所喜的风格来表现美国题材。在体制层面，两个

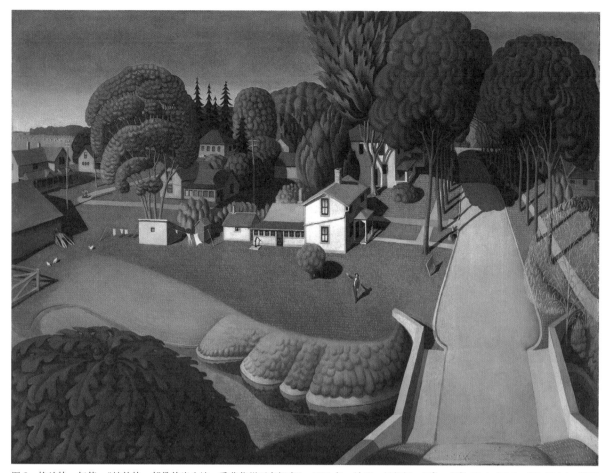

图8 格兰特·伍德，《赫伯特·胡佛的出生地，爱荷华州西布朗奇》，1931 年，油彩、纤维板，29⅝×39¾ 英寸（75.2×101 厘米），明尼阿波利斯艺术学院，由明尼阿波利斯艺术学院与德斯·莫涅斯艺术中心合力购买，由约翰·R. 范·德利普基金、霍华德·H. 弗兰克先生与艾德蒙德森艺术基金资助，81.105。

Fig.8 Grant Wood, *The Birthplace of Herbert Hoover, West Branch, Iowa*, 1931. Oil on masonite, 29⅝×39¾in.（75.2×101cm）. Minneapolis Institute of Arts, Purchased jointly by The Minneapolis Institute of Arts and the Des Moines Art Center; with funds from the John R. Van Derlip Fund, Mrs. Howard H. Frank, and the Edmundson Art Foundation, Inc., 81.105.

博物馆在纽约的建立平息了这场争论，它们分别是 1929 年落成的现代艺术博物馆与 1931 年落成的惠特尼美国艺术博物馆。惠特尼虽致力于艺术的多元与兼容，却以美国为核心，偏爱写实，现代艺术博物馆则以艺术进步之意识形态为根基，偏好抽象。

第二次世界大战在欧洲爆发之后，不论对定义正统美国艺术由何组成的做法有多少嫌恶，这时都噤声了，它成了美国政府的营销工具，用来对抗纳粹的宣传。国务院与美国艺术联盟、美洲联合委员会、国家艺术博物馆等诸多公立、私立机构订下合约，组织巡回展览，将艺术传播到拉丁美洲和欧洲。在这些作品里，美国生活和谐融洽，社会蒸蒸日上。"二战"之后，国务院任命沃克艺术中心前主管 J. 勒罗伊·戴维森（J. LeRoy Davidson）直接统领这些项目。戴维森知道在欧洲知识分子眼中的美国是文化荒地，便决定组织一场激进绘画的巡回展览，呈现美国艺术高雅与创新的面貌。他不租

wasteland, Davidson determined to present American art as sophisticated and innovative by organizing a traveling show of progressive American painting. Rather than borrow work, he decided to buy it, reasoning it would reduce costs and allow him to tour the show for five years—longer than most lenders would allow their works to travel. He purchased seventy-nine oils from a wide array of artists, both realist and abstract, including Marsh, Davis, Louis Guglielmi, Ben Shahn, and Yasuo Kuniyoshi. *Advancing American Art,* as the exhibition was titled, demonstrated how far the United States had come as an innovative force in art, but it contained few examples of art that "made Americans feel comfortable about America."[20] After the show's inaugural opening at New York's Metropolitan Museum of Art, it was divided into two parts and sent to Latin America and Europe. The initial stops in both hemispheres were unqualified successes. However, reaction at home was a different matter. Attacks in the popular press began shortly after the

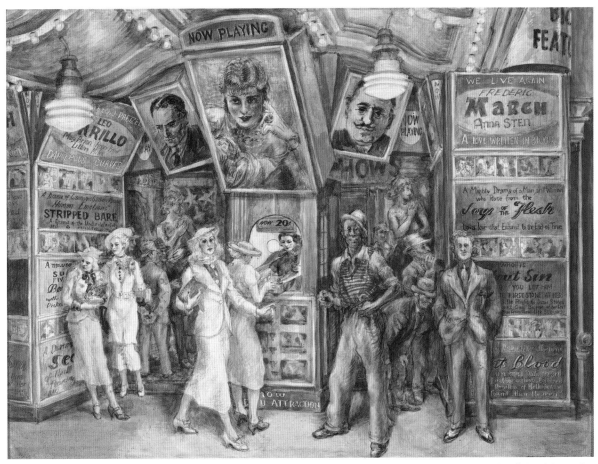

图9 雷金纳德·马什，《20 美分电影》，1936 年，炭笔、墨水、油彩、木板，30×40 英寸（76.2×101.6 厘米），惠特尼美国艺术博物馆，纽约；购买 37.43a-b. © 2013 雷金纳德·马什、纽约艺术学生联盟、纽约艺术版权协会（ARS）财产。

Fig.9　Reginald Marsh, *Twenty Cent Movie*, 1936. Carbon pencil, ink, and oil on composition board, 30×40in.（76.2×101.6cm）. Whitney Museum of American Art, New York; purchase 37.43a-b. © 2013 Estate of Reginald Marsh / Art Students League, New York / Artists Rights Society（ARS）, New York.

借作品，都是直接出手买下，一共购得 79 件，一来省下不少费用；二来他要巡回展览五年，大多数出借方都难以允诺这么长的租期。这些作品写实与抽象并重，涉及很多艺术家，其中包括马什、戴维斯、路易斯·古列尔米（Louis Guglielmi）、本·沙恩（Ben Shahn）和国吉康雄（Yasuo Kuniyoshi）等。展览定名为"前进，美国艺术"，顾名思义，为的是显示美国艺术的创新实力如何强大。然而在展览中，却少有作品"能让美国人舒心地感受美国"[20]。在纽约大都会博物馆开幕之后，展览一分为二，分别在拉丁美洲和欧洲巡展，地球两边巡回的首站都谈不上成功。然而，家门内的反应却很剧烈。大都会博物馆刚一开展，大众媒体的抨击就紧随而至，1947 年 2 月刊发的《看》上登出一篇贬损的文章，并从保守的赫斯特报业集团那里摘编过来两个版的插图。记者们批评这些绘画是费解的，非美国的。其中就有人写道："国务院这些收藏的根基……不在美国，而扎根在欧洲外来的文化、观念、哲学与弊病中……（作品）让

exhibition opened at the Metropolitan, with *Look* magazine running a derogatory article accompanied by a double-page spread of illustrations in its February 1947 issue that was picked up in syndication by conservative Hearst newspapers. Reporters criticized the paintings as incomprehensible and un-American. One critic wrote that "（the） roots of the State Department collection... are not in America—but in the alien cultures, ideas, philosophies and sickness of Europe...（the work gives） the impression that American is a drab, ugly place, filled with drab, ugly people."[21] Another critic claimed that the paintings were a blunt attempt to "uproot all that we have cherished as sacred in the American way of life."[22] The criticism prompted letters from irate citizens to congressmen complaining about the use of government tax money. Even President Harry Truman got involved, opining about Kuniyoshi's portrait of a circus girl （Fig.10）: "If that's art, I'm a Hottentot."[23] The ensuing congressional investigation resulted in the House Appropriations Committee voting to cut off funding for the show's

图 10　国吉康雄，《正在休息的马戏团女孩》，约 1925 年，39¼×28¾ 英寸（99.7×73 厘米），前进美国艺术收藏会，茱尔·柯林斯·史密斯美术馆、奥本大学，艺术 © 国吉康雄财产、VAGA 授权，纽约。

Fig.10　Yasuo Kuniyoshi, *Circus Girl Resting*, c. 1925. Oil on canvas, 39¼×28¾in.（99.7×73cm）. Advancing American Art Collection, Jule Collins Smith Museum of Fine Art, Auburn University. Art © Estate of Yasuo Kuniyoshi/Licensed by VAGA, New York, NY.

人觉得美国是一个阴沉、丑陋的地方，里面住着的都是阴沉、丑陋的民众。"[21] 还有批评家放言，这些绘画是要直愣愣地将"美国生活方式中的神圣美好连根拔除"[22]。这些批评煽动了愤怒的群众，也刺激了国会议员，他们写信谴责政府对税款的使用。甚至总统哈里·杜鲁门（Harry Truman）也掺和一手，他评论国吉康雄的一幅马戏团女孩的肖像（图 10）时说："这要是艺术，我就是个霍屯督人（译者注：霍屯督人是非洲南部的一个种族集团）。"[23] 随后，国会开展了调查，众议院拨款委员会投票裁减了展览巡回的资金，并威胁说要废除国务院的艺术项目。一波接一波的攻势最终说服国务院召回了两个展览，并在 1948 年卖掉了这些展品。

　　矛盾的是，正是在保守艺术组织们斥责进步的写实艺术"不美国"的时候，美国的先锋艺术世界里，有一支抽象风格却日益壮大，他们以普世主义之名，超越了国家、种族与阶级的界限。他们是杰克逊·波洛克（Jackson Pollock）、威廉·德·库宁（Willem de Kooning）、巴尼特·纽曼（Barnett Newman）和马克·罗斯科（Mark Rothko）等画家，集结在"抽象表现主义"的标语之下，不讲故事，不涉及特定题材，倾心于描绘意识的抽象状态。抽象表现主义遵从自发与自由的表达，因而它在对抗苏联文化扩张的心理战争中成了一把称手的利器。[24]在整个 20 世纪 50 年代，美国政府资助博物馆和私人组

tour and threatening to abolish the State Department's art program. The continuing attacks ultimately convinced the department to recall the two exhibitions and sell their contents, which it did in 1948.

Paradoxically, at the same time that conservative art groups were vilifying progressive realist art as "un-American," the vanguard art world in the U.S. was developing an abstract style that aimed to transcend national, ethnic, and class distinctions in the name of universality. Painters such as Jackson Pollock, Willem de Kooning, Barnett Newman, and Mark Rothko, grouped under the rubric "Abstract Expressionism," dispensed with storytelling and references to specific subject matter in favor of depicting abstract states of consciousness. Abstract Expressionism's dependence on spontaneity and freedom of expression made it an apt tool in the psychological fight against Soviet cultural expansion.[24] Throughout the 1950s, the U.S. government subsidized museums and private organizations to organize shows of Abstract Expressionism to send all over Europe. Within America itself, the verdict on Abstract Expressionism was more polarized, with institutions like the Whitney put off by the style's absence of recognizable subjects and its links to the formal practices and existential themes of European art. A decade later, Pop Art answered the burgeoning need for an art that was both self-consciously American and wholly modern by using hard-edged American advertising

织策划了很多抽象表现主义展览，并将它们送往欧洲各地。但在美国本土，对抽象表现主义还有另一种极端的看法，惠特尼这样的机构就反感这种缺乏可辨对象的风格，反感它跟欧洲艺术的形式探索与存在主义主题的关联。艺术既要有美国的自觉，又需是彻底的现代，这样的要求越来越强势，十年后，波普艺术终于做到了两全其美，它用硬边的美国广告技法来描绘流行文化中的图像，通常还带些批判色彩。无论在美国国内，还是国外，波普艺术都迅速成了媒体焦点，人们原本对西方艺术中心迁到美国的说法还疑虑重重，这下疑云散尽。有了波普艺术，固守地方与模仿他国之间的审美波动也停了下来。美国人第一次在自己的艺术里体验到了安全感。1964 年，罗伯特·劳申伯格（Robert Rauschenberg）在威尼斯双年展上获得大奖，也只是让人更确信了这些既成事实。

在 20 世纪后期，美国的审美霸权在国际上还都畅行无阻，直到后现代主义与全球化汇成合力，永远地扭转了艺术与国家身份的概念，迫使美国的美术馆开始反思自己的使命。全球化经济中，传统的艺术中心为跨国画廊与艺术展会的网络所取代，交通与信息技术转变了观念交流的形态，早先对美国艺术组成的确凿理解轰然崩塌了。不再有人把它看成只是美利坚公民创作的艺术。在很多致力美国艺术的博物馆中，惠特尼就是一个例子，它办了很多展览，参展艺术家有的在美国生活，有的只在美国待过，但都不是美国公民。我们会把 19 世纪的萨金特、惠斯勒和卡萨特看作美国艺术家，尽管他们大半人生都在国外度过，同样，那些出身他国，只与美国有些联系的艺术家，现在我们觉得参与展览也无可厚非。借此，美国博物馆拓展了美国艺术的定义，而且还不限于此。历史上，只有欧洲裔的美国艺术家受到重视，最近几十年里，博物馆的大门则向所有人群的作品大方敞开，包括我们漠视了很久的"工艺"或"民间艺术"。此外，从 20 年内很多的临时展里可以看到，美国博物馆齐心协力地在填补自己收藏中美国亚裔、美国拉丁人、美国土著和美国黑人之间的沟壑，在讲述他们的国家身份及其多重性时，故事才可以更宽容、更真实。美国自古就是多民族的熔炉，在经济、政治、科学和技术层面都是如此，艺术也不例外。作为移民国家，我们把自己看成一个民族，包容性长久以来都是核心。早在 1864 年，美国批评家詹姆斯·杰克逊·贾夫斯（James Jackson Jarves）写道："我们是一个混合的民族。我们的知识是折中的……艺术与其他文化一样，一直也都是折中的。为获得艺术财富，从各个来源习得先例、学识和想法……这是登上艺术巅峰的正确途径。"[25] 这一观点当时正确，现在也没有错。

techniques to depict images from American popular culture, often with subtle critical overtones. The art became an instant media sensation, both at home and abroad, putting to rest any lingering doubt that the center of Western art had migrated to the United States. With Pop Art, the aesthetic swings between provincialism and imitation ceased. For the first time, Americans felt secure about their art. Robert Rauschenberg's receipt of the grand prize at the 1964 Venice Biennale simply confirmed what had become a reality.

American aesthetic hegemony prevailed internationally until the late twentieth century, when the combination of post-modernism and globalization immutably changed notions about art and national identity, causing American art museums to rethink their mandate. In a global economy in which traditional art centers are being replaced by networks of multinational galleries and art fairs, and travel and information technology are transforming the exchange of ideas, earlier definitions of what constituted American art have collapsed. No longer is it seen as something made exclusively by citizens of the United States. The Whitney, as one example among many museums dedicated to American art, has mounted a number of exhibitions of artists who live, or have lived, in the United States but are not citizens. Just as the nation considered nineteenth-century artists such as Sargent, Whistler, and Cassatt to be Americans despite their having lived abroad for most of their lives, so now do we consider it appropriate to showcase the work of artists from other countries with connections to America. This is not the only way American museums have broadened their definition of American art. Whereas historically the primary focus had been on American artists of European descent, the past several decades have seen the doors of American art museums opened to include the work of all populations and demographics, as well as work long dismissed as "craft" or "folk art." In addition to temporary exhibitions, the past two decades have seen a concerted effort by American museums to fill gaps in their holdings of Asian American, Latino American, Native American, and African American artists in order to be able to tell a more inclusive and true story about the nation and the multiple identities of its people. America has always been a melting pot of nationalities, in art no less than in economics, politics, science, and technology. As a nation of immigrants, inclusivity has long been at the heart of who we are as a people. As early as 1864, American critic James Jackson Jarves wrote: "We are a composite people. Our knowledge is eclectic... It remains, then, for us to be as eclectic in our art as in the rest of our civilization. To get artistic riches by virtue of assimilated examples, knowledge, and ideas drawn from all sources... is our right pathway to consummate art."[25] The sentiment is as true now as then.

Notes:

1 Quoted in Oliver W. Larkin. *Art and Life in America.* New York: Rinehart, 1949. 217; Jules David Prown. *American Painting: From Its Beginning to the Armory Show.* Geneva: Skira, 1969. 81.

2 Charles Baudelaire. In：Benita Eisler. *The Red Man's Bones.* New York: W. W. Norton & Company, 2013. 326.

3 William C. Brownell. "The Younger Painters of America, First Paper". *Scribner's Monthly* 20. 1880（Mag）：1; Linda S. Ferber. "Albert Bierstadt: The History of a Reputation" In：Nancy K. Anderson Linda S. Ferber. New York: The Brooklyn Museum, 1990. 60-61.

4 H. Barbara Weinberg. "Cosmopolitan Attitudes: The Coming of Age in American Art". In：Annette Blaugrund.*Paris 1889: American Artists at the Universal Exposition.* New York: Harry N. Abrams for the Pennsylvania Academy of the Fine Arts, 1989. 36; Darrell Sewell. "Thomas Eakins and American Art". In：Darrell Sewell.*Thomas Eakins* Philadelphia: Philadelphia Museum of Art, 2001. xx.

5 Henry James."John S. Sargent". *Harper's Magazine,* 1887（10）；Sewell, xx.

6 John B. Cauldwell. "Report of the Department of Fine Arts" *Report of the Commissioner-General for the United States to the International Universal Exposition, Paris, 1900* Washington, D.C.: Government Printing Office, 1901.（2）：513-514; Diane P. Fischer. "Constructing the 'American School' of 1900". In: *Paris 1900: The "American School" at the Universal Exposition.* New Brunswick, New Jersey and London: Rutgers University Press for the Montclair Art Museum, 1999. 1; Sewell, xxii.

7 In reality, Robert Henri's art had been accepted; it was that of his students and friends that was rejected.

8 William Innes Homer. "The Exhibition of 'The Eight': Its History and Significance". *American Art Journal* 1969（1）：53; Elizabeth Milroy. *Painters of a New Century: The Eight & American Art.* Milwaukee: Milwaukee Art Museum, 1991. 15.

9 Robert Henri. "Progress in Our National Art". *Craftsman* 15. 1909（1）.387.

10 William B. McCormick. "Art Notes of the Week". *The New York Press,* February 9, 1908;Milroy, 48.

11 Frederick James Gregg, Preface to *The International Exhibition of Modern Art.* New York: Association of American Painters and Sculptors, 1913.

12 William Glackens. In: Lloyd Goodrich. *Pioneers of Modern Art in America: The Decade of the Armory Show, 1910–1920.* New York: Whitney Museum of American Art, 1963. 30.

13 Jerome Myers. In :Bruce Altshuler. *The Avant-Garde Exhibition: New Art in the 20th Century.* New York: Harry N. Abrams, 1994. 62.

14 Oscar Bluemner. "Audiator et Altera Pars: Some Plain Sense，on the Modern Art Movement". *Camera Work* special number，1913（7）. 27.

15 Paul Rosenfeld. *Port of New York: Essays on Fourteen American Moderns.* New York: Harcourt, Brace, 1924. 294; Wanda Corn. *The Great American Thing: Modern Art and National Identity, 1915–1935.*Berkeley: University of California Press, 1999. 9.

16 Robert Coady. In :Menno Hubregtse. "Robert J. Coady's *The Soil* and Marcel Duchamp's *Fountain*: Taste, Nationalism, Capitalism, and New York Dada". *RACAR* 34, No. 2（2009）：29.

17 Alfred Stieglitz. In :Sarah Greenough. *Modern Art and America.* Washington, D.C.: National Gallery of Art, 2001.306

18 Malcolm Cowley. *Exiles Return.* New York: Penguin Books, 1976.107; Henry McBride. "Art News and Reviews". *New York Herald*, October 15, 1922, sec. 7, 6; Daniel Catton Rich, ed. *The Flow of Art: Essays and Criticisms of Henry McBride.* New York: Atheneum Publishers, 1975.165.

19 Paul Strand. "Reviewing December 1921". *The Arts* 2, 1922（1）：151.

20 Edward Bruce. In：Richard D. McKinzie. *The New Deal for Artists.* Princeton, New Jersey: Princeton University Press, 1973. 57.

21 "Exposing the Bunk of So-Called Modern Art," *New York Journal American.* December 3, 1946; Margaret Lynne Ausfeld. "Virginia M. Mecklenburg. Circus Girl Arrested: A History of the *Advancing American Art* Collection, 1946–1948". *Advancing American Art: Politics and Aesthetics in the State Department Exhibition, 1946–1948* Montgomery, Alabama: Montgomery Museum of Fine Arts, 1984. 19.

22 "Hottentot" is a derogatory term once used to refer to people from Southern Africa; *Congressional Record* 93, No. 4. April 30, 1947–May 20, 1947: 5221.

23 Letter, President Harry S Truman to William Benton, April 2, 1947, RG PPF-45F, Harry S Truman Archives, Independence, Missouri; quoted in Ausfeld, 20.

24 In 1952, President Dwight Eisenhower discussed the use of culture for propaganda purposes, noting that it was a means of "psychological warfare"; Serge Guilbaut. *How New York Stole the Idea of Modern Art: Abstract Expressionism, Freedom and the Cold War.* Chicago and London: The University of Chicago Press, 1983. 205.

25 James Jackson Jarves, *The Art-Idea.* 1864. 197-198; John I. H. Baur *Revolution and Tradition in Modern American Art.* Cambridge, Massachusetts: Harvard University Press, 1951.151.

Suggestions for Further Reading:

[1] Altshuler Bruce. *The Avant-Garde Exhibition: New Art in the 20th Century*. New York: Harry N. Abrams, 1994.

[2] Anderson, Nancy K., et al. *Albert Bierstadt: Art & Enterprise*. New York: Brooklyn Museum/Hudson Hills Press, 1990.

[3] *Art Interrupted: Advancing American Art and the Politics of Cultural Diplomacy*. Athens, Georgia: Georgia Museum of Art, University of Georgia, 2012.

[4] Ausfeld, Margaret Lynne, et al. *Advancing American Art: Politics and Aesthetics in the State Department Exhibition, 1946—1948*. Montgomery, Alabama: Montgomery Museum of Fine Arts, 1984.

[5] Blaugrund Annette. *Paris 1889: American Artists at the Universal Exposition*. New York: Harry N. Abrams for the Pennsylvania Academy of the Fine Arts, 1989.

[6] Corn Wanda. *The Great American Thing: Modern Art and National Identity, 1915—1935*. Berkeley: University of California Press, 1999.

[7] Eisler Benita. *The Red Man's Bones*. New York: W. W. Norton & Company, 2013.

[8] Fischer Diane P. *Paris 1900: The "American School" at the Universal Exposition*. New Brunswick, New Jersey and London: Rutgers University Press for the Montclair Art Museum, 1999.

[9] Goodrich Lloyd. *Pioneers of Modern Art in America: The Decade of the Armory Show, 1910—1920*. New York: Whitney Museum of American Art, 1963.

[10] Greenough Sarah. *Modern Art and America*. Washington, D.C.: National Gallery of Art, 2001.

[11] Groseclose, Barbara S. *Nineteenth-Century American Art*. New York: Oxford University Press, 2000.

[12] Guilbaut Serge. *How New York Stole the Idea of Modern Art: Abstract Expressionism, Freedom, and the Cold War*. Trans. Arthur Goldhammer. Chicago and London: The University of Chicago Press, 1983.

[13] Haskell Barbara. *The American Century: Art & Culture 1900—1950*. New York: Whitney Museum of American Art, 1999.

[14] Howat John K. *American Paradise: The World of the Hudson River School*. New York: Metropolitan Museum of Art, 1987.

[15] Kushner, Marilyn, et al. *The Armory Show at 100: Modernism and Revolution*. New York: New-York Historical Society, 2013.

[16] Milroy Elizabeth. *Painters of a New Century: The Eight & American Art*. Milwaukee: Milwaukee Art Museum, 1991.

[17] Novak Barbara. *Nature and Culture: American Landscape and Painting, 1825—1875*. New York: Oxford University Press, 1980.

[18] Phillips Lisa. *The American Century: Art & Culture, 1950—2000*. New York: Whitney Museum of American Art, 1999.

[19] Prown, Jules David. *American Painting: From Its Beginning to the Armory Show*. Geneva: Skira, 1969.

[20] Sewell Darrell. *Thomas Eakins*. Philadelphia: Philadelphia Museum of Art, 2001.

[21] Weinberg, H. Barbara, et al. *American Stories: Paintings of Everyday Life, 1765—1915*. New York: Metropolitan Museum of Art, 2009.

积习难除：波士顿美术馆的地域性及其博物馆实践
Old Habits Die Hard: Locality and Museum Practice at Boston's Museum of Fine Arts

佩吉·莱维特　于小漫 * 　译

Peggy Levitt　　Translator: Yu Xiaoman

探讨博物馆与社区间的关系变化，我们需要将地域性考虑在内。在本文中，我会讨论城市的文化枢纽、国家及城市的机构分工，以及国家对自己在全球角色的历史理解与当代理解对博物馆的强烈影响，影响了它对国家及其地域在世界视野中的表现，也限定了它可行的改变。

尽管策展人们斩钉截铁地说，要把美国的艺术故事讲得更多元、更国际化，但在波士顿美术博物馆新建的美洲艺术展区里，国家赞歌依旧最为嘹亮。这符合观众对博物馆的期待——一直以来它在城市和国家文化景观中扮演的就是这个角色。博物馆是私人资金捐助的，因而它必须继续取悦那最忠诚的游客和捐助人。

此外，波士顿的文化枢纽以及它根深蒂固的价值观，也限制了博物馆在多大程度上可以做出改变。波士顿的创始人并没有严肃地对待世界主义，却强调他们是各国的行为榜样。他们觉得应该对"教化"的广大民众负责，却严格禁止他们进入到自己的圈子中。

人口统计学也允许美术馆继续这样来讲故事。到2010 年，外国出生的人占波士顿人口的 27%；他们主要来自亚洲和拉丁美洲，但这是最近的状况。在 20 世纪 80 年代，外国出生的大部分城市居民来自欧洲，他们在总人口中所占比例要小得多。[1] 同时，波士顿继续在居住隔离程度的榜单上名列前茅。在全美国黑白人种居住隔离最严重的大城市中，它位居第十一。亚裔隔离程度在都会地区里排名第五。而西班牙与白人隔离程度排第四，仅次于洛杉矶、纽约和纽瓦克。[2] 直到最近，要讲一个不一样的故事，其需求还潜伏在城市人口变化中，还未显露出来。城市文化机构要应对不断变化的种族和民族构成，如今的压力更大，但持续严重的居住区分化告诉我们前路依旧漫漫。将古代美洲的藏品摆在美洲艺术新区的显著位置，让更多背景的艺术家进到常规陈列里，是朝着正确方向迈出的一步。

Discussions about the changing relationship between museums and their communities need to take the role of locality into account. In this article, I argue that the urban cultural armature, the national and municipal institutional distribution of labor, and how the nation perceives its historical and contemporary global role strongly influence how museums represent the nation and its place in the world and also limit the extent to which museums can change what they do.

Despite firm commitments by curators to diversify and internationalize the American art story, the new Art of the Americas Wing at the Museum of Fine Arts in Boston is still overwhelmingly a celebration of the nation. Visitors expect this from the institution—it has long been the role it has played in the urban and national cultural landscape. Because the museum is privately funded, it must continue to please its most loyal visitors and benefactors.

Moreover, Boston's cultural armature, and the deeply held values upon which it is based, also limits the extent to which the museum can change course. Boston's founders flirted with cosmopolitanism while strongly asserting their position as a role model for the rest of the world. They felt responsible for "civilizing" the teeming masses but strictly forbade them from entering their clubs.

Demography also allowed the MFA to continue to tell a certain kind of story. By 2010, the foreign-born made up twenty seven percent of Boston's population; they came primarily from Asia and Latin America. But such diversity is a fairly recent development. Right through the 1980s, most of the city's foreign-born inhabitants were European-origin, and they constituted a much smaller proportion of the population.[1] Boston also continues to rank high on measures of residential segregation. Among the nation's big cities, it is number 11 among the places with the most extreme residential segregation between blacks and whites. The metro area

* 于小漫 北京市石景山业大社区学院美术教师（Yu Xiaoman Beijing Shijingshan Community College Art Teacher）

重新定义美洲艺术

"当你走进美洲艺术新展区",波士顿美术馆(MFA)美洲部主任埃利奥特·博斯特威克·戴维斯(Elliot Bostwick Davis)告诉我,"首先映入眼帘的是五个壮观的基切葬瓮,公元 750 年前后由危地马拉高原南部的玛雅人制作而成。玛雅文化高度发达,有自己的宫廷仪式、肖像绘制等。我们希望人们能如其本然地看到古老美洲艺术和美国土著艺术。"(图 1)[3] 博物馆策展人员还想让人们知道,美洲艺术不是凭空出现的。即使在早期,古代美洲的艺术匠人也会受到周边群落的影响。它是在与其他文化的交流中生根发芽的。

"我们要给这些艺术提供怎样的住处,这是我感兴趣的",该馆负责美国绘画的资深策展人艾丽卡·赫斯勒(Erica Hirshler)这么说道,她在那里供职已经近 30 年了,"在 20 世纪 80 年代,我最初来这里的时候,当我们谈论殖民艺术,谈论的是新英格兰和盎格鲁文化,

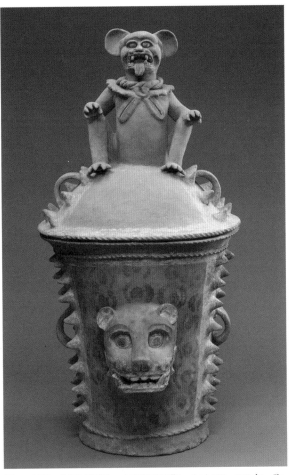

图 1 玛雅,《基切葬瓮》,古典时代晚期,公元 650—850 年,陶,26⁹/₁₆ × 25 英寸(67.5×63.5 厘米),1987.723B,照片版权 © 2014 波士顿美术馆。

Fig.1 Maya, *K'iché Burial or Cache Urn Base.* Late Classic Period, A.D. 650-850, Ceramics. $26^{9}/_{16} \times 25$ in. (67.5×63.5cm). 1987.723B. Photograph © 2014 Museum of Fine Arts, Boston.

ranks fifth in Asian-white segregation. In Hispanic-white segregation, it is fourth, behind only LA, New York, and Newark.[2] Until fairly recently, then, the need to tell a different story that was latent in the city's changing demography, has been fairly limited. The city's cultural institutions are now under more pressure to respond to its shifting racial and ethnic makeup, but its persistently high levels of residential segregation reveal that it still has a long way to go. Featuring the Ancient American collection so prominently in the new Art of the Americas wing, and including artists of more diverse backgrounds in the installation, was a step in the right direction.

Redefining the Art of the Americas

"The first thing you see when you walk into the new Art of the Americas Wing", Elliot Bostwick Davis, Chair of the Art of the Americas Department at Boston's Museum of Fine Arts (MFA), told me, "are five spectacular K'iché burial urns, produced by the Maya in the southern highlands of Guatemala in about 750 AD. These were produced by a highly sophisticated culture, with its own court rituals, portraiture, (and so on). We wanted people to see ancient American art and Native American art on their own terms." (Fig.1)[3] The Museum's curators also wanted people to realize that American art never developed in a vacuum. Even early on, links with neighboring societies influenced these Ancient American artisans. The roots of American art grew out of conversations with other cultures.

"What is interesting to me", said Erica Hirshler, the Senior Curator of American Paintings, who has worked at the museum for nearly 30 years, "is to see what kinds of real estate are being given to different kinds of art. When I first came here in the 1980s, when we talked about colonial art, we were talking about New England and Anglo culture. We were talking about Copley and his relationship with England…In the new wing, for the first time, we have a Spanish colonial gallery, and that is a huge change for us. It sounds like it shouldn't be, but it is for Boston, a kind of bastion of Anglo culture, to acknowledge that there was a huge colonial presence somewhere else."[4]

The story of American art's porous boundaries runs through all four floors of the Museum's new wing. When visitors see Paul Revere's iconic Sons of Liberty Bowl (Fig.2), commemorating the Boston Tea Party's organizers, they are supposed to recognize that it has a lot in common with the Chinese punch bowls made during the same period. "Almost any piece of silver in the last half of the 18^{th} century," said Dennis Carr, Assistant Curator of Decorative Arts and Sculpture, "would have been Chinese inspired."[5]

谈论的是科普利与英国的关系……在这个新展区，我们第一次有了一个西班牙殖民地画廊，这是一个巨大的改变。波士顿，这个盎格鲁文化的堡垒，承认自己殖民地的一面，听起来好像早应该这样。"[4]

关于美国艺术渗透性边界的故事贯穿于博物馆的整个四层新展区。当游客看到保罗·里维尔（Paul Revere）标志性的自由之碗（图2），纪念这位波士顿倾茶事件的组织者时，他们应该也认识到，它与同一时期中国大酒碗有很多共同之处。"在18世纪后半叶，几乎每一片银的使用都受到中国的启发。"[5] 装饰艺术和雕塑助理策展人丹尼斯·卡尔（Dennis Carr）说。同样，在三层的游客可以看到约翰·辛格·萨金特（John Singer Sargent）画的肖像（图3），大多数人都认为他是典型的美国画家。但萨金特是美国侨民，1856年出生在佛罗伦萨，童年他环游欧洲，甚至直到20岁才踏上美国领土。显然他不仅是一位美国画家，也是一位世界的公民。

"美国艺术与南北邻国的艺术是紧密相连的"，博斯特威克·戴维斯（Bostwick Davis）说，"这是新展区要给我们传达的讯息，它与这个国家的其他美国艺术展区相当不同，因它涵盖我们所能追溯的最久远的文化，再加上人类碰巧降落到这个星球上时留下的一些古物。所以，我们将北部、中部和南部看成一个统一体。人们边走边可以感受到层次性和丰富性，我希望每个人对关于什么是美国人有开放的认识。"[6]

波士顿美术馆开始收集古代美洲艺术品是在19世纪后半叶。但美术馆古代美洲艺术部主任多里·瑞恩－博迪特（Dorie Reents-Budet）仍承认与其他馆藏相比这部分还是薄弱。直到新展区落成了，还没有常任的策展人，因为普遍观念是，"棕色人种的东西很少，你知道，

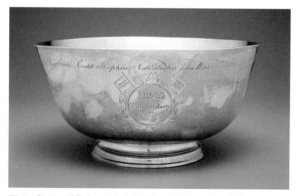

图2　保罗·里维尔，《自由之碗》，1768年，银，整体：5$\frac{1}{2}$×11英寸（14×27.9厘米）；基座：5$\frac{13}{16}$英寸（14.8厘米），照片版权© 2014波士顿美术馆。
Fig.2　Paul Revere, Sons of *Liberty Bowl*, 1768. Silver Holloware, overall: 5$\frac{1}{2}$×11in.（14×27.9cm）; other（Base）: 5$\frac{13}{16}$in.（14.8cm）, Museum of Fine Arts, Boston; 49.45. Photograph © 2014 Museum of Fine Arts, Boston.

Similarly, portraits by John Singer Sargent, who most people consider a quintessential American painter, greet visitors on the third floor（Fig.3）. But Sargent, born to American expatriates in Florence in 1856, spent his childhood traveling around Europe, and did not even set foot on U.S. soil until he was twenty. Clearly he was not just an *American* painter but also a citizen of the world.

"One of the messages of the new wing," said Bostwick Davis, "is that American art is intimately connected to its neighbors to the north and south. The wing is very different from every other wing of American art in the country because it includes the ancient cultures as far as we can go back, plus what we have from where we happened to land on this planet. So we are going north, central, and south to work with that as a continuum. We walk people through so they get a sense of this layering and richness, and I hope for each individual there is an opening of the mind（regarding）what is American."[6]

The MFA first started collecting Ancient American art in the late 1800s. Still, Dorie Reents-Budet, Curator of the MFA's Art of the Ancient Americas, admits that the collection is weak compared to the museum's other holdings. Until the new Wing became a reality, there was no permanent curator because the prevailing attitude held that "it's little brown people stuff, you know, it's not art… There are still many museums in the United States that have the pre-Colombian collections in the 'Hall of Man,'" representing "the 19th century attitude about non-Western cultures as being objects of study, of scientific inquiry into the science of human development rather than art."[7]

So why did Museum of Fine Arts' curators decide to feature this collection so prominently now? How does its retelling of the American art story succeed and where does it come up short? What can this tell us about possible constraints on changing museum practice?

Staff at the MFA see themselves as radically retelling the story of American art. In many ways, for this institution, they are. The new wing features Ancient and Native American materials more prominently, includes a Spanish colonial gallery, and showcases more works by Black, women, and Latino artists. But you have to look for them. The retelling is subtle and often overshadowed by the sheer volume of material from Colonial New England. The MFA exemplifies how locality constrains just how post-colonial museums can become. The cultural structures laid down by the city's founding fathers, and what my colleagues and I call the urban cultural armature（a city's social and cultural policies, institutions, demography, and endowments）still strongly influence how museums represent the nation in the world.[8] The organizational distribution of labor for representing his-

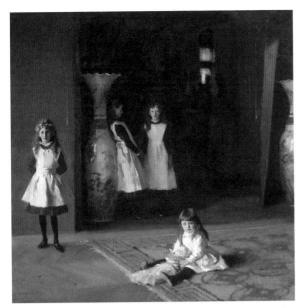

图 3 约翰·辛格·萨金特,《爱德华·达雷·博伊特的女儿们》,1882 年,布面油画,87³/₈ × 87⁵/₈ 英寸(221.9 × 222.6 厘米),波士顿美术馆,玛丽·路易莎·波伊特、茱莉亚·欧弗林·波伊特、简·休巴德·波伊特、弗罗伦斯·D.波伊斯以纪念父亲爱德华·达雷·波伊特捐赠,19.124,照片版权 © 2014 波士顿美术馆。

Fig.3 John Singer Sargent, *The Daughters of Edward Darley Boit*, 1882. Oil on canvas, 87³/₈×87⁵/₈ in. (221.9×222.6cm). Museum of Fine Arts, Boston; gift of Mary Louisa Boit, Julia Overing Boit, Jane Hubbard Boit, and Florence D. Boit in memory of their father, Edward Darley Boit, 19.124. Photograph © 2014 Museum of Fine Arts, Boston.

它不是艺术……在美国仍有许多博物馆的'人类大厅'放着前哥伦比亚时期的藏品",代表了"19 世纪对待非西方文化的态度,它们是供研究的东西,用来科学考察人类的发展,而不是艺术。"[7]

那么为什么波士顿美术馆的策展人现在却如此重视这些收藏?它怎样成功复述了美国艺术的故事,又存在哪些不足?博物馆实践的变革可能将会遇到什么壁垒?

美术馆的馆员们认为自己彻底把美国艺术故事重讲了一遍。对这个机构而言,在很多方面也确实如此。新展区使得古代与土著美洲的藏品更加显著,其中有一个西班牙殖民画廊,对黑人、女性、拉丁裔艺术家的作品则有更多展示。但你在展区中必须寻找才能看到他们。复述是微妙的,与来自于殖民地的新英格兰地区的作品比起来这种复述经常相形见绌。美术馆呈现了后殖民博物馆如何受地域的约束。文化结构如何由城市的开创者,以及我和我的同事所说的城市文化枢纽(一个城市的社会和文化政策、机构、人口和捐赠基金)建构,他们极大地影响了博物馆如何呈现国家。[8]在城市和国家内部,代表历史的劳动组织的分布,也限制了博物馆所表达的内容。

tory, within the city and within the nation, also constrains what stories the museum can tell.

Why Here, Why Now?

The idea of placing Ancient American art at the root of the American art story grew out of a happy convergence of factors. When MFA Director Malcolm Rogers arrived in 1992, he reorganized departments to promote communication across mediums and among the people in charge of them. He combined American Paintings and Decorative Arts, folding in some of the Latin American materials that had been included previously in Europe. Also placed under the "American" umbrella was the Ancient American collection, which had never before had a home of its own.

Demography also came into play. The U.S. is well on its way to becoming a majority-minority country. In 2008, the American Association of Museums launched its Center for the Future of Museums. Its first report, *Museums and Society 2034: Trends and Potential Futures*, illustrated the widening gap between American and museum visitor demographics.[9] Before 1970, minorities made up ten to thirteen percent of the U.S. population, but by 2008, the figure had risen to thirty four percent and was predicted to reach forty six percent by 2033. Yet, only nine percent of museums' core visitors were minorities. The report, according to founding Director Elizabeth E. Merritt, "went viral." It "painted a troubling picture of the 'probable future'— a future in which, if trends continue in the current grooves, museum audiences are radically less diverse than the American public and museums serve an ever-shrinking fragment of society."[10]

The changing face of Boston mirrors the changing face of the nation, but the MFA's visitor profile has not kept pace. The museum's traditional donor base is white, upper class, and aging. Because it is privately funded, the MFA urgently needs to recruit a new generation of visitors and donors. This was certainly on the minds of the Art of the Americas staff when they thought about their reinstallation. They wanted to tell stories that appealed to more diverse audiences. They wanted Bostonians, future Board of Trustee members, and tourists of color to see themselves in the walls. One such narrative is that what is made in America is not just made in the U.S.A.

To get this message across, curators added more than just Ancient American materials. The new Spanish colonial gallery contains beautifully crafted religious objects from sixteenth century Bolivia and Peru that rival those made by the best New England silversmiths. Nineteenth century American landscape painting are hung "salon style" to drive

为什么是这里，为什么是现在？

把古代美洲艺术放在美国艺术故事的开端，这个想法来自一次愉快的整合。当美术馆主任马尔科姆·罗杰斯（Malcolm Rogers）于1992年就职，他重组部门以促进不同艺术媒介及其在各媒介部门负责人之间的交流。他将美国绘画和装饰艺术相结合，加入一些以前归入欧洲的拉丁美洲的材料。美洲古代收藏也囊括在美国的展品中，而它在之前从未有一个真正的归宿。

人口的改变也有影响。美国正在成为一个少数民族占多数的聚居国家。2008年美国博物馆协会成立了未来博物馆中心。它的首份报告《博物馆与社会2034：趋势和潜在的未来》，诠释了美国人口和博物馆观众人口之间日益扩大的差距。[9]1970年以前，少数民族占美国人口的10%~13%，但到2008年，这一数字已上升到34%，预计到2033年将达到46%。然而，只有9%的博物馆核心观众是少数民族。据创始董事伊丽莎白·E.梅里特（Elizabeth E. Merritt）所言，这份报告"描绘了一幅令人不安的未来图像——如果这种趋势继续发展下去，未来的博物馆观众相比美国的大众将极度缺乏多样性，博物馆会为一个日益碎片化的社会服务"。[10]

波士顿的变化反映了国家的不断变化，但美术馆的游客并没有保持同步。博物馆的传统捐赠以来自白色人种、上层阶级和成熟作品为基础。因为它是私人创办的，美术馆迫切需要招募新一代的游客和捐助者。这当然是想重新布置美术馆美洲艺术的员工的想法。他们讲述能吸引更多不同观众的故事。他们想让波士顿人，即未来的董事会成员和有色人种的游客在墙上看到他们自己。这样叙述就成了什么构成了美国而不仅仅是美国制造了什么。

就此来理解，策展人添加上的不只是美国古老的材料。新西班牙殖民画廊藏有精巧美丽的来自16世纪玻利维亚和秘鲁的文物，可以与那些新英格兰最好的银匠的工艺品媲美。从19世纪美国风景画边上挂着"沙龙风格"的作品，其创作者很多都是在国外学习和工作的。为了使收藏更多样化，美术馆进行了多次战略收购，包括阿根廷画家塞萨尔·帕特诺斯（Cesar Paternosto）的作品《断奏》和古巴艺术家维尔弗雷多·拉姆（Wilfredo Lam）1943年的绘画。策展人不认为这些作品是少数民族的，因此也没有把它们放进特殊的展厅。"没有非裔美国人或女性艺术家艺术展厅，"艾丽卡·赫施乐说。"女性艺术家应该与男性艺术家的作品放在同一的展厅展出，法则是改变不了的，除非将它们整合起来。"[11]

自然地，对新展区有批评，也有赞誉。很多人对博物馆拓宽美国故事的边界非常赞赏，人们很高兴看到古

home that many of the artists who created them studied and worked abroad. To diversify its collection, the MFA made several strategic acquisitions, including Argentinian painter Cesar Paternosto's "Staccato" and a 1943 painting by Cuban artist Wilfredo Lam. Curators opted not to ghettoize these works by putting them in a special gallery. "There is no gallery of African American art or of women artists," said Erica Hirshler. "Women artists should be in the same gallery as male artists. It's not helpful to set them apart in a different room. You cannot change the canon unless you integrate the canon."[11]

Naturally, the new wing met with criticism and acclaim. Many applauded the Museum for its courageous broadening of the American story and were thrilled to see the Ancient and Native American materials so prominently featured. Holland Cotter of *The New York Times* lauded the MFA for asking the question "what does 'Americas' mean?" up front and for doing the "big, inclusive term justice" by bringing all of the Americas together, "hook (ing) them up, and seat (ing) them as equals at a hemispheric table." He concludes, "in the present political climate… opinions about what America was, is and should be are so polarized and proprietorial. And maybe this is where art itself comes to the rescue. So much about the new Americas Wing is so startling, stimulating and beautiful that you just want to lay down your arms."[12] But others felt the new wing came up short. Greg Cook of the *Boston Phoenix*, while impressed overall, highlighted significant gaps in the wing's representation of war and social conflict, noting wryly that "After the American Revolution, social critics need not apply."[13]

Moreover, while the take-away message of the new wing is that American art has always been shaped by international forces, whether they be pre-Columbian, Native American, European, or Asian,[14] this is still a national story. Visitors gain a more diverse view looking inward at what shaped the U.S., but they do not learn much about what that means when they look out— about how that interplay shaped the country's connection to the rest of the world. "The Art of Americas," said one anonymous museum professional, "is a peculiar thing to do in thinking about future. While it may sound trite, the community we live in now is not bounded by space and time, cultural boundaries are all merging together. There is little homogeneity but much more cross over and exchange and the creating of new kinds of cultures everywhere. So such a nationalistic push is interesting at a time when the world is really, truly global. They could have done a much more interpretive approach that would have connected America to the world."[15] America's place in the world, he concludes, is just not a central part of the story.

代和美国本土的材料受到如此重视。《纽约时报》的霍兰德·科特（Holland Cotter）认为美术馆问了一个问题，"'美洲'是什么意思？"赞扬它将美洲整合起来，那是"大的、具有包容性的正义之举"，"将它们连接，并赋予平等的地位。"他总结说，"目前的政治气候……有关美国是什么，应该是什么的看法，是如此的偏激和具有所有权倾向。也许这就是艺术本身需要拯救的。新展区是如此惊人的、具有刺激性和美丽的，以至于你想放下武器。"[12] 但其他人觉得新展区有不足之处，《波士顿凤凰报》的格雷格·库克（Greg Cook）的整体印象是新展区在体现美国革命和社会冲突上存在重大差距，并冷漠地提示"美国革命之后，不需要社会批评。"[13]

此外，虽然新展区所传达的明显信息是美国艺术总是在国际力量下不断成形，无论是哥伦布发现美洲大陆以前的艺术，美国土著艺术，欧洲艺术，还是亚洲艺术都施加了影响，[14] 但这仍是一个国家的故事。参观者通过探寻什么塑造了美国，获得了更加多样化的观点，但关于这种相互作用如何塑造它与世界其他地区的关联，其中的意义他们并没有获悉多少。"美洲艺术"，一位匿名的博物馆专业人员表示，"在考虑未来时那是一个独特的点。虽然听起来老套，我们现在生活的这个社会不受空间和时间的约束，文化界限都融合在一起。同质性很小，但更多的跨越以及交换，创建新类型的文化无处不在。所以国家的推动对于真实的世界，真正的全球化是有趣的。"[15] 他总结说，美国在世界上的地位恰好不是故事的核心部分。

在博物馆实践中变化的边界

关于博物馆实践的政治研究、诗学研究都表明，国家展现的形象各不相同。[16] 博物馆是表达和传播这些想象的核心舞台。[17] 许多世界首屈一指的博物馆的创造正好与民族国家的诞生相一致。在 19 世纪，一个有凝聚力的"人民"或国家必须有自己的文化。将数以百万计的可能永远不会见面的人建立为统一的"家庭"，需要大量的努力和想象力。[18] 新的国家力量取决于它用知识和实践展现自己及其人民的能力，让一无所知的人都能理解。博物馆工作项目在建立归属感中发挥了重要作用，尽管它只是延伸到国家边界。[19]

原本的皇室收藏现在面向更广泛的公众开放，这使得艺术民主化了，并创造了更多有文化的公众，这从来就不是一个平等主义的项目。普适意义的博物馆，总是向观众传播社会最受尊敬的信仰。[20] 博物馆的收藏中包含什么以及谁创造了它，明确传达了谁属于国家，这个国家的价值的信息。物品的摆放顺序，以及他们如何呈

The Boundaries of Change in Museum Practice

As studies of the politics and poetics of museum practice have shown, nations perform themselves differently[16] and museums are central stages where these imaginings are articulated and disseminated.[17] The creation of many of the world's premier museums coincided with the birth of the nation-state. In the nineteenth century, to be a cohesive "people" or nation, you had to have culture. Creating a unified "family" of millions of people who would never meet required a great deal of effort and imagination.[18] The new nation's strength depended on its ability to perform itself to its members using knowledge and practices that complete strangers would be able to understand. Museums played an important role in the effort to project a sense of connection, although it only extended to the national border.[19]

While opening up the former royal collections to the broader public democratized art and created more cultured publics, it was never an egalitarian project. Universal survey museums functioned primarily to transmit society's most revered beliefs to visitors.[20] What was included in the museums' collection and who created it sent clear messages about who belonged to the nation and what the nation valued. The ordering of objects and how they were displayed in relation to each other legitimized a particular social and political hierarchy that privileged some ways of knowing while excluding others.[21] Because the nation was defined in opposition to other nations and ethnic groups, "outsiders" such as migrants or non-Christians were depicted as backward or morally inferior. They were unlikely to see themselves represented without serious biases, if at all.

These tensions persist today, and museums actively seek to address them.[22] The challenge, writes Bennett, is to "reinvent the museum as an institution that can orchestrate new relations and perceptions of difference that both break free from the hierarchically organized forms of stigmatic othering that characterized the exhibitionary complex and provide more socially invigorating and, from a civic perspective, more beneficial interfaces with different cultures."[23] Professionals try to reconstruct museums as "differencing machines" that facilitate cross-cultural dialogue. According respect and recognition to previously marginalized groups, inviting their members to tell their own stories, combining exhibits with educational programming, and repatriating objects with questionable provenances are now standard parts of museum practice. Various museums, especially those in former settler societies with official policies of bi- and multiculturalism, have done this with varying degrees of.[24]

Meanwhile, others see museums as simply too flawed

现彼此的关系，使特定的社会和政治等级合法化，知识以某种方式给予某人特权而排除了其他人。[21] 因为国家是相对于其他国家和民族而定义的，"外来者"如移民或非基督徒被描绘成落后或道德低劣的。他们认为自己代表的是一个备受偏见的群体。

这些紧张关系今天仍然存在，博物馆积极设法解决这些问题。[22] 贝内特写道，我们面临的挑战是"重新发现博物馆作为可以协调新的关系和感知打破丑恶的等级组织形式的差异，而非展示复杂性和提供更多的社会振兴的公共机构，从一个公民的角度来看，不同的文化间的交流更有益[23]。专业人士试图将博物馆重建为促进跨文化对话的"差异化机器"。通过对以前边缘化群体的尊重和认可，邀请其成员讲述自己的故事，结合教育项目并退还来源不确定的展品，现在成为博物馆实践的标准组成部分。不同博物馆，尤其是在之前有双边和多元文化的官方政策的移居者的集群中，已经在不同程度上的这样做过。[24]

与此同时，其他人认为博物馆在纠正历史错误上有太多的缺陷。加桑·哈格（Ghassan Hage）写过"动物多元文化论"，认为博物馆经常成为显示多样性的他者收藏，并将此作为国家的拥有物。[25] 因为占多数的白人仍控制着博物馆的层次关系和可视化工具，差异经常以自满的方式描绘在一个夸张的自我指涉中。

还有第三种观点驳斥了这些批评。回应了评论家眼中的博物馆设施和博物馆是"有永远意识形态动机和战略决定的，"詹姆斯·库诺（James Cuno）问他的读者："这是你所体会到的博物馆吗？当你穿过当地博物馆画廊会有受到某种意义的控制的感觉吗？你觉得被某种更高层的力量操控的感觉吗？"[26] 他认为，博物馆依然重要，"启蒙"原则仍然适用。[27] 收集、分类和呈现事实，质疑偏见和迷信，"对严谨的、有助于人类进步的世界真理知识调查的自信的承诺"仍是博物馆使命的核心。[28]

这些争论没有给地域如何影响博物馆实践的问题足够的关注。在本文的其余部分，我简要从三个方面讨论地域在多大程度上限制文化机构进行改变的举措——特定机构在国家和城市文化劳动力分布中、城市文化枢纽中发挥的作用，以及国家如何理解其在世界上的角色。

地方的作用

波士顿在美国国家博物馆学景观中扮演了一个非常特别的角色，正如美术馆在波士顿的组织领域发挥着独特的作用一样。许多游客去波士顿了解美国殖民历史，公众期望博物馆讲述那部分国家故事。博物馆对游客费用和赞助者捐款的依赖性，限制了美国艺术的故事可以

to redress their historical wrongs. Ghassan Hage, writing of "zoological multiculturalism", argues that all too often museums become collections of otherness that display diversity as a national possession.[25] Because the White majority still controls museums' discursive and visual tools, difference is too often depicted in an exaggeratedly self-referential, self-congratulatory manner.

Still a third view dismisses these criticisms. Writing in response to critics who see museum installations and museums themselves as "never not ideologically motivated and strategically determined," James Cuno asks his readers: "Is this your experience of museums? Do you walk through the galleries of your local museum and feel controlled in any significant way? Do you feel manipulated by a higher power?"[26] He believes that museums still matter and that "Enlightenment principles still apply."[27] Collecting, classifying and presenting facts, calling into question prejudice and superstition, and being "confident in the promise of rigorous, intellectual inquiry to lead to truths about the world for the benefit of human progress" are still at the core of the museum's mission.[28]

These arguments do not pay sufficient attention to how locality shapes museum practice. In the remainder of this article, I briefly discuss three aspects of place that constrain how much cultural institutions can change what they do—the role that particular institutions play in the national and urban cultural distribution of labor, the urban cultural armature, and how the nation perceives its role in the world.

The Role of Place

Boston plays a very particular role in the national museological landscape in the United States, just as the MFA plays a unique role in Boston's organizational field. Many tourists come to Boston to learn about colonial American history, and the public expects the Museum to tell that piece of the national story. The museum's reliance on visitor fees and benefactors' donations limit just how much the story of American art can be changed. "European art," said Erica Hirshler, "is not being asked to tell a story about European history in this context in the same way that these objects are asked to tell our national story."[29]

Similarly, the MFA plays a particular role in the urban organizational distribution of labor. Just as few institutions could trump its role in telling regional colonial history, few look to the MFA to be on the cutting-edge contemporary of American art. That is what the Institute for Contemporary Art and several New York cultural institutions do. In contrast, the Peabody Essex Museum, located just north in Salem, Massachusetts, can use its colonial holdings to tell a

改变的程度。"欧洲艺术，"艾丽卡·赫斯勒说，"不像这些要讲述我们国家的故事的藏品那样要讲述一个关于欧洲历史的故事。"[29]

同样地，美术馆在城市组织劳动力的分布中扮演特定的角色。正如只有几个机构可以胜任告知地区殖民历史的角色，少数几个指望美术馆成为当代美国艺术的前沿。这就是纽约当代艺术研究所和一些文化机构所做的。相比之下，皮博迪·埃塞克斯博物馆，位于马萨诸塞州萨勒姆北部，可以利用其殖民占有的东西讲述更多的全球故事，因为游客不视他为了解北美殖民地"应该去"的地方。中国艺术策展人昊升、吴东（音）说："美术馆在新英格兰如同它理应富有的全球性那样。它仍然必须满足欧美游客的期望。"[30]

城市的经济和政治谱系及其早期的地理政治层级也构成了文化机构的种类，以及反映国家和世界的方式。早期居民播种的价值观和信仰成为一个城市的文化机构的一部分。这些有弹性的文化结构，如社会等级模式，对于共同利益的承诺，对团体道德的假设，在城市的历史中反复出现。[31] 当他们随着时间的推移，变得更加根深蒂固，他们影响着城市所创建的各种机构，包含了政治政策、从底层加固的价值观——不断变化的文化枢纽。

城市和国家也有根深蒂固的方法处理差异——我们称为多样性管理制度——回应和构成文化机构的职责。这些制度反映了谁属于国家，谁可以成为成员的神话。美国告诉自己它是一个移民国家，建立在多元化的宗教原则上，总是让新移民成功融入美国人中去。相比之下，新独立的新加坡领导人采取的措施则把人系统地划分为华人、马来族、印度裔或"其他"血统，因为他们认为这将创建一个成功的多元文化国家。这些历史遗产回应着今天这些文化机构在差异结构上的作为，并逐渐适应（或不适应）它们的差异管理。

波士顿美术馆如何讲述国家故事和它在世界所处的地位，以及它借以讲述的藏品，反映出波士顿为文化枢纽。马萨诸塞州湾公司领导约翰·温思罗普（John Winthrop）让一群衣衫褴褛但的确怀着不满的信徒，跨越大西洋去追寻波士顿城市将成为什么。因为他们相信被拯救的灵魂也是富有的灵魂，他们强调努力工作、节俭、节制。他们重视教育、学术成就和社会责任。这些传统及所建立的机构保证他们为波士顿的文化枢纽奠定了基础。甚至早在城市 25 岁生日时，历史学家托马斯·奥康纳（Thomas O'Connor）写道，"波士顿城发展出某些基本的主题，不仅具有其殖民地起源的特点，而且也可能被认为是目前独特性的重要的一部分"。[32]

波士顿的创始人认为他们所创建的城市将成为世界其他国家的一个模型。他们的"山巅之城"能激励所有

more global story because visitors do not look to it as the "go to" place to learn about colonial America. "The MFA," said Hao Sheng, Wu Tung Curator of Chinese Art, "is as global as a museum in New England can be. It still has to meet the expectations of Euro-American visitors."[30]

A city's economic and political genealogy and its early position in the geopolitical hierarchy also shape the kinds of cultural institutions it creates and how they reflect the nation and the world. The values and beliefs of early residents sow seeds that become part of a city's cultural institutions. These resilient cultural structures, such as patterns of social hierarchy, commitments to the common good, or moral assumptions about community appear and reappear throughout a city's history.[31] As they become more deeply rooted over time, they affect the kinds of institutions a city creates, the policies it embraces, and the values that undergird them—its ever-evolving cultural armature.

Cities and nations also have deeply rooted ways of dealing with difference—what we might call *diversity management regimes*—that respond to and shape what cultural institutions do. These regimes reflect myths about who belongs to the nation and who can become a member. The United States tells itself it is a country of immigrants, founded on principles of religious pluralism, which has always succeeded at making newcomers into Americans. In contrast, the leaders of newly independent Singapore adopted policies that systematically slotted people into Chinese, Malaysian, Indian, or "Other" origin categories because they thought it would create a successful multicultural state. These historical legacies and responses to difference structure what cultural institutions do today and how they get used （or not） to manage difference.

How the MFA tells the story of the nation and its place in the globe, and the objects it uses to tell it, reflect Boston's cultural armature. John Winthrop, the governor of the Massachusetts Bay Company, led a ragged yet determined group of disgruntled believers across the Atlantic Ocean to found what would become the city of Boston. Because they believed that saved souls were also wealthy souls, they stressed hard work, thrift, and sobriety. They valued education, intellectual achievement, and responsibility to the community at large. These traditions and the institutions they established to preserve them laid the foundation for Boston's cultural armature. Even as early as the city's 25th birthday, writes historian Thomas O'Connor, the "town of Boston had developed certain basic themes that were not only characteristic of its colonial origins but which also may be considered an essential part of its present-day distinctiveness."[32]

Boston's founders believed they were creating a city that would serve as a model to the rest of the world. Their

人类，将成为吸引"所有人的眼睛"。[33] 波士顿不会成为别的任何城市，但它的杰出成就，以上帝的名义完成，将使人类受益。

然而，严格的清教徒思想束缚很早就开始松动。[34] 在 18 世纪早期，长途贸易蓬勃发展。随着港口城镇波士顿和萨勒姆的成长，不同文化的差异性不断增加，更重要的是，不同观念也在不断形成。但是到了 19 世纪，之前许多船长转向制造业。到 19 世纪 20 年代晚期，大约 40 个波士顿家庭结成一个相互串通的有自我意识团体，非常引人注目，并慢慢地控制了迅速现代化的城市。

如同他们的清教徒前辈，这个群体也强调公共服务。他们创造的机构不是个人的，而是一个有着共同姓氏和共同的经济利益的具有凝聚力的社区。波士顿精英的相互联系是如此密切，家庭和商业伙伴，学生和老师，朋友和堂兄弟姐妹简直难以区分。到 1861 年，奥利弗·温德尔·霍姆斯（Oliver Wendell Holmes）创造了"新英格兰的婆罗门种姓"来形容当时发达的上层阶级。波士顿精英仍觉得该地区代表和传达着美国最好的道德和智力水准。对他们来说，这个城市是"宇宙的中心"，或至少是"美国的雅典"。[35]

然而，在 19 世纪期间，多样性降临到城镇上。到 1849 年超过四分之一的波士顿居民，至少有 35000 人是爱尔兰人。为了照顾和控制这些新来者，统治精英出于大局考虑的责任感和维持秩序的渴望，创办了慈善医院和诊疗所。当爱尔兰人拒绝参加提升自我的讲座时，城市的富人阶层担心这些新来者逃避繁重的工作，而投身于疾病、恶习和犯罪活动。正如戴泽尔（Dalzell）所指出的"爱尔兰不仅是陌生人，他们是外来者。"[36]

在内战之后，波士顿的精英与美国、欧洲，以及他们自己和越来越多的外国出生的居民作了更加清晰的区分。他们创建的机构体现了城市的核心矛盾：精英主义的信仰和想要引入他们的文化的冲动，是要用高雅文化的力量来提升群众；对世界主义的兴趣和勉强的尊重，掺杂着美国需要勾画出自己的方式，以及这个城市和国家应该成为世界其他地区的样板的想法；还有对于在国外太久的人可能不忠的怀疑。[37]

多里·仁兹·布德特（Dorie Reents-Budet）说，"这就是为什么古代美国文物仍在新展区的底层展出。在另一个城市，如洛杉矶，它就在顶层展出，但波士顿是一个北欧的城市，而不是拉丁美洲。"[38] 这一方面"使美国人种颜色趋向褐色，但也让白色人种的人们认识到这是好的。这些人来自拉丁美洲，有着令人难以置信的来自这些国家的历史遗产。"

从根本上来看，波士顿博物馆所要表达的是美国如何于世界中看待自己。很久以前，贡纳尔·默达尔

"city upon a hill" would inspire all of mankind, a shining beacon that would attract "the eyes of all people…upon" them.[33] Boston would never be just any city but a place distinguished by its accomplishments, achieved in God's name, which benefitted mankind.

Early on, however, the straitjacket of strict Puritan ideals began to fray.[34] During the early eighteenth century, long-distant trade flourished. As the port towns of Boston and Salem grew, so did the visibility of different cultures and, more importantly, different *ideas*. But, by the nineteenth century, many of these former sea captains had turned to manufacturing. By the late 1820s, a strikingly interconnected, self-referential group of about forty Boston families, known as the Boston Associates, emerged and slowly assumed control of the quickly modernizing city.

Like their Puritan forefathers, this group also stressed public service. They created institutions not as individuals but as a cohesive community that shared economic interests as well as last names. The Boston elite were so interconnected, that differentiating between family and business partner, student and teacher, friend and first cousin was practically impossible. By 1861, Oliver Wendell Holmes coined the tag "Brahmin Caste of New England" to describe what by then was the city's well-developed upper class. Elite Bostonians still felt the region represented and communicated the best of what America offered morally and intellectually. To them, the city was the "Hub of the Universe," or at the very least the "Athens of America."[35]

During the nineteenth century, however, diversity came to town. By 1849, more than a quarter of Boston's residents, at least 35,000, were Irish. To care for and control these newcomers, the ruling elite founded charitable hospitals and dispensaries out of a sense of responsibility for the greater good but also out of a desire to maintain order. While the Irish rejected the proffered lectures on self improvement, the city's upper crust worried that newcomers eschewed hard work in favor of disease, vice, and crime. As Dalzell notes, "the Irish were not just strangers, they were outsiders."[36]

After the Civil War, Boston's elite made even clearer distinctions between the United States and Europe and between themselves and the increasing numbers of foreign-born residents. The institutions they created reflected the conflicting legacies at the city's core: a faith in elitism and the power of high culture alongside an impulse to elevate the masses by introducing them to that culture; an interest in and begrudging respect for cosmopolitanism combined with a sense that America needed to chart its own way and that the city and the nation should be a model to the rest of the world; and a suspicion that people who spent too much time abroad were possibly disloyal.[37]

（Gunnar Myrdal）将美国人描述为谨守美国信条或美国理想的人——他将之定义为"搭建伟大的和不同国家结构的水泥。"[39] 这些关于这个国家和它的国际地位的根深蒂固的假设，也是困扰我的谜题。美术馆的选择反映了美国在世界上如何看待自己——作为一个如此庞大和强大的全球领袖，它不需要与任何人接洽，即便它需要也只会按自己的方式。因为它认为自己处于经济和政治生活的中心，它的公民不需要特别全球化，因为全球化就等同于美国化。即使美术馆将美国故事国际化，也是一个有关什么构成了国家的新的故事，而不是有关重新定位它在世界上的位置的故事。博物馆并非是唯一的获得这种自信和自恋的地方。地域性限制了后殖民的可能性。城市文化枢纽、劳动力的机构分布，以及国家如何理解其在世界的位置，创建了路径的依赖性。正如一位被调查者所说的，"博物馆毕竟是用灰泥和砖盖成的，它们不是灵活的媒体。只能依靠自己的藏品讲述故事。"[40] 我想说的是，叙事不仅是由博物馆馆藏的东西决定的，还取决于历史、人口、城市以及国家和政策本身。

That is why, says Dorie Reents-Budet, the Ancient American materials are still "on the bottom floor of the new wing. In another city, like Los Angeles, this stuff would have been on the top floor, but Boston is a Northern European city, not a Latin American one."[38] This is, on the one hand about "the browning of America, but it's also about getting the white folks to recognize that this is okay. That these folks who are coming from Latin America are coming from these countries with this incredible historical heritage."

Ultimately, what museums do in Boston says something about how the United States sees itself in the world. Long ago, Gunnar Myrdal described Americans as clinging tightly to what they think of as the American creed or the American ideal—which he defined as "the cement in the structure of this great and disparate nation."[39] These deeply rooted assumptions about the nation and its global role are also a piece in my puzzle. The MFA's choices reflect how the United States sees itself in the world—as a global leader that is so large and powerful, it does not really have to engage with anyone else and, when it does, only on its own terms. Because it believes it lies at the center of economic and political universe, it's citizens do not need to be particularly globally-oriented because being global is equated with being American. Even when the MFA internationalized the American story, it was a new story about what constitutes the nation rather than a repositioning of its place in the world. Museums are not the only places where this self-confidence and narcissism comes through.Locality, then, constrains the possibilities for post-coloniality. The urban cultural armature, the institutional distribution of labor, and how the nation understands its position in the world, create path dependency. Museums are, after all, as one respondent put it, "made of bricks and mortar. They are not an agile medium. They can only tell the stories their collections allow them to tell."[40] What I have argued is that the arc of the narrative is not just determined by what sits in the museum's storerooms but by the history, demography, and policies of cities and nations themselves.

Notes:

1 Alvaro Lima. "New Bostonians". *Boston Redevelopment Authority*: http://www.bostonredevelopmentauthority.org/news-calendar/news-updates/2012/10/12/newly-released-publication-new-bostonians-2012, accessed March 3, 2014.

2 "2010 Census Shows Boston Among Most Segregated Cities" *Radio Boston* http://radioboston.wbur.org/2011/04/04/boston-segregated, accessed March 3, 2014.

3 Elliot Bostwick Davis, Chair of the Art of the Americas Department, Museum of Fine Arts（MFA）, Boston, July 31,

2010.

4　Erica Hirshler, Senior Curator of American Paintings, Museum of Fine Arts（MFA）, Boston, July 15, 2010.

5　Dennis Carr, Assistant Curator of Decorative Arts and Sculpture, Museum of Fine Arts（MFA）, Boston, November 17, 2010.

6　Elliot Bostwick Davis, Chair of the Art of the Americas Department, Museum of Fine Arts（MFA）, Boston, October 25, 2010.

7　Dorie Reents-Budet, Curator of the Art of the Ancient Americas, Museum of Fine Arts（MFA）, Boston, March 14, 2011.

8　Nadya Jaworsky et al. "Rethinking Immigrant Context of Reception: The Cultural Armature of Cities". *Nordic Journal of Migration and Ethnicity* 2, 2012（1）: 78-88

9　Betty Farrell and Maria Medvedeva. *Demographic Transformation and the Future of Museums*. Washington, D.C.: American Alliance of Museums, 2010. 1-42

10　American Alliance of Museums, "Museums & Society 2034: Trends and Potential Futures," Washington, DC: *American Alliance of Museums, Center for the Future of Museums （CFM）*, December 2008, http://www.aam-us.org/docs/center-for-the-future-of-museums/museumssociety2034.pdf?sfvrsn=0, accessed January 18, 2010.

11　Erica Hirshler, Senior Curator of American Paintings, Museum of Fine Arts（MFA）, Boston, January 21, 2011.

12　Holland Cotter. "Art of the Americas Wing at Museum of Fine Arts, Boston: Seating All the Americas at the Same Table". *New York Times*. November 18, 2010, New York edition, C23, www.nytimes.com/2010/11/19/arts/design/19americas.html?pagewanted=all&_r=0, accessed February 4, 2014.

13　Greg Cook. "OMFG: The New MFA" *Boston Phoenix*, November 17, 2010, http://thephoenix.com/Boston/arts/111581-omfg-the-new-mfa/, accessed March 3, 2014.

14　Nevertheless, European influences predominate. In the scholarly volume produced about the new wing, two chapters on Native American and pre-Columbian influences precede seven chapters on European influences, followed by four chapters on Africa, the Near East, and Asia.

15　Interview with anonymous museum professional, January 16, 2010. All interviews were conducted in confidentiality, and the names of interviewees are withheld by mutual agreement.

16　Andrew McClellan. "Art Museums and Commonality: A History of High Ideals". In：*Museums and Difference* Bloomington, IN: University of Indiana Press, 2007. 25-60; Annie Coombes. "Museums and the Formation of National and Cultural Identities". In：Donald Preziosi, Claire Farago *Grasping the World: The Idea of the Museum*. Aldershot: Ashgate Press, 2004. 278-298; Nelia Dias. "Cultural Difference and Cultural Diversity: The Case of the Musee Du Quai Branley".In：*Museums and Difference*. Bloomington,

In: University of Indiana Press, 2007. 124-155

17　Donald Preziosi，Claire Farago. "What are Museums For?". In：Donald Preziosi，Claire Farago. *Grasping the World: The Idea of the Museum*. Aldershot: Ashgate Press, 2004.1-13

18　Benedict Anderson. *Imagined Communities*. London: Verso, 1983. 54

19　Sharon Macdonald. *Memorylands: Heritage and Identity in Europe Today*. Milton Park, Abingdon, Oxon: Routledge, 2013.

20　Carol Duncan，Alan Wallach. "The Universal Survey Museum".In：Bettina Messias Carbonell.*Museum Studies: An Anthology of Contexts*. New York: Wiley-Blackwell, 2004. 51-80; Annie Coombes. "Museums and the Formation of National and Cultural Identities".In：Donald Preziosi, Claire Farago*Grasping the World: The Idea of the Museum*. Aldershot: Ashgate Press, 2004. 278-298; Vera Zolberg. "Museums as Contested Sites of Remembrance: The Enola Gay Affair". In：Sharon Macdonald , Gordon Fyfe *Theorizing Museums: Representing Identity and Diversity in a Changing World*, Sociological Review Monograph Series. Cambridge, MA: Blackwell, 1996. 69-83

21　Eilean Hooper-Greenhill. *Museums and the Interpretation of Visual Culture*. London: Routledge Press, 2000. 93

22　Rhiannon Mason. *Museums, Nations, Identities: Wales and its National Museums*. Cardiff: University of Wales Press, 2007.

23　Tony Bennett. "The Exhibitionary Complex". *Grasping the World: The Idea of the Museum*. London: Ahgate, 2006. 59

24　Bennett, 46-70

25　Ghassan Hage. *White Nation: Fantasies of White Supremacy in a Multicultural Society*. New York, NY; Annandale, NSW: Routledge ; Pluto Press, 2000. 78

26　James B. Cuno. *Museums Matter: In Praise of the Encyclopedic Museum*.Chicago: University of Chicago Press, 2011. 44

27　Cuno, 7

28　Cuno, 55

29　Erica Hirshler, Senior Curator of American Paintings, Museum of Fine Arts（MFA）, Boston, May 23, 2011.

30　Hao Sheng, Wu Tung Curator of Chinese Art, April 5, 2011.

31　Jeffrey C. Alexander，Philip Smith. "The Strong Program: Origins, Achievements and Prospects".In：John R. Hall, Laura Grindstaff,et all.*The Handbook of Cultural Sociology*. New York: Routledge, 2010. 13-24

32　Thomas H. O'Connor. *The Athens of America: Boston, 1825—1845*. Amherst: University of Massachusetts Press, 2006. 18

33　John Winthrop. "A Modell of Christian Charity（1630）". *Collections of the Massachusetts Historical Society*. 3rd series 7: 31-48, 1838. http://history.hanover.edu/texts/winthmod.html.

34　Richard D. Brown ,Jack Tager. *Massachusetts: A Concise History*. Amherst: University of Massachusetts Press, 2000.

95-96

35 O'Connor, 84-85

36 Robert F. Dalzell. *Enterprising Elite: The Boston Associates and the World They Made*. Cambridge: Harvard University Press, 1987.140

37 Mark Rennella.*The Boston Cosmopolitans: International Travel and American Arts and Letters*.New York: Palgrave MacMillan, 2008. 21

38 Dorie Reents-Budet, Curator of the Art of the Ancient Americas, Museum of Fine Arts（MFA）, Boston, March 14, 2011.

39 Gunnar Myrdal. *An American Dilemma: The Negro Problem and Modern Democracy*.New York: Harper 1944. 54

40 Interview with anonymous respondent, January 16, 2010.

Suggestions for further Readings:

[1] Anderson Benedict. *Imagined Communities*. London: Verso, 1983.

[2] Anderson Gail. *Reinventing the Museum: Historical and Contemporary Perspectives on the Paradigm Shift*. Walnut Creek, CA: AltaMira Press, 2004.

[3] Cuno James B. *Museums Matter: In Praise of the Encyclopedic Museum*. Chicago: University of Chicago Press, 2011.

[4] Dalzell Robert F. *Enterprising Elite: The Boston Associates and the World They Made*. Cambridge: Harvard University Press, 1987.

[5] Hooper-Greenhill, Eileen. *Museums and the Interpretation of Visual Culture*. London: Routledge Press, 2000.

[6] Khagram Sanjeev, Peggy Levitt. *The Transnational Studies Reader.* New York and London: Routledge Press.

[7] Macdonald Sharon. *A Companion to Museum Studies*. London:Blackwell, 2011.

[8] Messias Carbonell, Bettina. *Museum Studies: An Anthology of Contexts*, New York: Wiley-Blackwell, 2004.

[9] Preziosi Donald, Claire Farago. *Grasping the World: The Idea of the Museum*. Aldershot: Ashgate Press, 2004.

[10] Sherman, Daniel J. *Museums and Difference*. Bloomington, IN: University of Indiana Press, 2007.

[11] Macdonald Sharon and Gordon Fyfe.*Theorizing Museums: Representing Identity and Diversity in a Changing World*. Sociological Review Monograph Series. Cambridge, MA: Blackwell, 1996.

展示黑人——非裔美国人与美国艺术博物馆
Exhibiting Blackness: African Americans and the American Art Museum

布里奇特·R.库克斯　　张梦阳 * 　译
Bridget R. Cooks　　　Translator: Zhang Mengyang

中国有增加博物馆数量的计划，而其中令人兴奋的地方就是为人们提供了一个以史为鉴的机会。本人写过一本书，名为《展示黑人——非裔美国人与美国艺术博物馆》，以帮助读者了解以往展览中的不和谐以及美国博物馆中始终存在的种族差异和白人至上主义氛围。在此，我将通过对于美国艺术史的描述，努力创建一个理解种族、权力、可视性和公共机构体制的评论框架。我分析的主题是美术馆——一个物质和意识的空间，艺术表现和诠释在这里产生。

美术馆有责任反映其服务的文化并启发参观者产生新的思考与领悟。在美国，国家政治、经济和审美概念的复杂性经常被美术馆简化，从而成为对艺术文化的完整性、秩序性以及同质性的简单叙述。我将列举一些在艺术展览中发生的事件，这些事件在呈现非裔美国艺术时粉碎了美术馆内种种民族平等的假象。

根据在美国主流美术馆参观和工作的经验，我发现，展览总是把黑人艺术家的作品拒之门外。首先，当展出黑人艺术家的作品时，他们往往会集体以黑人的身份展出。黑人艺术家的作品通常不会出现在某一艺术风格或特定主题的专题展览中，并很少与非黑人艺术家的作品同时展览。其次，黑人艺术家作品的作品标签常标识为黑人艺术家所作，但是，白人艺术家作品的标签却并未标出是白人艺术家的作品。最后，当展出黑人艺术家的作品时，大多数美术馆参观者均表示以前从未欣赏过黑人艺术家的作品。他们常常表达出这种展览是第一次，并希望还会举办这种展览的想法。以上三点发现激励我对艺术博物馆展览和非裔美国艺术家之间的关系进行研究，以便编写一部相关的历史。

美术馆展览对非裔美国人有着至关重要的意义。虽然黑人在历史上一直被美术馆边缘化，无论是以艺术家、参观者或美术馆工作人员的身份来讲都是如此，但

One of the exciting aspects about the plan to increase the number of museums in China is the opportunity to benefit from the lessons of the past.

I wrote the book, *Exhibiting Blackness: African Americans and the American Art Museum*, to help readers learn about the ghosts of exhibitions past and the haunting that persists regarding the specter of racial difference and white supremacy in American museums. What I will offer you here is presented in the effort to create critical frameworks for understanding race, power, visuality, and the institutional politics of representation within the discourse of American art history. The subject of my analysis is the museum: the physical and ideological space in which this process of artistic presentation and interpretation happens.

Museums have the responsibility to reflect the cultures they serve and to inspire visitors toward new meditations and insights. In the United States the complexity of national politics, economy, and conceptions of beauty have often been reduced in museums to a simple narrative of unity, order, and homogeneity of art and culture. I will outline some of the issues in art exhibitions that have emerged to disrupt this illusion of racial placidity concerning the representation of African Americans in museums.

In my experience visiting and working in mainstream American museums, I have found that art created by Black artists has been regularly excluded from exhibition. When works by Black artists are exhibited, they tend to be featured in museums within group exhibitions about Black identity. They are not shown regularly in thematic exhibitions organized around a style of art or specific topic. And their work is rarely shown alongside artists who are not Black. Second, the object labels for work by Black artists states that the artists are Black, however, labels for work by White artists do not identify them as White. Third, when an exhibition of

* 张梦阳 当代艺术家，艺术史学者（Zhang Mengyang Artist、Independent Scholar）

从国家主义和美国艺术史的角度来看，美国艺术对于非裔美国人的呈现都具有说教性并扮演着拥护者的角色。艾伦·沃勒克（Alan Wallach）在其《展示矛盾：论美国艺术博物馆》一书的序章中对艺术博物馆展览的作用进行了诠释，他说道："很明显，我认为美术馆参观者漫步于挂满图片的画廊时，已然实现了艺术史的某种版本，并在某种程度上将其内在化了。"[1] 美术馆具有教化的功能，沃勒克将这一社会现实具体化，即展览空间本身具有某种能量，而不仅仅是满足"展现物品"的这种看似简单的功能要求。展览还通过传授艺术、文化、社会运动和国家历史的价值发挥说教作用。正是由于拥有这种特殊权力，展览空间一直是非裔美国人十分渴望争取的领域。与文化的高度关联性和观众对于美术史的内化使美术馆以及画廊成为黑人体现、参与和干预艺术的关键场所。我的研究将此需求放入到美国美术的整体背景中，并从历史和当代的艺术实践进行考量。

整个 20 世纪中，美术馆首次展出非裔美国人的作品时总是与非裔美国人当时的处境吻合，这体现在许多方面。1927 年，芝加哥艺术学院提出举办《黑人艺术周：原始非洲雕塑、现代绘画、雕塑、素描、应用艺术和书籍展览》，这并不是非裔美国人艺术家的首次展示机会。然而，这是第一次在美术馆中展出非裔美国人的艺术作品。[2] 这成为策展人、艺术家、参观者和评论家等群体表达对当时美国美术馆内种族差异担忧的第一个平台，涉及黑人的展览时，这种功用延续至今。

展览最初由黑人哲学家和文化领袖阿兰·洛克（Alain Locke）构思，由芝加哥妇女俱乐部组织，该组织的成员均为白人女性。黑人艺术周展览声称有 205 件作品：其中包括非洲雕塑家创作的 116 件作品以及由 22 名美国艺术家创作的 89 件作品，这些美国艺术家包括雕塑家梅塔·沃克斯·瓦里克·富勒（Meta Vaux Warrick Fuller）、画家爱德华·米切尔·班尼斯特（Edward Mitchell Bannister）、亨利·奥萨瓦·坦纳（Henry Ossawa Tanner）和黑尔·伍德鲁夫（Hale Woodruff）以及摄影师 K.D. 甘纳韦（K.D. Ganaway）。[3] 该艺术展对洛克和芝加哥妇女俱乐部来说是为黑人艺术成就证明的机会，因此也是阐述艺术平等以鼓励种族之间社会公平的论据。事实上，将艺术探索这一概念作为一个社会变革的渠道恰恰是新黑人运动的一部分，正如洛克在《新黑人》（1925 年）宣言文章中所定义的一样。洛克描述了 20 世纪 20 年代黑人艺术家对于改善这一严酷问题所起的至关重要的作用，他在文中写道："他们得到的特殊'文化'认同应反过来证明，对于黑人的重估必须领先或同步于所有可能的改善种族间关系的尝试。"[4] 然而，对于黑人来说，艺术跨文化曝光的可见性和流动性是有限的。黑人可以在艺术

works by Black artists is on view, the majority of museum visitors who comment about the exhibition state that they had never seen artwork by a Black artist before. They also often express a belief that the exhibition is the first of its kind and that they wanted to know more. These three observations encouraged me to research the relationship between art museum exhibitions and African American artists in order to write a history of their engagement.

Museum exhibitions have crucial significance for African Americans. Although they have been historically marginal for the art museum as artists, visitors, and museum professionals, representations of African Americans in American art have served a didactic and often supportive role in nationalism and American art history. In the introduction to his book, *Exhibiting Contradiction: Essays on Art Museums in the United States*, author Alan Wallach writes about the role of the art museum exhibition, saying, "It became evident to me that, by walking through a gallery space hung with pictures, museum visitors acted out, and thus in some sense internalized, a version of art history."[1] Wallach crystallizes a social truth about the role of art museums as pedagogical institutions: the exhibition space has power; it does more than fulfill the seemingly simple function to display objects. Exhibitions also play didactic roles by teaching the values of art, cultures, social movements, and national histories. Because of this particular potency, the exhibition space has been a contested domain for African Americans. The dominant narratives of culture and art history by internalized the visiting public have made museum galleries critical spaces for Black representation, participation and intervention. My work explores this demand for inclusion into the American art scene in historical, and contemporary exhibition practices.

The case of the first museum exhibition of art by African Americans is in many ways emblematic of the fraught situation of African American art in museums throughout the twentieth century. In 1927, the Chicago Art Institute presented *The Negro in Art Week: Exhibition of Primitive African Sculpture, Modern Paintings, Sculpture, Drawings, Applied Art, and Books.* This was not the first exhibition opportunity for African American artists. However, it marked the first time that an exhibition of art made by African Americans was presented in an art museum.[2] It served as the first theater for curators, artists, visitors, and critics to act out anxieties around racial difference in American art museums that continue to this day.

Conceived by Black philosopher and cultural leader Alain Locke and organized by the Chicago Woman's Club, whose members were all White women, *The Negro in Art*

领域赢得文化认同，但改变不了种族隔离的现实。⁵黑人艺术家之前做出的进入现代美术馆的努力推动了人们对于艺术品质量、等级、美和种族制度问题的关心，以及对于保留美国主流文化里存在的欧洲中心论的文化认同。

此次芝加哥展览让非洲和美国的黑人艺术联合呈现，这应和了洛克和芝加哥妇女俱乐部将非洲的文化遗产作为新黑人运动艺术家作品灵感源泉的论调。但是，对于找寻白人主流文化认可的中产阶级黑人而言，艺术界对新黑人运动和非洲雕刻艺术之间关系的"特定"理解是很重要的。中非埃通比民族和西非旦族的雕塑是现代艺术中立体主义美学发展的基础，并通过国际艺术市场转化为有价值的艺术品。⁶矛盾在于，为了避免混淆于"原始"非洲雕塑，展览的副标题为现代黑人艺术，以此将有能力并对社会有贡献的新黑人与人们印象中的不文明和不发达的非洲过去区别开来。

《黑人艺术周》展览目录（图1）的封面也采用了一个与非洲文化完全不同的图像来定义新黑人。在查尔斯·C.道森（Charles C. Dawson）作品的左侧，有一位仰着头的埃及法老，他的姿势似乎就表达出种族振兴的意味。他的左臂拿着一幅打开的卷轴，画卷中注明了在芝加哥

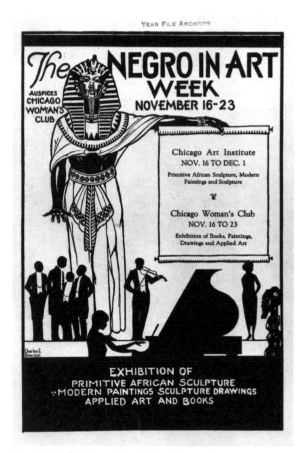

图1 《黑人艺术周》，芝加哥艺术学院，1927年11月16—23日，展览画册封面，照片来源：芝加哥艺术学院。
Fig.1 *The Negro in Art Week*, November 16–23. Chicago Art Institute, 1927, catalogue cover. Photo: The Art Institute of Chicago.

Week boasted two hundred five artworks: hundred sixteen objects by African sculptors, and eighty-nine objects by twenty-two American *Negro* artists, including sculptor Meta Vaux Warrick Fuller, painters Edward Mitchell Bannister, Henry Ossawa Tanner, and Hale Woodruff, and photographer K.D. Ganaway.³ The art exhibition was an opportunity for Locke and the Chicago Woman's Club to present evidence of Negro artistic achievment and therefore an argument for equality of all art to encourage social equity between the races. Indeed, this notion of exploring the arts as an avenue for social change was part of the New Negro movement as defined by Locke in his manifesto essay "The New Negro"（1925）. Locke prescribed the emerging role of Negro artists in the 1920s as crucial to improving the problem between the races in America, writing, "The especially *cultural* recognition they win, should in turn prove the key to that revaluation of the Negro which must precede or accompany any considerable further betterment of race relationships."⁴ And yet, for Negroes, the visibility and mobility of cross-cultural exposure through the arts was limited. The artistic fields in which they could win cultural recognition maintained racial segregation.⁵ These early efforts by Black artists to enter the modern art museum motivated concerns about quality, class, beauty, racial hierarchy, and the preservation of a Eurocentric cultural identity within American mainstream culture.

The joint presentation of African and Negro American art in the Chicago exhibition, allowed Locke and the Chicago Woman's Club to claim an African heritage for the New Negro artists. But, for middle-class Negroes seeking acceptance into White mainstream culture, it was important that the art world recognize *a particular* understanding of the relationship between the art of the New Negro and African sculpture. The sculpture of the Etoumbi peoples of Central Africa and Dan peoples of West Africa had been fundamental to the development of Cubist aesthetics in modern art and was transformed into valuable art objects by the international art market.⁶ Simultaneously, and in contradiction, the subtitle of the exhibition announced the modern art of Negroes as distinct from the so called "primitive" sculpture of Africa, distinguishing the New Negro as a contributing and productive member of society clearly evolved from what was widely perceived as an uncivilized and undeveloped African past.

The cover art of *The Negro in Art Week* exhibition catalogue（Fig.1）invokes another, quite different connection with an African culture to define the New Negro. On the left side of Charles C. Dawson's drawing, an Egyptian pharaoh raises his head in a gesture of racial uplift. His muscular left arm lifts a scroll which provides the location and date information for the two-part exhibition held in the Children's Museum section of the Chicago Art Institute and the Chi-

艺术学院儿童博物馆和芝加哥妇女俱乐部举行的有关两部分展览的地点和日期信息。他的右臂沿着他的躯干向下伸展，仿佛在赐予从过去到现在的精神福祉。他的手指张开，放在一群穿着无尾礼服的男歌手的上方，这些男歌手想必是新黑人。另外一位穿着类似服装的女钢琴家和男小提琴家陪伴在歌手的身旁。画面的右边，站着一位穿着紧身连衣裙的女子，可能是该乐团的主唱，正头朝下看一尊高大的非洲雕塑，而这尊雕塑看起来正在聚精会神地聆听着演奏着的音乐。上方大幅的古代雕塑形象与下方渺小的"黑色非洲"形象形成了鲜明对比，这种安排使新黑人似乎在舞台上只为想象中的观众演出。道森绘画中穿着无尾礼服的人物并非视觉艺术家，而是音乐家，以强调文化领域中非裔美国视觉艺术家的缺席。

虽然《黑人艺术周》展出了多种媒介和内容的艺术作品，但是学院主管要求对艺术家进行挑选以"尽可能符合正规的美术馆展览和展厅指定的标准。"[7] 这种强迫的一致性反映了主流艺术界批评家和策展人的共同想法，即非裔美国人艺术质量低劣。[8] 为避免展览降低学院一贯的高标准，消除黑人艺术可能带来的恐惧，这一学院指令成为明确招安黑人艺术家的一个关键标准。此外，学院主管对于黑人艺术质量具有较低期望值，所以决定儿童区是举办展览最合适的地方。无论在国外还是美国国内，很多黑人都与欧洲人以及美国白人在相同的艺术院校学习，20世纪20年代的黑人艺术家被灌输了伟大的欧洲大师的传统，并被希望继续保持这些传统。新黑人运动的兴起和洛克希望黑人艺术家们将目光投向其非洲祖先以启发现代黑人艺术创作的号召，都被证明是一种对学院派地位的威胁。

为参加展览，新黑人艺术家不得不选择19世纪（而不是当代）欧洲审美传统认可的欧洲中心论的表达方式。这些新黑人艺术家陷入了与艺术博物馆看门人之间的"要么服从，要么离开"的博弈中。对于艺术学院而言，维护美术馆的高标准艺术和反映黑人身份的某些证据的艺术是不可能并存的。作为策展人和作家，洛里·斯托克斯-西姆斯已注意到了黑人艺术家的处境：想要清楚认识黑人对现代性的贡献所面临的最大挑战将会是与当代艺术圈的对抗，这真是一种讽刺。尽管现代主义流派，如抽象派，植根于非洲艺术，黑人舞蹈和音乐引领了现代声音和感觉艺术，非裔视觉艺术家却被视为白人现代艺术先驱的追随者和模仿者。[9]

在芝加哥艺术学院的例子中，艺术博物馆将黑人艺术家视为固守于作品内容要求的欧洲中心主义美学的模仿者。而作为现代艺术家，黑人正参与美国当代艺术文化，而不是模仿欧洲中心主义美学，这一点并未被考虑。相反，当代舞台上黑人艺术家的贡献被贬低为衍生物。

cago Woman's Club. As if sending a spiritual blessing from the past to the present, his right arm stretches down rigidly along his torso. His fingers spread over a group of male, presumably New Negro, singers silhouetted in tuxedoes below. A similarly silhouetted female pianist and male violinist accompany the singers. At the right edge of the scene, a woman standing in a simple sheath dress, perhaps the vocalist of the group looks downward at a large figurative African sculpture that seems to listen intently to the music performed before it. Visually mapped between the massive protection of ancient Egypt above and the comparatively diminutive "black Africa" below, New Negroes perform their identity on stage for an imagined audience. The silhouetted figures in Dawson's drawing are not visual artists but musicians, reinforcing the absence of African American artists on the cultural scene.

Although *The Negro in Art Week* exhibition consisted of artworks diverse in media and content, selected artists were required by the director of the Institute to "conform as near as possible to standards set by regular art museum exhibitions and exhibition galleries."[7] This enforced conformity reflected the common belief held by mainstream art world critics and curators that art by African Americans was inferior in quality.[8] To avoid an exhibition that lowered the Institute's high standards and waylay the fear of what Negro art may be, this institutional mandate became a key criterion explicitly stated in the call for submission to Negro artists. Further, it is quite plausible that the Institute decided that the children's section of the museum was the most appropriate place for the exhibition based on the director's low expectations of the quality of Negro art. Trained in many of the same academies as European and White American artists both in the U.S. and abroad, Negro artists in the 1920s were indoctrinated in the traditions of the great European masters and trained to continue them. The emergence of the New Negro movement and Locke's call to Negro artists to look toward their African ancestry for inspiration to create modern Negro art proved to be a threat to the status of the Institute.

In order to participate in the exhibition, New Negro artists had to choose the path of Eurocentric expression acceptable to nineteenth-century （not contemporary） European aesthetic tradition. These New Negro artists were caught in an either/or paradox with the gatekeepers of the art museum. For the Institute, art that maintained the museum's high standard *and* reflected some evidence of the Negro identity of its maker was not a possibility. As curator and author Lowery Stokes-Sims has noted about the treatment of Black artists，the greatest challenge to recognizing the contributions of black people to modernity would, ironically, be en-

欧洲美学显然是展出作品的核心，如坦纳的《三个叫玛丽的人》（1910 年）和《逃往埃及》（1923 年）、伍德鲁夫的《黎明》（1926 年）及威廉·A.哈珀的《风景》（c.1905 年）。《黑人艺术周》未被艺术评论家视为一项严肃的艺术展，也未出现在媒体的艺术报道栏目中。[10] 芝加哥妇女俱乐部并未收到任何其他艺术机构的关于报道展览的请求。然而，俱乐部倒是收到了跨种族委员会和宗教团体前往展会的请求，进一步证实了展览被视为社会学事件而不是美学事件。

在美术馆这样的神圣空间内首次展览非裔美国艺术十分特别，应该被重视，而不该被看成是一场普通的展览。正如历史学家和评论家卡罗尔·邓肯（Carol Duncan）认为的那样，"事实上，在现代世界中，政治组织和社会制度的权力希望变得美丽、自然并合理，而美术馆正是实现这一贪婪愿望的现场之一。因此，美术馆擅长于研究权力的交集以及文化形式的历史。"[11] 在美术馆中展出非裔美国艺术家的作品从传统上逾越了所谓权力、美学和社会秩序的形式，这种逾越不是因为艺术作品本身的特点，而是因对"美丽、自然和合理"的定义中不包括非裔美国人。接纳非裔美国艺术家的现代美术馆——即支持和维护这些美学范畴的机构——的出现标志着现状已被显著打破。邓肯详细阐述了美术馆的能量，指出美术馆必须对他们所代表的群体进行定义，其称，"我们在艺术博物馆中看到的和未看到的——并依据何种形式或谁的授权以至于我们能够真正的看见与否——与由谁构成该群体以及由谁定义其身份这两个大问题有着密切的关系。"[12] 因此，什么作品能在美术馆展出以及展览决定权由谁持有是一种挑战，而这与非裔美国人的社会地位和文化定义又有着十分复杂的联系。种族的界限为保护和强制种族等级的神话而设，在美术馆内展览非白人艺术无疑是公开冒犯了这种界限。

一系列的案例分析构成了我所写的这本书的主要内容，其中囊括了在美术馆举办的非裔美国艺术最具影响力、最有价值的展览。在第一章我分析了 20 世纪 30 年代美国美术馆举办的两次关于非裔美国艺术家的展览，分别是由纽约现代艺术博物馆（MoMA）举办的《威廉·埃德蒙森雕塑展》（1937 年），以及由巴尔的摩美术馆（BMA）举办的《当代黑人艺术展》（1939 年），这些展览展现了关于现代美术馆中黑人艺术展品含义的争论，这一争论至今仍未结束。哈蒙基金会、阿兰·洛克、美国风景绘画以及曾在现代艺术博物馆中盛行一时的原始艺术，均通过展览来表明各自对于黑人艺术及整个民族的定义。本章也探讨了在纽约现代艺术博物馆和普利斯纪念画廊展出的画家雅各布·劳伦斯（Jacob Lawrence）的主要作品《黑人移民》（1940—1941 年）。劳伦斯的作

countered within contemporary art circles. Despite the fact that modernist genres such as abstraction were grounded in African art, and given that black dance and music has ushered in a modern sound and sense of the body, artists of African descent were positioned as followers and imitators of white artists recognized as the pioneers of modernism.[9]

In the case of the Chicago Art Institute, the art museum positioned Negro artists as imitators of Eurocentric aesthetics as the requirement of their inclusion. The notion that as modern artists, Negroes were participating in contemporary American artistic culture, rather than imitating Eurocentric aesthetics was not considered. Instead, the contributions of Negro artists on the contemporary scene were devalued as derivate.

While European aesthetics were clearly central to exhibited works such as Tanner's *The Three Marys* （1910） and his *The Flight into Egypt* （1923）, Woodruff's *Twilight* （1926）, and William A. Harper's *Landscape* （c.1905）, *The Negro in Art Week* was not considered by art critics as a serious art exhibition, nor was it reviewed in the art review sections of the press.[10] The Chicago Woman's Club did not receive requests by any other art institutions interested in mounting the show. However, the Club did receive requests from interracial committees and religious societies to travel the exhibition, further confirming that the exhibition was perceived in sociological, not aesthetic terms.

The first exhibition of art by African Americans within the sacred space of the American art museum is too significant to be dismissed as just another show. As historian and critic Carol Duncan has argued, "Indeed, in the modern world, art museums constitute one of those sites in which politically organized and socially institutionalized power most avidly seeks to realize its desire to appear as beautiful, natural, and legitimate. Museums are therefore excellent fields in which to study the intersection of power and the history of cultural forms."[11] The exhibition of artworks by African Americans in art museums transgresses traditionally acceptable forms of power, aesthetics, and social order, not due to any features of the works of art, but because the definitions of what is "beautiful, natural, and legitimate" have excluded African Americans. The inclusion of African American people into the modern art museum—the institution that validates and upholds these aesthetic categories—marks a significant disruption of the *status quo*. Duncan elaborates on the power that museums have to define the communities they represent, saying "What we see and do not see in art museums—and on what terms and by whose authority we do or do not see it—is closely linked to larger questions about who constitutes the community and who defines its identity."[12] Thus the challenge of what is seen

品展应和了两种相竞的期盼，即黑人艺术在美术馆中的原始性以及当代性的双重角色。在20世纪30至40年代，劳伦斯带有民间美术风格的绘画备受瞩目，他展现出一种将黑人看作"现代原始人"的强烈兴趣。然而，他以当代语言讲述种族根基的作品填补了美术馆中关于黑人历史及文化的空白。他在《黑人移民》中展现出的独特风格和人物画法，宣告了一位黑人艺术家在艺坛中成了领军人物，实现了洛克对黑人艺术摆脱追随模仿的期盼。这一开创性的展览，为其他美国主流美术馆认真考虑为现代黑人艺术家举办个展打好了基础。

20世纪下半叶，公共利益在黑人社区中开始成为主流话题，部分原因是因为民权运动的影响以及美国黑人要求拥有和白人相同的社会经济地位。20世纪50年代中期开始直到70年代早期，美国黑人出现在新闻媒体中，使得观众和读者对南方和北方、城市和乡村、远方和本地社区黑人的生存困难变得敏感。全球观众对于非暴力策略遇到的暴力反应以及民事抗议遭到的残忍打压心生同情。黑人领袖展现的尊严和黑人群众的勇气甚至改变了种族隔离坚定支持者的想法，并站在抵抗美国政府、高等教育机构、公立学校、图书馆和艺术中存在的种族制度的立场上。美国黑人吸引了世界的关注，他们坚持提高人们对于黑人在种族历史、国家贡献以及能力上的认可。而这一愿望以多种形式实施。在视觉艺术领域，艺术家、策展人和艺术活动家对贫困、种族主义、战争等20世纪五六十年代的社会弊病作出了回应，这种回应体现在抽象艺术、社会现实主义艺术和其他风格艺术的多产，雕塑、油画、纸上绘画都佳作频出，同时艺术家在城市中建筑墙上涂鸦的数量也爆发式增长。要满足民权运动的挑战，艺术团体的形成以及举办反映社会巨变的展览是十分必要的。建立美术馆和画廊以致力于直观表现黑人，并对抗主流美术馆反复无视非裔美国人的艺术和文化历史的态度，是这一时期改革运动的重要组成部分。

这本书的第二章从民权运动的结束开始，正当大都会博物馆展出《哈莱姆在我心中：美国黑人的文化首都（1900—1968）》（1968年）（图2），这一展览试图追溯纽约城主要黑人社区哈莱姆的历史价值。在策划这个美国历史上最具争议性之一的展览时，大都会博物馆决定拒绝哈莱姆人参与策展，并拒绝了艺术繁盛的哈莱姆艺术社区的艺术品。博物馆辩解说哈莱姆本身就是件艺术品，并且作品的混杂不齐只会有损于整个展览，博物馆以此来证明其决定的正当性。人们对于展品的选择感到失望，加上对跨文化关系的描述导致展览开放前就遭到了抵制。本章通过授权的展览摄影，研究人种文化在展览中的作用。同时也关注黑人应急文化联盟（BECC）采取的激进主义行动，这一黑人艺术家组织由本尼·安

in museums and who holds the power to decide its exhibition is intricately linked to the social standing and cultural definition of African American people. The exhibition of art by non-White artists in art museums is an affront to racial boundaries set to enforce and protect the myth of a racial hierarchy.

I organized my book *Exhibiting Blackness* as a series of case studies of the most influential and significant exhibitions of art by African Americans in art museums. Chapter 1 considers two exhibitions of African American art in American art museums in the 1930s: *Exhibition of Sculpture by William Edmondson* （1937）, organized by the Museum of Modern Art （MoMA）, and *Contemporary Negro Art* （1939）, organized by the Baltimore Museum of Art （BMA）. These exhibitions demonstrate the contestation over the meaning of exhibitions of Negro art in the modern art museum that continue today. The Harmon Foundation, Alain Locke, American Scene painting, and the brief popularity of "primitive" art in the modern art museum each stake a claim in defining Negro art and national identity through exhibition. This chapter also explores the exhibition of painter Jacob Lawrence's major work *The Migration of the Negro* （1940–1941） by MoMA and the Phillips Memorial Gallery. The exhibition of Lawrence's work fulfilled the competing desires for the role of Negro art in museums to be both perpetually primitive and contemporary. Lawrence's folk art aesthetic appealed to the 1930s and 1940s interest in Negroes as "modern primitive" people. Yet, his racially grounded and contemporary subject matter served as a corrective to the invisibility of Negro history and culture in museums. The blend of his unique style and iconography in *Migration* announced a leading Negro artist on the art scene, fulfilling Locke's prescription for a unique non-imitative Negro art. This groundbreaking exhibition set the stage for other mainstream American art museums to seriously consider the work of modern Negro artists through solo exhibitions.

In the latter half of the twentieth century, mainstream public interest in Black communities began in part because of the Civil Rights Movement and Black American demands for social and economic parity with Whites. Beginning in the mid-1950s through the early 1970s, the visibility of Black Americans in the news media sensitized viewers and readers to the difficulties of Black survival in southern and northern, urban and rural, and distant and local communities. Audiences were moved worldwide by nonviolent tactics that were met with violent responses and civil protest that was met by brutal confrontation. The dignity of Black leadership and courage of everyday Black people turned the heads of even the staunchest supporters of segregation and

图2　大都会艺术博物馆展出《哈莱姆在我心中》，1969年，照片来源：罗伊德·伊尔沃德，版权为罗伊德·伊尔沃德所有。
Fig.2　Metropolitan Museum of Art Façade（1969）. Photo: Lloyd Yearwood. All rights reserved, Estate of Lloyd Yearwood.

德鲁斯（Benny Andrews）领导，用来抗议非裔美国人作品在此展览中的缺席。

　　第三章讨论《两个世纪的美国黑人艺术》展（1976年）（图3a、图3b、图3c），这是非裔美国人的艺术作品在主流艺术博物馆中第一次历史性的综合展示。展览由洛杉矶郡美术馆的非裔美国艺术史部主任大卫·C.德里斯凯尔（David C. Driskell）策划，展示了被之前多数美国艺术史事件遗漏的非裔美国艺术的视觉证据，震惊了许多参观者。[13]《两个世纪的美国黑人艺术》展通过对作品深度多样的展示，对大都会博物馆的"哈莱姆在我心中"展对美国黑人艺术的轻微贬低做出了回应。这一展览以及广泛发放的宣传册，为黑人艺术的丰富历史一直被公然忽视的事实（不仅是主流艺术界，还有整个艺术史学科）提供了直观证据。本章讲述展览背后的故事，包括洛杉矶郡美术馆关于展览的最初概念、馆长的目的以及此次历史性展览受到的评价。在本章内，我分享了一些展览中艺术品选择上的逸闻，以及展览对美术馆种族排斥惯例的影响。

　　第四章聚焦于美国惠特尼美术馆的多媒体展览，探索了自1968年以来美国艺术中黑人的形象及流行文化。展览《黑人男性：当代美国艺术中黑人雄性气概的展示》（1994年），由于其大胆和复杂的主题，获得了大量的关注和批评。由于在主流机构中已经有过几次关于黑人文

stood in resistance to the maintenance of racial hierarchies in the United States government, institutions of higher learning, public schools, libraries, and the arts. Black Americans commanded the world's attention and insisted on increased public awareness of their history, national contributions, capabilities, and achievements in the United States. This desire for Black recognition took many forms. In the visual arts, artists, curators, and art activists responded to the social ills of poverty, racism, and war of the 1950s and 1960s through the prolific production of abstract, social realist, and narrative artworks in sculpture, on canvas, on paper, and through strategic collaborative explosions on the walls of urban buildings. The formation of artist groups and exhibitions about the social upheaval necessary to meet the challenges of the Civil Rights Movement, the founding of museums and galleries dedicated to the visual expressions of Black peoples, and the confrontation of mainstream art museums that repeatedly ignored the history of African American art and culture were a major part of the campaign for change that took place during this period.

　　Chapter 2 of the book begins at the end of the Civil Rights Movement, when the Metropolitan Museum of Art （Met） organized *Harlem on My Mind: Cultural Capital of Black America, 1900–1968*（1969）（Fig.2）, an exhibition that sought to trace the history and value of the predominantly Black community of Harlem in New York City. In organizing this one of the most controversial exhibitions in United States history, the Metropolitan decided to exclude people of Harlem from participating in the planning of the exhibition and to exclude artwork by Harlem's thriving artist community. The museum justified those decisions by arguing that Harlem itself was a work of art and the inclusion of artworks in *Harlem on My Mind* would only detract from the overall exhibition. Public frustration with the selection of objects and depiction of cross-cultural relationships led to boycotts of the exhibition before it even opened. This chapter examines the role of cultural ethnography in an exhibition of Black culture through photography commissioned for the exhibition.. It also focuses on the activism of the Black Emergency Cultural Coalition （B.E.C.C.）, the organization of Black artists led by Benny Andrews, which formed to protest the absence of art by Black Americans in the show.

　　Chapter 3 discusses *Two Centuries of Black American Art*（1976）（Figs. 3a, 3b, and 3c）, the first historically comprehensive exhibition of art by African Americans at a mainstream art museum. Curated by the dean of African American art history, David C. Driskell for Los Angeles County Museum of Art, this exhibition stunned many visitors by displaying visual evidence of a history of African

图 3a、3b、3c 《两个世纪的美国黑人艺术》展的三处展览现场，照片来源：布鲁克林美术馆档案，摄影部记录：《两个世纪的美国黑人艺术》展，大卫·C.德雷斯克尔提供。

Figs.3a, 3b, 3c Three installation views of *Two Centuries of Black American Art* Exhibition. Photo: Brooklyn Museum Archives, Records of the Department of Photography: Exhibition. *Two Centuries of Black American Art*. Courtesy of David C. Driskell.

化的展览，但是没有一次特别关注男子气概这一主题，试图反映参观者对 1968 年以来就黑人男子气概的个人定义，美术馆似乎在做着不可能的尝试。展品抵达洛杉矶阿曼德哈默博物馆时，洛杉矶郡美术馆前馆长助理及社区活动者森西尔·弗格森（Cecil Fergerson）做了一

American art production previously omitted from most accounts of American art.[13] *Two Centuries* responded to the demeaning slight of art by Black Americans in *Harlem on My Mind* at the Met by presenting the depth and variety of their work. The exhibition and its widely distributed catalogue provided visual evidence that the rich history of Black artists had been blatantly ignored, not just by the mainstream art world but by the entire discipline of art history. This chapter tells the stories behind the show, including the Los Angeles County Museum of Art's original conception for it and the curatorial objectives and critical reception of this historic exhibition. Within this chapter, I analyze the narrative of African American art told through the selection of artworks in the exhibition and address the exhibition's impact on museums' practices of racial exclusion.

Chapter 4 examines the Whitney Museum of American Art's multimedia exhibition that explored the image of Black men in American art and popular culture since 1968. *Black Male: Representations of Black Masculinity in Contemporary American Art* （1994） received a great deal of attention and criticism because of its ambitious theme and complex subject matter. Because there have been comparably few exhibitions shown in mainstream institutions that addressed Black culture, and none focused specifically on masculinity, the exhibition bore the impossible pressure of reflecting visitors' individual definitions of Black masculinity since 1968. Upon the exhibition's arrival at the Armand Hammer Museum in Los Angeles, former Los Angeles County Museum of Art curatorial assistant and community activist Cecil Fergerson created a series of alternative exhibitions titled *African American Representations of Masculinity* （*AARM*） to express his dissatisfaction with the discourse of Black masculinity presented in *Black Male*. This chapter addresses the intentions of the exhibition curator Thelma Golden and examines the support and contestation of *Black Male* within Black art communities. As indicated by its title, *Black Male* mixed anthropological and artistic methodologies. The chapter analyzes these approaches to Black representation and self-representation that were crucial for both the *Black Male* and the *AARM* exhibitions.

The last chapter maps the persistence of the anthropological interpretation of African American creativity through the popular traveling show *The Quilts of Gee's Bend* （2002） organized by the Museum of Fine Arts, Houston, and Tinwood Alliance, Atlanta. The art museum's appropriation of the traditional practice of quilt making engages in typical modernist discussions of transgressing the hierarchical boundaries of high and low art. This practice is not new to the art world; however, the comparative discussions of affinities （comparisons explored in reviews of the exhibi-

个外围展，命名为《非裔美国人的雄性气概》（AARM），来表达他对于《黑人男性》展中相关论调的不满。这一章讲述展览馆馆长希尔马古登的意图以及探讨黑人艺术社区内关于《黑人男性》展的赞成与争论。展如其名，《黑人男性》展混合了人类学和艺术学方法论。本章分析了这些黑人表现及自我表现的方法，这些方法对《黑人男性》展和AARM展有至关重要的作用。

最后一章通过由休斯敦美术馆和亚特兰大丁伍德联盟合作承办且颇受欢迎的旅游节目《吉氏湾的棉花被》（2002 年）对非裔美国人的创造力进行了人类学解读。美术馆通过选用棉被制作的传统做法，对跨越高等和低等艺术的分层界限进行了典型的现代主义讨论。这一做法对于艺术界来说并不新鲜，但是亲缘关系的比较讨论（展品和展品目录评论中探究的比较关系）通常用于"非西方"群体而非当代非裔美籍女性制造的人工艺术品。在本章中，笔者通过墙壁文字、物体标示以及亚瑟·罗特施泰因和马里昂·波斯特·沃尔科特拍摄的农场安全管理局纪实照片对展品进行了深入的分析。此外，本人还走访了棉被制作人员，并考察了他们成为主流艺术世界承认的艺术家的经验历程。文中重点讨论了收藏家威廉·阿奈特（William Arnett）以及丁伍德·米提亚（Tinwood Media）收藏的由吉氏湾女性制作的棉花被的"发现"和特殊营销。本人将探讨在棉花被置于主流艺术博物馆的过程中，失去了什么，得到了什么，又学到了什么。

美术馆和公众之间的矛盾、美术馆和艺术评论的矛盾以及美术馆之间的对话，在构建我们认识和理解艺术的情景中起重要作用。我希望本人对于这一历史时期的矛盾分析可以有助于大家在现在和将来去理解美术馆应如何向大众呈现文化和文化差异，当然，这也依赖于美术馆所能提供的最好的艺术展品。通过对这些矛盾及其责任的深入了解，希望能更多举办这样的展览：即使艺术家通过展品得到大众认可，又为大众提供经验，丰富大众的生活并鼓舞大众。

注释：

[1] 新黑人运动：New Negro Movement，发生于 20 世纪 20 年代，旨在提高黑人地位并反抗支持种族隔离的吉姆·克罗法案的文化运动，因始于美国纽约的哈莱姆区，也被称作"哈莱姆文艺复兴"。——译者注

[2] 民权运动：Civil Right Movement，是指第二次世界大战以后，美国黑人发起的一场旨在提高种族权利，反抗种族隔离的群众运动。——译者注

tion and the exhibition catalogue） are usually reserved for artifacts made by "non-Western" groups instead of contemporary African American women. In this chapter, I offer a close analysis of the exhibition through its wall text, object labels, and documentary Farm Security Administration photographs by Arthur Rothstein and Marion Post Wolcott. My writing is also informed by interviews with the quilters about their experience of becoming exhibiting artists in the mainstream art world. Important to this discussion is the "discovery" and exceptional marketing of the quilts made by the women of Gee's Bend by collector William Arnett and Tinwood Media. I discuss what is lost, gained, and learned by recontextualizing the quilts in mainstream art museums.

The sets of tension between the museum and the public, the museum and art critics, and the conversations that take place within the museum, play a big role in constructing the context in which we see and understand art. I hope that my analysis of this these tensions in this history will assist in our current and future understanding of how museums present culture and cultural differences to a public that depends on museums to show the best of what art has to offer. With greater understanding of these tensions and the responsibilities that accompany it, there is potential to curate exhibitions that both validate the artists represented in exhibitions, and offer experiences to audiences that enrich and inspires their lives.

Notes:

1 Alan Wallach. *Exhibiting Contradiction: Essays on the Art Museum in the United States*. Boston: University of Massachusetts Press, 1998. 1.

2 A scarce number of African Americans had been exhibiting their art in private studios, galleries, regional art clubs, abolitionist fund raising events, and world's fairs since the mid-nineteenth-century. The earliest exhibitions of African American art were presented in Chicago in 1917 at the Arts and Letters Society of Chicago and the Wabash YMCA in 1923. Beryl J. Wright. "The Harmon Foundation in Context: Early Exhibitions and Alain Locke's Concept of a Racial Idiom of Expression". *Against the Odds: African American Artists and the Harmon Foundation.* Newark: The Newark Museum, 1989. 17.

3 Chicago Woman's Club, *The Negro in Art Week, November 16-23: Exhibition of Primitive African Sculpture, Modern Paintings, Sculpture, Drawings, Applied Art, and Books* （Chicago: Chicago Woman's Club, 1927）; Daniel Schulman, "White City" and "Black Metropolis": African American Painters in Chicago, 1893—1945" in *Chicago Modern, 1893—1945: Pursuit of the New* （Chicago: University of Chicago

Press in conjunction with the Terra Museum of American Art and Terra Foundation for the Arts, 2004）, 46. "The Negro in Art Week" exhibition followed the establishment of Negro History Week in 1926 by historian Carter G. Woodson and his Association for the Study of Negro Life and History. Although similarly named, the exhibition was not held during the same week in February as Negro History Week. Instead, the exhibition was mounted by the Chicago Art Institute November 16-December 1, 1927（23 days）and the Chicago Woman's Club November 16-23（8 days）.

In the U.S., the term Negro was one of the terms commonly used to refer to people of African descent in the first half of the twentieth century. The term Black was used by people of African descent during and after the modern Civil Rights Movement (approximately 1954—1968) as a term announcing their empowerment as an equal part of the national political scene. The term African American is used today along with Black to refer to people of African descent.

4 Alain Locke. "The New Negro". In：Alain Locke. *The New Negro: Voices of the Harlem Renaissance*. New York: Boni, 1925. Reprint, New York: Touchstone Press, 1999.15

5 As art historian Lisa Meyerowitz explains, the exhibition revealed the "inherently paradoxical nature of the exhibition of works by black artists in white institutions" and "problems of defining a race through art exhibition, problems which still persist today." Lisa Meyerowitz. "The *Negro in Art Week*: Defining the 'New Negro' Through Art Exhibition". *African American Review* Vol. 31, No. 1, 1997（Spring）: 75.

6 The African presence was represented through the Blondiau Collection of African Art from the Belgian Congo owned by the Harlem Museum of African Art. European Cubist paintings were first exhibited in the United States in the infamous Armory Show in 1913, an exhibition that the Chicago Art Institute sought to present. Meyerowitz, 80.

7 Letter from Robert B. Harshe to Miss Zonia Baber, October 12, 1927, Chicago Woman's Club Papers- Box 52, *The Negro in Art Week Scrapbook*. Chicago Historical Society Archives.

8 Some African Americans shared this belief also. Archibald Motley, an accomplished Chicago-based artist who did not participate in *The Negro in Art Week* stated that he chose not to submit work "because Negroes were putting out such poor work". Wendy Greenhouse. "Motley's Chicago Context, 1890—1940".In：Jontyle Theresa Robinson，Wendy Greenhouse. *The Art of Archibald J. Motley Jr.* Eds. Lincoln, Massachusetts: Sewall Co., 1991. 51.

9 Lowery Stokes Sims. *Challenge of the Modern: African American Artists 1925—1945, Volume 1*. New York: The Studio Museum in Harlem, 2003. 13-14. This conformity to European aesthetics extended to the exhibition programs also. At this exciting time for jazz music, particularly in Chicago,

the exhibition's musical program consisted of traditional Negro spirituals, chorales and concertos by Bach, and vocal and piano accompaniment of Handel, Delibes, Vitali, Chopin and others.

10 Ironically, "Negro Types Found in Haiti", an exhibition of drawings made by Russian artist Vladimir Perfilieff at the Carson-Pirie-Scott Galleries was reviewed in the art section of the *Chicago Daily News* during the run of The Negro in Art Week exhibition. The first sentence refers to *The Negro in Art Week* but the author does not go on to review the exhibition. The drawings of Negro people exhibited at a gallery by a Russian artist was considered worthy of review in the art section of the mainstream press. However, the art by Negroes that conformed to Eurocentric standards on view at the city's premier art museum was not deemed worthy of review. Marguerite B. Williams. "Here and There in the Art World". *Chicago Daily News*, November 16, 1929, unpaginated.

11 Carol Duncan. "Introduction". *Civilizing Rituals: Inside Public Art Museums*. New York: Routledge, 1995.6

12 Duncan, 9.

13 The exhibition premiered at the Los Angeles County Museum of Art and traveled to three different venues: Los Angeles County Museum of Art, September 30-Noveember 21, 1976; The High Museum of Art, Atlanta, January 8-February 20, 1977; Museum of Fine Ats, Dallas: March 30-May 15, 1977; The Brooklyn Museum, June 25-August 21, 1977.

Suggestions for Further Reading:

[1] Carol Duncan. *Civilizing Rituals: Inside Public Art Museums*. New York: Routledge, 1995.

[2] Locke Alain.*The New Negro: Voices of the Harlem Renaissance*. New York: Boni, 1925. Reprint, New York: Touchstone Press, 1999.

[3] Meyerowitz Lisa. "The *Negro in Art Week*: Defining the 'New Negro' through Art Exhibition" *African American Review* Vol. 31, No. 1, (Spring, 1997）.

[4] Reynolds, Gary A. et al. *Against the Odds: African American Artists and the Harmon Foundation*. Newark: The Newark Museum, 1989.

[5] Robinson Jontyle Theresa ,Wendy Greenhouse.*The Art of Archibald J. Motley Jr.* Lincoln, Massachusetts: Sewall Co., 1991.

[6] Stokes Sims, Lowery. *Challenge of the Modern: African American Artists 1925—1945, Volume 1*. New York: The Studio Museum in Harlem, 2003.

[7] Wallach Alan. *Exhibiting Contradiction: Essays on the Art Museum in the United States*. Boston: University of Massachusetts Press, 1998.

在水晶桥博物馆展览美国艺术：为全球经济进行的本土策划

Presenting American Art at Crystal Bridges: Curating Locally for a Global Economy

凯文·墨菲　　葛华灵 ＊　译

Kevin Murphy　　Translator: Ge Hualing

2011 年 11 月 11 日，位于美国阿肯色州本顿维尔市的水晶桥美国艺术博物馆向公众开放，其宗旨是"集自然之美，艺术之力，欢迎所有人来歌颂美国之精神"[1]（图1）。水晶桥博物馆开馆的时候，在美国各地也有很多美国艺术藏品正要搬进全新或翻新的展览里，其中有纽约布鲁克林博物馆(2011 年)、芝加哥艺术博物馆(2005 年)、底特律艺术博物馆（2007 年)、加州圣马力诺市的亨廷顿图书馆艺术收藏和植物园（2008 年)、密苏里州堪萨斯市奈尔逊 - 阿特金斯博物馆、里士满弗吉尼亚美术馆（2010 年)、波士顿美术馆（2010 年)、纽约大都会艺术博物馆（2012 年)。[2]

The Crystal Bridges Museum of American Art in Bentonville Arkansas opened to the public on November 11, 2011, with the mission of "welcoming all to celebrate the American spirit in a setting that unites the power of art with the beauty of nature."[1] (fig.1)　　The museum's opening coincided with a number of reinstallations of American art collections in new or renovated spaces throughout the United including: Brooklyn Museum, New York （2001）; Art Institute of Chicago （2005）; Detroit Institute of Art （2007）; The Huntington Library Art Collections and Botanical Gardens, San Marino, California （2008）, Nelson-Atkins Museum of Art, Kansas City, Missouri （2009）; Virginia Museum of Fine Arts, Richmond （2010）; Museum of Fine Arts Boston （2010）; and Metropolitan Museum of

图 1　水晶桥美国艺术博物馆鸟瞰图，照片来源：水晶桥美国艺术博物馆提供，本顿维尔镇，阿肯色州。

Fig.1　Aerial view, Crystal Bridges Museum of American Art. Photo: Courtesy of Crystal Bridges Museum of American Art, Bentonville, Arkansas.

＊　葛华灵 上海大学上海美术学院 讲师（Ge Linghua Lecturer，Shanghai Academy of Fine Arts，Shanghai University）

表面上，水晶桥博物馆与上面这些博物馆在美国艺术的收藏和展示上有着类似的结构和使命。它收藏并展示美国艺术，让观众了解从殖民时代到现在生产于美国的艺术。水晶桥博物馆有一批经过专门训练的艺术教育工作者、策展人，以及志愿者所提供的讲解服务，面向不同层次的观众，从小学生到资深的艺术史学者。然而，2011 年建成的水晶桥博物馆比第一波美术馆的建立晚了一百多年，那些博物馆在 19 世纪后期和 20 世纪初期的"镀金时代"在美国各大城市建立。例如大都会博物馆建于 1870 年，波士顿美术馆建于 1876 年，芝加哥艺术博物馆建于 1879 年，底特律艺术博物馆建于 1885 年。[3]还有一些博物馆是在 20 世纪建立的，例如纳尔逊 - 阿特金斯博物馆，它还在 21 世纪扩展了对历史性美国艺术的收藏。它们都有自己的大楼用来放藏品，组织慈善，支持各项活动，有些是个人牵头，有些有家族背景。

无论是建立年代还是地理位置，水晶桥博物馆都与"镀金时代"成立的博物馆不一样。它坐落于封闭社区和家禽农场组成的半乡村地区，而不是大城市。不同于那些细水长流的捐赠和购买，它是仅凭一人之力，也就是由于沃尔玛集团的女继承人爱丽丝·沃尔顿（Alice Walton）在近 10 年来的疯狂采购而丰富了整个收藏。爱丽丝·沃尔顿及其家族与跨国公司，尤其是沃尔玛和它的供应商们持续不断地支持着水晶桥博物馆。它与那些历史悠久的博物馆间的这些关键差异深刻地影响了它的制度文化，同时这也是博物馆创建者和领导者的一个骄傲。

水晶桥博物馆的美国艺术展示为三种不同的人群服务，这也是它的内在动力：阿肯色州西北和欧扎克地区的当地人群，全国、全球的艺术观众和学者，还有和沃尔玛有生意往来的企业。他们的需求与提议各不相同，有时甚至互相冲突，这些水晶桥博物馆在展陈、教育、展览计划以及机构定位的长远发展上都必须要考虑。美国大多数博物馆都是靠富有的个人、家庭，有时还有企业支持，为企业利益做些平衡正常，但是很少有将博物馆作为企业整体形象的一部分的（大部分捐赠者不是沃尔顿家族的成员），而对于其他的观众，例如学者、博物馆专家和记者，口头上则宣称与自己的企业赞助商保持距离（沃尔玛及其供应商）。[4]水晶桥博物馆前两年的实践是独特的材料，对它的个案研究让我们能讨论商业与文化的交织中对美术馆的益处与不利。

水晶桥博物馆占地 120 英亩，毗邻阿肯色州的本顿维尔镇，该镇拥有 38000 人口，位于阿肯色州的西北部，靠近密苏里州的北部和俄克拉荷马州的西部的地方。阿肯色州本身在美国版图的东部偏南。美国下半部分的中西部和上半部分的南部主要是乡村，和美

Art, New York （2012）.[2]

Crystal Bridges shares superficial structural and mission similarities with the collecting and display practices of American art at the museums mentioned above. It acquires and presents American art to educate visitors about the history of art produced in America from the colonial era to the present. It offers interpretive programs led by specially trained art educators, curators, and volunteers to engage diverse audiences ranging from primary school students to senior scholars in art history. However, Crystal Bridges' establishment in 2011 took place more than a century after the first wave of museums were created in major United States cities during America's "Gilded Age" of the late 19th and early 20th centuries. The Metropolitan Museum of Art was founded in 1870, the Museum of Fine Arts Boston opened in 1876, Art Institute of Chicago in 1879, and Detroit Institute of Art in 1885.[3] These and other American museums established after the turn of the 20th century, such as the Nelson-Atkins Museum, had developed substantial collections of historical American art by the time they reinstalled them in the 21st century. They also had the buildings to house theose collections and long-standing. networds of philanthropy . guided by individuals and families, to support their activities.

Crystal Bridges differs from museums founded in the "Gilded Age" in its geographic location as well as chronology. It is located in a semi-rural region dominated by poultry farms and gated communities of single–family homes, rather than in a big city. Instead of a collection created by a mixture of gifts and purchases, one individual, Walmart Corporation heiress Alice Walton, amassed Crystal Bridges' collection during less than ten years of furious acquisition. Much of its continuing support comes from Alice Walton, her family, and transnational corporations, in particular Walmart and its suppliers. Those key differences between Crystal Bridges and longer-established museums deeply affect its institutional culture and are a point of pride with the museum's founder and leadership.

Crystal Bridges presentation of American art is driven by its desire to serve three distinct constituencies: its local community of Northwest Arkansas and the Ozark region, national and international art audiences and scholars, and the corporations who do business with Walmart. These stakeholders have diverse, at times conflicting, requirements and agendas that Crystal Bridges must consider in its installation, education, and exhibition programs as well as in the development of its institutional identity. Most museums in the United States rely on funding from wealthy individuals, families, and to some extent corporations, but few must balance the need to embrace corporations as an integral part of their image for one stakeholder （the majority of its donors who are not members of the Walton family）, while vocally distancing itself its corporate sponsor （Walmart and its vendors） for another audience comprised of scholars, museum professionals, and journalists.[4] A case study of Crystal Bridges during its first two years provides a unique opportunity to discuss the benefits and detriments of an art museum commingling commerce and culture.

国其他地区相比，这里人们的贫穷和肥胖程度都超过平均水平，而受教育程度则远低于平均水平。[5] 然而，本顿维尔和周边社区是世界上最大的连锁零售商沃尔玛、世界上最大的肉食供应商泰森食品公司、美国最大的货运物流企业之一 J.B. 亨特运输公司的总部所在地。与沃尔玛有生意往来的跨国公司，例如卡夫、米勒康胜、雀巢、玛氏、保洁都在本顿维尔设立了常驻办事机构。

企业对水晶桥博物馆的捐赠塑造了其游客体验。在博物馆的餐厅、咖啡馆和一些特殊宴会中，部分的食物和饮料是由捐赠企业提供的，比如可口可乐和米勒康胜。在 2013 年，水晶桥博物馆得到了一幅安迪·沃霍尔画的可口可乐瓶，于是品牌又延伸到了展厅里。可口可乐是水晶桥博物馆永久藏品开馆展的三个主要赞助者之一。[6] 这幅画的收购展现了一个消费奇观的循环，混合着平民主义与寡头资本，同时又展现了企业关系如何转身为慈善壮举，让捐赠、受赠双方受益。可口可乐和沃尔玛（以及艾丽丝·沃尔顿）先凭借卖软饮料，从数以百万中低收入的沃尔玛顾客身上获得收益。可口可乐通过给博物馆的这份大礼表达对沃尔顿家族的感激，它花了 5700 万美元买下安迪·沃霍尔的画，画中又是它的标志性产品。可口可乐公司对外发布了一篇通讯，庆祝画作的高价收购，并把它作为可口可乐在美国文化中的偶像地位的证明。[7]

展览的照明设备是由通用电气公司赞助的，算上可口可乐和高盛投资银行就是其永久收藏开馆展的三大赞助商。因此，参观者能看到这些绘画、雕塑等陈列的东西是一种企业关系的结果，而不是经过严格的调研或是咨询兄弟机构所做出最有利的博物馆照明。策展人和布展人员发现他们自己是在萨夫迪（Moshe Safdie）极具挑战的高穹顶空间中，却只有仅供外部安全照明的低功率灯泡来照亮展陈，一般博物馆要求的灯泡瓦特数和寿命都要高得多。[8]

博物馆建筑群包含 6 个曲线形的楼，相互连接，构成复杂，它们围着两个人工池塘，池塘里还有一条浅浅的峡谷（图 1 和图 2）。博物馆是由马萨诸塞州波士顿的建筑师摩西·萨夫迪设计，他在全球范围内设计过不少博物馆和文化机构，包括洛杉矶的史格博文化中心、马萨诸塞州塞勒姆县的皮博迪 - 艾克塞思博物馆和加拿大安大略美术馆。[9] 整个博物馆群的建造费用从未公布，但是根据税务资料保守估计 2011 年年底之前花费至少是 2 亿美元，这还不算土地的价钱。[10]

萨夫迪的建筑结构和设计经常会照顾周围的地形。水晶桥博物馆建于一片浓密的松树、杨树和山茱萸树林中，来参观的人不管是驾车还是步行都要经过一条专门

Crystal Bridges occupies a 120–acre site adjacent to the town of Bentonville, Arkansas, which has a population of 38,000 and is located in the extreme northwest of the state, near the borders of Missouri to the north and Oklahoma to the west. Arkansas itself is slightly south and east of the geographic center of the United States. The state and geographic region of the lower mid-west and upper south are predominantly rural, with higher than average levels of poverty and obesity, and much lower than average levels of educational achievement compared to the rest of the United States.[5] However, Bentonville and the surrounding communities are the headquarters for Walmart, the biggest chain of retail stores in the world, Tyson Foods, the largest producer of meat in the world, and J.B. Hunt Transport Services, one of the largest trucking and logistics companies in the US. Transnational corporations who do business with Walmart, such as Kraft, Miller Coors, Nestle, Mars, and Proctor and Gamble often maintain permanent offices and staff in Bentonville.

The corporations who donate money or goods to Crystal Bridges shape the visitor experience of the museum. Food and beverage options are in part provided by corporate donors such as Coca-Cola and MillerCoors, whose products are featured throughout the museum's restaurant, coffee bar, and at special catered events. In 2013, Crystal Bridges acquired a panting by Andy Warhol depicting a Coca-Cola bottle, extending the brand's presence at the museum into the galleries. Coca-Cola was one of three lead sponsors for the inaugural exhibition of the permanent collection.[6] The purchase of the painting represents a spectacular cycle of consumption, both populist and oligarchic, while demonstrating how corporate relationships can morph into philanthropy that benefits the donor and recipient. Coca-Cola and Walmart（and by extension Alice Walton）profit by selling soft drinks to millions of lower and middle–income Walmart shoppers. Coca-Cola demonstrated its appreciation for the Waltons through its gift to the museum, which in turn spent over $57 million on a painting of its signature product. The Coca-Cola Company created a press release celebrating the high price of the painting as evidence of the brand's iconic status in American culture.[7]

Exhibition lighting in the museum's galleries is sponsored by General Electric, which along with Coca-Cola and investment banking firm Goldman Sachs made up the three main sponsors for the inaugural exhibition of the permanent collection. Visitors' ability to *see* the paintings, sculpture, and other objects on display is thus the result of a corporate relationship rather than rigorous investigation into the current best practices for museum lighting or consultation with peer institutions. Curators and art installers found themselves trying to light the collection in Safidie's challenging curved and soaring spaces using underpowered bulbs meant for providing exterior security lighting for domestic environments rather than the more much more demanding wattage and longevity requirements of a museum.[8]

The museum complex consists of six interconnected pavilions in a variety of curvilinear shapes arranged around two artificial ponds and set within a shallow valley.（figs. 1 and 2）The

图2　水晶桥美国艺术博物馆鸟瞰图，照片来源：水晶桥美国艺术博物馆提供，本顿维尔镇，阿肯色州。
Fig.2　Aerial view of Crystal Bridges Museum of American Art. Photo: Courtesy of Crystal Bridges Museum of American Art, Bentonville, Arkansas.

设计的曲径，为的是把建筑都藏起来，让观众先沉浸在自然环境里。即使到了入口处，大约 201 000 平方英尺的建筑也只露出一小角，因为它都在下面一层。只有当观众乘坐电梯下行 50 英尺到达包含画廊、餐厅和商场的广场的入口，才能看清整个博物馆的全貌。

通向博物馆低调门厅的这条长路有意给观者一种局促的体验。他们刚刚路经平坦无垠的农田，经过中低档购物和餐饮连锁的公路商业区（入驻许多沃尔玛商店），经过了乏味单调的建筑，要进到某种纯艺术与高雅文化的环境里。这条蜿蜒的小路也给整个建筑物增添了戏剧性。然而，在欧扎克地区，这样的建筑的选址，远离主路，掩藏在树木与小径深处，也类同于沃尔玛、泰森等企业驻扎的工业园区和许多为泰森食品公司供货的家禽农场和加工厂的某种做法，躲到视线之外。

水晶桥博物馆的建筑融入了当地的环境。铜屋顶和灰白色的外墙与周围树木的颜色显得非常和谐。屋顶的形状向两个池塘内部弯曲，参照了山坡的方向和倾斜度。水晶桥博物馆宣称在建造过程中对周围的风景和环境非常留心，在可能的情况下尽量运用当地的材料，例如用阿肯色州的松树来做博物馆的内部吊顶（图3和图4）。博物馆的墙壁离次生林只有 6 英尺的距离，这是为了保住两棵树改动过的设计，这两棵树是以电影《末路狂花》

campus was designed by the Boston, Massachusetts-based architect Moshe Safdie, who had completed several other museums and cultural sites internationally, including the Skirball Cultural Center in Los Angeles, Peabody-Essex Museum in Salem, Massachusetts, and Art Gallery of Ontario, Canada.[9] The total cost of the complex has never been announced, but conservative estimates based on tax information suggest at least $200 million were spent through the end of 2011, without factoring in the value of the land.[10]

Safdie's architecture often takes structural and design influences from the surrounding landscape. Crystal Bridges is built on a densely forested site of pine, aspen, and dogwood. The visitor approaches the campus by vehicle or by foot along a winding path designed to hide the buildings from view and immerse the visitor within nature. Even upon arrival at the entrance, very little of the approximately 201,000 square foot complex is visible because it lies below grade. Only as the visitor makes their way to the elevators that descend approximately 50 feet to a plaza containing the entrance to the galleries, restaurant, and store can the visitor apprehend the museum completely.

The long pathway before the museum's modest entry pavilion provides a liminal experience for the visitor, who is taken out of the environment of flat agricultural fields, strip malls featuring middle and low priced shopping and dining chains （plus many Walmart stores）, and architecturally bland housing developments into one of fine art and high culture. The sinuous approach also adds an extra element of drama to the architecture. However,

041

中的两位主人公"塞尔玛和路易斯"来命名的，位于博物馆建筑群的西北角。保留塞尔玛和路易斯的故事被水晶桥博物馆当作担负环境责任的一个论据，为博物馆在这里挖掘、建造省去了一大笔税务费用。两个树的剪影成了博物馆餐厅的标志，水晶桥博物馆认为：它们"代表了美国人坚定不移的意志"。[11]

博物馆里现在还能看到的两个池塘代表了对当地环境最重要的干涉。它们源于天然的"水晶泉"，博物馆也因此得名。泉水经过了改道，流量也有一个精巧的水利系统控制，该系统藏在两个连贯东西建筑群的"桥式"展厅下面。

博物馆内部，大片的玻璃窗让观者能够回望户外的风景，阿肯色松树做成的倾斜天顶则将自然又带到了博物馆内部。展厅和活动空间占据了博物馆一半的建筑面积，剩下的一半空间留给了办公室、储藏室和机械设备。博物馆群中的4座建筑用于美国艺术的永久收藏。在任何开放时间都可以看到大约450件作品，油画占多数，但也包含纸上作品（水彩、版画和素描）和少量雕塑。博物馆一层有11000平方英尺的空间从行政区域中分出来，包括4个房间，用作临时展览。有时候是从永久收藏中选一些做展览，但到现在为止更多时候是美国其他机构在组织利用。[12]

一个包括三个策展人的小组和博物馆领导者、创始人艾丽丝·沃尔顿相互协作，2011年11月1日把藏品展现给观者。他们有意抛弃了传统的单一创始人的博物馆模式。在那样的模式中，往往是藏家自己安排展品，放在一个家居环境里，或者添一些说教性的内容，让你听到、看到收藏家及其藏品的历史，这就变成了个人趣味、财富和慈善的体现。[13]博物馆筹建期间，艾丽丝·沃尔顿在博物馆、艺术市场和学院中掀起了一股恐慌，她从那些著名的半公共收藏机构买进作品，包括纽约公共图书馆、费城的杰弗逊医学院以及田纳西州纳什维尔的菲斯克大学。艺术史家和批评家担心这些常被用于研究和教学的作品，从纽约或费城转移到遥远的阿肯色的私人博物馆后将很难与公众见面。这些引起争议的收购成了一场文化论战的象征，话题关于美国财富增长的不均，也关于沃尔玛的零售和企业战略，在一些人看来沃尔玛就在压榨较小的家庭商铺，压榨自己的雇员，甚至还压榨美国政府。[14]

博物馆的文案中没有出现艾丽丝·沃尔顿，展厅的标签上也没有她具体的收购细节。博物馆的领导层决定不在标签上列检索号，检索号通常对研究者有用，这也是有意识地和她拉开距离的方式。沃尔顿及其家族在本顿维尔本地，在全国性的媒体都经常露脸，但是博物馆看起来并没有她参与日常运营。官方数据里，修建美术馆中的8亿美元资金要归功于沃尔顿家族基

in the context of the Ozark region, such siting of buildings, away from the main road, screened by trees and down meandering paths, is reminiscent of the way in which industrial parks that house Walmart, Tyson, and other corporations, and numerous poultry farms operated by contractors for Tyson Foods and their associated rendering plants, are hidden from view.

The architecture of Crystal Bridges blends into its site. The copper roofs and bands of ash planks on the exterior walls of buildings harmonize with the colors of the surrounding forested landscape. The geometry of the roofs, which curve inward toward the two ponds, reference the degree of slope and direction of the hillsides. Crystal Bridges proclaimed its sensitivity to the landscape and environment during its construction, as well as their use of local materials wherever possible such as the Arkansas pine cladding the interior ceiling structure. （figs. 3 and 4） There is just a six-foot space between the walls of the museum and the second-growth forest beyond it, and the design was altered to retain two trees, named after the title characters in the movie "Thelma and Louise," located at the north west corner of the campus. The story of saving Thelma and Louise is used by Crystal Bridges as evidence of its environmental responsibility, allowing the museum to elide the significant toll excavation and construction exacted on the site. Silhouettes of the trees form the museum's restaurant's logo, and according to Crystal Bridges, they "represent the spirit of American determination and resolve."[11]

The two ponds represent the most significant intervention into the site still visible to the visitor. They are fed by a natural spring, "Crystal Spring," from which the museum gets the first part of its name. It has been redirected and its flow is controlled by elaborate weir systems underneath the two glass-walled "bridge" pavilions connecting the east and west sides of the complex.

Inside the museum, large expanses of windows providing views back on to the landscape and the sloping wood ceilings made from Arkansas pine bring the idea of the nature into the museum interior. Galleries and public spaces comprise about half of the square footage of the museum, with the remaining space occupied by administrative offices, art storage, and the physical plant. Four of the buildings are designated for the display of the museum's permanent collection of American art. At any given time, there are approximately 450 works of art on view from the collection, the majority are paintings but the installation also includes works on paper （watercolors, prints, and drawings） and a few sculptures. A separate 11,000 square foot space on the first floor of the administrative tower consisting of four connected rooms is used for temporary exhibitions. These are sometimes drawn from the permanent collection, but hitherto have been more often organized by other institutions throughout the United States.[12]

A team of three curators worked with senior museum leadership and the museum's founder, Alice Walton, to present the collection to the public on November 11, 2011. They have discarded traditional model of a single-founder museum as a

金会，又与艾丽丝·沃尔顿隔了一层，让这笔资金看起来是由一个慈善基金会捐助，怀着慈善的目的，并有专家管理。[15] 沃尔顿和博物馆对外宣称，藏品的收购，其目的是建成一个百科全书式的美国艺术收藏，在过程中不少学者提供了建议，如普林斯顿的退休教授约翰·威尔默丁（John Wilmerding），还有受过美国艺术史和博物馆管理专业训练的员工与策展人，包括执行馆长（现已卸任）唐·巴奇加卢皮（Don Bacigalupi）。具体操作中，收购最初的两年，先由策展人员提议、审核，并经艾丽丝·沃尔顿为首的董事会批准。[16] 但在水晶桥博物馆的神话中，艾丽丝·沃尔顿和他的家族是要将这个伟大的美国艺术收藏送给本顿维尔市，送给阿肯色州，送给美国，送给镌刻着个人与家庭荣耀的世界。

艾丽丝·沃尔顿及其家人谈起自己在水晶桥博物馆做的事情时很低调，这有个人的原因，也有战略的考虑。不管他们的动机，单看沃尔顿和水晶桥博物馆十年筹备汇集起来的东西，确实蕴藏着美国上下四百年里丰富多变的艺术历程，极具审美、文化和历史价值，与个人、家庭或公司议程无关。缩小了看，开馆展也为谴责沃尔顿掠夺东海岸机构的作品提供了一个语境，尤其是亚瑟·杜兰德（Asher B. Durand）的《知心伴侣》和托马斯·伊肯斯（Thomas Eakins）的《本杰明·兰德教授》，正好回答了对沃尔顿只收罗"杰作"，而不是精心规划收藏的批评，要求它跟华盛顿的国家美术馆、史密森美国艺术博物馆、纽约的大都会艺术博物馆、波士顿美术博物馆、亚卡特博物馆、德克萨斯州和费城艺术博物馆一样。

笔者也在策展团队中，策划了博物馆永久收藏的开馆展，其间没有来自董事会、捐赠者、个人或公司的直接压力，而叙述美国艺术、美国历史的时候，这些藏品又非常充分。我们主要是关心和服务那些几乎没有机会看到伟大艺术作品的本地民众。收藏民族艺术和工艺品的博物馆中，离水晶桥最近的是位于俄克拉荷马州的塔尔萨吉尔克里斯博物馆，去那儿大约有两个小时的车程。最近的百科全书式的博物馆是在堪萨斯城的奈尔逊-阿特金斯博物馆，距离密苏里州本顿维尔北部有三个小时的车程。策展主管大卫·休斯顿（David Houston）在布展时曾说过："在策展实践中，我们从一个简单前提出发：试图阐明从殖民地时期到现在的美国艺术的发展脉络。展览一开幕，美国艺术每一阶段都很清楚。"[17]

策展人也在实践着萨夫迪的建筑逻辑。正如建筑师、城市规划师乔·达伊（Joe Day）最近的研究，在最基本的层面上，博物馆和监狱功能相似。这两种建

strategy. In that model the museum becomes the embodiment of the taste, wealth, and philanthropy of an individual through display practices that refer to the collector's own arrangements of objects, often in a domestic setting, or through didactic texts, and audio or visual displays giving the history of the collector and their acquisitions.[13] Early in the museum's development |Alice Walton caused anxiety among museums, the art market, and the academy by purchasing art from high profile semi-public collections, including the New York Public Library, Jefferson Medical College in Philadelphia, and Fisk University in Nashville Tennessee. Art historians and critics worried that the paintings, often used for research and taught in American art courses, would become inaccessible when they moved from New York or Philadelphia to a private museum in remote Arkansas. The controversial acquisitions became emblematic of cultural debates about growing wealth disparity in the United States and Walmart's retail and corporate strategies, which some feel has been predatory toward smaller, family-run stores, its own employees, and the American government.[14]

Alice Walton is not mentioned on texts within the museum, nor are her purchases of specific objects acknowledged on object labels in the galleries. Museum leadership decided not to include accession numbers on labels, which are often helpful to researchers, as part of a self conscious strategy to distance the museum from her. Walton is a visible presence in the community of Bentonville, as is her family, as well as in the national media, but the museum suggests that she has been hardly involved in its day-to-day operation. Officially, the endowments of $800 million that established the museum is credited to the Walton Family Foundation, creating two steps of removal from Alice Walton and giving the funds a veneer of being donated by a charitable foundation under professional management with demonstrable philanthropic goals.[15] Walton and the museum have declared publically that acquisitions are made with the desire to create an encyclopedic collection of American art, in consultation with scholars such as John Wilmerding, professor emeritus of Princeton University, as well as staff trained in American art history and museum management, including the （now former） executive director Don Bacigalupi, and curators. In practice, acquisitions during the first two years were suggested and vetted by curatorial staff, and were approved by the board of directors, which Alice Walton chairs.[16] Yet, in Crystal Bridges' mythology, Alice Walton and her family's desire to give the gift of a great collection of American art to Bentonville, Arkansas, the United States, and the world overrides any need for personal or family glory.

Alice Walton and her family speak modestly about their involvement in Crystal Bridges for reasons both personal and strategic. Without awareness of those motives, the objects amassed by Walton and Crystal Bridges during the decade of the museum's planning simply encompass the rich and varied history of art created in the United States over a 400 year period; they are objects of high aesthetic, cultural, and historical importance unencumbered by personal, family, or corporate agendas. To a

图3 殖民地时期到19世纪展厅内景，水晶桥美国艺术博物馆，照片来源：水晶桥美国艺术博物馆提供，本顿维尔镇，阿肯色州。
Fig.3 Installation view, Colonial through Nineteenth Century Galleries, Crystal Bridges Museum of American Art. Photo: Courtesy of Crystal Bridges Museum of American Art, Bentonville, Arkansas.

筑形式的体系结构从根本上关注的都是观察和容纳。水晶桥博物馆的建筑容纳着参观者，并引导他们线性地通过四个永久藏品的展厅。很少有地方能向外看到整个建筑群，沿着长长的弯曲的内墙，参观者走过大大小小的展示空间，整个收藏缓缓地展现开来。（图3和图4）在每个馆之间有一个玻璃幕墙的前厅，可以看到建筑和风景，正好为游客在进入下一个黑暗的展厅空间之前提供一个休息。[18]

2011年水晶桥博物馆的开馆夹在两个对美国艺术做重新布局的高调事件中间。由福斯特事务所设计（诺曼·福斯特爵士）的波士顿美术馆美国艺术侧翼于2010年11月向公众开放，而大都会艺术博物馆在2012年1月重新开放它的美国侧翼。水晶桥博物馆的策展人时刻关注他们的同行在东海岸的进展，而且大都会的展览团队在2011年夏天还参观了水晶桥博物馆。

要去波士顿美术博物馆和大都会艺术博物馆的美国艺术展室，都要经过庭院。波士顿美术博物馆的展品垂直分布于三层，前面是玻璃墙，入口附近都摆着这个展厅年代标志性的作品，参观者据此可以找出自己想去的地方。那些观众最喜欢的作品也都放在展厅入口附近，他们不用走太远就能欣赏到。

lesser extent, the inaugural installation also provides context for works Walton was accused of looting from east coast institutions, particularly Asher B. Durand's *Kindred Spirits* and Thomas Eakins's *Professor Benjamin Rand*, answering criticism that Walton sought to amass a group of "masterpieces" rather than a carefully planned museum collection on par with the National Gallery and Smithsonian American Art Museum in Washington, D.C., the Metropolitan Museum of Art in New York, Museum of Fine Arts Boston, Amon Carter Museum in Ft. Worth Texas, and Philadelphia Museum of Art among others.

The curatorial team, which included the author, who organized the inaugural presentation of the permanent collection felt no direct pressure from the board or donors, individual or corporate, in designing the narratives of American art and American history that we felt the collection supported best. We were primarily concerned with serving the needs of a native populace who had little previous opportunity to see great works of art in the region. The closest museum to Crystal Bridges featuring a collection of national art and artifacts is the Gilcrease Museum in Tulsa, Oklahoma, approximately two hours by car. The closest encyclopedic museum is the Nelson-Atkins in Kansas City, Missouri, three hours north of Bentonville. David Houston, chief curator at the time of the installation has said "In terms of curatorial practice, we began with a simple premise: trying to articulate a line of American art from the colonial period to the

图 4　19 世纪晚期到 20 世纪早期展厅内景，水晶桥美国艺术博物馆，照片来源：水晶桥美国艺术博物馆提供，本顿维尔镇，阿肯色州。
Fig.4　Installation view, Late Nineteenth through Early Twentieth Century Galleries, Crystal Bridges Museum of American Art. Photo: Courtesy of Crystal Bridges Museum of American Art, Bentonville, Arkansas.

在大都会艺术博物馆，美国的绘画、各年代展厅和亨利·R. 卢斯（Henry R. Luce）美国艺术研究中心的开放库存都藏在一个意大利风格的立面后面。这个立面原来是博物馆的外墙，现在纳入到了查尔斯·安格哈德（Charles Engelhard）庭院中。美国绘画和雕塑放在朴素、规则的展厅里，可以最充分地利用墙壁空间展示丰富的藏品。房间之间的视线通常是不贯通的，有利于通过作品布置吸引人们进入下一个房间，因而体验是沉浸式的。

波士顿美术博物馆和大都会艺术博物馆的美国艺术收藏都称为"侧翼"，隶属于一个更大的体系，跨越了世界各地和各个时代的整个艺术史。因此，游客可以在世界其他国家的艺术创作的背景下体验美国艺术。例如，想要去大都会艺术博物馆的美国侧翼，人们会经过古埃及艺术，可能会因此反思文明的兴衰以及美国在世界历史进程中的位置。

水晶桥博物馆的建筑对策展带来的挑战，波士顿和纽约博物馆策展人也遇到过。在波士顿，玻璃和环境光在建筑物的许多地方是重要的元素，并与纽约一样，很少有全景视野能够使参观者一下看到多个对象。这里的情况是，展厅蜿蜒迂回，跨过低洼处的池塘，形成了一

present. At the time of the opening the line was segmented."[17]

Curators also worked within the logic of Safdie's building. As architect and urban planner Joe Day has recently suggested that museums function in similar ways to prisons at their most basic levels. The architecture of both types of institutions is fundamentally concerned with observation and containment. Crystal Bridges' architecture contains its visitors and herds them through the four permanent collection galleries in a linear manner. Just as there are few places for them to see the exterior of the entire complex, the collections unfold slowly as visitors move through galleries with long curving walls divided by multiple partitions and ancillary display spaces. (figs. 3 and 4) Between each pavilion is a glass-walled antechamber with views of the architecture and landscape, providing a pause before visitors enter the next darkened gallery space.[18]

Two high profile reinstallations of American art bookended the opening of Crystal Bridges in 2011. The Museum of Fine Arts Boston's Art of the Americas wing, designed by Foster + Partners （Sir Norman Foster）, opened to the public in November of 2010 and the Metropolitan Museum of Art reopened its American Wing in January of 2012. Curators at Crystal Bridges kept up with the progress of their colleagues on the east coast, and the team responsible for the Metropolitan reinstallation visited Crystal Bridges in the summer of 2011.

Both American wings at the Museum of Fine Arts Boston

系列形状各异、交错不均的展示空间。博物馆采光充足的巨大门厅更像是要把观众直接引到洞穴式的 11 号餐厅里，而不是进艺术展区。由于挤满了人，人们更容易关注水晶桥博物馆的社区、文化和演出空间，反而忽略了他本身作为艺术博物馆的功能。

第一次来的参观者会由引导人员带到前台，他们穿着特别设计的服装，口中是沃尔玛风格的问候。在前台上方的显示屏上，通告大家当前的展览，并提醒游客是沃尔玛公司，不是沃尔顿家族基金会，已经通过 2000 万美元的捐赠基金支付了他们进入博物馆的费用。因为博物馆没有把艾丽斯·沃尔顿及其家庭或者他们的慈善基金会放在前面，参观者要是把博物馆和公司混在一起也不奇怪。那些抗议沃尔玛劳工措施员工为表达自己的不满，2011 年和 2012 年曾在博物馆示威，并创建了一个假的水晶桥博物馆网站，发布一篇通讯声明艾丽丝·沃尔顿支持他们的诉求。[19]

沃尔玛的火花标志，还有以及可口可乐和通用电气的标志，也许是参观者进画廊前看到的最后图像。他们知道沃尔玛给自己支付了入场费，在欣赏艺术作品时，可能会受到沃尔玛及在其中售卖产品的企业价值观的影响，尤其是那些消费品（如可口可乐瓶）直接在画廊里变成了艺术的企业。这不必要的举措让人在展览和博物馆体验时觉得其教育立场不够明确。它还把沃尔玛的座右铭"省钱，让生活过得更好"放到了图片墙上，把博物馆收藏放进了一个企业的语境，使人们不禁产生疑问：谁真正拥有并经营着博物馆。[20]

一跨进展厅大门，游客会发现藏品是按年代排列。由于建筑空间本身的序列安排，策展人决定按时间先后展示藏品，并且因为博物馆开放时所具有的优势和缺陷，希望为美国艺术史创造一个情境。虽然有四个独立的大楼来摆放艺术品、但参观它们的途径是有限的。参观者进入第一个馆后必须以某种既定的顺序往前参观，策展人觉得时间顺序来安排藏品最合适。我们也知道，很大一部分的本地观众可能从来没有参观过一个艺术博物馆，或观看过美国艺术藏品。我们相信他们会发现从过去到现在，从熟悉的具象的物体，如查尔斯·威尔逊·皮尔（Charles Willson Peale）的美国独立战争约克镇战役中的乔治·华盛顿肖像，到更多的因为它们的主题、材料或过程对于观众来讲过于抽象或更具挑战性的当代艺术作品，比如克里·詹姆斯·马歇尔（Kerry James Marshall）的《我们的小镇》。水晶桥博物馆开馆时，我们发现从 18 世纪后期到 20 世纪初期的藏品最丰富，1950 年之后的艺术品要相对逊色，主要包括油画和纸上作品，缺少按主题或媒介的组织。[21] 大都会艺术博物馆和波士顿美术博物馆也选择以年代布置美国艺术侧

and the Metropolitan are accessed through courtyards. The Museum of Fine Arts Boston's vertical installation on three floors, fronted by a glass wall, allows visitors to orient themselves to the chronology of each space through a "destination" object placed near the entrance to that floor's suite of galleries. These objects, favorites of visitors, are also located so that people can experience them without going more deeply into the galleries.

At the Metropolitan, American paintings, period rooms, and open storage Henry R. Luce Center for the Study of American Art are hidden behind a Italianate facade that was once an exterior wall of the museum, but is now integrated into the Charles Engelhard Court. American paintings and sculpture are placed into modest, regularly shaped galleries that maximize wall space for the extensive collection. Sight lines between rooms are often truncated in favor of positioning art works to draw people into the next space. The experience there is immersive.

At the Museum of Fine Arts Boston and Metropolitan, the American art collections are "wings" within much larger institutions that purport to tell the entire history of art created across the world and across time. The visitor experiences American art within the context of other artistic creations. Walking to the American Wing at the Metropolitan, for example, one may pass through the art of ancient Egypt, potentially eliciting meditation on the rise and fall of civilizations and America's place within the continuum of world history.

Crystal Bridges' architecture presented similar curatorial challenges to that of Boston and New York. As in Boston, glass and ambient light are a significant element in many areas of the complex, and in common with New York, there are few sight lines that allow for panoramic viewing of multiple objects at once. Instead, the galleries meander across the lower museum pond in a series of eccentrically shaped pavilions set at angles to one another. The large light-filled entrance to the museum proper leads directly into Crystal Bridges' cavernous restaurant Eleven, rather than a space containing art. Crowded with people, it can be easy to miss the function of Crystal Bridges as an art museum rather than some other kind of community, cultural, or performance space.

Drawing first time visitors into the collections galleries requires interaction with Walmart-style greeting staff wearing specially designed uniforms, who direct people into lines for a reception desk. Above the desk, video monitors announce current programs and remind visitors that the Walmart Corporation, separate from the Walton Family Foundation, has paid for their admission to the museum through a $20 million dollar endowment. Because the museum does not foreground Alice Walton, her family or their charitable foundation, the visitor can be excused for conflating the museum and the corporation. Disgruntled Walmart employees protesting Walmart's labor practices demonstrated at the museum in 2011 and 2012, and created a fake Crystal Bridges website with a press release indicating that Alice Walton supported their cause.[19]

Corporate logos, Walmart's stylized spark, as well as those

翼，虽然这两个博物馆的建筑架构允许历时和主题内容，因为展厅有多个出入口，而不是单一入口向前延伸的水晶桥博物馆的展厅。

在整个年代顺序的展览中，策展人突出的主题就是所有的藏品涉及所有的时代，从最早的藏品一直到21世纪新生产的作品。其次强调的主题就是五个世纪艺术之间的联系（大约从1675年到2013年）。然而，主题表现得足够自由，因而作品意义不会因美国历史或艺术生产的叙事而过于限定。策展人加重了性别、阶级、种族，以及政治和社会历史中争议等问题，还有美国艺术家与美洲、欧洲、亚洲和非洲的艺术家之间的交流，展览通过不同作品并排陈列，加上展厅前言、额外标签，以及语音导览的说明性内容加以实现。

水晶桥博物馆的策略里有学术界和博物馆展览中的修正主义历史观，也有最近意识到的美国全球联系，尤其是大西洋沿岸的联系。[22] 通过强调更广阔的世界游历和体验，我们不仅希望将有助于激发人们在一个更广泛的文化和视觉历史的背景下讨论美国艺术，更希望能提供了一种方法在概念上连接地理和文化上孤立的美国阿肯色州西北部地区和美国其他地区，甚至美国以外的其他地方。游客在水晶桥博物馆看到的第一组作品是本杰明·韦斯特（Benjamin West），约翰·科普利（John Singleton Copley）和约翰·泰勒（John Taylor）的绘画，他们都出生在美国，并且都去英国开展自己的艺术生涯（图3）。在这些画旁边是一组由艺术家格拉尔杜斯·杜伊辛克（Gerardus Duycinck）创作的莱维-弗兰克斯（Levy-Franks）大家族肖像。画中的家族族长摩西·莱维（Moses Levy）以及他的女婿雅各·弗兰克斯（Jacob Franks）走了跟韦斯特、科普利和泰勒相反的方向，他们移民到美洲殖民地寻找商业机会。对于这些藏品全球背景的研究与阿肯色州西北部为跨国公司工作当地居民的经验是一致的，跟企业在世界上寻找产品的竞争优势或者拓展市场以促进产品消费是一致的。

水晶桥博物馆和当地的企业赞助者一直热衷的是定位和吸引消费者。水晶桥博物馆很大程度上衡量成功的标准是可量化的金钱或实物赞助、商店收入、付费项目以及一些活动，当然最重要的是参观人数。水晶桥博物馆有理由对于他的参观人数感到自豪，因为它开放后不到两年，2013年8月中旬游客参观人数已达到100万。截至2013年11月，他们已经接待了110万的参观者。[23] 要知道，阿肯色州本顿维尔的人口是38000人，而西北部所有人口也就是475000人左右。其次，博物馆将它的成功归因于本地会员基础，截至2013年11月，已经捐款的企业和私人捐助者的数量已

of Coca-Cola and General Electric, are the last images a visitor may sees before encountering the collection. Compounded with their knowledge that Walmart gave them the gift of admission, visitor experience of the art works may become associated with Walmart's values and those of corporations whose products are sold by Walmart stores, particularly when consumer goods such as the Coca-Cola bottle are transformed into art inside the galleries. While this does not necessarily make the experience of the collection or the museum's interpretation of it weaker from an educational standpoint, it brings Walmart's image in line with its motto "Save money. Live better." By placing the museum collection within a corporate context, this corporate presence raises questions about who actually owns and operates the museum.[20]

Once through the door to the galleries, visitors find the collection arranged chronologically. Curators decided to present the collection from chronological beginning to the end because of the sequential arrangement of the architectural spaces, desire to create a context for the history of American art, and because of the collection's strengths and weaknesses at opening of the museum. Although there are four separate buildings housing the collection, access to them is limited. After one enters the first pavilion one must proceed all the way through in a set order, which curators felt made a chronological installation most appropriate. We also knew that a significant proportion of visitors native to the region may have never visited an art museum, or a collection of American art. We believed they would find it logical to proceed from the past to the present; from familiar representational objects, like Charles Willson Peale's portrait of George Washington at the American Revolutionary War Battle of Yorktown, to more contemporary works that are abstract or challenging for viewers because of their subject matter, materials, or process, such as Kerry James Marshall's *Our Town*. (see figs. 3 and 5) When it opened, Crystal Bridges collection was strongest in the late eighteenth through early twentieth centuries, less so in art produced after 1950, and consisted mainly of oil paintings and works on paper, all of which we felt precluded thematic or medium-based object groupings.[21] The Metropolitan and Museum of Fine Arts Boston also chose to arrange their American art wings chronologically, although the architecture of both spaces allows for diachronic and thematic digressions because galleries have multiple entrances and exits, rather than the single entrance leading to a progression of gallery spaces at Crystal Bridges.

Within the roughly chronological installation, curators emphasized themes that spanned the entire sweep of the collection, from its earliest objects to those produced in the 21st century. A secondary emphasis on themes helped provide connections over the five centuries of art on display （works date from approximately 1675 to 2013）. However, themes were kept loose enough not to overdetermine narratives of American history or its artistic production. Curators highlighted issues of gender, class, race, contested political and social histories, and American artists' interactions with the Americas, Europe, Asia, and Africa through their juxtapositions of objects as well as didactic content

达到 7783。[24] 博物馆已经收到了支持艺术的企业的捐赠，但这不是最优先的慈善事业，最优先的是这些企业每年会因为水晶博物馆将一小部分年度捐款，如果有的话，捐赠给其他博物馆。[25] 水晶桥博物馆可能会成为一个榜样，增大博物馆和企业合作的可能性，从而扩大企业给其他博物馆的捐款。如果企业赞助者很满意他们在水晶桥博物馆的投资回报，他们更有可能给其他艺术机构捐款。

水晶桥博物馆开放前两年间的庞大参观人数已经使博物馆和该地区充满了希望：它可能引发对于阿肯色州西北部农村的转变，就好像 1997 年毕尔巴鄂古根海姆博物馆的开放给这个西班牙城市的旅游业和经济所带来的转变一样。因为水晶桥博物馆的开放，一些零售和餐饮场所已经在本顿维尔的小镇广场开业了。一个主要为满足富裕的游客、博物馆旅游团、艺术品经销商需求的新豪华酒店也开业了。本顿维尔所在本顿县，原来除了几个指定的餐厅之外曾经禁止出售酒精，但最近修改了法律，鼓励商业和旅游业发展。[26]

毫无疑问，本顿维尔商会和周边城镇很高兴因为游客而增加了收入，但更重要的是，水晶桥博物馆已成为沃尔玛和该地区的其他企业招聘和保留管理人才的工具。西北阿肯色州意识到自己是一个社会和文化落后的地方，但也强烈意识到它对美国及国际贸易的重要性。本顿维尔的市政当局将水晶桥博物馆作为使其文化和商业意义更紧密的决定性因素。沃尔玛企业总部位于本顿维尔，它的子公司山姆俱乐部、泰森食品公司和 J.B. 亨特运输公司明白为了将高管人才从美国的东部和西部海岸的城市中心吸引过来并留住他们，需要改善生活质量。基于这一点，他们主要关注文化设施，比如水晶桥博物馆等。2013 年 6 月，在本顿维尔的城镇广场上，水晶桥博物馆的边缘地带，一个新的儿童博物馆，业余爱好者博物馆（Amazeum）宣告落成。在贺词中，专门提到业余爱好者博物馆和水晶桥博物馆是为改善当前和未来的管理者和高管人才的生活而实施的重要战略。[27]

人们希望通过持续庞大的参观人数来保持博物馆的"毕尔巴鄂效应"。这也致使水晶桥博物馆突出特展，主要临时展，希望通过新内容吸引新的游客来博物馆，也让当地居民得以多次重看。一方面，这些展览中有哈德逊河画派、诺曼·罗克韦尔（Norman Rockwell）还有当代艺术家利奥·维亚里尔（Leo Villareal）创作的一个大型灯光装置，拓展了游客对美国艺术的理解，进一步实现了水晶桥博物馆的教育使命。另一方面，博物馆领导由于需要保持庞大的参展人数，似乎认为相对于开发其永久的艺术藏品的项目，从外部引进新的展品和项目

in the form of introductory texts in each gallery space, extended object labels, and audio guide content.

Crystal Bridges curatorial strategies were informed by revisionist histories in academia and museum displays as well as more recent recognition of America's global connections, particularly to the Atlantic littoral.[22] Emphasizing travel and experience of the wider world we hoped would also help not only to stimulate discussions of American art's place within a broader cultural and visual histories, but also to provide a way of conceptually connecting the geographically and culturally isolated region of Northwest Arkansas to the rest of the United States and beyond. The first groups of objects the visitor encounters at Crystal Bridges are paintings by Benjamin West, John Singleton Copley, and John Taylor, all of whom were born in America but went to Britain to make their careers as artists. (fig.3) Adjacent to these paintings are a series of six portraits of the extended Levy-Franks family, attributed to the artist Gerardus Duycinck. The patriarch of the family, Moses Levy, as well as his son-in-law Jacob Franks, made the reverse journey of West, Copley, and Taylor, when they immigrated to the American colonies in search of business opportunities. This global approach to the collection also corresponded well with the experiences of those in the local population of Northwest Arkansas who work for transnational corporations and are involved in searching the world for competitive advantages in production or to develop markets for the consumption of their products.

Locating and attracting consumers has also been a keen interest of Crystal Bridges and its local and corporate constituencies. Crystal Bridges has largely measured its success in quantifiable metrics of monetary or in-kind support, revenues from the store, paid programming, and events, but above all, attendance. The museum has justifiably been proud of its attendance, reaching one million visitors by mid August 2013, less than two years after its opening. As of November 2013 they welcomed almost 1.1 million people.[23] To put this in perspective, Bentonville's population is 38,000 and Northwest Arkansas as a whole has approximately 475,000 residents. Secondarily, the museum emphasizes its local membership base, which was 7,783 as of November 2013, and the number of corporations and private donors who have given donations.[24] The museum has received contributions from corporations for which supporting the arts is not their highest priority for charitable giving, and which disperse a very small percentage of their annual donations, if any at all, to other museums.[25] For this Crystal Bridges potentially serves as a model for the possibilities of museum-corporate partnerships that could expand corporate giving to other museums. If the corporate donors are pleased with the return on their investment in Crystal Bridges, they may be more likely to give to other arts organizations.

The large attendance during Crystal Bridges first two years had made the museum and region hopeful that it may have spurred the same kind of transformation to rural Northwest Arkansas that the opening of Guggenheim in Bilbao in 1997 had

图5 "二战"后到当代展厅内景,水晶桥美国艺术博物馆,照片来源:水晶桥美国艺术博物馆提供,本顿维尔镇,阿肯色州。
Fig.5　Installation view, Post-War and Contemporary Gallery, Crystal Bridges Museum of American Art. Photo: Courtesy of Crystal Bridges Museum of American Art, Bentonville, Arkansas.

要更容易、更快和更有效。

　　博物馆注重新展、临时展来维持其庞大的参观人数,并且保持企业捐赠者的支持,这会影响藏品的解读、护理等资源分配。尽管博物馆刚开馆及之后一段时间里,博物馆和媒体的焦点是那些永久藏品,但水晶桥博物馆没有再就这些藏品做些深入解读、创新项目和研究工作。2011年11月以来,博物馆各方面硬件条件已经改变,墙壁上也添加了新的东西,但说明文本、旅游音频和数字讲解方法仍然相对不变。尽管现在包含了更多的图片,但比起2011年11月11日,博物馆的网站并没有就藏品提供更多信息。

　　水晶桥博物馆举办了一些展览,包括与泰拉美国艺术基金会、卢浮宫和亚特兰大高级博物馆合作组织的为期四年的系列展,它被称为"美国相遇"。这些都是基于4~7件作品的主题展,规模较小。2013年11月,水晶桥博物馆首次为艺术家乔治娅·奥基夫(Georgia O'Keeffe)捐给菲斯克大学的一批美国现代主义收藏办了展览,菲斯克大学是田纳西州纳什维尔的一所历史性的黑人学院。在艾丽斯·沃尔顿通过博物馆捐赠了3000万美元给学校后,这批展品就由水晶桥博物馆和菲斯克大学共同拥有了。菲斯克大学为此还卷入一场持久的法

on tourism and the economy of that Spanish city. Since Crystal Bridges' opening, several retail and dining establishments have opencd on Bcntonville's small town square. A new luxury hotel caters primarily to wealthy visitors, museum tour groups, and art dealers going to Crystal Bridges. Benton County, in which Bentonville is located, historically forbade the sale of alcohol except in a few designated restaurants, but recently changed the law to encourage business and tourism.[26]

No doubt the chambers of commerce of Bentonville and the surrounding towns are happy for added revenue from tourists, but more than that, Crystal Bridges has become an executive recruitment and retention tool for Walmart and the other corporations in the region. Northwest Arkansas is aware of both its reputation as a culturally and socially backward place, but also highly conscious of its importance to American and international commerce. Bentonville's civic authorities see Crystal Bridges as a determining factor in making its cultural and commercial significance more closely aligned. The corporations based in Bentonville, Walmart, its subsidiary Sam's Club, Tyson Foods, and J.B. Hunt Transport understand that to attract and keep top executive talent from the urban centers on America's east and west coasts, they need to improve quality of life, and have focused on cultural amenities such as performance spaces and Crystal Bridges. In June 2013, the announcement of a new children's museum, the "Amazeum", to be built on the edge

律纠纷，因它违背了奥基夫的遗赠，遗嘱中规定艺术品绝对不能离开学校，大学最终胜出。在这个法律案件尘埃落定后不久，博物馆就试图展示这些藏品，希望用它来进行营销和吸引捐款。这就意味着101件藏品的展览要马上操作。结果就是，除了一些说明、标签和一些数字内容，对这批作品的解读少之又少。它的首次展览竟没有学术著述或新的研究出版，无论说明性的还是分析性的。

水晶桥博物馆现在正计划举办一个关于当代美国艺术的大型展览，展品由博物馆馆长唐·巴奇加卢皮（Don Bacigalupi）的精心挑选，名为"艺术国度：发现现在的美国艺术"。他的目标是"挑选当今美国社会最好的当代艺术"，而这些艺术品他认为是由那些生活在美国的内陆地区艺术家所创作的。这些艺术品还未为国内和国际艺术世界所熟知。巴奇加卢皮对于卓越艺术品的追求表明博物馆正试图对于当代美国艺术行使掠夺性，也许是垄断性的权力。在巴奇加卢皮和水晶桥博物馆看来，此次展览包含的艺术家才是"最好的"，其他没有作品入选的艺术家只能占据较低的位置。然而，巴奇加卢皮已经承认他正在关注的当代艺术家是能够给水晶桥博物馆的参观者了解当代艺术实践提供一个切入点的。这表明阿肯色州人所找到的从概念、智力、政治或视觉角度看有挑战和争议的也许不能在展览中占据一席之地。2014年后期"艺术国度"展览的藏品将占据博物馆画廊的大部分位置，而且会在将来的某个时候在世界各地巡回展出同时突出其永久藏品。这意味着博物馆缺乏深厚的学术价值和公众参与的永久藏品将继续展览下去。[28]

最后，在开馆后，博物馆放松在永久藏品上的努力，这和它的成功无关。数据是本顿维尔企业文化的通用语，只要博物馆继续吸引人群并且得到社会和企业的支持，它会感到成功而且被本顿维尔社区支持者和企业捐助者视为成功。永久藏品展厅将继续按编年顺序和主题来展示美国艺术，作品已经布置好了，在2011年11月开放时其中大部分都有受过专业训练的馆员进行讲解。

博物馆试图创造令人兴奋的新体验，以维持或增加参观的人数，并展示艾丽斯·沃尔顿及其家庭之外的支持，但这种努力最终却使水晶桥博物馆缺乏能力满足当地选民教育方面的需求，没有钱投入研究和提供奖学金。截至2014年1月，博物馆的策展人们在博物馆的主要收藏品中并不专长，表明其机构文化不鼓励策展人参与到藏品的研究或学术性的发展项目中。[29]捐赠者和该地区的企业文化似乎也导致博物馆模糊了非营利的文化机构和商业性画廊之间的界限。2013年

of Crystal Bridges's grounds, took place in Bentonville's town square. During congratulatory speeches, the Amzeum and Crystal Bridges were touted as strategies for improving quality of life for current and future managers and executives.[27]

Desire to maintain a "Bilbao effect" at the museum through continued high attendance has led Crystal Bridges to emphasize special, mostly temporary, installations and exhibitions, hoping that novelty will drive new visitors to the museum and local residents to return frequently. On one hand, these exhibitions, which have included Hudson River School paintings, Norman Rockwell, and a large light installation by contemporary artist Leo Villareal further Crystal Bridges educational mandate by expanding their visitors' understanding of American art. Museum leadership, driven by the need to keep up attendance, seems to believe that it is easier, faster, and more efficient to bring in new exhibitions and programming from outside rather than develop projects around its permanent collection.

The museum's stress on the new and temporary to maintain its attendance, and incidentally the support of its corporate donors, affects resources allocated to the interpretation of, and care for, its collection. While the museum and the press focused on the permanent collection during and immediately after the opening of the museum, Crystal Bridges has not significantly enhanced its interpretation or produced innovative programming and research around its permanent collection. Aspects of the installation have changed and new acquisitions added to the walls, but didactic texts, tours, audio, and digital methods of interpretation have remained fairly static since November 2011. The museum's website does not provide much more information on the collection than it did on November 11, 2011, although it now includes more images.

Crystal Bridges has generated a few exhibitions, including a four-year series organized in partnership with the Terra Foundation for American Art, Musée du Louvre, and High Museum in Atlanta. Called "American Encounters", these are modestly scaled thematic shows based around four to seven objects. In November 2013, Crystal Bridges debuted the collection of American modernism given to Fisk University, a historically black college in Nashville, Tennessee, by the artist Georgia O'Keeffe. Crystal Bridges and Fisk now own the collection jointly after Alice Walton, through the museum, donated $30 million to the school and Fisk won a protracted legal battle to break the terms of O'Keeffe's bequest, which originally specified that the works were never to leave the university. The museum's ambition to show this collection, and leverage it for marketing and donor appeals, shortly after settlement of the legal case, meant that the exhibition of the 101 works had to be produced quickly. As a result, the installation of the Fisk objects had little interpretation beyond a few didactics, labels, and some digital content. It debuted without a scholarly publication or new research, either object-based or analytic.

Crystal Bridges is now planning a large exhibition of contemporary American art selected by the museum's President Don

11 月，博物馆宣布将开始出售由玻璃艺术家戴尔·契胡利（Dale Chihuly）创作的限量版雕塑装饰，在博物馆收藏中就有他的一件作品。博物馆冒了行为不端的风险。这可以被视为通过博物馆收藏的作品来推销契胡利的作品，使得低端的收藏市场的作品和水晶桥博物馆收藏的作品几乎没有分别。那么参观者这样想也就无可厚非了：自从水晶桥博物馆展示和收藏契胡利的作品以来，在博物馆商店购买一件他的作品作为纪念也许是一个不错的投资。[30] 比起其他博物馆（如波士顿美术博物馆和大都会艺术博物馆）同一时间重新设计他们的美国藏品，水晶桥博物馆通过策展者的策略、研究或出版物对于美国艺术品领域的影响可能没有那么大。然而，现在这个博物馆毕竟还年轻，它利用美国的企业资本的能力和充满了企业家精神的尝试为水晶桥博物馆的将来赋予了很有意思的可能性。这种尝试也可能会扩展到美国其他艺术机构。当然，结果可能很好，也可能非常糟糕。

Bacigalupi, under the title "State of the Art: Discovering American Art Now". His goal is to "select the best contemporary art in United States today", which he believes is being created by artists living in the hinterlands of America and who are unknown to the national and international art world. Bacigalupi's emphasis on excellence suggests that the museum is trying to exercise a predatory, perhaps monopoly power over contemporary American art. In Bacigalupi's and the museum's language, artists who are included in the exhibition are the "best"; those excluded must necessarily occupy lower tiers. However, Bacigalupi has admitted that he is focusing on artists that provide an accessible entry point into contemporary practice for Crystal Bridges' audience, indicating art that Arkansans could find conceptually, intellectually, politically, or visually challenging and controversial may not have a place in the exhibition. "State of the Art" will take over much of the museum's galleries in late 2014 and is supposed to travel along with highlights of the permanent collection to venues throughout the world at some point in the future, suggesting that the museum's lack of deep scholarly and public engagement with its permanent collection will continue.[28]

In the end, the museum's reduced engagement with its permanent collection since opening is irrelevant to its own metrics of success. Numbers are the *lingua franca* of the corporate culture of Bentonville, and as long as the museum continues to draw crowds and demonstrate levels of community and corporate support, it will feel successful and it will be seen as a success by Bentonville's community boosters and corporate donors. The permanent collection galleries continue to offer a chronological and thematic overview of American art, with works that had been arranged and for the most part interpreted by professionally trained curators at the time of its opening in November 2011.

However, the museum's attempts to create exciting new experiences to maintain or increase numbers and demonstrate support from those other than Alice Walton and her family ultimately undermines Crystal Bridges' ability to serve the educational needs of its local constituents as well as its engagement in research and production of scholarship. As of January 2014, the museum has no curatorial staff with expertise in its main collecting areas, suggesting that its institutional culture did not encourage curatorial engagement with the collection or development of scholarly projects.[29] The corporate culture of its donors and the region seems also to be leading the museum to blur the lines between non–profit cultural institution and commercial gallery. In November 2013, the museum announced that it would start selling limited edition decorative sculptures by the glass artist Dale Chihuly, who is also represented by a work in the museum's collection. The museum runs the risk of acting unethically. It could be seen as promoting the sale of Chihuly's work through the museum collection, making little differentiation between works created for the low end of the collector market and that acquired by Crystal Bridges. Visitors may not be blamed for thinking that since Crystal Bridges displays and has acquired Chihuly, purchasing one in the museum store might be a good investment

as a souvenir.[30] The impact of Crystal Bridges on the field of American art, through curatorial strategies, research, or publications, may not be as great as that of the other institutions that reengineered their American collections around the same time, such as the Museum of Fine Arts Boston and Metropolitan Museum of Art. However, it is early in the institution's history and their ability to harness America's corporate capital and propensity to act entrepreneurially presents interesting potential for the future of Crystal Bridges with ramifications–good or bad– that may extend to other arts institutions in the United States.

Endnotes:

1 www.crystalbridges.org I was Curator of American Art at Crystal Bridges from March 2011 to August 2013. I would like to thank Laura Jacobs, formerly Director of Communications at Crystal Bridges, for providing me with up to date information on attendance, membership, and other data.

2 A discussion of several of these installations from the perspective of their museums' curators is found in a special issue of *American Art* 24, No. 2, 2010 (Summer）.

3 Neil Harris. *Cultural Excursions: Marketing Appetites and Cultural Tastes in Modern America.* Chicago: University of Chicago Press, 1990 and Alan Wallach. *Exhibiting Contradictions: Essays on the Art Museum in the United States.* Amherst: University of Massachusetts Press, 1998 are excellent references for the history of museums in America.

4 Contradictions between Crystal Bridges collecting and display practices and its politics are also discussed in Michael Leja. "Crystal Bridges Museum of American Art, Bentonville, Ark.". *Art Bulletin* 94, No. 4，2012 (December）: 262 and Andrea Becksvoort. "Crystal Bridges Museum of American Art". *Caa. Reviews*, September 11, 2012, http://www.caareviews.org/reviews/1869 (accessed January 3, 2014）.

5 According to the Centers for Disease Control, Arkansas and two states that border it to the south, Louisiana and Mississippi had the highest rates of obesity in 2012. http://www.cdc.gov/obesity/data/adult.html (accessed January 3, 2014）. In 2009, the United States Census ranked Arkansas last in percentage of population with a graduate degree, and near the bottom of population percentage with an undergraduate degree.

6 See press releases from Crystal Bridges dated October 31, 2011 (Coca-Cola sponsorship) and December 20, 2013 (Warhol acquisition）, www.crystalbridges.org/press-releases/ (accessed January 3, 2014)

7 Jay Moye. "Warhol Coca-Cola Painting Sells for $57.3 Million at Christie's Auction", November 1, 2013, http://www.coca-colacompany.com/stories/warhol-coca-cola-painting-could-fetch-40-60-million-at-christies-auction (accessed January 5, 2014)

8 Curators, including me, advocated for trials of several different brands and types of bulbs, including Phillips and Sylvania. However, those companies are not sponsors of the museum.

9 For a survey of Safdie's projects see Donald Albrecht. *Global Citizen: The Architecture of Moshe Safdie* : Bentonville, Arkansas: Crystal Bridges Museum of Art and London: Scala, 2010.

10 Arts journalist and blogger Lee Rosenbaum has done the most comprehensive analysis of Crystal Bridges' expenditures for art and architecture. http://www.artsjournal.com/culturegrrl/2011/11/crystal_bridges_accounting_how.html (accessed January 3, 2013）. Since her report in 2011 the museum's publicly available Internal Revenue Service tax form 990 continue to support her findings, accessed January 5, 2014 through the Economic Research Institute, www.eri-nonprofit-salaries.com.

11 Quote from Eleven Restaurant tasting menu from December 2013, http://crystalbridges.org/wp-content/uploads/2013/12/Tasting-1213.pdf (accessed January 2, 2014）. See also Craig Schwitter and Cristobal Correa."American Beauty". *Civil Engineering* 2012 (February）: 49 http://www.civilengineering-digital.com/civilengineering/201202?pg=51#pg50 (accessed January 3, 2014）.

12 Exhibitions have included *The Hudson River School: Nature and the American Vision* organized by the New-York Historical Society (2012）, *American Chronicles: The Art of Norman Rockwell* organized by the Norman Rockwell Museum (2013）, *Angels and Tomboys: Girlhood in Nineteenth-Century American Art*, organized by the Newark Museum (2013）, The William S. Paley Collection: A Taste for Modernism organized by the Museum of Modern Art, New York (scheduled for March 2014）, and Picasso to Pollock: Masterpieces from the Albright-Knox Gallery (scheduled for 2015) organized by the Albright-Knox. With the exception of *Angels and Tomboys*, all of the exhibitions have been highlights from other museums' permanent collections rather than based on new research into American art.

13 Examples of the latter might include the Frick Collection in New York and the Huntington Library, Art Galleries, and Botanical Gardens outside of Los Angeles California.

14 Rebecca Solnit. "Alice Walton's Fig Leaf". *The Nation* , March 6, 2006. http://www.thenation.com/article/alice-waltons-fig-leaf, Lee Rosenbaum. "The Walton Effect: Art World is Roiled by Wal-Mart Heiress". *Wall Street Journal* , October 10, 2007. http://online.wsj.com/news/articles/SB119197325280854094, Jeffrey Goldberg, "Wal-Mart Heiress's Museum a Moral Blight", December 12, 2011, www.bloomberg.com. (All articles accessed January 3, 2014）.

15 Crystal Bridges press release May 4, 2011 www.crystalbridges.org/press-releases/ (accessed January 2, 2014）.

16 Stephen C. Dubin. "The Meet and Greet Museum". *Art In America* , February 3, 2012, http://www.artinamericamagazine.com/news-features/magazine/alice-walton-crystal-bridges/ (accessed January 3, 2014）. The museum's senior curatorial staff presented acquisitions to the Art Committee of the board of trustees, in a process that is typical of many American museums.

17 Patricia Failing. "1,000 Studio Visits, One Ambitious Crystal Bridges Show". *ARTnews*, November 27, 2013. http://www.artnews.com/2013/11/27/state-of-the-art/ accessed January 3, 2014.

18 Joe Day. *Collections and Corrections: Architectures for Art and Crime.* New York: Routledge, 2013, see in particular pages 38-49 and 207-217.

19 Max Brantley. "Satire Website links Crystal Bridges to Walmart Black Friday Protest". *Arkansas Times Arkansas Blog*, November 21, 2012. http://www.arktimes.com/ArkansasBlog/archives/2012/11/21/high-tech-spoof-links-crystal-bridges-to-walmart-protest (accessed January 2014.)

20 Solnit and Goldberg op. cit. suggest that the museum serves as a means for Walmart to polish its image although their concern was not how the architecture and signage of the museum operated in that context.

21 Reviews of this approach by academic art historians were ambivalent and often placed Crystal Bridges' installation within the context of Arkansas's cultural and political conservatism in the United States. Alan Wallach elsewhere in this volume and Becksvoort, "Crystal Bridges Museum of American Art" op cit. were perhaps most critical. The arrangement of objects chronologically and the highlighting of significant or popular works, seen as evidence of Crystal Bridges' traditionalism does not enter into criticism of the new installations at Boston and New York with the same frequency, although, as I note, the three museums had similar curatorial strategies. Crystal Bridges' collection is limited to paintings, watercolors, prints, drawings and other forms of work on paper, with few sculptures, photographs, mixed media, installation, or time-based works.

22 On the recent emphasis on trans-Atlanticism in American Art see David Peters, Sarah Monks. "Anglo-American Artistic Exchange Between Britain and the USA". special issue of *Art History* 34, No. 4. 2011 (September 2011) : 624-678.

23 Email to author from Laura Jacobs, former Director of Communications at Crystal Bridges, November 6, 2013.

24 ibid. Population data is from the United States Census Bureau, http://quickfacts.census.gov/qfd/states/05/05143.html (accessed January 2, 2014) .

25 General Electric's donation of $300,000 to Crystal Bridges is almost three times its total donation to other art museums in 2011. Of the $76,337,849 disbursed to charities and non-profit organizations by the Coca-Cola Foundation in 2011, $1,250,000 went to institutions with a connection to exhibiting art: $250,000 to the State Hermitage Museum in St. Petersburg and $1,000,000 to the Woodruff Arts Center in Atlanta. The Woodruff Arts Center houses the High Museum of Art but also several performing arts groups, so it is unclear what percentage of the gift went to the museum. "The Coca-Cola Foundation-2011 Grants" http://assets.coca-colacompany.com/c0/91/5c8a678246dd96470f4e306938ed/2011_grants_contributions_paid.pdf and "2011 General Electric Foundation Grants Above $10,000" http://static.gecitizenship.com.s3.amazonaws.com/wp-content/uploads/2012/07/5.3.3-DOWNLOAD-GE_2011_PhilanContrib_above10K_Foundation.pdf (both accessed January 5, 2014) . General Electric's contribution to Crystal Bridges is from the museum's 2011 IRS Form 990, op cit.

26 See for example Rebecca Mead. "Alice's Wonderland". *The New Yorker,* June 27, 2011. http://www.newyorker.com/reporting/2011/06/27/110627fa_fact_mead?currentPage=all and Phillip Kendicott. "Crystal Bridges in Arkansas: A World-class Museum from the Land of Wal-Mart". *The Washington Post*, October 1, 2011. http://www.washingtonpost.com/lifestyle/style/crystal-bridges-in-arkansas-a-world-class-museum-from-the-land-of-wal-mart/2011/09/27/gIQAN6OiDL_story.html (both accessed January 5, 2014) .

27 Literature from the Amazeum communications office as well as their list of donors, many of the same corporations who support Crystal Bridges including the Walton Family Foundation, Walmart, and Sam's Club make clear that it is designed to better quality of life for corporate families of Northwest Arkansas. See www.amazeum.org Although it is apparent who supports the Amazeum, its mission, purpose, and function remain difficult to ascertain through its literature and website.

28 Failing, op cit. I was also interviewed by Failing.

29 ibid.

30 Hilary Hutter. "Significant Careers of Determined Artists: Dale Chihuly". Crystal Bridges Blog, November 1, 2013. http://crystalbridges.org/blog/significant-careers-determined-artists-dale-chihuly/ (accessed January 3, 2014) . American museums do not typically sell art, and when they do it is controversial. See for example Robin Pogrebin. "The Permanent Collection May Not Be So Permanent". *The New York Times*, January 26, 2011. http://www.nytimes.com/2011/01/27/arts/design/27sell.html?_r=0 accessed January 2014.

Suggestions for Further Reading:

[1] Albrecht Donald. *Global Citizen: The Architecture of Moshe Safdie.* Bentonville, Arkansas: Crystal Bridges Museum of Art and London: Scala, 2010.

[2] Bourdieu Pierre. *Distinction: A Social Critique of the Judgment of Taste.* Cambridge, Massachusetts: Harvard University Press, 1984.

[3] Crosman, Christopher et. all. *Celebrating the American Spirit: Masterworks from Crystal Bridges Museum of American Art.* New York: Hudson Hills, 2011.

[4] Cuno, James et. all. *Whose Muse? Art Museums and the Public Trust.* Princeton: Princeton University Press, 2006.

[5] Davis, Elliot et. all. *A New World Imagined: Art of the Americas.* Boston: Museum of Fine Arts, 2010.

[6] Day Joe. *Collections and Corrections: Architectures for Art and Crime.* New York: Routledge, 2013.

[7] Deberry Linda. *Art in Nature: Crystal Bridges Museum of American Art.* New York: Scala, 2013.

[8] Duncan Carol. *Civilizing Rituals, Inside Public Art Museums.* New York: Routledge, 1995.

[9] Harris Neil. *Cultural Excursions: Marketing Appetites and Cultural Tastes in Modern America.* Chicago: University of Chicago Press, 1990.

[10] Wallach Alan. *Exhibiting Contradictions: Essays on the Art Museum in the United States.* Amherst: University of Massachusetts Press, 1998.

[11] Walton Sam. *Sam Walton: Made in America, My Story.* New York: Random House, 1992.

21世纪美国艺术的展示[1]
Exhibiting American Art in the Twenty–First Century[1]

艾伦·沃勒克　杨超越＊　译
Alan Wallach　Translator: Yang Chaoyue

美国在经济深陷泥沼的时期，艺术却呈现出前所未有的繁荣景象。不可否认，华盛顿的科科伦画廊作为19世纪与20世纪早期美国艺术的馆藏重地，彼时正徘徊于破产的边缘。[2]但是对于其他藏有重量级美国艺术品的博物馆来说，这时候可谓如鱼得水，不惜一掷千金新建或翻修侧翼和画廊，并高价购入藏品。在1995年与2009年之间，位于纽瓦克、芝加哥、华盛顿、底特律、旧金山和堪萨斯城等地的众多博物馆陆续扩张、翻新并重新陈列美国收藏品。2010年，诺曼·福斯特（Norman Foster）及其团队为波士顿美术博物馆设计建造了一座颇为壮观的四层石头和玻璃方盒子，今天其中陈列着5000件以"美国艺术"[3]为题的作品。2011年，艾丽斯·沃尔顿（Alice Walton）投资兴建了水晶桥美国艺术博物馆，该馆坐落于阿肯色州的本顿维尔市，由摩西·萨夫迪（Moishe Safdie）精心设计的几座展览次第相连，千呼万唤之下，博物馆最终集纳着"顶级收藏"（正如一位评论者所描述）亮相，馆内展品均来自沃尔玛的女继承人积累了近十年的收藏。[4]2012年1月，纽约大都会博物馆大张旗鼓地进行改造，并极力扩张美国馆的侧翼建筑。[5]即便是囊中羞涩的科科伦画廊最近也着手将美国1945年之前的艺术馆藏重新陈列。

这些扩建、重新陈列以及翻新展馆是否为美国艺术史开辟出了新的视野？对于非传统的博物馆观众而言，这些作为又在多大程度上增加了博物馆的吸引力？本文中，笔者试图通过梳理、考察不同博物馆的展陈状况来回答这些问题。文章重点将放在弗吉尼亚美术馆（后文简称VMFA）新的美国艺术展区上。VMFA是一间中型展馆，2010年开馆，美国艺术藏品规模也适中。它无法做领头羊，但我们从中可以看到，在今天，一家艺术资源一般的机构是如何处理、展示美国艺术的问题的。

In the depths of the Great Recession, American art is enjoying an unprecedented boom. To be sure, Washington, D.C.'s Corcoran Gallery, which houses one of the great collections of nineteenth and early twentieth century American painting, teeters on the verge of bankruptcy.[2] But for other museums with significant American holdings, these have been fat times with millions being spent on new or renovated wings and galleries, and on high-priced acquisitions. Between 1995 and 2009, museums in Newark, Brooklyn, Chicago, Washington, Detroit, San Francisco, and Kansas City （among other places） expanded, refurbished, and reinstalled their American collections. In 2010, the Museum of Fine Arts, Boston, inaugurated a spectacular four-storey stone and glass box, designed by Norman Foster and Partners, in which it now displays 5000 objects under the heading "Art of the Americas."[3] In 2011, Alice Walton's Crystal Bridges Museum of American Art, housed in an elaborate set of pavilions designed by Moishe Safdie and located in Bentonville, Arkansas, made its long-awaited debut with, as one commentator described it, "a top-tier collection" that the billionaire Wal-Mart heiress had amassed over a period of less than ten years.[4] In January, 2012, New York's Me-tropolitan Museum of Art launched with enormous fanfare its rebuilt and greatly expanded American Wing.[5] Even the cash-strapped Corcoran Gallery recently managed an innovative reinstallation of its collection of pre-1945 American art.

Have these expansions, reinstallations, and refurbishments opened new perspectives on the history of American art? To what extent have they increased the museums' appeal to non-traditional museum audiences? In this essay, I attempt to answer these questions via an examination of museum displays. My focus will be on the new American art galleries at the Virginia Museum of Fine Arts （hereafter VMFA）, which opened in 2010. The VMFA is a medium-

＊　杨超越　自由撰稿人（Yang Chaoyue Free–lancer）

为了评估 VMFA 的成果，我想首先列出一系列展陈的可能性——不是某些可能的理论，而是博物馆已经在实践中得出的解决方案。和我们期待的一样，这串展陈清单可以从革新的一端连着排到传统的一端。任何参观过美国博物馆的人都会料到——而且大抵不会猜错——大多数的展陈都介于创新和传统的中间段。但是一种展陈，是新是旧有何意义？或者换个问法，一种展陈怎样能够打开抑或关闭美国艺术史的新视野呢？

为了得出答案，我想首先列举一些极端、有限的例子。水晶桥博物馆对于新式展陈持有最保守的态度，其作品大多按编年顺序排列，并冠以"歌颂美国精神"的主题。在美国，爱国主义经常成为美国艺术收藏与展示首要的理由，但是目前很少再有博物馆像水晶桥那样顽固，非要将美国艺术与国家"景观"或国家"精神"混为一谈。[6] 这一观点也与艾丽斯·沃尔顿的首席顾问约翰·威尔默丁（John Wilmerding）教授意见相符，他既是收藏家、策展人，也是美术史学者，最近担任华盛顿国家美术馆的董事会主席。威尔默丁建议沃尔顿将一些他自己毫不犹豫称之为"杰作"的展品集中收藏展示。[7] 但是，如果水晶桥博物馆打算作为严肃的艺术史纪念品展场从公众或私人藏品中获取特别开支的话——正如爱国主义与商品拜物教频繁地携手并行——那么，它的做法可能也有些特别。当我 2012 年 5 月参观这个博物馆时，策展人将 18 世纪和 19 世纪的作品按类型（肖像、风景、流派）分门别类，在展墙上贴上了艺术家简介和历史信息，如果只是匆匆走过，你也可以知道这是关于美国发展的"艰辛"历程（有一面墙上确实也用了"艰辛"一词）。[8] 因此，在哈德逊河画派风景画（图 1）的一个展厅内，墙上就有这样一段美国原住民抵抗白人殖民的历史信息：1862 年，"阿尔伯特·比兹塔特创作了《印第安露营地》，那一年，美国政府想要重新安置土著部落，让他们搬离祖先的土地，而部落的起义延迟了第二次西进运动"。水晶桥博物馆的展出方案因此充其量是对当前艺术史成果及博物馆学实践最低程度的让步，可以说勉为其难，在这个方案中，策展人利用展墙的信息和其他手段（小册子、视频、语音导览）制造出一个较完整的艺术创作与使用历史语境，并且使传统的主客关系复杂化，心照不宣地假定博物馆的理想受众是白色人种、受过高等教育且富有的人群。[9] 在水晶桥博物馆，这种传统主客关系似乎作为一种制度性的反映被固化、承继下来。这一切源于博物馆对自我身份根深蒂固的保守认知。

布鲁克林博物馆 2001 年开展的"美国身份：新面貌"几乎与水晶桥博物馆的"歌颂美国精神"截然相反。布鲁克林博物馆那个招摇、争议不断的馆长阿诺德·莱曼（Arnold Lehman）策划了这一项目。据评论家安娜·梅库尼（Anna

sized institution with a relatively modest American collection. It is no bellwether, but as we shall see, its American installation suggests how an institution with relatively modest resources might today address the problems of exhibiting American art.

To evaluate what the VMFA has accomplished, I want to first establish a range of installation possibilities—not what might be possible in theory, but the solutions museums have arrived at in practice. As we might expect, the installations I listed a moment ago fall along a continuum from innovative to traditional. Anyone with any experience with American art museums would predict—and the prediction would not be wrong—that most of these installations lie somewhere in the middle of the continuum. But what does it mean for an installation to be innovative or traditional? Or to put the question somewhat differently, how does an installation open new perspectives on the history of American art—or close them off?

To arrive at an answer, I want to first consider the extreme or limiting cases. Crystal Bridges is the most conservative of the new installations, a mainly chronological lineup of works of art under the rubric "Celebrating the American Spirit." In the United States, patriotism often furnishes the principal rationale for collecting and displaying American art, but these days few museums are as insistent as Crystal Bridges on equating American art with a national "vision" or "spirit."[6] This emphasis accords with the views of Alice Walton's chief advisor, Professor John Wilmerding, a collector, curator, and art historian, who is currently chairman of the Washington National Gallery's board of trustees. Wilmerding advised Walton in assembling a collection of paintings that Wilmerding himself unhesitatingly describes as "masterpieces."[7] But if Crystal Bridges is meant to be experienced as a solemn display of art-historical trophies wrested at extraordinary expense from public and private collections—as so often, patriotism and commodity fetishism go hand-in-hand—it can also be experienced on somewhat different terms. When I visited the museum in May 2012, the curators had grouped eighteenth and nineteenth century paintings by type （portrait, landscape, genre） and posted wall texts with information about artists and brief historical comments that in a few instances acknowledged, if only in passing, the "difficulties," as one wall text put it, of American history.[8] Thus in a room dedicated to Hudson River School landscape painting （Fig.1）, a wall text pointed to a history of Native American resistance to white settlement: in 1862, "the year （Albert Bierstadt） painted Indian Encampment, insurrections among indigenous tribes over the United States government's displacement of Native peoples from ancestral lands delayed his second trip west."

图 1　画廊内景，水晶桥美国艺术博物馆，本特威尔，阿肯色州。摄影：艾伦·沃勒克。
Fig.1　Gallery View, Crystal Bridges Museum of American Art, Bentonville, Arkansas. Photo: Author.

Mecugni）所言："莱曼布置给员工的首要任务就是办一个参观者友好型展览，任何人都能够乐在其中，即使是他们没有任何艺术史背景。"莱曼希望"确保重新布置的画廊能够传达出文化多样性"，他希望展览能吸引布鲁克林不同种族、不同民族的人来参观，"他要求展览包含更多西班牙殖民地的作品、关于美国原住民作品的介绍以及关于非裔美国人或由非裔美国人创作的作品。"[10] 于是，由特蕾莎·卡蓬（Teresa Carbone）带领的博物馆策展团队将画廊按照时间顺序划分为八个主题单元——"从殖民地到国家""内战时期"和"百年时期（1876—1900）"等等——并将作品用各种各样的媒介进行展示。除了呈现油画、雕塑等高雅艺术之外，策展人还推出了装饰艺术、业余艺术、照片、早期默片、电影电视短片和流行音乐唱片以及诸如此类的作品。[11] 面对眼前紧凑的大杂烩，习惯于传统展示方式的观者可能会觉得不知所措，但是对于那些耐心观看的人来说，这种展示却提供了新的见解和乐趣。试想一下，例如，博物馆将威廉·威廉姆斯（William Williams）几乎真人大小的德博拉·霍尔（Deborah Hall，1766 年）肖像与 18 世纪秘鲁一个佚名画家创作的多纳·萨拉萨（Doña Mariana Belsunsey Salasar）的肖像并排放置，位于两幅画旁边的分别是罗伯特·费克（Robert Feke）和约翰·辛格尔顿·科普利（John Singleton Copley）创作的肖像作品

Crystal Bridges' didactic program thus represents at best a minimal—one might say grudging—concession to current art-historical scholarship and museological practice in which curators employ wall texts and other means （brochures, videos, acoustiguides） to develop a fuller sense of the historical contexts in which art was made and used, and to complicate a traditional subject-object relationship in which it is tacitly assumed that the museum's ideal visitor is white, well-educated and affluent.[9] This traditional relationship seems to persist at Crystal Bridges as an institutional reflex. It derives from the institution's deeply conservative conception of itself as an art museum.

The Brooklyn Museum's "American Identities: A New Look," which opened in 2001, represents almost the polar opposite of Crystal Bridges' "Celebrating the American Spirit." Arnold Lehman, the museum's flamboyant and often controversial director, set the terms of the project. According to the critic Anna Mecugni, "the primary mandate that （Lehman） issued to the staff was to create a visitor-friendly exhibition that could be enjoyed by anyone, even by people with no background in art history." Lehman wanted "to make sure that the reinstalled galleries conveyed cultural pluralism," which he thought would appeal to Brooklyn's multi-racial, multi-ethnic population, and "he requested the inclusion of more Spanish

图2　画廊内景，布鲁克林美术馆，布鲁克林，纽约。摄影：艾伦·沃勒克。
Fig.2　Gallery View, The Brooklyn Museum, Brooklyn, New York. Photo: Author.

（图 2）。通过将两幅来自殖民地的巨大肖像并置：一位是英属殖民地费城印刷商的妻子；另一位是 18 世纪西班牙殖民地利马的克里奥尔贵族，策展人不仅将美国殖民地肖像画放到国际维度中，而且也强调肖像画是上流社会表达观点的手段。[12] 最近，策展人在这两幅肖像旁边放上了一幅新购入的作品——18 世纪中叶艺术家托马斯·哈德逊（Thomas Hudson）创作的约翰·温特（John Wendt）夫人肖像，以此来进一步显示与国际艺术的联系，同时也表明对殖民地肖像画的看法，尽管这是策展人当下诉求的一部分，然而把这两幅画与来自伦敦的柔美作品放在一起还是有些难受。[13]

　　不出所料，传统主义者果然开始发难，用新保守主义评论家希尔顿·克雷默（Hilton Kramer）的话来说就是，"迎合低俗的品位……一切都被过度贴标签、过度包装，还被割裂成简单的类别。"[14] 即使是那些对布鲁克林将高雅艺术与通俗艺术混合的做法没有提出异议的评论家，有时也难以领会策展人的意图。在大量证据面前，有位著名的美国主义者依然强调它的愉悦感，完全错了方向，"展览所呈现的纯粹视觉愉悦证明策展人首要的用意是想让作品为自身说话。"[15] 实际上，如果布鲁克林的展陈说明了什么的话，就是与艺术界陈腐的做法对着干，艺术作品不会为自己说话，只有在与别的作品或别的多种语境的关系中才产生意义，其中有历史语境、社会语境、文学语境、视觉语境和美学语境，也包含博物馆本身的空间"语境"。

　　"美国身份"展是一个很有影响的先例。[16] 那些 20世纪 90 年代我们本来几乎不假思索的东西，比如把 19

Colonial pieces, the introduction of Native American objects, and the showcase of works by or about African Americans."[10] In response, the museum's curatorial team led by Teresa Carbone divided the galleries into eight chronologically defined thematic units—"From Colony to Nation", "The Civil War Era", "The Centennial Era, 1876—1900", etc.—and installed works in a wide variety of media. In addition to presenting high art—oil painting, sculpture—the curators also included decorative arts, outsider art, photographs, early silent films, film and television clips, recordings of popular music, and so forth.[11] Visitors accustomed to more sedate presentations may have found the tightly packed mélange bewildering, but for those with the patience for careful looking, the installation yielded new insights and new pleasures. Consider, for example, the museum's pairing of William Williams' nearly life-size portrait of Deborah Hall （1766） with a portrait by an anonymous eighteenth-century Peruvian painter of Doña Mariana Belsunse y Salasar （the two are flanked by portraits by Robert Feke and John Singleton Copley）（Fig.2）. By juxtaposing two mammoth colonial portraits—one of the wife of a Philadelphia printer, the other of a member of Lima's eighteenth-century Creole aristocracy—the curators underscored not only the international dimension of colonial American portraiture, but also the ways in which portraits were used to press claims to upper class status.[12] Recently, the curators added to the display the museum's newly-acquired portrait of Mrs. John Wendt, a mid-eighteenth century work attrbuted to the English portrait painter Thomas Hudson, thus further demonstrating international artistic connections as well as making a point about the colo-

世纪美国艺术放在奴隶与拓殖的野蛮史中来考虑，现在看来，至少想象成分居多。

2010年，VMFA在其新建的麦格洛辛侧翼里的美国藏品展示正处于我之前说的两种极端中间，意味着策展人在政治环境相对保守，只有极少资源的情况下仍可以完成布展。

VMFA的美国藏品包含了从17世纪中叶到20世纪中叶的油画、雕塑、纸上作品和装饰艺术。（图3）[17]七间展厅中没有哪样展品可以简单称为低俗或流行艺术，不像大都会博物馆[18]那样的老牌机构将高雅艺术、装饰艺术、民间艺术及业余艺术自由混合在一间年代展厅里，沃莎-洛克菲勒（Worsham-Rockefeller）2008年捐赠的卧室就是这类的展示。

伊丽莎白·奥利里（Elizabeth O'Leary）、苏珊·罗尔斯（Susan Rawles）、西尔维亚·扬特（Sylvia Yount）和大卫·帕克·柯里（David Park Curry，2005年离开里士满就职于巴尔的摩美术馆）是规划与监督展陈的策展人，他们将140多幅作品以标准的编年顺序排列（"殖民地和革命时期""早期共和国与杰克逊时期""南北战争前的岁月"等）。但是即使策展人坚持使用传统的方法为作品分期，仔细看还是会发现，他们还为作品在历史、主题以及风格上搭建联系，这是不寻常的。

在一间专门陈列美国内战期间及战后作品的展厅

nial portraits, which look awkward—although that is part of vtheir latter-day appeal—next to the suave product of an imperial metropole.[13]

Predictably, traditionalists condemned the Brooklyn Museum for, in the words of the neoconservative critic Hilton Kramer, "pandering to lowbrow tastes... Everything is overlabeled, overpackaged and otherwise divided into simplistic categories."[14] Even critics who did not take issue with Brooklyn's mixture of high and popular art, on occasion failed to comprehend the curators' aims. Thus in the face of massive evidence to the contrary, one well-known Americanist clung to the comforting if entirely wrongheaded idea that "the pure visual pleasure of the show demonstrates that the curators above all intended that the objects speak for themselves."[15] But if Brooklyn's installation demonstrated anything, it was that contrary to hoary artworld cliché, works of art do not speak for themselves, but acquire meaning only in relation to other art works and to a range of other contexts—historical, social, literary, visual, and aesthetic—including the "context" of the museum space itself.

"American Identities" set an influential precedent.[16] What was often almost unthinkable in the 1990s—for example, seeing nineteenth-century American art in relation to a brutal history of slavery and exploitation—has at least become more imaginable.

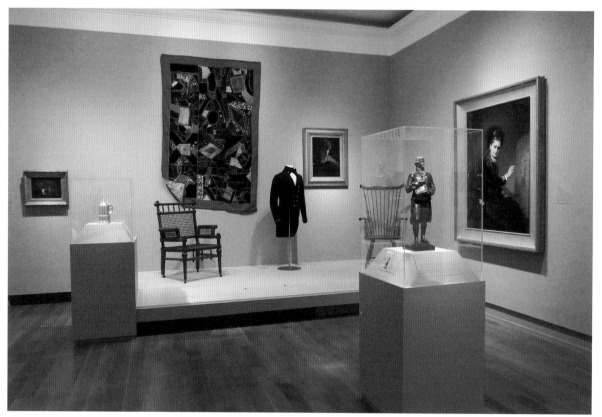

图3　画廊内景，弗吉尼亚美术馆，里士满，弗吉尼亚。摄影：艾伦·沃勒克。
Fig.3　Gallery View, The Virginia Museum of Fine Arts, Richmond, Virginia. Photo: Author.

里，有一张 1862 年由亚历山大·加德纳（Alexander Gardner）拍摄的林肯和乔治·B. 麦克莱伦（George B. McClellan）将军在安提耶坦战役中的照片，就挂在威廉·麦克劳德（William MacLeod）1864 年创作的油画《安提耶坦桥》旁边（图 4、图 5）。加德纳照片是一幅姿势呆板的官方肖像，林肯站在军帐前面，身高上要远

图 4　亚历山大·加德纳，摄影师，马修·布雷，出版人，《1862 年 10 月 3 日总统、麦克莱伦将军和士兵在安提耶坦战场》，1862 年，蛋白印相，图片大小 9¹/₁₆×8⁵/₈ 英寸（23.02×21.27 厘米），纸张大小 13¹/₂×19³/₄ 英寸（34.29×50.17 厘米），弗吉尼亚美术馆，里士满。凯瑟琳·布恩·塞缪尔纪念基金会，2011.74。
Fig.4　Alexander Gardner, photographer, Mathew Brady, publisher, *The President, General McClellan and Suite on Battle-field of Antietam October 3 1862,* 1862, albumen print, image, 9¹/₁₆×8⁵/₈in. （23.02×21.27cm）, sheet 13¹/₂×19³/₄in. （34.29×50.17cm）, Virginia Museum of Fine Arts, Richmond. Kathleen Boone Samuels Memorial Fund, 2011.74.

图 5　威廉·麦克劳德，《安提耶坦桥》，1864 年，布面油画，18×24 英寸（45.72×60.96 厘米），弗吉亚美术馆，里士满，弗吉尼亚。约翰·巴顿·佩恩基金会和莎拉、莱克斯·里夫斯为庆祝弗吉尼亚美术馆成立 75 周年捐赠，2011.26。
Fig.5　William MacLeod, *Antietam Bridge,* 1864, oil on canvas, 18×24in （45.72×60.96cm）, The Virginia Museum of Fine Arts, Richmond, Virginia. John Barton Payne Fund and partial gift of Sarah and Lex Reeves in Celebration of VMFA's 75th anniversary, 2011.26.

The American collection at the Virginia Museum of Fine Arts, installed in the museum's new McGlothin Wing in 2010, falls between the two extremes I have described. It demonstrates what curators working in a relatively conservative political environment and with far fewer resources can still accomplish.

The VMFA's American collection comprises painting, sculpture, works on paper, and decorative arts dating from the mid-seventeenth to the mid-twentieth century （Fig.3）.[17] The seven-gallery installation contains nothing that could readily be called low or popular art, but unlike more traditional institutions—for example, the Metropolitan Museum[18]—the museum freely mixes fine, decorative, and folk or outsider art, and includes a period room—the Worsham-Rockefeller bedroom, donated in 2008—in its sequence of galleries.

The curators who planned and oversaw the installation—Elizabeth O'Leary, Susan Rawles, Sylvia Yount, and David Park Curry （who left Richmond for the Baltimore Museum of Art in 2005）—deployed approximately 140 works following what is by now a standard chronological progression （"Colonial and Revolutionary Periods," "Early Republic and Jacksonian Eras," "Antebellum Years," etc.）. But if they adhered to tradition when it came to periodization, a close look at the galleries reveals they took unusual care in making historical, thematic, and stylistic connections.

In a gallery devoted in part to the Civil War and its aftermath, Alexander Gardner's 1862 photograph of Lincoln and General George B. McClellan at Antietam hangs next to William MacLeod's 1864 painting of Antietam Bridge （Figs. 4, 5）. Gardner's photograph is a stiffly posed official portrait in which, against a background of military tents, Lincoln towers over the general and his staff. By contrast, MacLeod's painting is a seemingly bucolic landscape complete with picturesque bridge, strolling couple, picnicking tourists, and placid stream. According to a wall text, "with close to 23,000 casualties from both Union and Confederate armies, the Battle of Antietam remains the deadliest day in American military history."[19] Photograph and painting depict different aspects of the battle's aftermath. One learns that Lincoln, unhappy with McClellan's failure to pursue the retreating Confederate army after the battle ended, eventually relieved the general of his command. The bridge at Antietam was the battle's focal point, and as a wall text notes, MacLeod's painting contains the diminutive figure of a Union soldier in a Zouave uniform as well as an ambulance wagon flying a red flag—details today's viewer would likely overlook or misconstrue, but which suggest the range of meanings the painting held for the artist's contemporaries.

远超出将军和士兵。相形之下，麦克劳德的画则表现了一幅惬意的田园图景，诗意的小桥、漫步的情侣、野餐的旅者与静谧的流水交相呼应。展墙上这样描述道，"联邦军和邦联军双方伤亡者合计将近 23000 人，安提耶坦之战成为美国军事史上最为血腥的一天。"[19] 摄影与绘画从不同角度描绘了战争的惨烈后果。可以看出，林肯对于麦克莱伦在战争结束后未能追赶上撤退的邦联军表示不满，并最终撤销了麦克莱伦的指挥权。安提耶坦桥是双方激战的焦点，正如展墙所提示的，麦克劳德的画中还有一个很小的身着轻骑兵制服的士兵以及一辆飘展着红旗、用于救护的四轮马车，今天的观者可能会忽略或错误理解这些细节，但是与艺术家同时代者却能解读画中的含义。

将加德纳的照片和麦克劳德的绘画配在一起显然是策展人的用心。[20]（绘画与照片都于 2011 年购入，可能当时想到了两幅作品可以并排展出。）相比之下，将主题不同但风格相近的作品放在一起就不那么突出。第六展厅（"现代时期"）有个角落特意将 20 世纪早期和中期的 7 个现代主义者的绘画和雕塑放在一起（图 6、图 7）。没有哪件作品称得上"杰作"或者高于其他作品（总的来说，这是 VMFA 美国藏品展陈的优点之一），但是放在一起，策展人给出的是美国和拉丁美洲的艺术家各自吸纳立体主义的方式。因此标签里提到道森（Manniere

The pairing of Gardner's photograph and MacLeod's painting seems an obvious curatorial choice.[20] (Both painting and photograph were acquired in 2011, probably with the idea that they could be exhibited side-by-side.) Less obvious was a decision to group together works that are thematically dissimilar but stylistically linked. A corner of gallery six ("Modern Era") features paintings and sculptures by seven early and mid twentieth-century modernists (Figs. 6, 7). No work is accorded "masterpiece" status or allowed to overwhelm the others (this is one of the great virtues of the VMFA's American installation overall), but together, they suggest ways in which U.S. and Latin American artists adapted cubism to their artistic aims. Thus the viewer registers how early in their careers, Manniere Dawson and William H. Johnson imitated the style of Picasso and Braque; how the sculptors Paul Manship and Richmond Barthé domesticated cubism by turning it into a version of Art Deco; how Diego Rivera and Oswaldo Guayasamin adapted the style to nationalist ends; and how the Regionalist Thomas Hart Benton used it as the basis for his distinctive folk-expressionist manner.

The grouping suggests how far the VMFA curators have gone to produce an inclusive history of American art. Between 2002 and 2009, the museum purchased paintings by three African American artists—Robert Duncanson, Edward M. Bannister, and Henry Ossawa Tanner—whose

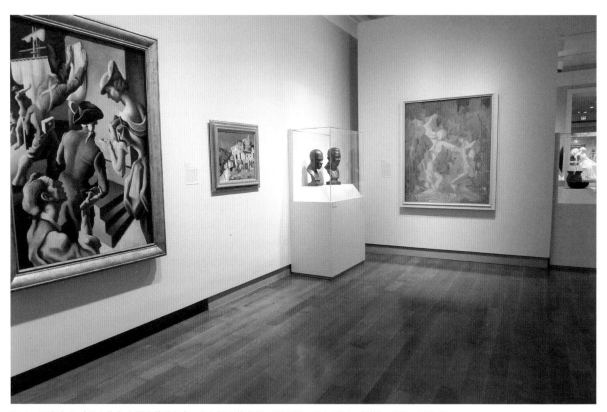

图 6　画廊内景（受立体主义影响的作品），弗吉尼亚美术馆，里士满，弗吉尼亚。摄影：艾伦·沃勒克。
Fig.6　Gallery View（cubist inspired work），The Virginia Museum of Fine Arts, Richmond, Virginia. Photo: Author.

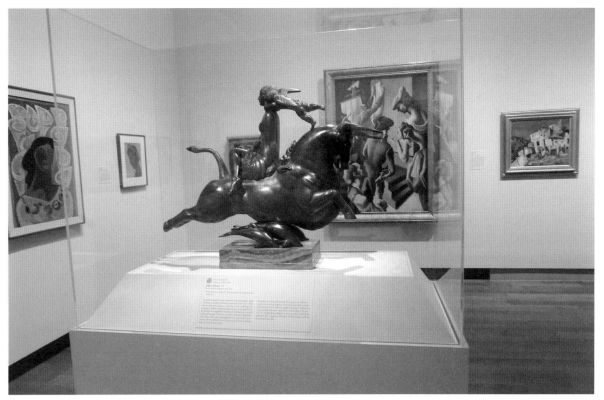

图7　画廊内景（受立体主义影响的作品），弗吉尼亚美术馆，里士满，弗吉尼亚。摄影：艾伦·沃勒克。
Fig.7　Gallery View （cubist inspired work）, The Virginia Museum of Fine Arts, Richmond, Virginia. Photo: Author.

Dawson）和威廉·H. 约翰逊（William H. Johnson）在生涯早期怎样模仿了毕加索和勃拉克的风格；雕塑家保罗·曼希普（Paul Manship）和里士满·巴特（Richmond Barthé）是如何将立体主义转换成装饰艺术的样式；迭戈·里维拉（Diego Rivera）和奥斯瓦尔多·瓜亚萨明（Oswaldo Guayasamin）是如何将立体主义最后变成了民族主义风格，以及乡土主义者托马斯·哈特·本顿（Thomas Hart Benton）是如何以立体主义为基础创作出独特的民间表现主义风格。

　　从这组作品可看出 VMFA 的策展人在制造美国艺术的多样性历史这一点上走到了很前面。从 2002 年到 2009 年，美术馆购入 3 位非裔美国艺术家的作品，分别是罗伯特·邓肯森（Robert Duncanson）、爱德华·M. 班尼斯特（Edward M. Bannister）、亨利·奥萨瓦·坦纳（Henry Ossawa Tanner），他们的作品相对来说都是较新的"发现"，而邓肯森和坦纳的作品是回顾展的首要主题，这源于艺术史的修正主义，布鲁克林的"美国身份"展就是这种修正主义的缩影。[21]策展人也依靠租借展品来扩充展览，从而丰富美国艺术的定义。为了上文那组描述的例子，博物馆借了非裔美国艺术家（巴特和约翰逊）和拉丁美洲艺术家（里维拉和瓜亚萨明）的作品用以展览。

　　但是，扩展美国艺术史的意涵并不那么简单，它不

relatively recent "discovery"—both Duncanson and Tanner have been the subject of major retrospectives—resulted from the art-historical revisionism epitomized by Brooklyn's "American Identities."[21] The curators also relied on loans in their effort to enlarge the definition of American art. Thus for the grouping just described, the museum borrowed works by African-Americans （Barthé and Johnson） and Latin Americans （Rivera and Guayasamin）.

But an enlarged sense of the history of American art is not simply a matter of adding works by minority artists or implying American art's global dimension via the inclusion of paintings by artists who, like Rivera and Guayasamin, were influenced by, and proved influential for, artists in the United States. American art museums have often presented redemptive histories, in which works of art could be interpreted, as at Crystal Bridges, as evidence of an American "vision" or "spirit," in effect obscuring or papering over unbearable historical realities. By contrast, the curators at the VMFA have opted for a version of the revisionism on view in Brooklyn—in particular, for a history of American art that encompasses slavery and racial discrimination.

One example will suffice: in the gallery dedicated to art of the colonial and revolutionary period, the museum displays a portrait by an artist known as the Payne Limner, which was donated to the museum in 1953 by a Payne fam-

单单是加几件少数人群的艺术家作品，或是把美国艺术家放进全球维度来考虑的问题，比如加一些里维拉和瓜亚萨明的作品，他们受美国艺术家影响，又反过来影响了美国艺术家。美国的艺术博物馆经常表现救赎的历史，艺术品可以被解释为美国"景观"或"精神"的证据，例如在水晶桥博物馆，实际上却模糊或掩盖了难以承受的历史事实。相反，VMFA 的策展人倾向于用跟布鲁克林美术馆一样的修正主义视角来看待美国艺术史，一部包含奴隶制和种族歧视的历史。

举一个例子就足够了：在殖民地和革命时期的展厅里陈列着一幅佩恩·林纳（Payne Limner）画的肖像作品，1953 年佩恩家族的后裔捐赠了这幅画，画中描绘了亚历山大·斯波茨伍德·佩恩（Alexander Spotswood Payne）和约翰·罗伯特·丹德里奇·佩恩（John Robert Dandridge Payne），两个富裕的种植园主的子嗣，边上还有不知名的黑人保姆。标签上的观点对有些人来说显而易见但仍是必要的：尽管缺乏学院派训练，佩恩·林纳还是通过画中摆设、人物衣着传达出其具有特权的家庭环境，另外，无名非裔美洲女孩是合法奴隶，画中把她表现成可征税的珍贵"财产"。尽管当时已经有自由和平等的革命性言论——包括阿彻·佩恩的亲戚帕特里克·亨利（Patrick Henry）的著名演说——但基于奴隶劳动的经济形式在美国南部还会持续 75 年。

在这幅群像前面，策展人在展箱里放了一枚约书亚·韦奇伍德（Josiah Wedgwood）用碧玉制成的反奴隶制纪念章，那是博物馆于 2001 年购入的（图 8）。韦奇伍德的纪念章最早由本杰明·富兰克林（Benjamin Franklin）引入美国，一时间成为如展墙所写"在大西洋两岸影响广泛、用来表明自己政治立场的饰物"。在废奴主义者的圈子里，纪念章以各种形式做成配饰，如做成挂坠或是镶在鼻烟盒上。绘画与奖章共同激起观众对那段压迫和反抗历史的记忆，其他的展陈也一再重复这个主题。

VMFA 是一家州立机构，它在的城市原本是联盟国的首府，城里到处都是纪念碑、博物馆，还有各种组织，以纪念南北战争中那场"命定败局"。（里士满纪念碑大道两旁的联盟国纪念碑依次排开，大道距博物馆只有几个街区之隔。）毫不夸张地说，VMFA 的美国艺术展，展现出博物馆致力于打造一个多文化、多种族共存的弗吉尼亚社区的决心。但据我所知，在里士满也与在别处一样，启蒙总是有其局限性。

2012 年参观 VMFA 时，我惊奇地发现，在靠近博物馆场地附近的人行道上，有一群人朝着过往的车辆挥舞联盟国的旗帜。博物馆的警卫告诉我，那些人在抗议博物馆将一面联盟国战争中的旗帜——"星条旗"——

ily descendent, and which depicts Alexander Spotswood Payne and John Robert Dandridge Payne, scions of a wealthy plantation owner, and their unnamed black nurse. The accompanying label makes a point that may seem obvious to some but is nonetheless necessary: although lacking academic training, the Payne Limner.

Conveyed the family's privileged circumstances through setting, clothing, and the addition of the unnamed African American girl, whose legal status as a slave rendered her valuable taxable "property." Despite recent Revolutionary rhetoric about liberty and freedom—including the famous speech by Archer Payne's relation Patrick Henry—an economic system based on slave labor would continue in the South for another seventy-five years.

In front of the group portrait, the curators have placed a case containing one of Josiah Wedgwood's jasperware anti-slavery medallions, which the museum acquired in 2001 (Fig.8). First imported to the United States by Benjamin Franklin, Wedgwood's medallions became, in the words of the wall text, "popular and persuasive political ornaments on both sides of the Atlantic. In abolitionist circles, they were variously framed, worn as pendants, and inlaid on snuff boxes." Together painting and medallion powerfully evoke a history of oppression and resistance, a theme that is repeated elsewhere in the installation.

The VMFA is a state funded institution located in a city that served as the capital of the Confederacy—a city that overflows with monuments, museums, and organizations dedicated to keeping alive the memory of the Lost Cause. (Richmond's Monument Avenue, which is lined with Confederate Memorials, is only a few blocks from the museum.) It would be no exaggeration, then, to call the VMFA's display of American art enlightened, a reflection of the museum's determination to serve a multicultural, multiethnic Virginia community. But as I learned, in Richmond, as elsewhere, enlightenment often has its limits.

While visiting the VMFA in June 2012, I was amazed to discover a group of men on the sidewalk adjoining the museum grounds waving Confederate flags at passing cars. A museum guard informed me that the men were protesting the museum's decision to remove a Confederate battle flag—the "Stars and Bars"—from in front of the Pelham Chapel, a memorial to the Confederate dead that is a part of the VMFA's campus. The Confederate battle flag remains a potent symbol, and although its display ostensibly honors the memory of the soldiers who served the Confederacy, given a long and tortured history, it is also, inescapably, a signifier of white racism.

After the museum closed that day, I decided to pay the "Virginia flaggers," as they call themselves, a visit. The

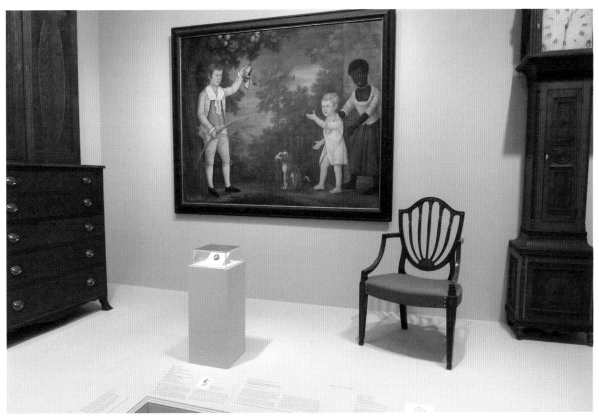

图8 画廊内景，反奴隶制纪念章，弗吉尼亚美术馆，里士满，弗吉尼亚。摄影：艾伦·沃勒克。
Fig.8 Gallery View, The Virginia Museum of Fine Arts, Richmond, Virginia. Photo: Author.

从佩勒姆礼拜堂前面移走的决定，佩勒姆礼拜堂也是 VMFA 的一部分，用以悼念联盟军牺牲者。联盟国战旗作为一个强有力的符号，尽管展示它在表面上唤起了人们对联盟国阵亡将士的怀念，并记载了一段漫长而苦难的历史，但是同时，它也不可避免地沦为白人种族主义的象征符号。

当天博物馆闭馆之后，我决定探访那些自称为"弗吉尼亚护旗者"的人。跟我聊天的三个自称是联盟国士兵后代的白人工人阶层事实上很友善、平易近人。他们非常配合地拍了幅照片（图9），当我问他们为什么呼吁抵制博物馆时，他们回答说，弗吉尼亚美术博物馆挪走旗子的决定侮辱了他们，也侮辱了士兵的记忆，这些士兵曾"挺身为弗吉尼亚而战"，在他们递给我一张传单上如是写道。这些"护旗者"看上去并不是公然的种族主义者，但是也很难相信他们对"星条旗"可能会让信念不同的人难受、害怕的情况毫无意识。

拍完照后，我陷入了沉思，在心里仔细揣摩这一常见的两难困境。VMFA 似乎在做其力所能及的一切来教育公众。然而，公众是异质性的，虽然美国的艺术博物馆轻而易举地吸引到大批观众和被教育者，但他们并没有那么成功，尤其是对处于社会经济梯级底层的人群而言时。[22] 这就是"旗帜"事例所要讲述的；无论如何，他

three I spoke with—white working class men who claimed to be descended from Confederate soldiers—proved to be an affable lot. They willingly posed for a photograph （Fig.9）, and, when I asked them why they were urging a boycott of the museum, they said they considered the VMFA's decision to remove the flag a personal affront and an affront to the memory of the soldiers who, in the words of the flyer they handed me, "gallantly answered Virginia's call to defend her." The "flaggers" did not appear to be overtly racist, but it was impossible to believe they were unaware that the sight of the Stars and Bars could be painful and intimidating to those who do not share their beliefs.

After I took my picture, I was left contemplating a familiar dilemma. The VMFA seemed to be doing everything in its power to educate its public. That public, however, is heterogeneous, and while art museums in the United States readily attract the affluent and the educated, they are less successful when it comes to those lower down on the socio-economic ladder. [22] This was the case with the "flaggers"; in any event, their identity was bound up not with "the love of art," as Pierre Bourdieu might have put it, but with nostalgia for the Lost Cause.

The Virginia Flaggers, who on several occasions have publicly confronted Alex Nyerges, the VMFA's director,

图9 弗吉尼亚护旗者，里士满，弗吉尼亚，2013 年 6 月 12 日。摄影：艾伦·沃勒克。

Fig.9 Virginia Flaggers, Richmond, Virginia, 12 June 2013. Photo: Author .

们的身份与皮埃尔·布迪厄（Pierre Bourdieu）所提出的"对艺术的热爱"并无关联，而是与对曾经那场"命定败局"的怀旧之情相关。

"弗吉尼亚护旗者"在某些场合公抨击 VMFA 的馆长亚历克斯·尼厄格斯（Alex Nyerges），对他来说也就是个麻烦事，但他们在 VMFA 馆外面的活动，生动地提示我们博物馆在外部政策上的缺失。在文章开头我提出了如何开启新视野、扩展博物馆受众的问题，答案不仅要依靠机构内部政策——策展人如何理解自己的位置，选定的总监是否支持创新，这些也许可以称为机构的政治文化——博物馆还要取得不同政治信仰群体的支持——理事和收藏家，市、州和联邦政府，基金会，合作的保险公司，艺术评论家，还有一点至关重要的是博物馆需要走向公众。如今，当博物馆要做美国艺术展时，他们发现自己夹在刚才那些观众和学院派艺术史家中间，后者从 20 世纪 70 年代晚期开始倡导新的、有时甚至激进的或者貌似激进的研究方法。这些方法现在看来很平常——结构主义、社会史、解构、女性主义等，还有从人种、阶级、性别和种族问题来研究美国艺术史的视角。20 世纪 80 年代，这些问题理所当然地在艺术史的课堂和学术出版物上出现并被讨论，但是，它们没有、事实上也不能简单地转变为展览的构思。我们可能将此归结为制度上的阻力，但是我们也不能忽略当时的公众，或者当时的上下文背景，这二者当时对美国艺术史修正主义的研究方法准备尚不充分。

与此相关，1991 年华盛顿史密森美国艺术博物馆的《美国西部》展是一个人尽皆知的例子。那个时候正是乔治·H.W. 布什执政的低潮时期，展览的举办震撼了批评家、政治家以及普通大众。展览并没有再现西部边境的牛仔和印第安人英勇斗争迈向"文明"的神话，而

may be no more than a nuisance, but their presence at the VMFA furnishes a vivid reminder that museums do not exist outside politics. The answers to the questions I raised at the outset of this paper about opening new perspectives and enlarging the museum audience depend in large measure not only upon institutional politics—how curators construe their role, whether or not a given director supports or opposes innovation, what might be called the institution's political culture—but also on the politics of the different constituencies the museum relies upon for support—trustees and collectors; city, state, and federal governments; foundations; corporate underwriters; art critics; and, not least, the museum-going public. These days, when it comes to exhibiting American art, museums have found themselves caught between the constituencies just named and academic art historians, who since the late 1970s have been pursuing new and sometimes radical—or seemingly radical—approaches. These approaches are by now familiar—structuralism, social history, deconstruction, feminism, and so forth; so too perspectives on the history of American art focused on issues of race, class, gender, and ethnicity. However, questions that by the late 1980s were routinely being taken up in art history classrooms and scholarly publications, did not, indeed, could not, readily translate into ideas for exhibitions. We might attribute this to institutional resistance; but we might also observe that the public at the time, or a large section thereof, was ill-prepared for revisionist approaches to the history of American art.

A notorious case in point was the Smithsonian American Art Museum's The *West as America* exhibition, which opened in Washington, DC, in 1991. The exhibition, which took place during the waning days of the George H.W. Bush administration, shocked critics and politicians as well as members of the public. Instead of recapitulating cowboy-and-Indian myths of a heroic struggle to advance "civilization" along the western frontier, the exhibition related western American art to a brutal history of imperial expansion and conquest, of efforts to destroy Native American populations and cultures, and of the merciless exploitation of industrial and agricultural labor. The exhibition exemplified a critical approach not only to history but also to the works of art themselves, seeing them as representations of a tendentious viewpoint, as ideological, rather than treating them, as earlier commentators had often done, as realistic depictions of western history and landscape. Conservative critics were incensed. Politicians threatened to curtail the Smithsonian's funding. Controversy raged for weeks and months in the pages of the Washington Post and other newspapers and journals. The response to the show traumatized the Smithsonian American Art Museum, which overnight abandoned

是将美国西部艺术与其帝国扩张与征服的野蛮历史联系起来，与摧毁美国原住民及其文化的处心积虑联系在一起，与对工农业劳工无情的剥削与压迫联系在一起。展览所阐明的批评视角和方法不仅针对历史，也针对艺术作品本身，它将这些作品视为含有政治倾向的、意识形态的代表，而不是像早先评论者那样将它们看成对西部历史和景观的如实描摹。这可激怒了保守的批评家。政治家威胁要削减史密森博物馆的财政拨款。《华盛顿邮报》以及其他报纸杂志上的论战持续数周乃至数月。这些回应严重挫伤了史密森美国艺术博物馆，使其一夜间放弃了修正主义和其他的创新公共项目，自从 1991 年以后就只做分内之事，以避免争议。[23]

《美国西部》展引发的愤怒势必挫伤了 20 世纪 90 年代早期在美国艺术展中兴起的修正主义的热情。回想起来，从展览引起的争议来看，它成为一个转折点。再没有任何官方博物馆试图激进行事；尽管如此，正如我们所见，其他博物馆都或多或少接受了修正主义的方法，或者至少开始从修正主义的角度考虑问题。如前所述，即使是水晶桥博物馆也不得不承认，西方扩张与殖民所引起的灾难如果能一笔带过就好了。

我说的这种改变很难只归因于《美国西部》展。尽管美国保守派相信正在进行一场"文化战争"，尽管他们像希尔顿·克雷默一样抨击"政治正确"，在《美国西部》展之后的 20 年间，美国公众对艺术多样性愈加宽容，且对于理解美国过去那段残酷的现实也有了更加充分的心理准备。[对此我很想举个例子，就是 2013 年秋季在全美上映的《为奴十二年》，本片由史蒂夫·麦奎因（Steve McQueen）执导，上映后广受好评，一度成为继《飘》之后最卖座的影片。] 美国公众这种态度上的转变是美国艺术展开修正主义角度的重要前提。正如我们所观察到的，一个美术馆是像布鲁克林那样选择修正主义立场，或是像水晶桥博物馆那样坚持传统道路，都需要依赖大量的条件，也许最重要的条件是政治气候。20 世纪 90 年代，当布鲁克林博物馆构想它那激进的修正主义的《美国身份》展时，部分原因是出于展览能够吸引公众的兴趣和支持——不顾博物馆与当时纽约市长鲁道夫·朱利安尼（Rudolf Giuliani）有过一段争议关系的历史，后者在 1999 年针对博物馆一个展览的争论中，试图切断博物馆的资金并将展览驱逐出去。[24]

因为美国人越来越了解自己民族的历史，了解历史如何在当下立足，我认为我们有理由期待布鲁克林和里士满引人注目的启示最终能够取胜。尽管美国社会存在各种深刻的分歧，尽管美国政治中极端保守者兴起，我仍旧期待修正主义对美国艺术展的影响能够日益增强。

revisionism and innovative public programming, and has ever since 1991 done everything in its power to avoid controversy.[23]

The outrage that greeted *The West as America* dampened whatever enthusiasm there may have been in the early 1990s for mounting revisionist exhibitions of American art. But for all the controversy surrounding "The West as America," the exhibition appears in retrospect as a turning point. No government museum would again attempt anything as radical; however, as we have seen, other museums have to a greater or lesser degree embraced revisionist approaches or at least taken revisionist perspectives into account. Thus, as noted earlier, even Crystal Bridges feels obliged to acknowledge, if only in passing, the horrors of western expansion and settlement.

The changes I am describing can hardly be attributed to *The West as America* alone. Despite American conservatives' ongoing "culture war," despite their attacks à la Hilton Kramer on "pc" or "political correctness," in the two decades since *The West as America*, the American public has become far more accepting of diversity and better prepared to comprehend the hard realities of the American past. （At this point, I am tempted to cite as evidence the popular and critical success of Steve McQueen's *Twelve Years a Slave*, a long overdue riposte to *Gone with the Wind*, which opened in the fall of 2013 at movie theaters across the United States.） This change in the American public has been a necessary precondition for revisionist presentations of American art. As we have observed, whether a given museum opts for revisionism as at Brooklyn, or hews to tradition, as at Crystal Bridges, depends upon a host of circumstances, perhaps most importantly political climate. In the 1990s, when the Brooklyn Museum conceived of its then radically revisionist *American Identities,* it did so at least in part because it anticipated community interest and support—this despite a history of contentious relations between the museum and New York City's then mayor, Rudolf Giuliani, who in 1999, in a dispute about one of the museum's exhibitions, attempted to cut off the museum's funding and evict it from its building.[24]

Because Americans are becoming better informed about the nation's history and about how that history maintains its hold on the present, I think we have reason to hope that the enlightenment in evidence in Brooklyn and in Richmond will in the long run prevail. Thus despite deep divisions in American society, despite the rise of ultra-conservative extremists in American politics, I look forward to revisionism's increasing influence on the exhibition of American art.

Notes:

1 Some of the material presented here appears in a different form in Alan Wallach. "The New American Art Galleries at the Virginia Museum of Fine Arts, Richmond, Virginia". *Museum Worlds: Advances in Research 1.* New York and Oxford: Berghahn, 2013. 222-228.

2 At this writing, the Corcoran trustees are in negotiation with the University Maryland over details of a memorandum of understanding that was signed in April 2013, and that anticipates the transfer the museum and the Corcoran College of Art and Design to the university. See Marge Ely. "Museums in transition: Corcoran Gallery sees its finances improve after rough patch". *The Washington Post*, September 27, 2013. http://www.washingtonpost.com/entertainment/museums/museums-in-transition-corcoran-gallery-sees-its-finances-improve-after-rough-patch/2013/10/03/4598787c-2497-11e3-b75d-5b7f66349852_story.html (accessed 28 December 2013) .

3 See reviews by Justin Wolff, http://www.caareviews.org/reviews/1690 (accessed 22 June 2012) , and Kristina Wilson, http://www.caareviews.org/reviews/1691 (accessed December 28, 2011) .

4 Linda Wertheimer, transcript of National Public Radio's "Weekend Edition," 12 November 2011. http://www.npr.org/2011/11/12/142270045/wal-mart-heiress-show-puts-a-high-price-on-art (accessed November 13, 2011) .

5 See Carol Vogel. "Grand Galleries for National Treasures" . *The New York Times*, January 6, 2012. http://www.nytimes.com/2012/01/06/arts/design/metropolitan-museum-completes-american-wing-renovation.html?pagewanted=all (accessed 7 January 2012) ; and Holland Cotter. "The Met Reimagines the American Story". *The New York Times*, January 15, 2012. http://www.nytimes.com/2012/01/16/arts/design/metropolitan-museum-of-arts-new-american-wing-galleries-review.html?pagewanted=2&_r=1&hpw (accessed January16 , 2012) .

6 When I visited Crystal Bridges on 18-19 May, 2012, the two traveling exhibitions on display were called "The Hudson River School: Nature and the American Vision," and "American Encounters: Thomas Cole and the Narrative Landscape."

7 For Wilmerding, see "Wilmerding, John [Currie]" in the Dictionary of Art Historians (http://www.dictionaryofarthistorians.org/wilmerdingj.htm (accessed June 24, 2012) . For "masterpieces," see Joel Rose. "Wal-Mart Heiress' Show Puts a High Price On Art". National Public Radio, November 12, 2011.http://www.npr.org/2011/11/12/142270045/wal-mart-heiress-show-puts-a-high-price-on-art, (accessed June 22, 2012) . See Clare O'Connor, "Inside the World of Walmart Billionaire Alice Walton, America's Richest Art Collector," Forbes (7October, 2013) , http://www.forbes.com/sites/clareoconnor/2013/09/16/inside-the-world-of-walmart-billionaire-alice-walton-americas-richest-art-collector (accessed 20 September 2013) .

8 Quotations from Crystal Bridges' wall texts recorded by the author 18, 19 May 2012.

9 Michelle Bradford. "Water Under the Bridge: Crystal Bridges Defies Critics, Wins Hearts". Museum 91, No. 4 , 2012, (July-August) : 32, describes the museum's recent advertising campaign in nine Midwestern and Southern metropolitan markets as follows: "geared to an upscale, better-educated audience, the ads (for the museum) appeared in the April issues of Elle Décor, Food and Wine, Forbes, Fortune, Real Simple and Town & Country."

10 Anna Mecugni. "American Identities: The Case of the Brooklyn Museum of Art". *The International Journal of the Humanities 3*, No. 11 , 2005—2006. 34-35

11 See Elizabeth Hutchinson's review of "American Identities," http://www.caareviews.org/reviews/527 (accessed 17 June, 2012) , for a fuller description of the galleries and the range of objects displayed.

12 The idea of juxtaposing these two paintings predates the opening of "American Identities." See Mecugni, p. 56.

13 See Karen Sherry. "The British are Coming" http://www.brooklynmuseum.org/community/blogosphere/2011/05/12/the-british-are-coming (accessed June 24, 2012) .

14 Hilton Kramer, "The Brooklyn Museum Gives Open House On Dumbing Down," The New York Observer (May17, 2004) , http://observer.com/2004/05/the-brooklyn-museum-gives-open-house-on-dumbing-down (accessed June25, 2012) . Kramer's article is an attack on director Lehman's regime overall, not on "American Identities" per se, but it is suggestive of how conservatives might view the installation.

15 Katherine E. Manthorne. "American Identities: A New Look". *Archives of American Art Journal 41*, nos 1-4 , 2001. 57

16 The controversial "West as America" exhibition (1991) along with the rise during the 1990s of identity politics are key aspects of the history leading up to "American Identities." For "The West as America," see Alan Wallach, "The Battle over 'The West as America,'" in Exhibiting Contradiction (Amherst, Mass.: University of Massachusetts Press, 1998) , pp. 105-117.

17 For details, see the excellent scholarly catalog published to coincide with the opening of the new American galleries: Elizabeth L. O'Leary, Sylvia Yount, et al. American Art at the Virginia Museum of Fine Arts. Richmond: Virginia Museum of Fine Arts in association with the University of Virginia Press, 2010.

18 Save for its period rooms, which date to the opening of the American Wing in 1924, the Metropolitan Museum displays painting and sculpture separately from furniture and other

decorative arts. See the museum's website, which provides a detailed map and photographs of the galleries (http://www.metmuseum.org/collections/galleries, accessed 25 June 2012).

19 All quotations from VMFA wall texts and labels were recorded by the author 13, 14 June 2012.

20 Both painting and photograph were acquired in 2011, perhaps with the idea that they could be exhibited side-by-side.

21 See Joseph D. Ketner. The Emergence of the African-American Artist: Robert S. Duncanson, 1821—1872. Columbia: University of Missouri Press, 1994; Anna O. Marley ed., Henry Ossawa Tanner. Modern Spirit. Berkeley: University of California Press, 2011. For Bannister, see Juanita Marie Holland. "'Co-Workers in the Kingdom of Culture': Edward Mitchell Bannister and the Boston Community of African American Artists, 1848—1901". unpubl. diss., Columbia University, 1998. The VMFA acquired Bannister's Moonlight Marine in 2009, apparently too late to be included in the collection catalogue (as in n. 17, above).

22 See Pierre Bourdieu and Alain Darbell. The Love of Art: European Museums and their Public. Stanford: Stanford University Press, 1990; originally published as L'amour de l'art (Paris: Éditions de Minuit, 1966). See also Alan Wallach. "Class Rites in the Age of the Blockbuster". In : James Collins ed., High-Pop. Oxford: Blackwell, 2002. 114-128. A demographic profile of "core" art museum visitors (those who are members or on museum mailing lists) reveals that more than 80% hold college or university degrees, and that overall, 50% hold post-graduate or higher degrees. See "Temples of Delight," The Economist (21 December 2013), p. 4.

23 See Wallach. "The Battle over 'The West as America'"; for additional information about the exhibition and the public's response, "The West As America Art Exhibition," Wikipedia, https://en.wikipedia.org/wiki/The_West_As_America_Art_Exhibition (accessed December 28, 2013).

24 See David Barstow. "Art, Money and Control: A Portrait of 'Sensation'," The New York Times, December 6, 1999); Lawrence Rothfield ed., Unsettling "Sensation": Arts-Policy Lessons from the Brooklyn Museum of Art Controversy. New Brunswick: Rutgers University Press, 2001; "Sensation (art exhibition)," Wikipedia, https://en.wikipedia.org/wiki/Sensation_%28art_exhibition%29 (accessed 28 December 2013).

Suggestions for Further Reading:

[1] Bourdieu Pierre. Distinction: A Social Critique of the Judgment of Taste. Translated by Richard Nice. Cambridge, Mass.: Harvard University Press, 1984.

[2] Bourdieu Pierre, Alain Darbell. The Love of Art: European Museums and their Public. Translated by Caroline Beattie and Nick Merriman. Stanford: Stanford University Press, 1990.

[3] Hutchinson Elizabeth. Review of "American Identities: A New Look." CAA Reviews (2003). Accessed June 17, 2012. doi:10.3202/caa.reviews.2003.34.

[4] Mecugni Anna. "American Identities: The Case of the Brooklyn Museum of Art." The International Journal of the Humanities 3, No. 11 (2005—2006): 34-35.

[5] O'Leary, Elizabeth L., et. American Art at the Virginia Museum of Fine Arts. Richmond: Virginia Museum of Fine Arts in association with the University of Virginia Press, 2010.

[6] Truettner, William H. et al. The West as America: Reinterpreting Images of the Frontier, 1820—1920. Washington, D.C.: Smithsonian Institution Press for the National Museum of American Art, 1991.

[7] Wallach Alan. Exhibiting Contradiction. Amherst, Mass.: University of Massachusetts Press, 1998.

[8] "The West As America Art Exhibition." In Wikipedia. Accessed January 8, 2013. https://en.wikipedia.org/wiki/The_West_As_America_Art_Exhibition .

军械库展览的启示
The Lessons of the Armory Show

安吉拉·米勒　李云　译
Angela Miller　Translator: Li Yun

　　1987 年，中国艺术家黄永砅把两本艺术史书投入洗衣机里，搅拌了两分钟。两本书，一本关于中国绘画，另一本关于欧洲现代绘画，在这一过程中破碎、溶解、交融在一起，变成了某种既非中国也非欧洲的东西。取出的文本损毁严重，难以辨读，任何一方都不能另作他用。黄永砅生动、直接地表明他的态度，文化交流与迁移的路径从来都不会光洁顺滑，各自不同的渊源会逐渐将文化原料转换成新的模样。这一观念作品是一则寓言，讲的是不同文化揣着各自独特的审美，揣着各自的形式传统与历史，在全面遭遇时所会经历的变化。然而，作品的调子似乎是悲观的，它告诉我们诸如中国之民族传统在与异质文化相接触时，会面临一种瓦解的压力，丧失自己在形式与文化上的整体性，其中相助的外力，作品中代以水和运动。相应的，现代主义一与民族传统相遇，也转变为别的东西，成了一堆零乱稀烂、不可方物的杂碎。在文章末尾，我会再回到这件作品，因为黄永砅指出的文化交流与迁移的结果是退化，这份悲观我不认同。若将文化迁移理解为一个积极的进程可能更为有益，迁移不是单纯被动地接受，而是对异质文化内容的主动重塑，是一种误读的形态。文化从一处迁移至另一处，接受一方的担忧、抵触以及趣味总是在深刻影响迁移的过程。

　　本文考察了 1913 年纽约军械库展览这个特定历史篇章，其中大规模的文化交流与迁移，正是近几十年里中国与西方艺术家所经历的。这一篇章，揭示了 20 世纪早期美国艺术家吸收欧洲现代主义翻新、激进的形式语言的某些方式。美国保守的现实主义与欧洲（以法国现代主义为主）非摹写的新艺术形态一相交汇，两种历史传统便全面接触、相互同化，尽管刚过去的 2013 年已是军械库展览的百周年纪念，其中的挑战与机遇仍不断在给我们启示。军械库展览是文化大事，影响深远，美国艺术家极大地拓展了视野，不得不面对欧洲现代主义的新式审美与多样表达，但影响与变化再广，仍是接受文化容忍的作为。可以说，接受文化给出了交流通道

In 1987 Chinese artist Huang Yong Ping took two books about art history—one on Chinese painting and the other on modern European painting—and put them through a washing machine for two minutes. In the process they crumbled and fused, melding together into something new, neither Chinese *nor* European. The resulting text is so mangled as to be illegible, and therefore impossible for either party to appropriate or exploit for its own uses. Huang Yong Ping's gesture exposes in a graphically direct manner the ways in which cultural exchange and transfer is never neat, but bears the traces of its multiple origins, generating the raw material for new forms. Ping's conceptual work stands as an allegory for the transformations that occur in the unfolding process of encounters between cultures with very distinct aesthetic, and formal traditions and histories. But Ping's work also seems pessimistic, suggesting as it does that national traditions such as the Chinese lose their formal and cultural integrity when they come into contact with the disintegrating influence of other cultures, aided by external forces, in this case water and motion. Modernism in turn is transformed into something else by its contact with national traditions, becoming a pulpy, degraded, and formless mass. I will return to this work at the end of my essay, for I do not share Ping's pessimism about the degradations that result from cultural exchange and transfer. It might help to think about cultural transfer as an *active* process, not simply an act of passive reception but a willed recasting of the content of other cultures, a form of *mistranslation*. Such acts of transfer from one culture to another are always deeply shaped by the concerns, the defenses, the driving interests of the receiving cultures.

This essay examines one specific historical episode of large-scale cultural exchange and transfer, parallel to that which has been going on now for several decades between Chinese artists and the West. This episode—the New York Armory Show of 1913—exposes some of the ways in which American artists in the early 20th century went about assimi-

的形状，一些新文化的形状可以通行，另一些则滤在了门外。在美国的这个例子里，军械库上的欧洲进步艺术穿行的通道非常独特，这正是本文所要讲的。我们可以看到，美国艺术家、批评家和收藏家对待现代艺术形式的用意不同。不少人把欧洲现代主义的外在特征看成某种流行风标，这是美国日渐兴旺的商业文化的重要品质，世俗程度可见一斑。也有艺术家多年来追随现代艺术，在这些新语言里，他们找到了实验、成长与走向文化繁荣的良机。

军械库展览正式名称为国际现代艺术展，1913 年在纽约市的 69 团军械库举办。美国公众、艺术家、批评家和收藏家第一次近距离地看到了当时最新的欧洲艺术。本是前卫现象的欧洲的现代主义，一夜间却在美国有了大量拥趸。军械库的参展名单很长，有印象主义、后印象主义的凡·高（Van Gogh）、高更（Paul Gauguin）、法国象征主义的奥迪隆·雷东（Odilon Redon），还有塞尚（Paul Cézanne），以及马蒂斯（Henri Matisse）领军的野兽派，毕加索（Pablo Picasso）与勃拉克（Georges Braque）则展出了他们最早的立体主义实践，名单最后还有马歇尔·杜尚（Marcel Duchamp）的《下楼梯的裸女》，它应该算是纽约展览上最臭名昭著的作品了。军械库展览共有1600 余件作品参展，多数是法国和美国的绘画，也混编进欧洲其他国家的一些作品。

这个大型展览原本是为游离在纽约官方国家设计学院之外的独立艺术家组织的。但是到了 1912 年，组委会信心暴涨，要大量引入欧洲现代主义。扩充之后，欧洲的 700 件作品就成了主角，很多人都为此不满，觉得扩容的展览将美国置于低欧洲一等的被殖民地地。

早些年有几次大型回顾展览，为军械库展览策划者们提供了经验，它们将现代主义的历史追溯至 19 世纪早期，从安格尔（Jean-Auguste-Dominique Ingres）、德拉克洛瓦（Eugène Delacroix），到柯罗（Jean-Baptiste-Camille Corot）、杜米埃（Honoré Daumier）、夏凡纳（Pierre Puvis de Chavannes）、雷诺阿（Pierre-Auguste Renoir）和莫奈（Claude Monet），再延至现代，展望未来。其中，影响卓著的有 1905 年伦敦的印象主义展览；及由批评家兼画家罗杰·弗莱（Roger Fry）策划，1910 年和 1912 年在伦敦连办两次的后印象主义展览；在德国科隆，则有 1912 年的分离主义联盟展。这些大事件都意在搬出历史依据，表明现代主义与前代大作一脉相承，是欧洲重要艺术传统之发展。[1] 有了这种以旧衬新的系统，现代主义就树立了血统正宗，调和了以学院为根基的历史传统与新艺术激进主义的关系。后来得证，这一对策极为紧要，使得现代艺术在艺术商、博物馆和收藏家间能够适销。[2] 军械库展的组织者之一，艺术家瓦尔特·库恩（Walt Kuhn）在分离主义联盟展开幕前夕抵

lating the radical new formal language of European modernism. The 100th anniversary of the Armory Show has just been celebrated in 2013, but it continues to offer a timely case study of the challenges and opportunities afforded by the broader process of exposure and assimilation that occurs at the meeting point of two distinct historical traditions—a conservative American realism and the new non-mimetic forms of European—mostly French—modernism. The impact of any major cultural event, like the Armory Show—which vastly expanded the understanding and exposure American artists had to these new aesthetic and expressive possibilities in European modernism—is only as broad or transformative as the receiving culture allows it to be. That receiving culture provides the shape of the gateway, so to speak, through which new cultural forms pass, as well as filtering those forms that do pass through. In the case of the United States, the advanced European art presented at the Armory Show entered through a very particular gateway, which forms the subject of this essay. We will see that modernist forms served very different purposes for American artists, critics, and collectors. Many appropriated the surface qualities of European modernism as a badge of the stylish and up-to-date, an important quality for the burgeoning new commercial culture of the US, and a measure of its worldliness. Other artists apprenticed themselves to modernism over a longer period, finding in the new languages an opportunity for experimentation, growth, and cultural enrichment.

Known officially as the International Exhibition of Modern Art, the Armory Show was staged in 1913 at the 69th Regimental Armory in New York City. For the first time, a broad American public, along with American artists, cri-tics, and collectors, were able to see at close range the most advanced European art of the present moment. In one leap European modernism went from being a vanguard phenomenon to finding a mass reception in the United States. The Armory Show brought together—among a long list of artists—works by the Impressionists and Post-Impressionists, Gauguin and Van Gogh, the French symbolist Odilon Redon, Cézanne, the Fauves, featuring Matisse in particular; and the earliest experiments in Cubism by Picasso and Braque, culminating in what may have been the most notorious work shown in New York: Marcel Duchamp's *Nude Descending*. The exhibition, which numbered over 1600 works, was dominated by French and American paintings, but contained a mixture of artists from other European countries.

Originally the American planners of the exhibition had meant to organize a large exhibition of American independents—that is, artists not associated with the official National Academy of Design in New York. But by 1912 the organizing committee had vastly enlarged their brief to

达了科隆，恰逢良机，考察了大量的现代艺术。随后的几周内，库恩与其同伴瓦尔特·帕克（Walter Pach）、阿瑟·B. 戴维斯（Arthur B. Davies）疾风迅雨般地了解到现代主义各式各样的实践，他们一路途径巴黎、慕尼黑、柏林、海牙，直到伦敦，参观了罗杰·弗莱在格拉夫顿画廊组织的第二次后印象主义展览。这趟旋风之旅之后，才过了几个月，为纽约展览选好的作品已经穿过大西洋，抵达纽约城。同时，组织者也租下了一个巨大的公共空间（图1），广邀美国艺术家参展，并公开向圈子之外的艺术家征集作品。

对研究文化迁移趋动力的史家而言，军械库展览提供了很多启示。当时的反应极其多元，有人对开启美国文化新纪元的承诺狂热不已，也有人扼腕美国艺术出生未久即遭镇压，为另一大陆涌来的艺术大潮扑灭。1913年，美国的经济与文化正迈着狂乱的扩张步伐，当时有作家写道："一个文明，粗野、璀璨、自私、友善、自觉、可亲，……一个国家，财富不尽，领土无垠，却没有传统。"[3] 在迈向20世纪新世界的关键转型时刻，美国的艺术家、批评家，还有普通公众对军械库的反应遵照的也是前几十年的路子，若概括出两方，一方是偏狭的地方主义，另一方则是开放的世界主义。

从1776年共和国成立，甚至更早的殖民地时期算起，美国艺术就可以大概归纳为这两方面：一端是对新生国家传统的固守态度；另一端则是较开放的文化世界主义态度。共和国膨胀的自信心驱策着美国艺术以国家为中心，封闭自己，对抗于自我身份的挑战，自信之余还有种严阵迎敌的意识。文化世界主义却恰相反，它将美国艺术放到更大的文化历史渊源中，回溯到文艺复兴，以那个时候艺术家的修养、品位和学识来要求自己，而不太在乎己方的地域渊源与国家渊源。在其看来，广博的跨国传统是可资模仿借鉴的无尽资源。世界主义就是

图1 俯视军械库展览现场，1913年，摄影：瓦尔特·库恩
Fig.1 Overhead view of the Armory Show, 1913. Photo: Walt Kuhn

include an ambitious range of European modernism. The newly expanded exhibition would feature 700 European works, provoking resentment from many who felt that the enlarged exhibition now positioned American art in an inferior or colonial relationship to European art.

The planners of the Armory Show looked for inspiration to a series of earlier large-scale retrospective exhibitions that placed modernism within a history going back to the early 19th century, from Ingres and Delacroix, to Corot, Daumier, Puvis, Renoir and Monet, and forward to the present and future. Influential exhibitions of this kind included the 1905 Impressionist show in London, two Post-Impressionist shows—also in London—organized by the critic and painter Roger Fry in 1910 and 1912, and the Sonderbund in Cologne Germany, in 1912. These massive events were all intended to use history *as argument*—that is, to show that modernism was in line with the most important art of the past, an extension of the vital traditions of European art.[1] Such a framing of the new in relation to the old helped to validate modernism by giving it an ancestry, reconciling historical traditions rooted in the academy with the radicalism of the new art. These strategies proved crucial in establishing the marketability of modern art among dealers, museums, and collectors.[2] Artist and co-organizer of the future Armory Show Walt Kuhn arrived in Cologne on the closing day of the Sonderbund exhibition, just in time to survey the full range of modernist art on view. Over the next few weeks, Kuhn and his collaborators Walter Pach and Arthur B. Davies had a whirlwind education into the varieties of modernist practice, stopping in Paris, Munich, Berlin, the Hague, and London, where they saw Second Post-Impressionism exhibition at Roger Fry's Grafton Gallery. Within a few months of their whirlwind tour the paintings they chose to include in their New York exhibition had been shipped across the Atlantic and arrived in New York City. The organizers also leased a large open public space （fig.1）, and issued invitations to a range of American artists to participate, along with an open call for submissions from others beyond this group.

The Armory Show carries many lessons for the historian interested in the dynamics of cultural transfer. The exhibition provoked a fascinatingly diverse set of responses, ranging from wild enthusiasm and excitement for a new phase of American culture that the show promised to open, to a despairing sense that a fledgling tradition of American art that had begun to take hold was being squashed—annihilated—by the massive influx of arts from another continent. The United States in 1913 was a culture and an economy undergoing a maddening pace of expansion; as one writer at the time described it—"a civilization crude, brilliant,

这样，让艺术家归认到西方丰富多彩的文化史中，不囿于民族国家的樊笼。

实际上，如若细察，自我封闭、以国家为中心的一方与世界主义、国际化的一方并不严格对立。18世纪以来，即使是美国民族情结最重的艺术家也都去欧洲求学过，要从事严肃的艺术创作，习得技法，了解欧洲艺术的历史文化至关重要，到后来仍是如此。但回过头来，到了20世纪，关于艺术身份的讨论仍跳不出这种二元对立的框架（一方忠于国家，另一方忠于欧洲人文主义艺术大潮），它影响了公众与专业批评对军械库展览的接受。

激进审美还与激进的政治有关，这使得争论愈加复杂。尽管有很多人努力将现代主义扎根在西方艺术传统中，但在较保守的学院成员、普通公众眼里，欧洲现代主义的实验艺术与炸药包，与无政府主义脱不了瓜葛。还有批评家怨毒地将新艺术归为恶习，归为文明道德的退化。[4]纽约公众是保守的，其审美还建立在忠于自然的艺术语言、文艺复兴以来的透视空间与以模仿为目的的艺术理解基础之上，突然闯至眼前的是一种标新立异、不知所云的艺术，色彩、形状、空间与自然毫无关联。新艺术甩开了任何令它摹写世界的要求。艺术家自己设定规则，形式形状可以放开探索，自由表达，汇成新的语言。在很多人眼里，这些审美实验不仅攻击了"事物本然"，还攻击支持这些规则的社会体制，攻击建立在"永恒之永恒"的自然规律常识之上的旧式权威，这是一场对文明生活既定法则的突袭。这种无政府主义与破坏性的语汇，在历史学家对军械库的理解中已经是根深蒂固的组成。

然而，有人把1913年的展览当成社会崩溃的凶兆，也定会有人把它看成社会革新与重生的信标。20世纪早期，投身新文化的男男女女得知自己的城市纽约能有一处新艺术的实验田，都是满怀期待的。军械库展览的律师、法律顾问约翰·奎恩（John Quinn）就知道文化的开放交流与创造力成长密切相关："生活即是成长……伦勃朗、透纳……马奈、莫奈等伟大艺术家已经告诉我们这个道理……成长也即是生活，停滞，不再成长，是艺术的大悲剧。"1913年，奎恩成功说服国会废除了1909年定下的艺术品进口关税，当时错误地相信封锁文化交流对本土艺术发展有益无害。关税立废的争论也告诉我们美国艺术成长发展的途径还远未有定论。[5]富有的梅布尔·道奇（Mabel Dodge）是艺术与文化赞助人，也是艺术家、作家、劳工运动组织者和文化激进分子的朋友与情人，她以狂喜的笔调写信给格特鲁德·斯坦（Gertrude Stein），认为军械库会掀起"一场暴乱、一场革命，之后的世界将焕然一新。"[6]几十年后，在20世纪中期，美国批评家哈罗德·劳森伯格（Harold

selfish, kind, self-conscious, amiable,. ..a country of boundless wealth and boundless space, without traditions."[3] In this moment of critical transition toward a new 20th century world, American artists, critics, and publics responded to the Armory Show in terms that recapitulate patterns of insularity and cosmopolitan openness that characterized previous decades.

Since the founding of the republic in 1776, and even before—during its colonial phase—American art had been defined around two poles: a self-defensive attitude toward emerging national traditions, and a more open attitude of cultural cosmopolitanism. Nation-centered concepts of American art turned inward toward the challenges of self-definition, driven by an expansive new pride in the republic. But such nation-centered approaches were also fed by an embattled feeling of national pride. Cultural cosmopolitanism by contrast defined American art as part of a much longer history of culture reaching back to the Renaissance, toward which artists of sophistication, taste, and learning would orient themselves, regardless of their provincial or national origins. This broad transnational tradition they saw as a rich resource to draw from and emulate. Art should not be tethered to national identity. Such cosmopolitanism allowed artists to define themselves as part of a rich and distinguished history of western culture, no longer limited by the narrow confines of the nation-state.

In practice, such tidy oppositions between inward-turning and nation-centered, on the one hand, and cosmopolitan and international on the other, break down as soon as one looks more closely. Even the most nationalistic artists working in the US had been traveling to Europe for training since the 18th century, and would continue to do so, acquiring the technical tools and knowledge of European art history and culture that were so essential to making serious art. Nonetheless, these polarized loyalties—to the nation and to the broader currents of humanist art produced in Europe and beyond—would continue to define the debate over artistic identity in the US well into the 20th century. These debates would cast their shadow over the public and critical reception of the Armory Show.

Further complicating these debates was the association that many drew between radical aesthetics and radical politics. Despite their efforts to anchor modernism within the traditions of western art, more conservative members of the academy and the public would link the experimental art of European modernism with bomb-throwing and anarchism. Other critics darkly linked the new art to vice, and to the decline of civilized morals.[4] An aesthetically conservative New York public still grounded in the language of truth to nature, Renaissance-inspired perspectival space, and art as

Rosenberg）提起1913年的展览也是眉飞色舞，把它与1917年圣彼得堡冬宫的无产阶级起义，与美国独立战争相提并论。他还认为，军械库提供了一个先例，合法化了新艺术，即激进的艺术，后来的美术馆主管和批评家无法再无动于衷了。这意味着震撼的艺术新作在一两代人的时间里会转化为经典或传统，即"新的传统"。[7]一旦在现代艺术版图中对号入座，颠覆性的气质随即得到驯服。

对随后几十年里走入了生涯关键期的艺术家与作家来说，军械库展览夯实了他们的信念，让他们坚信现代艺术是一股自由的革新力量，一股没有国界的力量。对那些相信革新是时势之必然的人而言，现代主义桀骜的创新能量则会将国家送入一个激动人心的新未来。1956年，批评家鲁迪·布莱什（Rudi Blesh）重新谈到了军械库展览，他说道："施蒂格利茨只将门挪开了一条缝，这个冲击波却直接把门铰链轰断了。美国融入了世界。"[8]开门的比喻也有其他人用，现代主义诗人威廉·卡洛斯·威廉斯（William Carlos Williams）的感受是："曾在某处开了一缺口，我们奔流而入……"，威廉斯为现代主义的新审美观唤醒，很多年后他在《自传》中说，杜尚的《下楼梯的裸女》惹得他大笑不已，但不是嘲笑，而是"欢乐、放松"的笑。[9]军械库展览在他看来是革新美国文学艺术旧世界的众多事件之一。他所说的缺口，既开在国家层面，也开在形式层面，让人从中窥见一整套艺术的新思维。"……我们中多数人都是艺术的初习者，这是无法掩盖的事实；雏鸟，当然无法和蒙马特的老手一争高下。"[10]尽管老手们对立体主义也是争得面红耳赤。于是威廉斯得出了结论，军械库展览在某种程度上就是一扇大门，通往全新的思维方式，只是他说的不是绘画，而是诗歌——他自己的创作媒介。对现代主义画作的观看启发了他的"诗行，借此图像落在了书页上……"[11]军械库的启示是大文化转向的一部分，美国作家约翰·多斯·帕索斯（John Dos Passos）称之为"文字思维"向"视觉思维"的转向，图像得以从教化内容中解脱出来，从旧的文化权威统治中解脱出来。[12]艺术本来还拴在自然主义上面，现代主义的新形式语言解开了这道绳索。查尔斯·席勒后来回忆，军械库让他知道艺术是一种独立的语言，可以不依据真实世界的标准来调校自己的语言；乔尔·施伯因干（Joel Springarn）谈起来更有热情："一开始我就觉得，艺术终于重归疯狂本质，现代画家、雕塑家夺得了别的艺术家都没有的勇者称号。"[13]博物馆主管劳埃德·古德里奇（Lloyd Goodrich）参观展览的时候还是个小孩，在他看来，展览揭开了"一个新的艺术世界，充盈着新鲜、强劲的活力，这种生机与欢愉，超越了任何我曾看过或感受过的东西"。[14]

mimesis found itself confronting wildly new and unfamiliar forms, in which color, shape, and space now had a purely arbitrary relationship to nature. The new art broke free from any requirement to resemble the world. Modernist artists now made their own rules, free to experiment with form and shape as a liberating new language of expression. Such aesthetic experimentation however was perceived by many as an attack not only on "things as they are" but on the very rules that supported social institutions and older forms of authority grounded in "timeless and eternal" commonsense natural laws—an assault on the established order of civilized life. This rhetoric of anarchy and disruption has become very much a part of how historians have come to understand the Armory Show.

But if the 1913 exhibition for some threatened social collapse, for others it promised social renewal and rebirth. The men and women associated with new forms of cultural expression in the early 20th century were thrilled at the prospect of a laboratory of the new art in their own city of New York. John Quinn, lawyer and publicist for the Armory Show, recognized the link between open cultural exchange and creative growth: "... life means growth ... shown in the work of the great artists, from Rembrandt to Turner,... Manet and Monet... Growth is life; stagnation, the failure to grow, is the great tragedy of art." Quinn had successfully lobbied Congress in 1913 to remove the 1909 tariff on imported works of art, created in the misplaced belief that closing off cultural exchange would help rather than hinder native developments. The debate over the tariff revealed a major disagreement about what American arts needed in order to grow and flourish.[5] The wealthy art and cultural patron Mabel Dodge—a friend and lover of artists, writers, labor organizers, and cultural radicals—wrote ecstatically to Gertrude Stein that the Armory Show would launch "a riot and a revolution and things will never be quite the same afterwards."[6] Decades later, in the mid-20th century, the American critic Harold Rosenberg—in a similar tone of exhilaration—compared 1913 to the storming of the Winter Palace by the Petrograd proletariat in 1917 as well as to the American Revolution. Rosenberg went on to argue that the Armory Show legitimized the new and apparently radical art by setting a precedent that later generations of museum directors and critics could not ignore. Its lesson was that shockingly new works of art would—within a generation or two—be assimilated into a canon or tradition —the 'tradition of the new.'[7] Their subversive character would soon be domesticated as they took their place within familiar landscape of modern art.

For these and other artists and writers who would go on to important careers in the following decades, the Armory

我们也应该知道，军械库展览在新一代的收藏家、艺术商和批评家的培育方面也起了重要作用。莉莉·布利斯（Lillie Bliss）就是收藏家的一个代表，她一人就买下了 26 件塞尚作品，同时还买了几件卢梭、凡·高、勃拉克和毕加索。后来她成了现代艺术博物馆的三位女性创始人之一，如今，这个博物馆已是世界上致力现代艺术中收藏最丰的。瓦尔特·库恩就说，没有军械库展览，就不可能有现代艺术博物馆。[15] 另一个 20 世纪早期的重要收藏家瓦尔特·阿伦斯伯格（Walter Arensberg）同样也饿极似地吃进军械库的作品，在这个过程里还磨砺了自己眼光。在展览之后，他们继续买进作品，逐渐成为现代艺术的主要赞助人。

对实验的开放态度是军械库展览的重要影响之一。然而，这一态度却未打入保守的美国文化，反而促成了一股对抗新艺术的反作用力。罗亚尔·科蒂索兹（Royal Cortissoz）就是当时保守一方的批评家，他为土生土长的本国艺术说话，措辞激烈。他认为，展览是"外国人发起的颠覆性运动，目的是要瓦解美国艺术"，又说，"现代主义绝对也是源于国外的异类，同样也将共和国的艺术置于危险境地。"[16] 画家杰尔姆·迈尔斯也表示了惋惜之情："我们把满地的机会拱手都让给了国外艺术，不加限制，还为此洋洋得意。"[17] "……我们的国家比以往任何时候都更像是殖民地；我们也比以往任何时候更像乡巴佬。"[18] 玛丽·范东·罗伯茨（Mary Fanton Roberts），笔名是贾尔斯·埃杰顿（Giles Edgerton），她认为"模仿的疫病还未除"，"模仿"成了习惯，意味着一种"甘心受精神奴役的品质……"[19] 在这个以欧洲标准衡量艺术价值的地方，罗伯茨为垃圾箱艺术家做的辩护极有说服力，垃圾箱是美国城市现实主义的第一个"本土"流派，笔触粗率随性，以新的多文化民主景观为题材，这些题材前代的优雅艺术从来都不用："男的在矿上工作，既勇莽，又忧心；孩子们都破衣烂衫，在城市广场上奔跑嬉闹，衣着粉艳的女郎，向东区咖啡馆里的男士飞着媚眼……一个乞丐跪求施舍，一手张开接受财物，一手紧握坚持罢工……深夜大雨，男子排在救济队伍里，满脸绝望，满眼凶光……"[20] 罗伯茨发现，20 世纪早期的城市现实主义是一种"孤立""乡土"和自主的国家艺术，它们从本国的民众、语言和生活方式出发，充分自信。沃尔特·惠特曼（Walt Whitman）是他们的灵感来源，正是由于这个 19 世纪的诗人，20 世纪早期的叛逆潮流落实在对本土艺术的追求上。当然，即使在为本土的现实主义者倾情辩护，罗伯茨也知道这些画家是在巴黎、慕尼黑接受的训练，他们的创作可以追溯到委拉斯贵支（Diego Velázquez）、弗朗兹·哈尔斯（Franz Hals）、戈雅（Francisco Goya）、杜米埃和其他前辈大师。再"本土"

Show vindicated the belief in modernist art as a liberating new force of change, a force that knew no national borders. For those who believed in the necessity of change, the unruly creative energies of modernism would send the nation hurtling into an exciting new future. Writing about the event later in 1956, the critic Rudi Blesh declared that "(Alfred) Stieglitz had opened the door an inch, this blast had blown it clear off its hinges. America had joined the world."[8] Continuing the metaphor of the open door, the modernist poet William Carlos Williams expressed his sense that "There had been a break somewhere, we were streaming through..." For Williams, awakening to the new aesthetics of modernism, Duchamp's *Nude Descending* provoked Williams' laughter, not in mockery but "happily, with relief," as he put it in his *Autobiography* many years later.[9] Williams conflated the Armory Show with a number of other events that promised renewal in the conservative world of American arts and letters. The break of which Williams spoke represented an opening of borders both national *and* formal, a glimpse into an entirely new way of thinking about art. "...most of us were beginners in matters of art, no matter how we might struggle to conceal the fact; bunglers, surely, unable to compete in knowledge with the sophisticates of Montmartre."[10] Yet, they argued for hours about Cubism. The Armory Show was one factor, Williams would conclude, in a broader opening into an entirely new way of thinking—not about painting in his case, but about *poetry*—his own chosen medium. Looking at modernist painting for Williams opened up ideas about "the poetic line, the way the image was to lie on the page..."[11] The lessons of the Armory Show were part of a broader cultural shift away from what the American writer John Dos Passos called "word-minded" to "eye-minded," a shift that liberated the image from its moorings in didactic content and in older forms of cultural authority.[12] Modernism offered a new formal language untethered to naturalism. Charles Sheeler recalled that the Armory Show taught him the lesson that art was an independent language no longer gauged by its relationship to the real world; Joel Springarn wrote rhapsodically, "I felt for the first time that art was recapturing its own essential madness at last, and that the modern painter-sculptor had won for himself a title of courage that was lacking in all the other fields of art."[13] For the museum director Lloyd Goodrich, the Armory Show—which he saw as a child—revealed "a whole new world of art, alive with a freshness, a direct physical power, a vitality and delight, beyond anything I had ever seen or felt."[14]

We should also note the important impact of the Armory Show in educating a new generation of collectors, dealers, and critics. Lillie Bliss was one of several such collectors, purchasing twenty six works by Cezanne alone,

的现实主义者，也身处在一个悠久的国际传统中。

在美国艺术的讨论中，有三分之一的人都拥护欧洲现代主义，问题是美国艺术家们犯险跃入了新潮大浪，发现却追赶不上。在科蒂索兹、埃杰顿等人看来，军械库展览意味着美国艺术的一次再殖民化。他们觉得美国艺术家试着跳上欧洲现代主义的游行花车，放弃了本土化运动的前景，国家再次落于被欧洲殖民的境地。艺术家斯图亚特·戴维斯（Stuart Davis）打了一个很阴暗的比方，把军械库展览比作"一次受虐式的宴请，餐馆里，欧洲的远客把天真的主人踩在脚下，百般蹂躏"[21]。这份悔恨，杰尔姆·梅尔奎斯特（Jerome Mellquist）同样也表露过，尽管总体上他还是持支持态度的："我们中的一些人也许动摇了，也许他们太想追随塞尚的野心，太想当小毕加索，还想画得比马蒂斯还亮堂。不管怎样，他们总归抛弃了旧秩序，而以一种新的秩序作画……"这是一种记录了"现代生活"[22]痕迹的秩序。

军械库展览的那些年里，还有一些法律与文化上的举措，支撑着这些信念，以驱散欧洲对美国文化的影响，其中有关税、反移民法上的举措，也有在言论上对标新立异之举的抵制。但这种文化保护主义的方式一开始就注定不能成功。现代主义放开艺术实验，才能激发出新的活力，美国的文化表达才能迈向未来。与欧洲的文化交流，于美国艺术传统的发展而言至关重要；没有了交流，技术与社会变迁的鲜活力量，国家正在现代化进程，文化中将没有同步的表现。

早在1900年，纽约的文化已极为多元，数百万新移民从南欧、东欧、俄国、亚洲蜂拥入城，与非洲的老移民毗邻而居。文化评论家兰道夫·伯恩（Randolph Bourne）在军械库展览几年之后这样说道："我们早就生活在世界主义的美国。现在需要的是对这新理想的清晰认识，哪里都需要。"[23] 要认识到世界主义的前景，就需打开国门，向世界开放。旅行是促进美国现代艺术发展的一支重要力量，旅途在外，文化交流不会受既定观念阻碍，也不会受到国内体制权威的麻痹。

在美国艺术发展中，任何时段几乎都有国际艺术的强势参与。没有国际背景，就不会有美国的国家艺术。在军械库展览前夕，这种国际背景来得更为真切，那个时候，美国艺术家在国际舞台上树立了名望，还有不少在巴黎沙龙上赢得大奖，他们行法国人之事，有时还胜于法国人。[24] 亨利·詹姆斯说过一句很出名的话："要找美国艺术，几乎只能去巴黎，终在巴黎之外找到了它，里面还是有很多巴黎的调调。"[25] 但是到了1910年，新一代艺术家又发现，欧洲有了激动人心的发展，他们又落到了边缘。那些年里，很多人都积极地跟进欧陆上那

along with works by Rousseau, Van Gogh, Braque, and Picasso. Bliss was one of three women who founded the Museum of Modern Art, now the largest collection in the world dedicated to modernism. Walt Kuhn declared that the Museum of Modern Art would never have been possible without the Armory Show.[15] Walter Arensberg—another important collector in these early decades of the 20th century, also hungrily consumed the Armory Show for its power to educate him in the new art. Each would buy works out if the show, and go on to become major patrons of modernist art.

One of the most important effects of the Armory Show was the permission it granted to experiment. Yet, such experimentation also unsettled the conservative wing of American culture, causing a backlash *against* the new art. The conservative critic Royal Cortissoz argued ferociously on behalf of a national art made by *native-born* artists. Cortissoz attacked the show as "a subversive movement on the part of aliens to disrupt American art." "Modernism," he continued, "is of precisely the same heterogeneous alien origin and is imperiling the republic of art in the same way."[16] The painter Jerome Myers lamented that "Our land of opportunity was thrown open to foreign art, unrestricted and triumphant."[17] "...more than ever before our great country had become a colony; more than ever before we had become provincials."[18] Mary Fanton Roberts, who wrote under the pen name of Giles Edgerton, attacked what she termed "the blight of imitation... still upon us," a habit of "mimicry" suggesting "a quality of cheerful mental slavery..."[19] In place of an art whose measure of value was European, Roberts launched an eloquent apology for the first "native" school of American urban realism, the so-called Ash Can artists whose slashing and spontaneous brushwork translated the energies of a new multicultural democracy into subjects that had been off limits to the refined art of the previous generation: "men at work in the mines, reckless and frightened; ragged children romping on city squares, tawdry women singing to leering men in East Side cafes... a beggar pleading for alms, with one hand open to receive and the other clenched to strike... men standing hopeless and sinister in the bread line on a rainy midnight..."[20] Roberts found in these early 20th century urban realists a national art that was proudly "insular," "provincial," and independent, drawn from the nation's people, language, and ways of life. This new American art took its inspiration from Walt Whitman, the 19th century poet to whom the insurgents of the early 1900s turned to validate the call for a native art. Yet Roberts' passionate defense of the native realists also acknowledged that these painters received their training in Paris and Munich, and traced their art back to Velasquez, Franz Hals, Goya, Daumier, and others. Even the 'native' realists were part of a longer interna-

些最大胆的实验艺术。哈罗德·劳森伯格等人后来都提到，很多先行一步的美国现代主义艺术家早在欧洲受过了教育，早于军械库展览，他们知晓巴黎艺术的最新进展，也能创作极具才华的作品。阿尔弗雷德·莫勒（Alfred Maurer）、莫里斯·普兰德加斯特（Maurice Prendergast）、马克斯·韦伯（Max Weber，图2）、约翰·马林以及马斯登·哈特利都是在欧洲走向成熟的，那是生涯中最重要的时期，通过独立沙龙，依凭格特鲁德·斯坦的关照，他们直接能接触到新艺术，格特鲁德是当时美国艺术家在巴黎民间的女主人。早在1906年，亚伯拉罕·瓦尔科维茨（Abraham Walkowitz）和摩根·拉塞尔（Morgan Russell）都置身在巴黎的现代主义艺术之中；帕德里克·亨利·布鲁斯（Patrick Henry Bruce）和斯坦顿·麦克唐纳德-赖特（Stanton Macdonald-Wright）则是在1907年。这些艺术家给予我们极有价值的启示，说明了持久的思想与艺术交流对新艺术的产生非常重要。韦伯决定不参加军械库展览，因他贪图再加展两件作品，却未能得愿。[26]

同时，那些待在国内的艺术家却有着另一番挣扎。他们忽然被亮在新艺术面前，自己的成果看起来要么文法不通，要么情理不合，像是在还牙牙学语，结结巴巴。面对新艺术，在思想与审美上，他们都缺乏确凿的上下文，像马尼耶尔·道森（Manierre Dawson，图3），做画家前是芝加哥的一个建筑师，还有阿瑟·戴维斯（Arthur Davies，图4），在遭遇现代主义之前是位杰出的符号学者，他们对艺术语言的理解没有时间纵深，因而创作出一些怪异的混合体。道森在1907年的时候就直觉地找到了抽象表达的道路，可能他在阿尔弗雷德·施蒂格利茨的《摄影作品》（1903—1917年）那里接触过一些欧洲现代主义作品，得到了启蒙。《摄影作品》的发行很广，并在1910年开始译介欧洲对现代主义的评论文章。此外，1910年6月，道森到欧洲旅行，去过格特鲁德·斯坦的居所，之后又参观了安布鲁瓦兹·沃拉尔（Ambroise Vollard）的画廊，看到了大师名作，也见到了塞尚的作品。在那里，他继续将塞尚的语言收归己用，转化成纯色平涂的适合图形，既像是拼图游戏，又有点像连线图表。同时，国内的资源与影响也成为道森师法塞尚的媒介，作为建筑系的学生，他可能对建筑装饰中的几何、抽象的处理，比如弗兰克·劳埃德·赖特（Frank Lloyd Wright）事务所的作品，早就有过熟悉。[27]道森还读过阿瑟·道（Arthur Dow）的重要著作，很多刚出道的现代主义者也都读过（包括更有名的乔治娅·奥基芙，也是到了生涯晚期才游历欧洲），道在《构图》（1899年）一书中说，在纸面或画布的二维平面上，组织形式需追随自己的设计法则，独立于再现自然的自然主义态度，这是当时最前沿的解释。当1913年的军械

tional tradition.

The problem was that in pitching American art within a forum one third of which was dedicated to European modernism, American artists risked exposing just how far behind they were in their embrace of the new trends. For Cortissoz, Edgerton, and others, the Armory Show represented a *recolonization* of American art. In their view, American artists trying to jump onto the bandwagon of European modernism betrayed the promise of a native movement, and placed the nation once again in a colonial relationship to Europe. The artist Stuart Davis, in a humorously dark image, compared the Armory Show to "a masochistic reception whereat the naïve hosts are trampled and stomped by the European guests at the buffet."[21] Jerome Mellquist had an equally rueful assessment, though it was framed within an overall endorsement of the event: "Perhaps some of our men faltered. Perhaps they too often sought to be ambitious Cezannes, or little Picassos, or brighter Matisses. Nevertheless, they painted according to a new order, not an old one..." an order that registered the impact of "modern life."[22]

In support of these beliefs, the years surrounding the Armory Show witnessed legal and cultural initiatives intended to stem the tide of European influence on American culture. These efforts included tariffs, anti-immigration laws, and angry rhetoric against the new and the strange. Yet such forms of cultural protectionism were doomed from the start. Modernism promised experimentation in the fine arts, and stimulated new energies that directed cultural expression in the United States toward the future. Cultural exchange with Europe was critical to the growth of an American tradition in the arts; without such exchange, US cultural expression would continue to be out of step with the dynamic new forces of technological, and social change that this modernizing nation was undergoing.

New York in 1900 was already profoundly multicultural, with millions of new arrivals from Southern and Eastern Europe, Russia, and Asia, alongside its older diaspora from Africa. As the cultural critic Randolph Bourne would put it a few years after the Armory Show, "Already we are living in this cosmopolitan America. What we need everywhere is a vivid consciousness of the new ideal."[23] To realize the promise of this new cosmopolitanism meant opening the nation to the world. A critical force encouraging the growth of a modern American art was travel, which offered a field on which cultural exchange could occur without the pressures of received ideas, and the paralyzing effect of institutional authority long in place at home.

Nearly every stage of American artistic development had been robustly engaged with international art. There would be no national art in the US without this internation-

图 2 马克斯·韦伯，《浴女》，1909 年，布面油画，14¹⁵/₁₆ × 18³/₁₆ 英寸（38×46 厘米），巴尔的摩美术馆，考恩藏品，由加利贝尔·考恩博士和埃塔·考恩女士组织，马里兰州，巴尔的摩美术馆，1950.309。

Fig.2 Max Weber, *Bathers,* 1909, oil on canvas, 14¹⁵/₁₆×18³/₁₆in. Baltimore Museum of Art, The Cone Collection, formed by Dr. Claribel Cone and Miss Etta Cone of Baltimore, Maryland, BMA 1950.309

图 3 马尼耶尔·道森，《窗边人物》，1915 年，布面油画，伊利诺伊州立博物馆收藏，摄影：道·卡尔，伊利诺伊州立美术馆。

Fig.3 Manierre Dawson, *Figure by a Window,* 1915, oil on canvas. Collection of the Illinois State Museum. Photo: Doug Carr, Illinois State Museum

库巡展到芝加哥，道森接触了更多样的现代艺术风格，他刚成型的这种地域性现代主义就变复杂了。展览上，他看到了马蒂斯和康定斯基的画作，这个年轻艺术家为此激动万分："我太兴奋了。一直以来，我都以为自己

alism. And never was this internationalism of American art more true than in the decades immediately preceding the Armory Show, when American artists were establishing themselves on the international stage, winning prizes by the dozens at the Paris Salon, and doing what the French did—in some instances—better than the French themselves.[24] As Henry James famously put it, "When we look for American art we find it mostly in Paris, and when we find it outside of Paris we find a lot of Paris in it."[25] But by 1910 a younger generation of artists would find themselves once again on the periphery of the most exciting major developments in Europe. Many in these years would energetically pursue knowledge of the boldest and most experimental art being produced on the continent. As Harold Rosenberg among others later noted, many of the leading modernist American artists in these years had already had an education on site in Europe in the years directly prior to the Armory Show, and were producing highly accomplished works informed by the most advanced art of Paris. Alfred Maurer; Maurice Prendergast, Max Weber （fig.2）, John Marin, and Marsden Hartley all found their most significant formation in Europe, gaining exposure to the new art directly, through the Salon des Independents, and through the services of Gertrude Stein, the unofficial hostess of American artists in Paris. Abraham Walkowitz and Morgan Russell were both exposed to French modernism in Paris as early as 1906; Patrick Henry Bruce and Stanton Macdonald-Wright, by 1907. These artists offered a valuable lesson in the impact of sustained intellectual and artistic exchange on the emergence of significant new art. Weber chose not to be included in the Armory Show because he wanted more than two works by him to be included.[26]

Those who stayed at home, however, had a different kind of struggle. Exposed suddenly to the new art, their efforts often appeared awkward and ungrammatical, like the phonetic stutterings of a person trying to learn a language by imitating sounds. Confronting the new art with little defining context—intellectual or aesthetic—artists such as Chicago architect turned painter Manierre Dawson （fig.3）, and Arthur Davies （fig.4）—an accomplished Symbolist before his encounter with modernism—flattened out, and schematized, the elements of the language they were seeking to understand, creating strange hybrids. Dawson had intuitively found his way toward an abstract idiom beginning in 1907; he may have had some preliminary exposure to European modernism through Alfred Stieglitz's *Camera Work* （1903—1917）, a journal that circulated broadly, and which began in 1910 to reproduce European articles on modernism. A trip to Europe in June of 1910 exposed Dawson to Old Master work as well as to Cézanne, first at the

过于出格，多少次克制，为的就是不疯掉；但现在在艺术中心〈芝加哥艺术中心，军械库巡展的举办地〉，很多艺术家都显出了自己对学院极富创造性的叛离。"[28] 与欧洲现代主义的接触，并没有全然改变道森的绘画之路，尽管在1913年之后，他的作品实验性更强了，色彩跨度、风格跨度都很大，一会儿是平涂色彩的锯齿状构成，一会儿又实验阴影与立体主义的"管道"——尝试不同的块面结构。他早期的程式——接触的欧洲艺术相对有限——是一种非常个人化的现代主义方言，从未被美国的艺术经典吸收，却给了我们一个十分有趣的启示，用来考虑文化转译的受益与挑战。[29]

其他的艺术家，看过军械库之后也尝试了多样的现代主义风格，在他们看来，现代主义就是一路表面功夫，套在本质上还基本保守的具象艺术外面。军械库展览的核心策划者之一阿瑟·B.戴维斯（Arthur B. Davies）可能就是一个极端的例子。哈罗德·劳森伯格这样形容戴维斯，"如果只有一个审美国际主义者的话，非他莫属。"[30] 杰尔姆·梅尔奎斯特夸得克制一些，他说戴维斯是"披上彩衣，终成现代"[31] 戴维斯的画作《舞者》（图4）完成于军械库展览的后一年，即1914年，画面色彩斑斓，用色依循野兽派，既抒情又有些程式化。画中人物摆动跳跃，让人想起国际舞星伊莎多拉·邓肯（Isadora Duncan），也有些像马蒂斯1909年至1910年间的作品《舞蹈》。在军械库展出的是他为这个巨幅壁画所作的习稿，语言平面化、装饰化。但作为追随法国现代主义（尤其是马蒂斯）的习作，戴维斯的《舞者》看起来也有些机械、呆板。另一些艺术家受到军械库展览感召，也一路追仿，瓦尔特·帕克把他们称为"小德兰、小毕加索、小塞尚"，要么就是"学院化的后印象主义和立体主义"。靠着攀附现代主义，这些艺术家在经济上获得了一些成功，但在帕克话里，他们明显是在"投机取巧"、"掩饰空虚"。[32]

对学院一系的艺术家而言，比如利昂·克罗尔（Leon

apartment of Gertrude Stein, and then at the gallery of Ambroise Vollard. Dawson would go on to translate Cézanne's influence into his own idiom of relatively flat, unmodulated color planes fitted together like jigsaw pieces, as well as diagrammatic shapes traced in lines. Dawson's apprenticeship to Cézanne, however, was mediated by sources and influences closer to home; as a student of architecture, he would have been familiar with the geometricized and abstracting approach taken in architectural decoration by the office of Frank Lloyd Wright, as one example.[27] Like many emerging modernists in these years, including the better-known Georgia O'Keeffe, who also did not travel to Europe until much later in her career, Dawson had exposure to the important work of Arthur Dow （1857—1922）, whose book *Composition* （1899） first introduced the idea that forms organized on the two-dimensional plane of the paper or the canvas followed their own rules of design independent of the need for naturalistic representation of nature. Dawson's emerging regional modernism was further complicated by his fuller exposure to a range of modernist styles at the Armory Show in 1913, when it travelled to Chicago. This experience was profoundly stimulating for the young artist—exposing him to Matisse and Kandinsky: "I am feeling elated. I had thought of myself as an anomaly and had to defend myself, many times, as not crazy; and here now at the Art Institute many artists are presented showing these very inventive departures from the academies."[28] Dawson's encounter with European modernism did not substantially change his way of painting, although after 1913, his paintings became more broadly experimental, shifting among several styles and palettes, and alternating between jagged linear compositions of flat color and experiments with shading and Cubist "passage"—the modulation between the planar structures of the painting. His early formation—punctuated as it was by limited exposure to European art—produced a highly idiosyncratic personal dialect of modernism, never assimilated into the American

图4　阿瑟·B.戴维斯，《舞者》，1914—1915年，布面油画，底特律艺术学院藏，由拉尔夫·哈曼·布斯捐赠，摄影：布里奇曼艺术图书馆。
Fig.4　Arthur B. Davies, *Dancers*, 1914—1915, oil on canvas. Detroit Institute of Arts, gift of Ralph Harman Booth. Photo: Bridgeman Art Library

Kroll），展后几年只吸取了某些法国现代主义的特殊要素，实质上没有多少变化（图5）。在国家学院他一直延续着自己的成功生涯。展览时他29岁，正是艺术风格成型的关键期，他旁征博引地折中出一种风格，既有雷诺阿的轻快调子，又有凡·高式的饱和色彩，但明显根子还是学院风格的肖像，他把现代主义者考虑的抽象体块，以及图案化的平面和轮廓处理得平易温和，让多数人能够接受。这一发展可看成某种中庸的现代主义——中产阶级的真实口味还没能适应高度现代主义的形式要求，于是就有了一种润饰得较为传统的现代主义。不少观众都热心于书本、艺术、音乐及观念，却还不能理解当前艺术的激进挑战，中庸的现代主义提供了一个跟进的切入点。

观众与收藏家使得现代主义逐渐变成了某种最新最热的时髦，在美国艺术家习得的风格样式与审美趣味的过程中，这是个重要因素。随着奢侈品消费市场日渐壮大，美国的艺术家们发现，要吸引收藏家和批评家的注目，需得和欧洲现代主义们一较高下。而要增添新颖、时尚的附加值，简单的做法就是用些现代主义式色彩，只在形式上做一些变形，比如要借鉴立体主义，通常都不会做深入的分析理解。多数美国人对欧洲现代主义的接受都是做做表面文章，从一开始就如此，以显示自己对欧洲艺术的新潮流了若指掌，但都浅尝辄止，不会持续忠于某种风格。像戴维斯那样的艺术家投诚于现代风格后，通常都会筛掉审美上激进的形式实验，留下平面化的装饰语言，这都基于对立体主义、野兽派等艺术运动的不完全理解。

反过来，这些元素又让他们能从容跻身奢侈时尚与高档商品的新兴市场（图6）。因而我认为，美国文化对现代主义最广泛的吸收，是在商业、时尚和设计层面。[33]

canon but offering an interesting lesson in the rewards and challenges of translation.[29]

For other artists who experimented with a range of modernist styles after their exposure to the new art at the Armory Show, modernism represented a series of surface gestures superimposed onto what was essentially a still largely conservative figural art. Arthur B. Davies—who had played a central role in planning the Armory Show—is perhaps the most extreme example of this. Harold Rosenberg described Davies as "an aesthetic internationalist if there ever was one."[30] Jerome Mellquist was not so generous, calling Davies an artist who "would put on a colored cloak so as to be a modern."[31] Davies' painting *Dancers* （fig.4）, completed a year after the Armory Show, in 1914, is a harlequinesque paint-by-numbers work that melds vaguely fauvist color into a sentimental and formulaic work. The swaying and leaping figures recall not only the international dance star Isadora Duncan, but also Matisse's *Dance* of 1909-10. The work exhibited at the Armory show was actually intended as a study for a large-scale mural, which may explain its flat decorative language. But as an effort to process the lessons of French modernism （Matisse in particular）, Davies' *Dancers* seems mechanical and stilted. Other artists in the wake of the Armory Show pursued the path of imitation, becoming "little Derains, Picassos or Cezannes," or "academic Post-Impressionists and Cubists," as Walter Pach referred to them. Such artists, even as they achieved some financial success by profiting from a superficial association with modernism, nonetheless had clearly taken "the easiest way" and learned 'to disguise their emptiness,' in Pach's cutting phrase.[32]

Other American artists of a more academic bent—such as Leon Kroll—adopted specific features of French modern-

图5　利昂·克罗尔，《夏天》，1931年，布面油画，59×76英寸（150×193厘米），史密森尼美国艺术博物馆：基尼维尔维·L.克罗尔遗赠，1988年4月。

Fig.5　Leon Kroll, *Summer*, 1931, oil on canvas, 59×76in. Smithsonian American Art Museum: Bequest of Genevieve L. Kroll, 1988.4.

军械库展览后的几个月里，"新风格"开始频繁出现在广告、时尚、百货和产品设计中。对美国人的衣食住行而言，现代主义的实验没有太多深意，只是种现代的面貌而已，抽丝剥茧之后只留下最基本的要素：野兽派的任意色彩成了一种独立元素，不再用来表现形状；加之以碎片化、几何化的构图及压缩的形体。形状也与精确刻画越行越远，走向平面，走向几何。"立体主义"、"未来主义"和"现代主义"迅速成为居家日用的词汇，可用来形容多种商品与风格，从立体主义连衣裙、礼服，到"立体主义褶皱"、立体主义发型。时尚潮女把头发染得蓝一块紫一块，皮肤做成黄一块绿一块，竞仿野兽派的用色。1913年之后没只多久，在《每日女装》等刊物上就有专文评述立体主义艺术的影响。从这些商业和时尚渠道可经常感受到，欧洲现代主义的革新形式完全渗透到了普通美国人的意识中。[34]

在这个方面，较之审美和艺术上的革命，军械库展览可能更像是一场消费革命。纯艺术融入了奢侈品的新兴市场，通过与"新"及前卫的结合，双方都赢得了更多关注。"新"的展示至关重要，可以开拓市场，扩充买家，同时也能刺激创新，那是资本主义发展的引擎。展览才过了数月，欧洲现代主义的商业化就已经开始了。1913年5月，由金贝尔百货资助，在密尔沃基举办了欧

图6 《每日女装》插图，1913 年 2 月 14 日。
Fig.6 Illustration from *Women's Wear Daily, February 14, 1913*

ism without substantially altering the fundamental character of their art in the following years （fig.5）. Kroll, who would go onto a career as a successful member of the National Academy, was twenty nine at the time of the Armory Show. During these formative years he absorbed an eclectic range of styles, blending the suavity of Renoir with the saturated colors of Van Gogh in a pleasingly recognizable style of academic portraiture and studio works that introduced modernist concerns gently to a broader public through a new studied awareness of abstract volume, patterned flatness, and silhouette. This development may be identified as a form of *middlebrow* modernism—a modernism adapted to the more conventional if earnest tastes of a middle-class public not quite ready for the formal demands and rigors of high modernism. Middlebrow modernism offered an entry point into new developments for audiences who were serious about books, art, music, and ideas, but who were not prepared to understand the most challenging advanced art of the present moment.

A major factor in how American artists processed the stylistic and aesthetic lessons of modernism was the emerging association that audiences and collectors drew between modernism, the new, and the fashionably up-to-date. In the expanding commercial world of luxury consumption, American artists found themselves in competition with European modernism in an effort to capture the attention of collectors and critics. The desire to engage the surplus value of the new and fashionable was easily served by a superficial adaptation of modernist color and formal distortion, an adaptation that often fell short of a deeper analytic understanding of such movements as Cubism. The mass American reception of European modernism was, almost from the start, a matter of surface gestures that announced familiarity with the new currents of European art, but stopped short of a full-fledged or sustained commitment to working within these styles. When artists such as Davies turned to modernism, it was often in a form that drained away the more aesthetically challenging formal experimentation in favor of a flattened decorative language based on an incomplete understanding of such movements as Cubism and Fauvism.

These elements in turn lent themselves easily to assimilation into an emerging market for luxury fashion and high-end consumer goods （fig.6）. The broadest assimilation of modernism into American culture, I would argue, thus happened at the level of commerce, fashion, and design.[33] Within months of the closing of the Armory Show, the elements of the "new style" would begin to appear in advertising and fashion, department stores, and product design. In many areas of American life, what would come to substitute for the more complex understanding of modernist experi-

洲立体主义的小型展览,后来还巡回到克利夫兰、匹兹堡、纽约和费城。[35] 瓦尔特·帕克在他的回忆录里说,军械库展览"成了一个社会事件"[36]。他接着又评论了现代艺术的商业化:"……我们为艺术商打开了一门新生计。尽管还需要一段时间,但他们觉得现代艺术会生存下来,而且一旦市场准备完全了,里面会有钱。后来,这个市场的热度堪比华尔街,价格起起伏伏,时而激增,时而滑坡,反复无常就像那证券一样。"[37] 帕克很看不起这些面子上做新艺术文章的艺术家,认为他们与历史上那些模仿真正的创新者,后却遭人遗忘的艺术家是一样的:"他们原来也是小英尼斯,或是小萨金特,因而没什么分别。"但在商业化之外,在那些阉割了伟大艺术的创造力的艺术家之外,帕克对那些"……血管里一直纯然流淌着创造血液,继续自己巅峰生涯的伟人……"还是赞赏有加。他总结道:"这就是最杰出的宣传。"[38]

最后还有一批艺术家,在他们身上可看到军械库展览最深远的影响。对斯图亚特·戴维斯而言,很多年后还处在这种影响之下,但在1913年时反映最为显著,军械库上的欧洲现代主义一下让他领悟到之前运用的自然主义语言的不足。戴维斯后来回忆,在军械库生机盎然的画作之前,他意识到这是种"自由体验"[39]。"在展览上我十分激动,尤其在高更、凡·高和马蒂斯跟前,因为对形的概括,对色非模仿的运用,在我原本早就都实践过。"[40] 戴维斯对现代主义综合、微妙的吸收是美国现代主义走向成熟的一个阶段[41]。他是一个鲜活的实例,从中可见这些艺术家接触军械库上新艺术之后的深刻转变。早年,他是城市现实主义的青年军(图7),经历军械库的顿悟后,当起了后印象主义的学徒,学高更和凡·高(图8),后又转向立体主义,从而迈入了盛期,他的一系列作品都可以归入美国现代主义艺术最独创、最杰出的行列(图9)。学习欧洲新艺术的过程迟缓且持久,经历了近二十年。

在1913年军械库展览这一丰沃的文化篇章中,要总结艺术交流与转移复杂多样的特质,我还想回到黄永砯的作品。鉴于上述的启示,我们也许可以将两部书搅和成纸浆的过程看作利好,而非是退化,新的文化形态会从中诞生,即便眼前没有,经历一段文化与审美的变质过程,终究会出现。在此过程中,新锐人物们会冲破物质与政治的束缚、边界及税费壁垒,就像过去最伟大的艺术家与作家做过的那样:打下一口深井,从历史、文化记忆以及不同时代的审美语言中汲取资源,汇集可及的一切,为我所用,为当前的一刻所用。在1938年,军械库展览25周年庆的时候,展览的组织者之一瓦尔特·帕克总结道:"……要创造伟大,其中因素难以预料,我们所能做的就是把环境,把工具打理得更好些……"[42]

mentation was the *look* of the modern, stripped down to its most basic signifiers: arbitrary or fauvist color functioning as a distinct element rather than serving its older purpose of describing form; fragmented and asymmetrical composition, telescoped forms. Forms in turn would move away from precise delineation, pushed toward greater flatness and geometric precision. Such terms as "Cubistic," "futuristic," and "modernistic" quickly emerged as household words, applied to a range of consumer goods and styles, from cubist frocks and gowns, to "New Cubist Drapes" to cubist haircuts. Fashionable women dyed their hair blue and violet, and tinted their complexions with orange and green, in emulation of Fauvist colors, while editorials on the impact of the new Cubist art appeared in *Women's Wear Daily* and elsewhere soon after 1913. It was frequently through such commercial and fashion avenues that the revolutionary new forms of European modernism would fully enter the awareness of ordinary Americans.[34]

In this respect, the Armory Show was perhaps less an aesthetic and artistic revolution than a consumer revolution that bound the fine arts to emerging markets for luxury products, each acquiring a new and expanded appeal through association with the "new" and the vanguard. Exhibiting the new was a crucial part of the expansion of the market to accommodate a wider range of buyers, as well as to fuel innovation, the very engine of capitalist growth. Within months of the closing of the show itself, the process of commercializing European modernism had already begun. Smaller exhibitions of cubist works from Europe were already being sponsored by department stores such as Gimbel's by May 1913, opening in Milwaukee, then touring to Cleveland, Pittsburgh, New York, and Philadelphia.[35] Walter Pach noted in his memoirs that the Armory Show "became a society event."[36] Pach continued to comment on this new commercialization of modern art: "...we opened up a new business for the dealers. It took time, but they saw that modern art had come to stay, and that there was money in it, once the market was thoroughly prepared. Later on, it became as active a market as that of Wall Street, with fluctuations of price, boostings, and shrinkages quite like those of the things so whimsically called securities."[37] Pach wrote dismissively of artists who merely imitated the surface qualities of the new art, linking them to past and forgotten artists who had imitated the true innovators: "But they would have been just little Innesses or Sargents otherwise, so it made no difference." Despite the commercialization of art—those artists who scavenged the creative energies of the great figures of art—Pach wrote admiringly of those creative juices that continued to "flow healthily in the veins of the great men, those who survive and continue with the art of

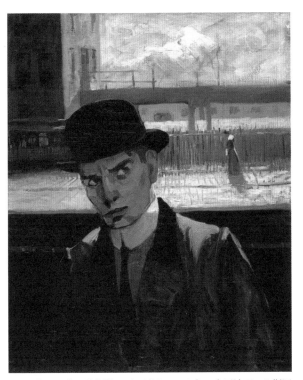

图 7 斯图亚特·戴维斯，《自画像》，1912 年，布面油画，© 斯图亚特·戴维斯艺术财产，VAGA 授权，纽约，纽约州。

Fig.7 Stuart Davis, *Self-Portrait,* 1912, oil on canvas, Art © Estate of Stuart Davis/ Licensed by VAGA, New York, NY.

图 8 斯图亚特·戴维斯，《男子肖像》，1914 年，布面油画，30×23³/₄ 英寸（76×60 厘米），柯蒂斯画廊，明尼阿波利斯，明尼苏达州。

Fig.8 Stuart Davis, *Portrait of a Man,* 1914, oil on canvas, 30×23³/₄ in. （76×60cm）. Curtis Galleries, Minneapolis, MN.

their prime..." That, he concluded, "is the most wonderful of advertisements."[38]

One final group of artists reveal the more profound lessons of the Armory Show. For Stuart Davis, these lessons unfolded over a number of years, but they began most fully in 1913 when the European modernism he saw at the Armory Show revealed to him the limitations of the earlier language of naturalism within which he had worked. Davis would recall his reaction to the Armory Show as "an experience of Freedom," demonstrated to him by the range and vibrantly creative paintings on display.[39] "I was enormously excited by the show, and responded particularly to Gauguin, van Gogh, and Matisse, because broad generalizations of form and the non-imitative use of color were already practices within my own experience."[40] Davis's complex and nuanced assimilation of modernism was one phase of an evolving and maturing American modernism.[41] He offers a dramatic instance of the depth of transformation for certain artists exposed to the new art of Europe at the Armory Show. Beginning his career as a youthful practitioner of urban realism （fig.7）, he would—in the wake of the Armory Show—apprentice himself first to Post-Impressionism, especially that of Gauguin and Van Gogh （fig.8）, and then to Cubism, culminating in a series of paintings that remain among the most original and engaging works of American modernism ever produced （fig.9）. This slow and sustained apprenticeship to the new art of Europe however occurred over nearly two decades.

In concluding this reflection on the mixed and varied nature of artistic exchange and translation through the rich cultural episode of the 1913 Armory Show, let me return to Huang Yong Ping's work, in light of these lessons. Perhaps we can now see the two books washed together into a formless wood pulp not as degraded but as a new form of enriched matter out of which new cultural forms might now arise, forms that do not immediately take shape but emerge over time through a process of cultural and aesthetic transubstantiation. This is a process whereby creative figures –unencumbered by physical and political restrictions, borders, and tariffs—may do what the most significant artists and writers have always done: that is, draw from the deep wells of history, cultural memory, and older and newer aesthetic languages, in order to engage their own moment with the fullest range of resources available to them. Writing on the 25th anniversary of the Armory Show, in 1938, co-organizer Walter Pach's conclusion is measured and wise: "...the ingredients for producing greatness are beyond the imagination; all we can do is to furnish better surroundings and tools..."[42]

图 9 斯图亚特·戴维斯，《抽象》，1937 年，水彩与水粉，17⅞×23⅜英寸(45×59厘米)，史密森尼美国艺术博物馆，华盛顿特区。

Fig.9 Stuart Davis, *Abstraction, 1937*, watercolor and gouache on paper, 17⅞×23⅜ in. (45×59cm) . Smithsonian American Art Museum, Washington D.C.

© 1995 Smithsonian Institution; Courtesy National Museum of American Art

Notes:

1 Robert Jensen. *Marketing Modernism in Fin-de-Siecle Europe*. Princeton, NJ: Princeton University Press, 1994.

2 Rudi Blesh. *Modern Art USA: Men, Rebellion, Conquest, 1900—1956*. New York: Alfred A. Knopf, 1956.47.

3 Giles Edgerton. "The Younger American Painters: Are They Creating a National Art?". *The Craftsman*，1908（2）：512.

4 Russell Lynes. *The Tastemakers*. New York: Grosset and Dunlap: The Universal Library, 1949. 219.

5 John Quinn. *Arts and Decoration*，1913（3）. In：Jerome Mellquist. "The Armory Show 30 Years Later", 1943（12）：301.

6 Steven Watson. *Strange Bedfellows: The First American Avant-Garde*. New York: Abbeville Press, 1991.172.

7 Rosenberg. "The Armory Show: Revolution Re-enacted". *The Anxious Object: Art Today and its Audiences*. New York: Collier Books, 1964.187.

8 Blesh. *Modern Art USA* 58.

9 William Carlos Williams. *The Autobiography of William Carlos Williams*. New York: New Directions, 1948.134.

10 Williams. *The Autobiography*. 137.

11 Williams. *The Autobiography*. 138.

12 Susan Hegemann. "A 'Wordminded People' Encounters the Armory Show". In：Marilyn Satin Kushner，Kimberly Orcutt. *The Armory Show at 100：Modernism and Revolution*. New York: New-York Historical Society, 2013.155-165.

13 Lynes. *The Tastemakers*. 207.

14 Barbara Haskell. "The Legacy of the Armory Show: Fiasco or Transformation?". *The Armory Show at 100*. 408.

15 Blesh. *Modern Art USA*, p. 67. See also Rosenberg,...

16 Lynes. *The Tastemakers*, p. 207.

17 Blesh. *Modern Art USA,* p. 64.

18 Myers. *Artist in Manhattan*（1940）；In：Virginia Mecklenberg. "Slouching Toward Modernism: American Art at the Armory Show". *The Armory Show at 100*, p. 244.

19 Edgerton. "The Younger American Painters," pp. 512-532; quote on，p. 512.

20 Edgerton. "The Younger American Painters,", pp. 521-522.

21 Bruce Altshuler. *The Avant-Garde in Exhibition: New Art in the 20ᵗʰ Century*（New York: Harry N. Abrams, Inc., 1994），p. 69.

22 Mellquist. "The Armory Show 30 Years Later"

23 Randolph Bourne. "Trans-national America" first published in *The Atlantic Monthly*（July 1916）. *The Radical Will: Selected Writings, 1911—1918*（New York: Urizen, 1977），pp. 263-264. http://www.swarthmore.edu/SocSci/rbannis1/AIH19th/Bourne.html

24 Lois Marie Fink. *American Art at the Nineteenth-Century Paris Salons*. National Museum of American Art, in conjunction with Cambridge University Press, 1990.

25 James. in *The Painter's Eye: Notes and Essays on the Pictorial Arts*（Cambridge, MA: Harvard University Press, 1956），p. 216; first published in *Harper's Magazine*（October 1887）.

26 Milton Brown. *The Story of the Armory Show*,（1963; 2ⁿᵈ ed. New York: Abbeville Press, 1988），p. 148.

27 Randy J. Ploog. "The First American Abstractionist: Manierre Dawson and His Sources" In: *Manierre Dawson: American Pioneer of Abstract Art*（New York City: Hollis Taggart Galleries, 1999），p. 64.

28 Henry Adams. "Manierre Dawson, 1887—1969" In *Manierre Dawson*, p. 39.

29 Mark H. Bessire. Mary Jo Peer, *Manierre Dawson: Early Abstractionist*. New York: Whitney Museum of American Art, 1988; and *Manierre Dawson* ,1999. See also Susan Ann Prince, ed., *The Old Guard and the Avant-Garde*. Chicago: University of Chicago Press, 1990; and Judith Barter. "'The Great Confusion': The Armory Show in Chicago". *The Armory*

Show at 100. 363-373.

In an interesting related episode, the Spanish artist Amadeo de Souza-Cardoso's painting of a walled town in Spain was also included in the Armory Show, and was later purchased by Dawson out of the Armory Show, perhaps identifying with both his struggles to make Cubism serve his own needs as a Spanish artist.

Cardoso, however—unlike Dawson—lived and worked in Paris during the crucial years of his formation.

30 Rosenberg. "The Armory Show". 188.

31 Mellquist. "The Armory Show 30 Years Later". 1943（12）. 298-301.

32 Walter Pach. *Queer Thing, Painting: Forty Years in the World of Art*. New York and London: Harper and Bros., 1938. 201.

33 George Cram Cook's 1915 short play about the Armory Show was titled in an unwittingly revealing way, "Change your Style." It is reproduced in Adele Heller and Lois Rudnick.*1915: The Cultural Moment*. New Brunswick, NJ: Rutgers University Press, 1991. 292-99.

34 For these details, I am indebted here to the ongoing research of Professor Elizabeth Carlson, Lawrence University, for her presentation "Cubist Chic: Mainstreaming Modernism After the Armory," at "The Armory Show at 100: New Perspectives," Symposium, New-York Historical Society, November 9, 2013. See also Blesh. *Modern Art USA*. 67; and Walt Kuhn. *The Story of the Armory Show*. New York, 1938. 66-67.

35 Aaron Sheo. "1913: Forgotten Cubist Exhibitions in America". *Arts Magazine*. 1983（3）. 93. Sheon discusses responses to the new art of Europe through the lens of consumer fads.

36 Pach. *Queer Thing, Painting*. 194.

37 Pach. *Queer Thing, Painting*. 201.

38 Pach. *Queer Thing, Painting*. 201. 217.

39 Rosenberg. "The Armory Show". 191

40 Diane Kelder, "Stuart Davis and Modernism: An Overview". In：Lowery Stokes Sims. *Stuart Davis: American Painter*. New York: The Metropolitan Museum of Art, distributed by Harry N. Abrams, Inc., 1991. 20

41 Charles Sheeler noted, according to Rosenberg, that it took him nine years "to bail out and make a new beginning." Quoted Rosenberg. "The Armory Show". 190

42 Pach. *Queer Thing, Painting*. 202.

Suggestions for Further Reading

[1] Altshuler Bruce. *The Avant-Garde in Exhibition: New Art in the 20th Century*. New York: Harry N. Abrams, 1994

[2] Bourne Randolph. "Trans-national America" in *The Radical Will: Selected Writings, 1911—1918*. New York: Urizen, 1977. http://www.swarthmore.edu/SocSci/rbannis1/AIH19th/Bourne. html

[3] Brown Milton. *The Story of the Armory Show*, 1963. New York: Abbeville Press, 1988.

[4] Davidson Abraham. *Early American Modernist Painting, 1910—1935*. New York: Harper and Row, 1981.

[5] Fink, Lois Marie. *American Art at the Nineteenth-Century Paris Salons*. National Museum of American Art, in conjunction with Cambridge University Press, 1990.

[6] Haskell Barbara. *The American Century: Art and Culture, 1900—1950*. New York: Whitney Museum of American Art, in conjunction with W. W. Norton, 1999.

[7] Heller Adele, Lois Rudnick. *1915: The Cultural Moment*. New Brunswick, NJ: Rutgers University Press, 1991.

[8] Jensen Robert. Marketing Modernism in Fin-de-Siecle Europe. Princeton, NJ: Princeton University Press, 1994.

[9] Kelder Diane. "Stuart Davis and Modernism: An Overview". In：Lowery Stokes Sims. *Stuart Davis: American Painter*. New York: The Metropolitan Museum of Art, distributed by Harry N. Abrams, Inc., 1991.

[10] Kennedy Elizabeth, ed. *Chicago Modern, 1893—1945: Pursuit of the New*. Chicago: Terra Museum of American Art, in conjunction with the University of Chicago Press, 2004.

[11] Kushner, Marilyn Satin,et al. *The Armory Show at 100: Modernism and Revolution*. New York: New-York Historical Society, 2013.

[12] *Manierre Dawson: American Pioneer of Abstract Art*. New York City: Hollis Taggart Galleries, 1999.

[13] Miller Angela, Janet Berlo, et al. *American Encounters: Art, History, and Cultural Identity*. Upper Saddle River, NJ: Pearson Education, Inc., 2008.

[14] Rosenberg Harold. *The Anxious Object: Art Today and its Audiences*. New York: Collier Books, 1964.

[15] Schapiro Meyer. *Modern Art, 19th & 20th Centuries*. London: Chatto and Windus, 1978.

[16] Watson Steven. *Strange Bedfellows: The First American Avant-Garde*. New York: Abbeville Press, 1991.

消逝的种族环球巡展：美国主办的爱德华·柯蒂斯摄影展

Circling the Globe with the Vanishing Race: U.S. Sponsored–Exhibitions of the Photographs of Edward Curtis

伊丽莎白·哈钦森　徐达艳 * 译

Elizabeth Hutchinson　　Translator: Xu Dayan

自 2005 年以来，以"神圣的遗产"为题的爱德华·柯蒂斯（Edward Curtis）摄影展在全球举行巡回展（图 1）。最近的一次统计表明，该展览已经在遍布全球各大洲（除南极洲以外）的 85 个城市中展出。北京是较早的一站——2007 年 6 月，这些作品在大山子美术馆展出。克里斯托弗·卡多索（Christopher Cardozo）——一位来自明尼苏达州明尼阿波利的摄影师兼照片交易商——负责展览的组织工作，美国国务院国际信息计划局使得此次展览能够在各国文化中心、图书馆以及艺术、历史、科学博物馆中作临时展出。[1]

此次展览中的照片由美国摄影师爱德华·柯蒂斯拍摄，作为记录"传统"美国原住民生活这一宏大项目的一部分（图 2），囊括了柯蒂斯在 1900 年至 1930 年间的大部分作品。这些照片第一次发表于他的 24 卷著作——《北美印第安人》中（此书在 1907 年至 1930 年分卷出版）。柯蒂斯曾以摄影师的身份参与对阿拉斯加和蒙

Since 2005, an exhibition of Edward Curtis photographs titled "Sacred Legacy" has been circling the globe （Fig.1）. At last count, the exhibit had been in over 85 different cities in every continent except Antarctica. Beijing was an early stop—in June 2007, the photographs were on view at the National Library DaShanZi Art Gallery. Organized by Christopher Cardozo, a photographer and photo dealer from Minneapolis, Minnesota, "Sacred Legacy" is circulated by the Bureau of International Information Programs of the United States Department of State for temporary display in cultural centers, libraries, and museums dedicated to art, history, and science.[1]

The images on display were made by the American photographer Edward Curtis as part of his epic project to document "traditional" Native American life. （Fig.2） They were originally published in his monumental twenty-volume work *The North American Indian,* published in installments between 1907 and 1930, which included Cur-

图 1　2006 年阿根廷布宜诺斯艾利斯"神圣的遗产"展览。照片来源：承蒙明尼苏达州明尼阿波利斯的克里斯托弗·卡多索先生提供。

Fig.1　"Sacred Legacy" exhibition on view in Buenos Aires, Argentina, 2006. Photo: Courtesy of Christopher Cardozo Fine Art, Minneapolis, Minnesota

* 徐达艳 自由撰稿人（Xu Dayan Free-lancer）

图2 爱德华·柯蒂斯，"消逝的种族"，参见《北美印第安人》卷1，1907 年。照片来源：华盛顿国会图书馆。

Fig.2 Edward Curtis, "The Vanishing Race," from volume 1 of *The North American Indian*, 1907. Photo: Library of Congress, Washington, D.C.

大拿科学考察，并在西南地区进行了一次个人旅行，这些经历激发了他对于霍皮（Hopi，印第安人的一支）文化的痴迷。1905 年，他开始正式提议对北美部落进行全面的研究。[2]

作品最终按照地区、原住民民族进行分类。柯蒂斯和他的助手们 [其中包括人类学家弗雷德里克·韦伯·霍奇（Frederick Webb Hodge）] 撰写了相关部落的习俗和信仰的文字。发行时每卷还包括 20~30 张散装照片。这些散装照片是柯蒂斯认为最具美感的，所以他用凹版印刷将它们放大，并印在和纸上。如此一来，该项目同时展示了科学性与艺术性。

柯蒂斯书中收集照片总数超过了 2000 张（包括夹在书中的 720 张）。这个项目让柯蒂斯痴迷不已，为此，他花去了生命中将近 30 年的时间。尽管在 1906 年到1911 年，这个项目得到了 J.P. 摩根（J.P. Morgan）的资金支持，但这位摄影师最终还是因为这个项目而破产。为了努力得到预付款，该著作以订阅的形式售卖，一套书起售价为 3000 美元，然后 3500 美元，最后 4000 美元。柯蒂斯预计出版 500 套，但实际只卖出 222 套。起初，《北美印第安人》的科学与美学价值得到大家的交口称赞，但在"一战"期间慢慢被人们忽略，等到 1930 年全书完成时，人们几乎已经彻底遗忘这个项目。因此，书中所包含的照片也相当罕见。

"神圣的遗产"巡回展终能实现，是因为展出的并不是当时柯蒂斯冲洗出来的照片。1996 年，展览的承办者克里斯托弗·卡多索获得了柯蒂斯照片中的 60 张底片。他的团队利用这些底片冲洗照片并出售，同时编写与柯蒂斯作品相关的各类书籍，在不同的场所举办展览，其中就包括"神圣的遗产"。[3]

艺术史家通常不会花很多时间讨论盈利性的巡回展

tis's photographs taken between 1900 and 1930. Curtis envisioned the project as a result of his experiences as a photographer accompanying scientific expeditions to Alaska and Montana as well as a personal trip to the Southwest, which sparked what would be a lifelong enchantment with Hopi culture. In 1905 he began making formal proposals to produce a comprehensive study of North American tribes.[2]

The resulting volumes were organized by region and native nation. Texts on tribal practices and beliefs written by Curtis and his assistants, including anthropologist Frederick Webb Hodge accompanied the photographs. The publication also included portfolios of 20-30 unbound prints per volume. Curtis considered those images to be the most aesthetic and printed them as large photogravures on Japanese paper. Thus the project demonstrated a dual commitment to science and art.

All told, there are over 2,000 Curtis images, including 720 within the portfolios. The project was Curtis' obsession. It took nearly 30 years to complete and, despite financial support from J.P. Morgan from 1906 to 1911, it bankrupted the photographer. In an effort to get money up front, it was sold by subscription, first for $3,000 and, later for $3,500, and finally for $4,000 for a set of volumes. Curtis projected an edition of 500 copies, but only 222 were sold. Initially received with great acclaim for its scientific and aesthetic value, *The North American Indian* lost attention during World War I and by the time it was completed in 1930, the project was largely forgotten. The photographs that comprised it are thus reasonably rare.

The circulation of the Sacred Legacy exhibition is possible because it does not comprise prints made during Curtis' time. The organizer of the exhibition, Christopher Cardozo, acquired the negatives for 60 of Curtis's images in 1996. His team prints and sells modern photographic prints from these originals, produces books on different aspects of Curtis' work and creates exhibitions for different venues, including Sacred Legacy.[3]

Art historians do not usually spend a lot of time discussing for-profit traveling exhibitions. Sacred Legacy has not been shown in major art institutions or gathered significant critical reviews. However, it is important for scholars to pay attention to this exhibition because by reaching a broad audience in venues that are *not* associated with the artistic elite, it reaches viewers who are less likely to ask difficult questions about what they see, in terms of either the aesthetic choices behind the appearance of the work or the influence that such choices may have on the attitudes of viewers toward the subjects in the pictures and the institutions that make the exhibitions possible. In this essay, I will explore the ways in which international exhibitions of Curtis' work

览。"神圣的遗产"既没有在主要的艺术机构展出,也没有得到重要的艺术批评家的评论。但是,关注此次展览对于学者来说非常重要,因为展览举办的场所并不是针对美学精英开放的,这样反而可以触及更大范围的观众群体。这些观众也不太可能问很难的问题,例如,这些作品背后的审美选择是什么,或者这些审美选择如何影响观众和主办机构对于照片主题的态度。在这篇文章中,我将要探讨柯蒂斯作品国际展运用怎样的方式使美国以外地区的观众对美国原住民形成一定认识。在文章的结尾,我还将"神圣的遗产"与"大使馆中的艺术"(该项目也是由美国国务院实施的)中所使用的柯蒂斯照片进行对比,以证明,尽管两个展览都试图致敬北美原住民,并歌颂他们的文化多样性,但最终的效果并不相同。"神圣的遗产"让人记住了与当代历史和全球政治剥离开的土著观念,使美国原住民的文化成为美国国家遗产的一部分。相比之下,"大使馆中的艺术"则使观众看到原住民正在遭遇现代艺术和现代生活的复杂处境,引发了对于当代社会土著民生存状况的疑问。

2000 年,卡多索(Cardozo)在巴黎、瑞士和德国成功地举办了一个包含 160 幅摄影作品的巡回展,此次展览后,"神圣的遗产"展览的构想就产生了。据他回忆,国务院的官员看完展览后与他联系,准备创作一个小规模的展览,作为一种"柔性国家政策"在西半球巡回展出。随后策划的展览共展出 50~60 幅摄影作品,大多是从卡多索收藏的底片中冲洗出来的。[4]

就展览情况与国务院工作人员进行的联系并无结果。在第一次展览后,其中几位工作人员就退休了,国际信息计划局也进行了重组,员工们找不到一份与该项目有关的文档。与其他有外交官员参加的展览一样,"神圣的遗产"很有可能在美国政府文印局制作的宣传册中有所描述,不过主持展览的官员也可能直接与其他展区的同事联系,从而了解到该展览。[5]

尽管每次巡回展览都会有所不同,但都遵循一项基本原则。每次展览的作品都来自不同卷的《北美印第安人》,重在突出大平原和西南部落民族的标志性形象。在展览中看到的大部分照片都使用了当代碳素纸晒版技术,使之看上去像是柯蒂斯工作室冲印的凹版印刷照片。与此同时,每次展览还包含一组精选图片,这部分图片是使用与柯蒂斯当时所使用的不同冲印技术冲洗出来的。这些技术不仅包括凹版印刷和铂金印相,还包括氰版照相以及柯蒂斯开发的一种使用黄金进行的湿版印刷技术。一些展览中也设置了少量来自柯蒂斯工作室制作的老照片展块。卡多索的团队还制作了一套文本放置在作品旁,描述不同地区原住民的文化特征,解释作品所采用的摄影技术,并展现历史上的政治家和原住民领导

have shaped an understanding of Native Americans outside of the United States. At the end, I will contrast "Sacred Legacy" with the use of Curtis' images in exhibitions created by the Art in Embassies program, also administered by the United States Department of State, and argue that, while both types of exhibition seek to honor indigenous North Americans and celebrate their rich and diverse cultures, they do so to different ends. "Sacred Legacy" perpetuates a notion of indigenous identity separate from contemporary history and global politics and situates Native American culture as part of an *American* national heritage. By contrast, the Art in Embassies program allows viewers to see Natives as confronting the complexities of modern art and modern life in ways that can invite questions about the status of indigenous people in contemporary society.

"Sacred Legacy" was created after Cardozo organized a successful exhibition of 160 photographs that traveled to Paris and venues in Switzerland and Germany in 2000. As he recalls it, someone from the State Department saw the exhibition and approached him to create a smaller show that could travel around the Western hemisphere as a form of "soft public policy." The resulting exhibition includes between 50 and 60 images, including primarily modern prints from the negatives in Cardozo's collection.[4]

Correspondence with State Department employees about the creation of the exhibition has been inconclusive. Several staff members have retired since the initial "Sacred Legacy" and the Bureau of International Information Programs has recently relocated. Staff members could not locate a file related to the project. As with other exhibitions made available to officials in diplomatic posts, "Sacred Legacy" was probably described in a brochure produced by the Government Printing Office, though the officials hosting the exhibition may also have learned of it through direct contact with colleagues from other exhibition venues.[5]

While each iteration of the exhibition differs somewhat, each follows a basic formula. The exhibition includes works from different volumes of *The North American Indian*, emphasizing the iconic images of Great Plains and Southwest tribal nations. Most of the pictures on view are contemporary pigment prints designed to look like the photogravures printed by Curtis' studio, but each exhibit includes a selection of prints made using the different printing techniques Curtis employed. Those include not only photogravure and platinum, but also cyanotypes and a technique developed by Curtis using gold called an orotone. Some installations also include a small number of vintage prints made by Curtis' own studio. Cardozo's team has also produced a set of texts to be installed alongside the prints, which describe the traits of Native culture in different areas, explain the photographic

者对于照片价值的认可。

由于每一张照片能够制作多份拷贝，卡多索可以在几个不同的展场同时举办"神圣的遗产"。起初他策划了两个由美国国务院订制的展览，一个是在墨西哥的巡回展，历时5年；另一个是在巴西的巡展。不久后，另外两个配套展也编制完成，其中一个面向非洲地区，另一个面向亚太地区。卡多索还在美国展出这些作品。这些装有外框的现代照片可以在一系列美术馆中陈列，不用担心光和空气会损毁作品，且非常易于运输，这使得巡展可以临时添加新场所，而不影响展览的其他相关方。《福布斯》杂志称赞了卡多索明智的经营计划。[6]卡多索公司希望将"神圣的遗产"发展成类似于"灰与雪"——一个赞美人类与动物关系的巡回展那样，可以为世界各展览馆提供了完整的展品，包括有框照片、文字和其他展览用品。[7]

在分析"神圣的遗产"的意义之前，全面的介绍柯蒂斯项目的细节非常重要。《北美印第安人》反映了那时对于原住民的普遍态度。在《北美印第安人》里出现的第一张名为"消逝的种族"（图2）的照片里，列纳瓦霍（Navajo，印第安部落之一）的一位骑手正远离观者的视线，朝着远方走去，进入一片广阔崎岖的景色中。书中写道："这幅作品想要传达的思想是，印第安作为一个民族，已经丧失了部落的力量，他们脱去了原始服装，正走向迷茫、未知的将来。"[8]柯蒂斯的作品跳过了对原住民和美国之间棘手的现实关系的讨论，从侧面支持了美国对于土著人的殖民统治。照片中的纳瓦霍人并不是毫无理由地消失的。由于美国在19世纪60年代实施的四年监禁制度，在此期间，他们被迫放弃自己牧场、果园，徒步450英里前往物资短缺的萨姆特堡军事战俘集中营，印第安人的部落力量遭受了巨大的损失，服饰习惯也有改变。[9]照片只表明了原住民的"消失"，却没有说明原住民人口的减少是由于美国的殖民化对他们生活方式、自治权和支撑部落运行的方法的摧毁而造成的。面对这样的照片，普通观众只对原住民社会的衰落感到悲伤，却不觉得他们需要对这样的困境承担责任。这种态度被人类学家雷纳托·罗萨尔多（Renato Rosaldo）称为"帝国主义的怀乡病"。[10]《北美印第安人》被评论为拯救民族志的典范，是在土著消失前保护其文化资料的行为。"拯救"计划沉迷于一个臆想出来的，与外界还没有任何接触之前的，纯粹的原生态文化，把它当作真正的印第安文化，这否定了原住民的历史，在印第安人的过去和现在之间制造了断层。

在柯蒂斯的许多实践活动中，我们都能发现他对展示美国原住民参与现代社会生活的照片的反感。例如，他避免拍摄来自美国东北和东南部的众多族群，几

techniques used to produce the work, and offer endorsements of the value of the images from historical politicians and Native leaders.

Because he has the ability to make multiple copies of each image, Cardozo can send "Sacred Legacy" to several venues at once. Initially he created two exhibitions that were purchased by the State Department, one that traveled in Mexico for five years and another that traveled around Brazil. Later two additional sets were compiled, one destined for African venues and another for Asia and the Pacific. Cardozo also shows the work in the United States. The framed modern prints can be displayed in a wide array of galleries without concern for damage due to light or atmosphere and are easy to ship from place to place, allowing for new venues to be added to a regional tour without compromising other aspects of the business. Cardozo was celebrated for his sound business plan in Forbes Magazine.[6] Among other things, his company aspires to develop "Sacred Legacy" into a "nomadic museum" akin to "Ashes and Snow," a traveling exhibition of photographs celebrating human relationships with animals that similarly offers venues around the world a complete exhibition package including framed prints, accompanying texts and other display pieces.[7]

Before analyzing the significance of "Sacred Legacy," it is important to introduce Curtis' project in more detail. *The North American Indian* reflects attitudes about Native people that were common during the time it was produced. In the photograph titled "The Vanishing Race" （Fig.2）, which appeared as the very first image in *The North American Indian,* a line of Navajo riders moves away from the viewer into a vast and rugged landscape. The caption provided in the book reads, "The thought which this picture is meant to convey is that the Indians as a race, already short of their tribal strength and stripped of their primitive dress, are passing into the darkness of an unknown future."[8] Curtis' work implicitly supports American colonial control over indigenous people by eliding discussion of the painful reality of Native-U.S. relations. The Navajo people pictured in this image did not vanish without cause. Rather they experienced the greatest loss of tribal strength （as well as a change in habits of dress） as a result of a four-year incarceration by the United States in the 1860s, during which they were forced to abandon their pastures and orchards and walk 450 miles to a poorly-supplied Army prison camp at Fort Sumter.[9] By suggesting that Native people "vanish" instead of presenting the loss of population as a result of the destruction of Native lifeways, autonomy and access to the means of sustaining their communities because of U.S. colonization, pictures like these allow non-Native viewers to feel sad about the decline of Native communities without

百年以来，他们的文化活动早已适应了欧裔美国人的习惯，但这并没有抹去他们马斯科吉、易洛魁、雷纳配（Muscolge, Haudenosaunee, Lenape，均为印第安人分支）或者其他原住民民族的身份认同感（图3）。

与他照片中的内容相反，柯蒂斯的项目刚好与美国人在东西部对印第安人社会进行大量干预的时间重合。在1886年道斯（Dawes）法案通过后，政府制定了一项法律，旨在撤销之前的条约赋予部落的集体土地所有权，取而代之的是分给每一个原住民一小块私有土地。印第安事务办公室将重心转向印第安人的教育，将原住民的孩子从家中带走，让他们在寄宿学校接受职业教育，在那里他们被强制说英语，遵从基督教礼仪，并且穿着欧洲服饰。[11] 由于在寄宿学校、宗教传道和现代劳动中的文化交流，他们早已接受了现代服饰，而柯蒂斯在拍摄西部、西南部和西北海岸的原住民时，所要呈现的是符合他原生态观点的照片，所以他购买服装、手工艺品供拍摄对象使用，这样他们就不会以穿着现代服饰的形象出现。有趣的是，他在不同部落的被拍摄者身上使用相同的物品，从而露出了人为摆拍的马脚。此外，一旦柯蒂斯发现照片无意间透露了原住民现代生活的细节时，他会对照片进行修描，在派岗族（Piegan）住处拍摄的一张著名照片上，他就这么做过。这处对比显示，这

图3 爱德华·柯蒂斯拍摄区域的地图。图片来源：华盛顿国会图书馆。

Fig.3 Map of areas photographed by Edward Curtis. Source: Library of Congress, Washington, D.C.

feeling responsible for their plight. This attitude has been named "imperialist nostalgia" by the anthropologist Renato Rosaldo.[10] *The North American Indian* has been critiqued as an example of salvage ethnography, the practice of preserving documents of indigenous cultures before they disappear. "Salvage" projects fetishize an imagined pure pre-contact Native culture as the authentic one, creating a discontinuity between Indianness and modernity that denies Native history.

Curtis' bias against making images that demonstrate Native American's participation in modern history can be found in many aspects of his practice. For example, he avoided taking photographs of any of the numerous groups from the North- and South eastern parts of the United States, whose cultural practices had been adapting to Euro-American presence for centuries without eliminating their identities as members of Muscolge, Haudenosaunee, Lenape or other native nations （Fig.3）.

Contrary to the image produced by his photographs, Curtis' project coincided with a period of tremendous American intervention in Indian communities in both the east and the west. Having passed the 1886 Dawes Act, a law designed to evacuate tribes collective title to land granted by treaties and instead grant each Native a small plot of personal property, the Office of Indian Affairs turned its attention to Indian education, by removing Native children from their families and offering them vocational education in boarding schools where speaking English, practicing Christianity, and wearing European dress were mandatory.[11] Yet, when photographing Natives in the West, Southwest and Northwest Coast, Curtis staged pictures to conform to his notion of pre-contact life. He purchased clothing and handicrafts for his models to use so that they would not appear in the modern clothing they had adopted as a result of intercultural exchange through boarding schools, religious missionization and modern labor. Interestingly, his use of the same items in pictures of sitters from diverse tribes reveals the artificiality of the poses. Moreover, when his pictures inadvertently included details that showed Native people as part of contemporary life, Curtis would retouch them, as he did in a famous image inside a Piegan lodge. As this comparison shows, the offending object—an alarm clock—has been removed from the image[12] （Figs. 4 and 5）.

Scholars of the history of photography are aware that all photographs are constructed, that the photographer's choices about what to shoot, how to frame an image, and the medium and style of a print all help shape photographic meaning, and thus the fact that Curtis manipulated his pictures is not itself surprising.[13] He made changes because of his desire to make better pictures, and no one can deny his

图 4 爱德华·柯蒂斯，"在派岗族小屋里"，见《北美印第安人》卷 6，1911。照片来源：华盛顿国会图书馆。

Fig.4　Edward Curtis, "In a Piegan Lodge," from volume 6 of *The North American Indian*, 1911. Photo: Library of Congress, Washington, D.C.

图 5 爱德华·柯蒂斯，"在派岗族小屋里"（被替代的照片）。照片来源：华盛顿国会图书馆的爱德华·柯蒂斯藏品。

Fig.5　Edward Curtis, "In a Piegan Lodge（alternate print）." Photo: Edward Curtis Collection, Library of Congress, Washington, D.C.

个恼人的物体—— 一个闹钟——被从照片中抠掉了[12]（图 4 和图 5）。

　　摄影史学者明白，所有的照片都是造出来的，摄影师可以选择拍摄内容、取景方式、冲印媒介和风格，这些都有助于塑造照片的意义，因此柯蒂斯篡改照片这个事实本身并不令人惊讶。[13] 他的改动是希望创造出更好的照片，没人可以否定他在创作这些充满力量的标志性作品时对审美性炉火纯青的控制力。但柯蒂斯对于原住民生活的看法并不是摄影师中独一无二的。他们都遵循彼时优势文化对所谓的原始民族的普遍性看法，这样做可以创作出具有说服力的文献来支持广为流传的印第安文化。

　　研究柯蒂斯的学者米克·吉德利（Mick Gidley）认为，柯蒂斯影响着当时流行的"国民态度"，同时也被之影响。[14] 美国权贵阶层的支持为他的工作提供了便利。西奥多·罗斯福（Theodore Roosevelt）总统为《北美印第安人》写了前言。商业巨头 J.P. 摩根（J.P. Morgan）为摄影师提供了资金支持。在项目开始时，柯蒂斯向摩根承诺：他会在《北美印第安人》一书以外，保持对当时印第安人所采取的政策和管理的讨论，他几乎完全兑现了这一承诺。

　　柯蒂斯及其支持者认为美国人对于印第安人的统治是理所当然的，并且认为从他的工作中受益的是美国白人，而不是印第安人。人种学学者 C. 哈特·梅里亚姆（C. Hart Merriam）写道："这本如此精良的书创作于美国，每一个看到这套作品的美国人都应该为此而骄傲；这本书如此真实且艺术地记录了美国土著居民生活，从而丰富了美国的民族学和历史学，每一个聪明人都会为此感到欣喜。"[15]

masterful use of aesthetics to create powerful, iconic images. But Curtis' ideas about Native life are not unique to the photographer. They conform to ideas about so-called primitive peoples that were widely held by members of dominant culture at the time, and in so doing, they create persuasive documents to support widespread beliefs about the nature of Indian culture.

As Curtis scholar Mick Gidley has argued, Curtis both affected and was affected by prevailing "national attitudes."[14] His work was facilitated by the support of powerful Americans. President Theodore Roosevelt wrote the introduction to *The North American Indian.* Business magnate J.P. Morgan provided the photographer's financial backing. At the beginning of his project, Curtis pledged to Morgan that he would keep a discussion of contemporary Indian policy and administration out of his book, a promise he broke only rarely.

Curtis and his supporters took American dominance over Indian people for granted and assumed that the people benefitting from Curtis' work were white Americans, not Indian people. Ethnographer C. Hart Merriam wrote of *The North American Indian* "Every American who sees the work will be proud that so handsome a piece of book-making has been produced in America; and every intelligent man will rejoice that ethnology and history have been enriched by such faithful and artistic records of the aboriginal inhabitants of our country."[15]

This nationalist presentation of Indian people offered in *The North American Indian* is problematic because it assumes that Americans are the natural heirs to Native culture. More importantly, the description of indigenous people as part of the United States patrimony denies their legal status.

在《北美印第安人》中，印第安人是以国家主义者的角度呈现的，这是有问题的，因为这其中隐藏着美国人是本土文化天然继承者的假设。更重要的是，把土著人当成美国所继承的财产的一部分，这否定了他们的法律地位。美国宪法将印第安人视为独立的民族，他们与美国的关系是建立在国际条约的基础上。无论是柯蒂斯的时代，还是现在，美国都再三地违反这个原则，但土著人依然重视他们的主权，敦促美国对历史条约的尊重。[16]从历史的角度来看，政府通过对印第安文化的再现（如柯蒂斯的摄影作品），强化了对印第安人身份的否定。

在20世纪的最后25年里，柯蒂斯的作品被重新发现，许多评论家很快发现了其中含蓄的种族偏见。[17]美国原住民在照片里认出了熟悉的样板化形象，有骑马的勇士，五彩的萨满巫师和迷人的印第安少女，从19世纪一直到好莱坞西部片，这些都是印第安人的代表形象。与此同时，一些印第安人被这些照片视觉上呈现的自豪感与高贵感打动。另一些人也很高兴找到了他们祖先的记录，使得他们可以了解祖先确切的形象，并看到与他们的土地和部落历史相关的资料。

此外，一些人认为照片里描绘的原住民应该被看成作品的联合作者，尽管他们比摄影师弱势。虽然这些照片力图消除印第安人的主体特征，但这些照片应该被看成历史上原住民抗争的记录。在最近几十年，吉德利（Gidley）、艾伦·特拉亨伯格（Alan Trachtenberg）和其他一些学者做了很重要的工作，试图复原与柯蒂斯一起工作的印第安人的经历，这些印第安人为他摆造型，为他的工作提供便利，并且偶尔作为翻译。[18]这段历史记录的是在镜头前穿成这样从而得到各种各样的机会的印第安人——有时是为了自己的怀旧情结，有时是为了挣钱，有时是希望通过他们的工作打破文化隔阂，从而影响原住民和白人的关系。在安妮·梅克皮斯（Anne Makepeace）的获奖纪录片《大白天下》（Coming to Light）中，电影制作人与当代印第安人讨论了柯蒂斯的作品，引发他们的批评与赞扬，同时也让柯蒂斯的照片激发对未能被他相机所记录的事件和记忆的重述。举个例子，这张照片中的模特是在寄宿学校生活，放假回家时他们有机会穿上正式的传统服饰在镜头前摆拍，为此他们感到很高兴。[19]（图6）

在举办"神圣的遗产"时，这段充满批评和修改的历史对于克里斯托弗·卡多索（Christopher Cardozo）来说相当熟悉，他承认柯蒂斯对于印第安人的态度有问题，甚至在展览现场举办研讨会，让当地的策展人更好地了解作品的历史背景。重要的是，卡多索的展览吸收了比《北美印第安人》更多的原住民的声音。除了在墙上有19世纪原住民酋长的引述文字外，展览目

The American constitution identifies Indians as members of separate nations whose relationship to the United States is established through international treaties. Although the United States has repeatedly violated this principal, in Curtis' time as today, indigenous North Americans valued their sovereignty and pressed for the honoring of historic treaties.[16] The denial of the status of Indian people through governmental action has historically been reinforced by cultural representations of Indian people such as those produced by Curtis.

When Curtis' work was rediscovered in the last quarter of the twentieth century, many critics were quick to identify its implicit racism.[17] Native Americans recognized familiar stereotypes in pictures of mounted warriors, painted shamans and alluring Indian maidens that echoed themes in Indian representation tracing from the nineteenth century through Hollywood Westerns. At the same time, some Indian people were moved by these pictures' visual rhetoric of pride and nobility. Others are simply happy to have records of their ancestors that allowed them to know their physical features and see lands associated with the histories of their tribes.

Moreover, some people believe that the Native people depicted in the photographs must be seen as collaborators in the making of those images, even if they had less power than the photographer. Thus the pictures should be seen as a document of Native historical struggle even as they strive to erase Indian subjectivity. In recent decades, scholars such as Gidley, Alan Trachtenberg, and others have done important work recovering the experiences of the Indian people who worked with Curtis, posing for him, facilitating his work with others and, on occasion serving as translators.[18] What this history records is Indian people for whom dressing up for the camera provided opportunities of various kinds—at times to serve their own nostalgia, at times as a means of making money, at times in the hope of influencing Native-White relations through their work as culture brokers. In Anne Makepeace's award-winning documentary "Coming to Light," the filmmaker discusses Curtis' work with contemporary Indian people, eliciting criticism and praise, but also allowing Curtis' pictures to prompt the retelling of events and memories that were *not* recorded by his camera. For example, the models in this pictures recal their delight at being on vacation from boarding school and having the opportunity to dress up in formal traditional attire to pose for the camera[19]（Fig.6）.

This history of critique and revision was familiar to Christopher Cardozo when he organized "Sacred Legacy," and he acknowledges Curtis' problematic attitudes toward Indian people and even offers to lead seminars at exhibition

图6 爱德华·柯蒂斯，"在泉旁闲逛"，参见《北美印第安人》卷12，1922。照片来源：华盛顿国会图书馆。
Fig.6 Edward Curtis, "Loitering at the Spring," from volume 12 of *The North American Indian*, 1922. Photo: Library of Congress, Washington, D.C.

录还包括基奥瓦族（Kiowa，北美印第安人一支）作家N. 斯科特·莫马代（N. Scott Momaday）和阿安宁宁族（A'aninin，印第安人一支，又称 Gros Ventre）策展人乔治·霍斯·卡普切（George Horse Capture）写的文章，他们两人都表达了能够看到祖先形象的喜悦之情。展馆内还能选择放映梅克皮斯的电影录像。

卡多索认为柯蒂斯照片中的模特是柯蒂斯作品的合作方，他们与摄影师一起为后来人留下记录。他认为"神圣的遗产"在观众与原住民间创建了一种"亲近感"，并且声情并茂地讲述了展览在创造土著民族正面形象方面展示的力量，对于其他土著民族以及有自己原住民的国家的观众来说这种感受尤为强烈。在明尼苏达展览时，一位参观者给予的评价令他非常自豪，这位参观者写道："感谢你为我展示了我的文化。"在福布斯杂志的采访中，他表示希望将柯蒂斯照片的冲印版本"遣返"给那些拍摄地的部落群落。[20]

卡多索表示展览是为了"致敬和歌颂"原住民及他们的历史。"神圣的遗产"表明，柯蒂斯认为印第安人会消失的观点是错误的，事实上现在的印第安人比科蒂斯时期的还要多。但展览的文化焦点还是落在被柯蒂斯验证过的那些方面，并没有揭示美国原住民的历史。这样的做法导致了将原住民的身份定格在永远的过去式上，而不是将印第安人抗争史作为当下进行历史抗争谈判者的范例，这只能强化土著人的原始感。我想清楚表明，我不认为卡多索或者美国国务院传播"神圣的遗产"的目的是推广老掉牙的成见。这个展览聚焦于一个具有广泛国际吸引力的话题，在很多方面与这两个机构公开声称的目标相符。但是，不加鉴别地赞扬柯蒂斯，就会一次次重蹈覆辙。

venues to give local curators a greater sense of the historical context of the work. Importantly, Cardozo's exhibition incorporates more Native voices than *The North American Indian*. In addition to offering wall text with quotations from nineteenth century Native chiefs, the exhibition catalog includes essays by Kiowa writer N. Scott Momaday and A'aninin （Gros Ventre） curator George Horse Capture, both of whom express happiness at having access to images of forebears. Exhibition sites are also offered the option of showing a video of Makepeace's film.

Cardozo considers the sitters in Curtis' photographs as Curtis' collaborators whose work with the photographer was undertaken with the goal of leaving a record for future generations. He believes that "Sacred Legacy" creates "a sense of affinity" with Native people for its viewers and speaks with emotion about the power the exhibition has to create a positive image of indigeneity, particularly for members of other indigenous groups and audiences in countries with their own Native populations. He is particularly proud of a comment by a visitor to an exhibition he mounted in Minnesota who wrote, "Thank you for showing me my culture." In the *Forbes* interview discusses his desire to "repatriate" Curtis photographs by sending modern prints to the communities in which they are made. [20]

Cardozo describes the exhibition as designed to "honor and celebrate" Native people and their histories. "Sacred Legacy" notes that Curtis' belief that Indian people would disappear was false, making it clear that there are, in fact, *more* Indians alive today than in Curtis' time. But the exhibition reveals very little about Native American history and focuses only on those aspects of culture that were validated by Curtis. In so doing, it directs attention to a notion of Native identity associated with a timeless past, instead of directing curiosity to Indian people's historical struggles as an example for people negotiating the historical struggles of the present, reinforcing primitivist stereotypes of indigeneity. I want to be clear that I do not believe that either Cardozo or the Department of State have circulated "Sacred Legacy" with the intent of promoting stereotypes. It is a popular exhibition focused on a topic of widespread international appeal that in many ways fits the avowed goals of both institutions. However, the uncritical celebration of Curtis reinscribes many of the problematic aspects of the original project.

For example, it makes sense that the exhibition reinforces Curtis' belief that Indian culture exists only West of the Mississippi, because there are no pictures to display of other cultural regions, yet this association between two American icons—the noble savage and the Western landscape—plays into the expectations of global audiences instead of challenging them to think about how and why these

例如，展览强化了柯蒂斯所认为的印第安文化只存在于密西西比河以西的错误观点，因为展览中几乎没有照片显示其他区域存在这种文化，并且这两种美国符号——高贵的野蛮人和西部风景——之间的结合，符合全世界观众的预期，但这些照片不能使他们去思考这些形象是如何成为美国形象的象征，以及为什么这些形象会成为象征，为什么原住民的其他方面或者非原住民的美国人却没有成为象征。实际上，虽然展览包括来自西北海岸和山间高原的照片，但大部分照片来自大平原和西南部，这也与好莱坞西部片这样的流行文化留给大家的印象相符。

"神圣的遗产"还重复了柯蒂斯对于殖民前原住民真实生活的怀旧。柯蒂斯通过模特摆拍和修改照片来回避文化交流或现代性的痕迹，文字介绍也没有让大家注意到这一点。有关西南部分的文字介绍是这样叙述的，柯蒂斯在西南的旅行，"给予他罕有的机会，一瞥白人到来前的印第安人生活"。这种说法否认了西南区域实际上是美国原住民和非原住民文化交流历史最长的地区之一，与实际情况严重不符。[21]

除了将原住民文化定格成永恒不变外，展览还造成了对于原住民身份的一种狭隘理解，将印第安人的形象定型为高贵的野蛮人。一面墙上有来自印第安人的引述，全部是男人的话，而且说话者不是酋长就是军事领导。另一面墙上，大平原印第安人被描述成"情感深沉，极度自尊，独立"的"勇士"。这些说法都支持了部落领导权完全掌握在军人手中这样一个错误认识，完全无视不同部落间领导权的差异，土著社会中男人承担的其他职责，氏族母亲和其他女性在社会事务中承担的重要角色，以及印第安人拥有不同的特长和个性这些事实。

"神圣的遗产"中一些刻板印象信息的产生原因在于，每个地方的展览都是重新策划的。在卡多索提供的展览布置照片中可以看出，当地的展览协办方可以自由地强调他们所认为的最适合他们观众的内容（图7）。举例来说，2007年6月在河内，策展人在展览空间的中央放置了一个跟实物一样大小的印第安人帐篷，并将墙上文字贴在薄板上，这些薄板看上去就像拉伸的皮肤。在河内展的前一年，即于2006年6月在摩尔多瓦举办的展览时，展览场地设在一个人种学博物馆内，在开幕式上，策展人请来了土著音乐家和一位帕瓦仪式舞者来表演源自部落传统的歌舞。印第安帐篷和帕瓦仪式无疑属于当代原住民生活的一部分，但突兀的提供这些与柯蒂斯的百年照片不太一致的形象，只能强化传统原住民的习俗才是"真正的"原住民生活方式的观念。

为了迎合观众对于"真正的"原住民生活的想象，

images have become iconic and other aspects of Native and non-Native American life have not. Indeed, while the exhibition includes pictures from the Northwest Coast and the intermontaine Plateau, the majority of pictures are from the Great Plains and Southwest, the locations of the Native groups most familiar through popular culture such as Hollywood Westerns.

"Sacred Legacy" also repeats Curtis' nostalgic construction of authentic Native culture being one before colonial contact. Text panels do not call attention to Curtis' manipulations of his models and his prints to eschew signs of intercultural exchange or modernity. In fact, the panel on the Southwest section states that Curtis' trips to the Southwest "afforded him an unusual glimpse into pre-white Indian life," a claim which denies the fact that the Southwest is actually one of the areas of the United States with the longest history of Native non-Native intercultural exchange and, importantly, conflict.[21]

In addition to presenting Native culture as timeless and unchanging, the exhibition creates a narrow understanding of Native identity that reinscribes stereotypes of the Indian as a noble savage. A wall panel with quotations from Indian people includes exclusively the words of men and identifies each speaker as a chief or military leader. On another wall panel, Great Plains Indians are describes as "warriors" who all demonstrate "emotional depth, fierce pride, and independence." This can support a false understanding of leadership being exclusively in the hands of military men, disregarding tribal differences in leadership, the many other roles played by men in indigenous communities, the important role of clan mothers and other women in community affairs, and the fact that Indian people do not all share the same personal strengths and personality types.

Some of the stereotypical messages of "Sacred Legacy" derive from the fact that the exhibition was re-curated at each venue. From the installation shots of exhibitions provided by Cardozo, it is clear that the local exhibition coordinators have freedom to emphasize what they see as most apt for their viewers (Fig.7). In June 2007 in Hanoi, for example, the curators installed a life-sized tipi in the middle of the exhibition space and hung the wall text up on boards which look like stretched skins. In Moldova exactly a year earlier (June 2006), the exhibition was displayed in an ethnography museum and the curators invited Native musicians and a pow-wow dancer to perform songs and dances rooted in tribal traditions at the opening. Tipis and pow-wows are certainly part of contemporary Native life, but to offer these images without counterbalancing ones less consistent with Curtis' century-old photographs can reinforce the idea that traditional Native practice is the only "authen-

图 7　2007 年越南河内"神圣的遗产"展览。照片来源：承蒙明尼苏达州明尼阿波利斯的克里斯托弗·卡多索先生提供。
Fig.7　"Sacred Legacy" exhibition on view in Hanoi, Vietnam, 2007. Photo: Courtesy of Christopher Cardozo Fine Art, Minneapolis, Minnesota.

卡多索的展览对于素材的选择以及不同地区的策展人对于现场的布置都作了相应调整，尽管如此，展览也不止于仅仅强化刻板印象。展览再现了柯蒂斯所认为的美国原住民文化是继承美国传统文化的一部分这一殖民主义观点。例如，有一段文字认为印第安人是"我们的原住民"。还有一段文字复制了《北美印第安人》中西奥多·罗斯福（Theodore Roosevelt）总统的一封信，称这个项目为宝贵的"美国人"事业，是这个国家的一座丰碑。

"神圣的遗产"是通过美国国务院推广的，为的是在国际上树立美国的正面形象，这增强了展览和国家主义的联系。正如越南展的新闻稿中所说，"美国政府赞助了这项介绍美国文化和民族的展览……通过相互理解，一个国家的不同民族间的关系变得更加紧密"。[22]

"神圣的遗产"符合美国国务院对于艺术展览进行赞助的传统，这一传统可以回溯到 20 世纪中叶。虽然更早一点，美国政府也和艺术机构、博物馆、出版社或非政府组织联合举办巡回展的案例，但从 1946 年举办的"进步美国艺术"展后，国际信息和文化事务办公室对艺术展产生了特别专注的兴趣。这些项目是"冷战"期间为了传播美国的影响力而进行的文化外交。起初，展览聚焦于前卫抽象艺术，以此作为美国外交自由的一种视觉表达方式。之后的展览中拓展了作品类型，通过仔细筛选展示作品，向特定地区的观众介绍美国文化，展示"高水平的美国文化成就"。"大使馆中的艺术"就是美国国务院的另一个艺术项目，此展在 1953 年由纽约现代艺术博物馆创办，10 年后，在约翰·F. 肯尼迪（John F. Kennedy）总统主政时期，由美国国务院接手。"大使馆中的艺术"如今仍然以私人与政府的合作形式延续，主要在美国国务院的外交场所举办短期展览，并且最近有了永久收藏。现代艺术博物馆与该项目的合作在 1970 年结束，政府方策展人接管了组织展览和制作展览图册

tic" Native lifestyle.

While the decisions behind Cardozo's exhibition materials and the installations of curators in diverse venues may have been tailored to meet viewers' assumptions about "authentic" Native life, these exhibitions did more than confirm stereotypes. They also reinscribed Curtis' colonialist presentation of Native American culture as part of the heritage of the United States. For example, one text panel identifies Indians as *"our* Native peoples." Another reproduces the letter from President Theodore Roosevelt, which was part of *The North American Indian,* and describes the project as valuable "American" work that serves as a monument to the nation.

The nationalist associations of the exhibition are reinforced by the fact that "Sacred Legacy" was circulated by the Department of State, whose exhibitions serve support the construction of a positive international image of the United States. As the press release for the exhibition of "Sacred Legacy" in Vietnam states, "The U.S. Government sponsors exhibits which introduce the cultures and peoples of the United States... Through understanding, the peoples of [all] nations grow closer together."[22]

"Sacred Legacy" fits within a tradition of State Department sponsorship of art exhibitions that dates back to the mid-twentieth century. While there are earlier examples of the U.S. government circulating exhibitions put together by arts organizations, museums, publications or Non-Government Organizations, the Office of International Information and Cultural Affairs began a dedicated interest in showing art with the short-lived "Advancing American Art" exhibition organized in 1946. These projects were designed to provide cultural diplomacy for spreading American influence during the Cold War. Initially the shows focused on avant-garde abstract art as a means of demonstrating a visual ex-

的工作。负责传播"神圣的遗产"的国际信息计划办公室是国务院的另一个机构,主要在外交机构以外的地方举办公众活动,包括在美国与当地公众之间建立联系。它继承了美国新闻署的职责。美国新闻署于1999年被取消,它过去作为管理富布莱特(Fulbright)项目的机构而为人所知。[23]

这些机构的工作都是通过文化外交建立美国和世界各地间的联系。除了彰显美国文化成就和展示宪法对于自由表达的承诺,还介绍了美国文化的许多其他方面,包括展现全国各地多样化的文化表达方式。早在"进步美国艺术"中,主办者就试图在国际展览中囊括来自不同地区和背景的艺术家。"大使馆中的艺术"和美国新闻署都努力想在他们的项目中引进有色人种和不同的移民群体。因此,大家有可能把"神圣的遗产"看成对于多元文化性的一种持续的承诺。但是,使用土著人的形象来表明美国的文化多样性,抹去了美国原住民独特的法律身份。他们和移民不一样,是完全的独立的土著民族。"神圣的遗产"在为外国观众构建美国知识时,没有展现美国土著民历史,也没有告诉他们原住民对于美国殖民控制的持续抗争。虽然展览组织者不太可能带着故意否定原住民主权的目的来构想展览,但我认为"神圣的遗产"还是实现了否定的效果。

考虑到展览的意义,举办柯蒂斯巡回展的时机选择显得意味深长。"神圣的遗产"首次举办于2005年,那个时候联合国正忙于一项重要的讨论,即联合国对于世界各地的土著人民应该承担什么责任。2007年是亚洲巡回展的时间,联合国通过了关于土著民族权利的宣言,这是一份长而复杂的文件,正式宣布了世界各地原住民有权保留他们的语言、宗教习俗和传统领地。[24] 美国是少数投票反对该声明的国家之一,还有几个移民殖民地国家也投了反对票,如澳大利亚、新西兰和加拿大。这些国家就此提供了各种解释,包括担心该宣言没有对"土著"提供明确的定义,以及认为联合国关于土著传统领地权的声明侵害了他们国家制定和实施条约的权力。如果该宣言实施的话,这些国家会遭受最大的损失,所以他们对于承认联合国在处理这些问题上的权力感到非常担忧。现在,2007年投票反对该宣言的这些国家要么已经反转了立场,要么已经公告准备这么做,注意到这一点非常重要。尽管美国在改变投票意见上还没有行动,但奥巴马(Obama)总统已经表达过,他认为美国正朝着那个结果前进。[25]

如果"神圣的遗产"表达的是美国和其土著民的关系有问题,那么这样的关系如何才能被国际观众看到,以及展览如何才能促使外国观众去思考他们自己与土著民的关系?我们可以在美国官员的话语中找到答案。

pression of America's democratic freedom. Later programs broadened the types of work included in exhibitions by carefully tailoring what was being shown as an introduction to American culture to audiences in specific geographic regions in order to demonstrate the "high level of American cultural attainment." Another State Department art program, Art in Embassies, was established by the Museum of Modern Art in New York in 1953 and taken up at the Department of State under President John F. Kennedy a decade later. AIE continues today as a private-public partnership dedicated to installing temporary exhibitions and, more recently, permanent collections, in the State Department's diplomatic facilities. The Museum of Modern Art's association with the program ended in 1970, and the Bureau's own curators took over the task of assembling exhibitions and producing brochures to go with them. The Office of International Information Programs, which circulated "Sacred Legacy" is another bureau in the Department dedicated to working out of diplomatic offices to create public programming including exhibitions that build ties between the U.S. and local communities. It inherited the responsibilities of the United States Information Agency, of USIA, which was abolished in 1999. The USIA is probably best known as the agency that used to supervise the Fulbright Program.[23]

Each of these organizations has served to build ties between the United States and communities throughout the world through cultural diplomacy. In addition to demonstrating American cultural achievements and manifest the constitutional commitment to free expression, exhibitions were designed to introduce aspects of American culture, including illustrating the diversity of cultural expressions across the country. As early as Advancing American Art efforts were made to include artists from a wide range of regions and backgrounds in international exhibitions. Both the AIE and the USIA made efforts to include people of color and members of different immigrant groups in their projects. Thus, it is possible to see the support of "Sacred Legacy" as part of an ongoing commitment to multicultural programming. However, using images of indigenous people to illustrate the cultural diversity of the United States erases the distinctive legal status of Native Americans, who, unlike immigrants, are members of distinct Native nations. In creating knowledge about the United States for foreign audiences, "Sacred Legacy" does not present this aspect of American history or inform them of ongoing Native struggles against American colonial control. While the organizers of the exhibition of are unlikely to have intentionally conceived of the exhibition with the purpose of denying Native sovereignty, I would argue that "Sacred Legacy" nevertheless accomplishes this denial.

2007 年，当"神圣的遗产"在新加坡裕廊区域图书馆展出时，帕特里夏·L.赫博尔德（Patricia L. Herbold）大使将展览对于美国文化多样性的赞美和东南亚国家对同样原则的承诺联系起来。但是和在美国一样，对于文化多样性的赞美，并没有导致这些国家和当地土著人民——例如马来人，就文化和财产权利进行认真协商。[26]

尽管大使的话没有鼓励观众将照片和现在的土著权利问题联系起来，但"神圣的遗产"的一些观众仍然识别出了柯蒂斯作品中的殖民主义暗示。雅加达邮报对一张照片中的一位阿帕奇人"（Apache，印第安人部落之一）被描述成"西部的泰山"（Tarzan，美国影片《人猿泰山》中的主人公）这一现象进行了评论。"他来自西部，也为了永恒的西部"。作者指出，"柯蒂斯已经成为了美国原住民文化作家最喜欢的攻击对象，他们声称他通过操纵照片拍摄'错误呈现历史'，并且通过对照片人物的理想化修改引起对过往怀恋的不切实际的态度。"[27]

柯蒂斯的作品还推动了当地组织者创作以本地土著群体为特色的展览规划。这样并置的目的可能是为了提供对比传统服装和音乐的机会，但是这也推动了对于不同殖民地人民所共有的历史的思考。以新西兰为例，在艾干提哥美术馆（Aigantighe Art Gallery）举办的"神圣的遗产"开幕式上，来自阿若亨诺学校（Arowhenua School）的毛利族小孩表演了特色节目。正如一篇题为《展览显示了文化平行线》的文章中所说，一看到这个开幕式，美国大使就评论道："毛利人和北美印第安人在面临的问题和对此进行的斗争等方面产生了共鸣……我观察了这里的白人和毛利人是如何互相影响的，似乎彼此之间非常尊重，但我并不否认挑战仍然存在。"[28]这样的话语不仅引发了对于不同原住民群体的比较，而且也引发了对于不同殖民政府的比较。

阿尔弗雷德·马丁·达根-克罗宁（Alfred Martin Duggan-Cronin）是德比尔斯联合矿山的一位爱尔兰员工，他拍摄班图人（Bantu，非洲最大的民族）的家长主义形象。当"神圣的遗产"来到结束了种族隔离的南非时，他拍摄的照片和柯蒂斯的作品并置，也引发了类似的对比（图 8）。[29]有可能"神圣的遗产"创造出了一种对于柯蒂斯作品的亲近感，超越了它展览所在的具体城市。在 2007 年，当展览经过亚洲和太平洋岛屿时，澳大利亚堪培拉的报纸和马来西亚的《新海峡报》提到了柯蒂斯，虽然这两个地方都没有举办过这个展览。两篇文章的作者都将柯蒂斯对于北美印第安人的展示和当地采用类似殖民主义策略的人种志照片作了比较。[30]这些事实表明，尽管"神圣的遗产"重复了柯蒂斯所主张的种族主义和爱国主义，且柯蒂斯作品中的这种政治压

The timing of the creation of the traveling Curtis exhibition is very significant in thinking about the meaning of the exhibition. "Sacred Legacy" was first organized in 2005. At the time the United Nations was engaged in an important debate about its responsibilities to indigenous people around the world. In 2007, the year of the exhibition's tour in Asia, the UN adopted the Declaration on the Rights of Indigenous Peoples, a long and complex document proclaiming the rights of Natives around the world to retain their languages, religious practices, and traditional territory.[24] The United States was one of the few countries to vote against the Declaration, along with several other settler colonies, such as Australia, New Zealand, and Canada. These countries offered various explanations for their dissent, including concern that the declaration did not offer a clear definition of "indigenous" and the belief that the UN's statement about indigenous rights to traditional land violated their own countries' authority to make and enforce treaties. These were some of the nations with the most to lose if the Declaration was enforced and they were clearly anxious about acknowledging UN authority on these issues. It is important to note that all of those who voted against the Declaration in 2007 have either reversed their position or declared their intention to do so. While no move has been made to change the United States' vote yet, President Obama has expressed his belief that the US is headed toward that decision.[25]

If "Sacred Legacy" expresses a problematic American relationship to its own indigenous people, how is this relationship seen by international viewers and how might the exhibition prompt foreign audiences to think of their *own* relationships to indigenous people? An answer might be found in the words of U.S. officials. When "Sacred Legacy" was installed at the Jurong Regional Library in Singapore in 2007, Ambassador Patricia L. Herbold connected the exhibition's celebration of the cultural diversity of Americans with Southeast Asia's commitment to the same principle. But as in the United States, the celebration of cultural diversity does not translate into a serious negotiation with indigenous people such as the Malays or the Orang Asal over cultural and property rights.[26]

While the Ambassador's words did NOT encourage audiences to link the photographs to current questions of indigenous rights, some viewers of "Sacred Legacy" nevertheless identified the colonialist implications of Curtis' work. A review in the *Jakarta Post* describes an Apache man in one photograph as "Tarzan of the West. He is of the West and for the eternal West." The author notes that "Curtis has become the favorite target of writers on Native American culture who claim that he 'misrepresented history' by staging his photographs and having a romantic attitude by idealizing his

图 8 A.M. 达根克罗宁，《南非班图人：摄影研究的再现》（英国剑桥：戴顿出版公司，1935）卷 4，亨利·P. 朱诺，《瓦松加（松加尚加族人民）》，插图 32。照片来源：http://www.gutenberg-e.org/。

Fig.8 A. M. Duggan-Cronin, *The Bantu Tribes of South Africa: Reproductions of Photographic Studies*（Cambridge, U.K.: Deighton, 1935），vol. 4, Henri P. Junod, *The Vathonga*（*The Thonga-Shangaan People*），plate 32. Photo: http://www.gutenberg-e.org/.

制是符合美国当时的利益的，但国际巡回展推动了对于艺术和殖民主义关系的讨论。

"大使馆中的艺术"项目举办的柯蒂斯照片展与"神圣的遗产"中所使用的照片完全不同，而对这段历史做一个简短介绍能更好地说明"神圣的遗产"所做的文化工作。"大使馆中的艺术"将柯蒂斯的照片列入特定场所进行长期展示的展览名单中。事实上，在现代艺术博物馆组织的首场展览中，有一位原住民艺术家参展，该展览随后在 1953 年由"大使馆中的艺术"接手。尽管此后数十年的展览记录并不完整，但是有几位在世的原住民艺术家与圣达菲原住民艺术学校（由美国政府赞助）有联系，他们的作品在 20 世纪六七十年代在大使馆中展出过。在 21 世纪，弗里茨·施哥尔德（Fritz Scholder，路易赛诺族 [Luiseño]）、埃米·怀特霍斯（Emmi Whitehorse，纳瓦霍族 [Navajo]）、诺曼·埃克斯（Norman Akers，欧塞奇族 [Osage]）、拉里·阿卡瓦纳（Larry Ahkavana，因纽皮亚特族 [Inupiat]）和萨利·蒂伦（Sally Thielen，齐佩瓦族 [Chippewa]）参与了"大

figures and invoking nostalgia for the past."[27]

In several venues, the exhibition of Curtis' work prompted local organizers to create programming featuring members of local indigenous groups. Such juxtapositions may have been planned with the goal of offering the opportunity to compare traditional dress or music, but they also prompted a meditation on the common histories of colonized people. In New Zealand, for example, the opening of "Sacred Legacy" at the Aigantighe Art Gallery featured a performance by Maori children from the Arowhenua School. As an article titled "Exhibition reveals cultural parallels" states, upon witnessing this, the American Ambassador remarked on the "real resonance between the issues and the struggles of the Maori and the North American Indians...I look at how Pakeha（European settlers）and Maori interact here and there seems to be mutual respect. I'm not denying that challenges still exist."[28] Such words not only invite comparisons between different Native groups but also between different settler governments.

A similar comparison was prompted by the juxtaposition of Curtis' work with photographs by Alfred Martin Duggan-Cronin, an Irish employee of De Beers Consolidated Mines who made paternalist representations of Bantu people, when "Sacred Legacy" traveled to post-Apartheid South Africa[29]（Fig.8）. It may also be the case that "Sacred Legacy" created a familiarity with Curtis' work beyond the specific cities in which it was shown. In 2007, while the exhibition traveled through Asia and the Pacific Islands, Curtis was mentioned in newspapers from Canberra, Australia and New Straits Malaysia, though neither city was recorded as hosting the show. In each case the authors compared Curtis' representations of North American Indians with local ethnographic photographs that deployed similar colonialist strategies.[30] These reactions show that, while "Sacred Legacy" reasserted Curtis' racism and nationalism, and while this suppression of the politics of Curtis' work was in line with the United States interests at the time, the international tour of the exhibition prompted discussions about the relationship between art and colonialism.

The exhibition of Curtis photographs by the Art in Embassies Program is fairly different from their use in "Sacred Legacy," and a brief discussion of this history further illustrates the cultural work done by "Sacred Legacy." Art in Embassies has included Curtis photographs in exhibitions created for display in specific locations for a long time. In fact, a Native artist's work was included the first exhibition organized by MOMA for what was to become the AIE in 1953. While records of exhibitions from the following decades are incomplete, several living Native artists associated with the U.S. Government-sponsored Native art school

使馆中的艺术"许多展览。与柯蒂斯展示的美国原住民不同，这些艺术家来自美国各地，能够深入了解现代印第安人所面对的不断变化的美学、文化和经济现实，而这正是他们作品的素材和主题所要展示的内容。

值得注意的是，"大使馆中的艺术"有柯蒂斯的作品，也有许多当代土著艺术家的艺术作品，含蓄地对抗了柯蒂斯的怀旧信息。例如，2007年在摩尔多瓦基希讷乌举办的展览中，包含了柯蒂斯和霍皮族画家丹·纳明哈（Dan Namingha）的作品。纳明哈对于色彩和抽象主义的运用说明他从事的是现代主义绘画——但他不认为这与他的原住民身份不一致。柯蒂斯的长达百年之久的照片和活着的印第安民族的创造性作品并置，直接促使观众去比较土著民的形象，去思考两位作者的作品，他们都是有创造力的艺术家，密切结合了各自时代的美学趋势。这么做削弱了只有柯蒂斯作品才是真实印第安人形象的看法。

在"神圣的遗产"举办巡回展的时间段里，"大使馆中的艺术"项目拿到了特里吉特族（Tlingit，印第安人的部落之一）当代摄影师拉里·麦克尼尔（Larry McNeil）的几件作品，这些作品用批判性的历史镜头复制了柯蒂斯的照片（图9）。"大使馆中的艺术"曾委托原住民艺术家创作了一套石版画，并将之作为当代土著作品的固定收藏来展出，这些作品是固定收藏的一部分。这套作品促使观众去思考，原住民如何处理自身美国人的经历和部落公民的身份。麦克尼尔的两件作品将柯蒂斯的代表作"消逝的种族"系列照片摆在一片带有乌鸦图片的蓝色背景中。在西北海岸印第安文化中，乌鸦是一个重要形象，它既是印第安人的保护者，又是一个向人们展示骗术和难题的狡猾形象。乌鸦的出现促使我们仔细地观看柯蒂斯的作品，这时我们看到麦克尼尔很巧妙地改变了作品，插入了一些违反照片永恒性的细节。印第安人正在看着一辆麦克尼尔所认为的"雷兹汽

图9 拉里·麦克尼尔，"黎明，冬至"，2007年。照片来源：承蒙拉里·麦克尼尔提供。

Fig.9 Larry McNeil, First Light, Winter Solstice, 2007. Photo: Courtesy of Larry McNeil.

in Santa Fe had work displayed at embassies in the 1960s and 1970s. In the twenty-first century, artists such as Fritz Scholder （Luiseño）, Emmi Whitehorse （Navajo）, Norman Akers （Osage）, Larry Ahkavana （Inupiat） and Sally Thielen （Chippewa） have been included in numerous AIE exhibitions. Unlike the Native Americans represented by Curtis, these artists hail from across the United States and their work engages materials and themes that demonstrate their deep engagement with the changing aesthetic, cultural, and economic realities faced by modern Indian people.

Significantly, in a large number of cases where Curtis photographs have been seen in AIE exhibits, art work by contemporary indigenous artists was also on display, implicitly countering Curtis' message of nostalgia. For example, in 2007, an exhibition in Chisnau, Moldova, included both Curtis photographs and works by the Hopi painter Dan Namingha, whose use of color and abstraction demonstrate his engagement with Modernist painting—an engagement he does not find inconsistent with his Native identity. The juxtaposition of Curtis' hundred-year-old images with the creative work of living Indian people directly prompts viewers to compare and contrast the representations of indigeneity as well as to think about the work of both producers as creative artists engaged with the aesthetic trends of their time. In so doing, the power of Curtis' work to create an image of the authentic Indian is diminished.

During the years of the "Sacred Legacy" tour, the Art in Embassies Program acquired several works by contemporary Tlingit photographer Larry McNeil, which reproduce Curtis' photographs through a critical historical lens （Fig.9）. These pieces were acquired as part of a portfolio of lithographs by Native artists commissioned by the AIE to allow them to have a permanent collection of contemporary indigenous work for circulation. The portfolio challenges viewers to think about the ways Native people negotiate their experiences as Americans and their identities as tribal citizens. McNeil's two pieces situate iconic Curtis "Vanishing Race" images in a blue field filled with pictures of Ravens. Raven is an important figure in Northwest Coast Indian culture, where he serves both as a protector of Indian people and a trickster who presents people with deceptions and puzzles. His presence prompts us to look closely at Curtis' work and, when we do, we see that McNeil has subtly altered it, inserting details that violate the photographs' timelessness. The Indians are looking at what McNeil identifies as a "Rez car"—a broken down, perhaps even abandoned vehicle that can be found on many reservations. As he put it, "This image is a revised mythological view of Indians because it includes a Rez car and is not the romanticized

车"——一辆在很多印第安人居留地上都可以找到的坏掉的、甚至或许是被遗弃了的车辆。正如他所说明的，"这张图片是修改过的、虚构的印第安人景象，图片中的汽车改变了那种把印第安人当作消逝的种族进行传奇化的做法。"[31]

在麦克尼尔的网站上，他写道："创作一些作品，让这些作品成为我们特殊的大使，这种想法我喜欢。作为美国人，我曾想过我们究竟是谁，土著以及众所周知的'熔炉'共同构成了我们的身份。我想到了早期的牛仔和印第安人电影，它们塑造了世界对于我们是谁的看法，那更像是一个虚构。"然后，他专门提到柯蒂斯："19世纪到20世纪，许多关于印第安的照片（由非印第安人拍摄的）采用了传奇化的深褐色视图，它们暗含的信息是我们来自于过去，而非存在于当下。我通过再次使用这种特殊色调的照片来消遣印第安人来自过去这一观点，将这些照片带到当下的作品中做法，不过是一个让我们可以会心一笑的狡猾玩笑而已。如果我们可以知道这些刻板印象的信息，并且嘲笑它们，那么就是知道这些观点的确有一点荒唐，这样我们就能够以一种好的方式继续前进。"[32]正如麦克尼尔所认为的，将柯蒂斯的理想化的过去和更具不确定性的未来并置，使得观众容许我们以"继续前进"的方式面对殖民主义历史，这种方式是诸如"神圣的遗产"这样的展览所不具备的。

由美国国际信息计划办公室和"大使馆中的艺术"项目举办的展览，并不想获得国际艺术媒体的关注。然而，通过向全球观众介绍美国艺术的方式，这些展览成为传播文化政治的重要场所。不单是艺术品本身，选择什么来展示，如何将不同作者的作品并置，以及解说材料包含什么，都会影响观众的反应。展览场地的布置以及开幕式上的表演会进一步主导观众的感受，使得他们将艺术，艺术所处的文化背景，以及观众自己的文化背景联系起来。更密切地关注这些问题使我们看到，美国政府的两个机构对于爱德华·柯蒂斯照片的不同呈现方式，造成了对美国原住民文化和身份的截然不同的理解。"感谢你向我展示我的文化。"——这是卡多索为之骄傲的评论，而一个能让全球观众正视历史并且接受历史的展览可能才是配得上这样评价的展览。

view of Indians as being a vanishing race."[31]

On his website, McNeil writes, "I love the idea of making art that was designed to act so specifically as an ambassador for our people. I was thinking of who we really are as Americans, both Indigenous and the proverbial "melting pot" that forms our collective identity. I was thinking of early Cowboy and Indian films that formed the world's perception of who we are, especially as a mythical place." And then he specifically references Curtis: "A lot of the photographs of Indians （made by non-Indians） in the 19th and 20th centuries are romanticized sepia views whose implied message has us as being from the past and certainly not the present. By using this sepia toned photograph I am playing with the perception that Indians are only in the past and bringing them right into the present, and doing it with a bit of a sly joke that we can chuckle about. If we can take outdated stereotypical ideas and laugh about them, we acknowledge that they were indeed a bit absurd and we can move on in a good way."[32] As McNeil sees it, the juxtaposition of Curtis' idealized past and more problematic future allows viewers to confront colonial history in a way that allows us to "move on," in a way that exhibitions such as "Sacred Legacy" do not.

The exhibitions organized by the United States Office of International Information Programs and the Art in Embassies program are not intended to garner the attention of the international art press. Yet, by offering global audiences an introduction to American art, they are an important venue for the spread of cultural politics. The choices of what to display, how to juxtapositions objects by different makers, and what to include by way of explanatory materials can all shape the response viewers have not only to the works of art. The venues in which these exhibitions are installed and the events staged around exhibition openings can further shape the audience's experience and invite them to make connections between the art, the culture from which it hails, and their own cultural context. Close attention to these issues allows us to see that the presentation of Edward Curtis photographs by two United States government agencies evoked very different understandings of Native American culture and identity. Exhibitions that allow global audiences to confront history and come to terms with it may be the ones that most deserve the comment Cardozo is so proud of: "Thank you for showing me my culture."

Notes:

1 This and other information about the "Sacred Legacy" exhibition comes from Christopher Cardozo's website, www. edwardcurtis.com.

2 Edward S. Curtis. *The North American Indian* 20 vols. Cambridge: The University Press, 1907—1930. Biographical information on Curtis can be found in Mick Gidley. *Edward Curtis and the North American Indian Incorporated.* New York: Cambridge University Press, 1998.

3 I am grateful to Mr. Cardozo for granting me a telephone interview on July 31, 2013 and sharing information about the exhibition with me.

4 Cardozo, interview 7/31/13.

5 Cardozo interview 7/31/13 and emails between myself and United States Department of State employees Virginia Shore and Alan Cross, November 13, 2013.

6 Michael Charles Tobias. "J.P. Morgan, Edward Curtis, and Christopher Cardozo: An Inspired Collaboration," *Forbes* tech blog Apr.2,2013（http://www.forbes.com/sites/ michaeltobias/2013/04/02/j-p-morgan-edward-curtis-and-christopher-cardozo-an-inspired-collaboration/）accessed Dec.9,2013.

7 "Sacred Legacy: the Five Year Vision"（issuu.com/Cardozo/ docs/5yearvision）accessed Jan.6.2014.

8 Curtis. *op. cit.,* caption to plate 1, volume 1.

9 A scholarly treatement of the history of the Navajo Nation can be found in Peter Iverson. *Diné: a history of the Navajos.* Albuquerque: University of New Mexico Press, 2002. For the Nation's own presentation of their history, see http://www. navajo-nsn.gov/history.htm.

10 Renato Rosaldo. "Imperialist Nostalgi". *Representations* 26 1989（Spring）: 107-122.

11 An introduction to American Indian policy during the period before and after Curtis began his project can be found in Francis Paul Prucha. *The Great Father: The United States Government and the American Indians.* Lincoln: University of Nebraska Press, 1984.

12 Christopher M. Lyman. *The Vanishing Race and Other Illusions: Photographs of Indians by Edward S. Curtis.* New York: Pantheon Books, in association with the Smithsonian Insitution Press, 1982. 86.

13 An introduction to the constructed political meanings of photographic images can be found in John Tagg. *The Burden of Representation: Essays on Photographies and Histories.* Minneapolis: University of Minnesota Press, 1988. 1-34

14 Gidley. *op. cit.* 11.

15 C. Hart Merriam in Timothy Egan. *Short Nights of the Shadow Catcher: the epic life and immortal photographs of Edward Curtis.* Boston: Houghton Mifflin Harcourt, 2012. 186.

16 A thoughtful discussion of Native American sovereignty can be found in Joanne Barker. *Sovereignty Matters. Locations of Contestation and Possibility in Indigenous Struggles for Self-Determination.* Lincoln: University of Nebraska Press, 2005.

17 Lyman. *Op Cit.* Anishinaabe literary critic Gerald Vizenor offers a more complex approach to these issues in his essay for the Library of Congress, "Edward Curtis: Pictorialist and Ethnographic Adventurist" ,2000. http://memory.loc.gov/ ammem/award98/ienhtml/essay3.html#17 accessed 1/6/14.

18 Mick Gidley. *Edward S. Curtis and the North American Indian project in the field.* Lincoln: University of Nebraska Press, 2003; Alan Trachtenberg. "Ghostier Demarcations". in *Shades of Hiawatha: Staging Indians, Making Americans, 1880—1930.* New York: Macmillan, 2005. 170-210. See also Shamoon Zamir. "Native Agency and the Making of the North American Indian: Alexander Upshaw and Edward S. Curtis". *American Indian Quarterly* 31.4 2007（Fall）: 613-653 and Brad Evans. *Return to the Land of the Head Hunters: Edward S. Curtis, the Kwakwaka'wakw, and the Making of Modern Cinema.* University of Washington Press, 2014.

19 *Coming to Light: Edward S. Curtis and the North American Indians.* Bullfrog Films, 2005 directed by Anne Makepeace.

20 Cardozo. interview 7/31/13.

21 This quotation and all following come from transcripts of wall texts which were sent to me by Cardozo on 7/31/13.

22 "Sacred Legacy" Exhibition Opens in Hanoi, press release issued by the American Embassy in Vietnam, June 4, 2007, archived at Vietnam.usembassy.gov/pr060407.html（accessed Jan. 6,2014）.

23 For a discussion of "Advancing American Art," see *Art Interrupted: Advancing American Art and the Politics of Cultural Diplomacy.* Athens: Georgia Museum of Art, University of Georgia, 2012. For a history of the Art in Embassies（AIE）program see art.state.gov/history.aspx （accessed Jan. 6,2014）The quotation is from Senator Thomas J. McIntyre of New Hampshire, said in Congress 1965 and quoted on the AIE website. Additional information about the Art in Embassies program comes from an interview conducted with former AIE curator Diane Tepfer on Aug.5,2013. For the Office of International Information Programs, see www.gate.gove/r/iip.

24 The text of the declaration can be found here: www.un.org/esa/ socdev/unpfii/documents/DRIPS_en.pdf.

25 http://en.wikipedia.org/wiki/Declaration_on_the_Rights_of_ Indigenous_Peoples accessed Dec 9,2013.

26 Herbold's remarks of Oct.16, 2007 can be found at http:// singapore.usembassy.gov/sp_sacredlegacy.html（accessed Jan.6,2014）. For a discussion of indigenous rights issues in Southeast Asia, see the website of the International Work Group for Indigenous Affairs: http://www.iwgia.org/（accessed Dec.9,2013）.

27 Eilish Kidd. "Sacred Legacy: Picturing the oasis in the badlands". *Jakarta Post* Jan.19, 2008.

28 "Exhibition reveals cultural parallels," *Fairfax (NZ) News* Jan.9.2007.

29 Sean O'Toole. "Flipping the Portrait," *Sunday Times*. South Africa. Dec 6, 2009.

30 "Mirror images Cover Story". *The Canberra Times*. June 1, 2007; Lucien de Guise. "Taking a breath of fresh air and fuel" *New Straits Times*. May 31, 2007.

31 http://www.larrymcneil.com/index.php#mi=2&pt=1&pi= 10000&s=24&p=1&a=0&at=0, "Image info" (accessed Dec.9,2013).

32 http://www.larrymcneil.com/index.php#mi=2&pt=1&pi=1000 0&s=24&p=1&a=0&at=0 (accessed Dec.9,2013).

Suggestions for Further Reading:

[1] Anthes Bill. *Native Moderns.* Durham, NC: Duke University Press, 2007.

[2] Bhabha Homi. *The Location of Culture.* London and New York: Routledge, 2004.

[3] Bolton Richard, ed. *The Contest of Meaning: Critical Histories of Photography.* Cambridge: MIT Press, 1992 (1989).

[4] Deloria Phil. *Indians in Unexpected Places.* Lawrence, KS: University of Kansas Press, 2004.

[5] Deloria Vine, ed. *American Indian Policy in the Twentieth Century.* Norman, OK: University of Oklahoma Press, 1985.

[6] Hutchinson Elizabet. *The Indian Craze.* Durham, N.C.: Duke University Press, 2009.

[7] Lippard Lucy. *Partial Recall.* New York: New Press, 1992.

[8] Rushing W. Jackson, ed. *Native American Art in the Twentieth Century.* New York: Routledge, 1999.

[9] Said Edward. *Orientalism.* New York: Vintage Books, 1994 (1977).

[10] Sontag Susan. *On Photography.* New York: Farrar, Strauss and Giroux, 2001 (1977).

[11] Truettner, William, et. al. *The West as America.* Washington, D.C.: Smithsonian Institution Press, 1991.

[12] Vizenor Gerald. *Fugitive Poses: Native American Indian Scenes of Absence and Presence.* Lincoln, NB: University of Nebraska Press, 1998.

太平洋之魅：战后巴黎的美国西部艺术

A Fascination with the Pacific: The Reception of West Coast American Art in Postwar Paris

凯瑟琳·朵欣　赵德阳＊译

Catherine Dossin　Translator: Zhao Deyang

从 2010 年开始，我一直在研究冷战时期西欧如何接受美国艺术这一课题。这一课题研究的实际目的是准确的表述在 1945—1970 年欧洲人所了解的美国艺术，并尽可能准确梳理在此期间美国艺术在欧洲传播的一系列标志性事件。为避免简单、笼统的回顾，此项研究应从三个最简单的问题切入：西欧人能看到的美国艺术是怎样的？什么时候看到的？在哪里看到的？要回答这些简单的史实问题，我先得为战后欧洲所举行过的美国艺术展览编出年表。虽然搜寻、编辑记录的工作让人生畏，但这对于重现那个时代欧洲文化的改变，重现美国艺术的各种表现都是极为必要的，更重要的是，它可以帮助我们跳出所谓的"美国艺术胜利"的不朽神话及与之相关的各种假说。[1]

ARTL@S：基于网络的展览数据检索系统

这份关于美国艺术展览的研究是名为 ARTL@S 的一项大型工程的一部分。该项目由比阿特里斯·茹瓦耶·普吕内尔（Béatrice Joyeux-Prunel）于 2009 年在巴黎的高等师范学院（École Normale Supérieure）发起，它将艺术史学家、历史学家以及对与视觉艺术史相关的社会问题、跨国问题感兴趣的地理学家汇聚在一起。力图建立起对本学科史料数据进行俘获、组织、分享，以及视觉化的特定方法。正因如此，ARTL@S 通过强调定量分析（就像叙事文学中的比较和专题研究），并引入地理学的分析方法（比如超越国家主义的视角）来重建艺术史。[2]

ARTL@S 含有四个相互联系的部分或系统。（全部基于数字媒体）（图 1）

□ 科研部分：一个国际性、跨学科、不断成长的学者团体，进行独立研究与合作性研究，承担组织学术会议，开展两月一次的学术讨论等任务。

Since 2010, I have been working on the reception of American art in Western Europe during the Cold War. The underlying ambition of this project is to plainly establish what Europeans could have known about American art during that period and to retrace, as accurately as possible, the chain of events that marked the dissemination of American art through Europe from 1945 to 1970. In order to avoid a retrospective or omniscient outlook, the investigation began with three straightforward questions: What could Western Europeans see of American art? When could they see it? And where could they see it? In order to answering these simple factual questions, I had to first establish the chronology of exhibitions and publications of American art in postwar Western Europe. Although tracking and compiling the records was a daunting task, it was a necessary for reconstructing Europeans' shifting and diverse representations of American art throughout the period, and, most importantly, for moving beyond the enduring myths and swift assumptions that surround the so-called "Triumph of American Art."[1]

ARTL@S: a Web-Based Atlas of Exhibitions

This research project on exhibitions of American art is part of a larger research initiative, called ARTL@S. Launched in 2009 at the École Normale Supérieure in Paris by Béatrice Joyeux-Prunel, ARTL@S bring together art historians, historians, and geographers interested in social and transnational issues pertaining to the history of the visual arts. Our ambition is to establish discipline-specific methods of capturing, organizing, sharing, and visualizing historical data. As such, ARTL@S is a part of a broader trend that aims at renewing the discipline of art history by giving greater importance to quantitative analyses（as a counterpoint to narrative and monographic studies）and by adopting a geographic approach（as a

＊　赵德阳 福建师范大学美术学院副教授（Zhao Deyang Associate Professor，Academy of Fine Arts，Fujian Normal University）

图1 Artl@s 的组织结构图表。
Fig.1 Artl@s's Organization chart

□ BasAr：一种"后全球展览信息数据系统"（a Post-GIS database of exhibitions），在这里，ART@s 全体成员能够储存、整理、研究和分享所有数据。

□ 图形系统（Maps）：两个具有交互作用的全球信息系统（GIS）界面，分别面向学者和公众。在 BasArt 上提出的不同层面的疑问通过此系统可以自动生成完备的地理分布图和图表，并执行空间分析（译者注：空间分析 spatial analysis，是基于地理对象的位置和形态的空间数据的分析技术，其目的在于提取和传输空间信息，是地理信息系统的主要特征）。

□ ARTL@S 简报：一本致力于推动空间化历史研究的学术期刊，与法国高师（Ecole Normale Supérieure，ENS）以及法国科学研究中心（CNRS）合作出版，由普渡大学出版社支持其在线阅读。

ARTL@S 的最终目标是使史学家可以通过对各国研究成果的数据和图形分析，对学术界内的某些定论，尤其是对中心和边缘的关系的定论提出质疑，使得各国学者共同书写一个全球、动态化的视觉艺术史。

在欧洲举办的美国艺术展览：
纽约画派 vs. 太平洋画派

通过 BasArt，我们收集到了 1945—1970 年在欧洲举办过的美国艺术展览的统计数据，并在全球信息系统的页面中对这些数据进行视觉化处理，由此，我能够指出"美国艺术的胜利"这一惯用说法中存在的几个历史性问题。其中一项涉及战后在欧洲的几位美国艺术家的名誉——马克·托比（Mark Tobey），萨姆·弗朗西斯（Sam Francis）等其他与太平洋画派（School of the Pacific）有关的艺术家。如今，人们并不把他们作为美国战后艺术

means to move beyond nationalistic perspectives）.[2]

ARTL@s is developing four interconnected （digital） environments （Fig.1）：

□ *Research*: an international, multidisciplinary, and ever growing group of scholars that undertake independent and collective research, organizes conferences, and holds bi-monthly seminars;

□ *BasArt*: a Post-GIS database of exhibitions, where ARTL@s members can store, organize, study, and share their data with other scholars;

□ *Maps*: two interactive GIS interfaces, one for scholars and one for the public, which can query BasArt at different levels to automatically generate complicated maps and graphs and perform spatial analysis;

□ ARTL@s *Bulletin*: a scholarly journal devoted to the promotion of a spatial （digital） history; co-published by the ENS and the Centre Nationale de la Recherche Scientifique （CNRS）. The online version of the ARTL@s *Bulletin* is hosted by Purdue Scholarly Publishing Services.

With ARTL@s, our ultimate goal is to enable historians to question canonical narratives, in particular centres-peripheries relationships, through quantitative and cartographic analyses of transnational circulations, and to collectively write a global, circulatory history of the visual arts.

Exhibitions of American Art in Europe: The New York School vs. The School of the Pacific

Collecting data on exhibitions of American art in Western Europe from 1945 to 1970, processing them through *BasArt*, and visualizing them on the GIS interface of ARTL@s has enabled me to expose several historiographical problems in the canonical narrative of the "Triumph of American Art." One of them pertains to the reputation in postwar Europe of Mark Tobey, Sam Francis and other American artists who were associated with the so-called School of the Pacific. Today these artists are not part of the pantheon of American postwar art; yet, in the 1950s they were regarded in Paris, and more widely in Western Europe, as the most original, most genuine, and most important American painters. They were also, as my data shows, the most exhibited American artists in Europe at the time.

As surprising as it may sound today, artists such as Mark Rothko, who have come to be regarded as major figures of postwar international art, were actually hardly visible on the international art scene in the 1940s and 1950s. In Rothko's case, it was not until the late 1950s that the artist began to attract significant attention. Between 1945 and 1950, Rothko was included in only two European shows. During the entire decade of the 1950s, he did not participate

家中最具代表性的人物，但是在 20 世纪 50 年代的巴黎乃至整个西欧，他们被认为是最具原创性、最有才华、最重要的美国艺术家。数据显示，在当时的欧洲，他们确实也获得了最多的展览机会。

也许下面将要列举的事实会令今天的人们感到惊诧：比如马克·罗斯科（Mark Rothko），虽然被认为是战后国际上声名显赫的大家，然而在 20 世纪 40 年代的国际展览中，几乎看不到他的作品。1945—1950 年，只有两个欧洲展览中出现了他的作品，由于他的作品没有足够的曝光率，整个 20 世纪 50 年代，西欧人几乎不知道他的存在（图 2），罗斯科引起大家的重点关注是在 20 世纪 50 年代末期。1958 年后，得益于现代艺术博物馆（MoMA）国际项目中一系列展览的推进，他的情况才开始改变（图 3）。如果再关注一下此时间段内，欧洲媒体发表的文章中涉及罗斯科的文章数量，我们会更加清楚地发现他所得到的关注之少：在 1957 年前的欧洲评论界，我几乎找不出任何关于他的文章，甚至在他成名后得到的关注和评论依然不多（图 4）。[3]

经过比较发现，罗斯科、杰克逊·波洛克（Jackson Pollock）、威廉·德库宁（Willem de Kooning）和罗伯特·马瑟韦尔（Robert Motherwel）等这些通常被称为纽约画派的艺术家们所得到的展览机会不如托比、弗朗西斯多，得到的公众关注也少（图 5）。当我们回顾这些艺术家在法国的表现时，这种差距就显得更加夸张。事实上，在 1945—1962 年，弗朗西斯和托比是获得展览机会最多的美国艺术家（图 6）。

这些数据只能展示欧洲或者巴黎的公众对战后美国艺术认知的概况。为了更好地理解欧洲人对不同的美国艺术家的熟悉度，我们需要考虑其他的因素，比如艺术家所参加的大型国际展览的情况（如在战后欧洲艺术界占有非常重要的地位的威尼斯双年展的情况）。托比在 1948 年、1956 年和 1958 年三次代表美国参加威尼斯双年展，获得了威尼斯绘画奖[4]，而波洛克从来没有出

in enough shows for Western Europeans to be familiar with his work （Fig.2）. Only after 1958 did the situation start changing thanks to a series of exhibitions that the International Program of the Museum of Modern Art （MoMA） sent to Europe （Fig.3）. If we consider the number of articles in European press mentioning Rothko during this period, his lack of visibility is even more obvious: I did not find any mentions of Rothko in European specialized and non-specialized press before 1957. Even later, he received little critical attention considering the number of shows in which he was then featured （Fig.4）.[3]

Comparing the exhibition records of Rothko, Jackson Pollock, Willem de Kooning, and Robert Motherwell, artists commonly associated with the New York School, with those of Tobey and Francis, it is obvious that the former were featured in fewer exhibitions and were less visible than the latter （Fig.5）. In particular, if we consider the situation in France, the gap between the New York and Pacific artists is even greater: Francis and Tobey were by far the most exhibited and visible American artists in Paris from 1945 to 1962 （Fig.6）.

These figures can only be considered as rough indications of what the European or Parisian public could have known about American postwar art. To better understand the familiarity Europeans could have had with different American artists, we need to consider other factors, for instance, artists' participation in major international shows, such as the Venice Biennale, which played an important role in the European postwar art world. While Tobey represented the United States in Venice three times, in 1948, 1956 and 1958, when he was awarded the Painting Award of the city of Venice,[4] Pollock was never featured in the US pavilion. In 1948, two of his works were shown in the Greek pavilion as part of the Peggy Guggenheim's collection of Abstract and Surrealist art, where they received little attention.[5] In addition to being featured thrice in the US pavilion, Tobey's work was also represented in 1952 at the Venice Film Festival through Robert Gardner's documentary *Mark Tobey, the Artist*,

图 2　马克·罗斯科在西欧的展览，1945—1956 年。
Fig.2　Exhibitions of Mark Rothko in Western Europe, 1945—1956

图 3　马克·罗斯科在西欧的展览，1945—1962 年。
Fig.3　Exhibitions of Mark Rothko in Western Europe, 1945—1962

Exhibitions in Western Europe, 1945-1962

Articles mentioning Rothko in European Press

■ 1945-1950 ■ 1951-1956 ▫ 1957-1962

图4 在欧洲所出版的有关罗斯科的文章，1945—1962 年。
Fig.4 Articles Mentioning Rothko in the European Press, 1945—1962

图5 美国艺术家在西欧的展览对比图表，1945—1962 年。
Fig.5 Comparative charts of exhibitions by American artists in Western Europe, 1945—1962

现在美国展馆内。1948 年，两幅波洛克作品作为佩吉·古根海姆（Peggy Guggenheim）的抽象和超现实主义的收藏在希腊展出，但并未受到过多的重视。[5] 除此之外，在 1852 年的威尼斯电影节中，罗伯特·加德勒（Robert Gardner）在纪录片《马克·托比，艺术家》中再现了托比的作品，此片陆续出现在后续几次欧洲电影节中。

另外，需重点考虑的因素还包括：这些艺术家进入公众视野的展览是群展还是个展？展览是在一个小画廊举办的还是在专业的博物馆举办的？这些展览是由美国主动输出的还是欧洲人邀请并且组织的？除去过多的细节，有一个需要注意的现象是波洛克和罗斯科在欧洲最早的展示源于佩吉·古根海姆（Peggy Guggenheim）的收藏。在 1948—1957 年，波洛克展出的 52% 的作品都是通过这种展览形式出现。展览中，波洛克、罗斯科和马瑟韦尔以年轻艺术家的形象出现，在巴勃罗·毕加索（Pablo Picasso）、康斯坦丁·布朗库西（Constantin Brancusi）、瓦西里·康定斯基（Wassily Kandinsky）、比特·蒙德里安（Piet Mondrian）等欧洲大师中显得黯然失色。即使波洛克的绘画可以代表自己的风格，罗斯科的水粉画和马瑟韦尔的拼贴却难以引起更多注意。[6] 反观托比，他早期的大部分展览都是在美国艺术展中出现，在这样的背景下，他的个人能力得到了充分展示。

如果对比一下波洛克和托比在巴黎的个展，同样能说明问题。1952 年，波洛克第一次在法国巴黎举行个人展览。所用的场地是摄影师保罗·法凯梯（Paul Facchetti）的工作室改建成的临时画廊。法国音乐家和诗人米歇尔·塔皮（Michel Tapié）从当时居住在巴黎的美国艺术家阿尔方索·奥索里奥手里借了他的一部分藏品才把展览组织起来。这次展览不论在学术上和商业上都不算是成功的。[7]《法国文学》（Lettres Françaises）刊登了皮埃尔·德卡尔格(Pierre Descargues)的一篇短篇评论，把波洛克描述成"现代艺术的一分子"（atomiste de l'art modern.）[8] 展览中只有

Exhibitions in Paris, 1945-1962

图6 美国艺术家在法国的展览对比图表，1945—1962 年。
Fig.6 Comparative charts of exhibitions by American artists in France, 1945—1962

which was subsequently presented at several film festivals in Europe.

Another important factor that has to be considered is whether the American artists were included in a group show or given a solo exhibition, whether the show took place in a small gallery or at a major museum, and whether the exhibition was sent from the United States or organized in Europe by Europeans. Without going into too many details, it is important to note that most early European showings of Pollock and Rothko could be traced to Peggy Guggenheim's collection. Fifty two percent of all Pollock paintings shown in Western Europe between 1948 and 1957 were presented as part of Peggy Guggenheim's collection. In these exhibitions, Pollock, Rothko and Motherwell appeared as junior figures, overshadowed by the towering reputation of Pablo Picasso, Constantin Brancusi, Wassily Kandinsky, Piet Mondrian, etc. Even if Pollock's paintings could stand on their own, Rothko's small gouache and Motherwell's collage could hardly make a statement.[6] In contrast most early showings of Tobey happened in the context of exhibitions of American art, in which he was always well represented.

两幅作品售出：一张被瑞士收藏家波拉克购得，另一张卖给了一位米兰的收藏家。[9] 形成鲜明对比的是，托比在巴黎的第一次个展就取得了巨大成功。该展览于 1955 年在著名的珍妮·鲍彻（Galerie Jeanne Boucher）画廊举办。该画廊和托比自 1945 年就开始联系，当时的画廊主珍妮·鲍彻在纽约见到了托比并购买了其部分作品。为了筹备这次展览，托比在巴黎待了 6 个月，这对该展览在商业、学术评论上获得巨大成功起了至关重要的作用。此次展览不仅获得了专业媒体的关注，还在《世界报》（Le Monde）[10] 等报纸上进行了报道。

对比两人在博物馆举办的第一个回顾展也会得出类似的结论。波洛克第一次欧洲回顾展于 1959 年在国立现代艺术馆举行，跟随当时纽约现代艺术博物馆策划的世界性巡回展抵达巴黎。这是一个非常重要的展览，巴黎民众第一次有机会见到大量的波洛克作品。瑞士杂志《视觉》（L'Oeil）的撰稿人之一弗朗索瓦·乔伊（Françoise Choay）写道："直到今天，波洛克的作品仍然以碎片化的方式呈现，这令人困惑"，[11] 而通过这次展览，能够"最终定位波洛克"。很明显，乔伊在将波洛克和托比进行对比，对于她的读者来说，托比是一个更加熟悉的人物，为了解释波洛克的作品，就将他与托比进行比较。例如她写道："在波洛克之前，托比是唯一一个对自我的行动保持极度的敏感，并且最终赋予他的作品以全新结构和形式的艺术家。"[12]（图 7）此次由美国策划的波洛克回顾展收到的评价褒贬不一，而托比于 1961 年在装饰艺术博物馆的展览却是法国人为他们所推崇的艺术家举办的一次朝圣活动。此次展览由与托比合作的法国博物馆一手操办，其中没有任何美国机构的介入，与夏加尔

图 7　马克·托比，《虚空吞噬工具的时代》，1942 年。木板坦培拉，55.3×76.0 厘米。© 2014 马克·托比的遗产 / 社会艺术家（ARS），纽约。数码图 © 现代艺术博物馆 /SCALA 认证 / 艺术史源，纽约
Fig.7　Mark Tobey, *The Void Devouring the Gadget Era*, 1942. Tempera on board, 55.3×76.0cm. © 2014 Estate of Mark Tobey / Artists Rights Society （ARS）, New York. Digital Image © The Museum of Modern Art/Licensed by SCALA / Art Resource, NY

Comparing the Parisian solo-shows of Pollock and Tobey is equally telling. Pollock's first solo-show in France took place in 1952 at the studio of the photographer Paul Facchetti, newly transformed into an art gallery. Michel Tapié, a French musician and poet, organized the show by borrowing works from the collection of the American artist Alfonso Ossorio, who was then living in Paris. The exhibition was neither a critical nor a commercial success.[7] The *Lettres Françaises* included a brief mention of the exhibition, in which Pierre Descargues described Pollock as the "atomiste de l'art modern."[8] Apparently only two paintings sold: one to a Swiss collector whose name was Pollack and one to a Milanese collector.[9] In contrast, Tobey's first Parisian solo-show was a great success. It took place in 1955 at the Galerie Jeanne Boucher, a long-established art gallery. Tobey maintained contact with the gallery since 1945, when Jeanne Boucher, its then owner, met him in New York and bought several of his works. To prepare for the show, Tobey spent six months in Paris, where his presence played an important role in the commercial and critical success of the exhibition. The show was reviewed not only in the specialized press, but also in newspapers such as *Le Monde*.[10]

By contrasting their first museum retrospectives one draws similar conclusions. Pollock's first European retrospective happened in 1959 at the Musée Nationale d'Art Moderne, when the touring exhibition organized by MoMA's International Program reached Paris. It was an important show because it was the first time the Parisian public had the opportunity to see a large selection of the artist's work. Françoise Choay, writing for the Swiss magazine *L'Oeil*, explained: "Until today the work of Pollock has been presented in fragmented manner that rose doubts."[11] With this exhibition it was finally possible to "definitely place Pollock." Tellingly, Choay made reference to Tobey, with whom her readership was much more familiar, to explain Pollock's work, placing him in the relation to Tobey. She wrote, for instance, "before Pollock, Tobey is the only one to have an acute consciousness of the sharp consequence of his action, fills his canvas according to a radically new structure."[12] （Fig.7） While Pollock's retrospective was a discovery sent from the United States that received mixed reviews, Tobey's 1961 retrospective at the Musée des Arts Décoratifs was a consecration offered by the French to an artist they admired. It was organized by the French museum in collaboration with the artist, without the intervention of any US agency, and came after similar retrospectives of Marc Chagall and Jean Dubuffet.

Reviewing the European press of the 1950s leaves little doubt that Tobey was considered as important, if not more important, than Pollock. To select a few examples among

（Marc Chagall）和让·杜布菲（Jean Dubuffet）的回顾展极为相似。

如果我们翻看 19 世纪 50 年代的欧洲出版物，即使当时的托比没有比波洛克更胜一筹，也至少和他平分秋色。1955 年，J. 鲁西奇（J. Lusinchi）以这样的口吻结束了纽约现代艺术博物馆在欧洲策划的大型展览"美国艺术 50 年"：毋庸置疑，最终是马克·托比赋予了抽象绘画的表现主义的形式 13。在我们反驳鲁西奇的观点，或认为此言论太过偏颇之前，要考虑到波洛克在这次展览中只展出了两件风格不同的绘画《母狼》和《数字 1A》，而托比不仅有一系列作品展示，还同时在珍妮·鲍彻画廊举办个展。在 1961 年，即使巴黎人在波洛克的回顾展中更好地了解了他的作品，巴黎评论家还是继续看好托比。由美国艺术评论家耶格（Jaeger）说："就个人而言，我发现托比的艺术明显地展示了内心生活的本质。因此我觉得它比波洛克那些尺寸较大，看起来更壮观的作品要深刻和丰富。我认为托比是在世的最伟大的美国艺术家，他超越了绘画的界限。" 14 这一年，法国杂志《艺术知识》发起了一项投票评选最重要的在世艺术家。马克·托比与马克斯·恩斯特（Max Ernest）并列第 8 位。萨姆·弗朗西斯（Sam Francis）第 11 位。而罗斯科和德库宁得到的选票则少得多。15

两年以后的 1963 年，当时的法国评论家皮埃尔·雷斯坦尼（Pierre Restany）在他的一篇介绍美国艺术的文章里打算介绍所谓美国艺术的"大人物"。反复斟酌、几易其稿之后，最终选择了托比、弗朗西斯和波洛克。

太平洋画派在战后巴黎的活动

雷斯塔尼文章中另一个涉及太平洋画派而颇有意思的方面是弗朗西斯和托比的关系。在这里，我不对太平洋画派存在与否进行争论，因为这个问题并不重要。重要的是 20 世纪 50 年代的巴黎评论界用了这个概念，并且使用它表示 20 世纪 40 年代的西雅图艺坛，这其中托比、莫里斯·格拉夫（Morris Graves）和肯尼斯·卡拉翰（Kenneth Callahan）担当了重要的角色，同时这个概念也代表了旧金山加利福尼亚州美术学院所进行的一系列活动，这是萨姆·弗朗西斯（Sam Francis） 16 读书的地方。

当时，法国人了解活跃的西雅图艺坛的一条路径是当时发表的一些文章，比如刊登在《生活》杂志上的 6 页文章"神秘的西北艺术家" 17；另一条路径就是来自美国的展览，这些展览强调了大西洋西岸的美国艺术，比如由西雅图艺术博物馆举办的展览"八个艺术家"，1958 年这个展览在法国展出，题为"美国西

many: in 1955, J. Lusinchi concluded his critique of the exhibition *50 ans d'art aux États-Unis,* a large exhibition sent to Western Europe by the Museum of Modern Art in New York, with the following statement: "It is unmistakably Mark Tobey who dominates the abstraction called expressionist of the last rooms."[13] Before dismissing his comment as biased or misinformed, keep in mind that Pollock was represented in this show by two dissimilar paintings, *She-Wolf* （1943） and *Number 1A* （1948）, whereas Tobey was not only represented by a consistent body of works, but was also featured in the abovementioned solo-show at the Galerie Jeanne Bucher at the same time. In 1961, even after Pollock's retrospective, when Parisians had the chance to become better acquainted with his work, Parisian critics continued to favor Tobey. Questioned by *Art in America*, the critic Jaeger said: "Personally, I find that Tobey's art expresses a remarkable essence of inner life and, accordingly, I feel it to be more profound and rich than the bigger, more spectacular paintings of Pollock. I consider Tobey to be the greatest living American artist for he goes beyond the bounds of painting."[14] That year, the French magazine *Connaissance des Arts* asked major players of the European art world to vote on the most important living artists. Mark Tobey was number 8, tied with Max Ernest, while Sam Francis was eleventh. Rothko and de Kooning received much fewer votes.[15]

Two years later, in 1963, while working on an article on American art, the French critic Pierre Restany made several drafts in which he tried to organize the major figures of American art. Predictably, Tobey and Francis appear along Pollock as *the* major American artists.

Presentations and Presence of the School of the Pacific in Postwar Paris

Another interesting aspect of Restany's essay is his reference to the School of the Pacific as the link between Francis and Tobey. I will not discuss here the polemic surrounding the existence of a School of the Pacific, because the question of whether or not such a school existed is unimportant. What matters is that critics in Paris in the 1950s were talking about it and by "it" they meant both the 1940's Seattle art scene in which Tobey played an important role along with Morris Graves and Kenneth Callahan, and the activities of the California School of Fine Arts in San Francisco, where Francis studied.[16]

Knowledge of the lively Seattle scene would have been brought to France through articles, such as the six page spread in *Life Magazine* on "The Mystic Painters of the Northwest,"[17] or exhibitions sent from the United States

部绘画与东部雕塑"。其实,真正使得巴黎人认识大西洋西岸美国艺术的恰恰是这些艺术家本身,他们中大部分都在欧洲生活了很长时间。比如托比,他经常前往欧洲,并且在巴黎居住了很长时间。在那里他交到了很多当地的艺术家朋友,比如塔皮和乔治·马蒂厄(Georges Mathieu),托比与他们保持了长期稳定的联系。[18] 1960 年,托比开始长期居住在瑞士。相反,波洛克从来没有去过欧洲,而仅仅是让欧洲人看到了他的作品上的签名。相比之下,托比几乎是欧洲艺坛的一部分,欧洲人近距离的接触到他本人和其具体的创作方法。卡拉汉和格雷夫斯还花时间在欧洲旅行、工作、展览、交流,并向他们的欧洲朋友们讲述自己在西雅图的活动。[19]

同样地,欧洲人也是通过 20 世纪 50 年代大量涌入巴黎的加州艺术家来了解加州艺坛的状况。萨姆·弗朗西斯是最典型的例子,他在 1950—1961 年一直待在欧洲,成为巴黎最著名的加州人物(图 8)。[20] 弗朗西斯是在加州美院院长道格拉斯·迈克杰(Douglas McAgy)辞职后大量涌入巴黎的艺术家之一,后者追求创新精神,曾聘请了克莱福德·思迪莱(Clyfford Still)和罗斯科来校任教。其他颇有影响力的加州艺术家还包括劳伦斯·卡卡格诺(Lawrence Calcagno)和克莱尔·费尔肯斯坦(Claire Falkenstein)。费尔肯斯坦曾在加州美院任教,1950—1963 年在法国居住。在这里她同弗朗西斯和塔皮成为非常要好的朋友,并成为当时巴黎艺术界中的活跃分子。[21] 卡卡格诺也是加州美院的学生,也在 1950 年来到巴黎,在接下来的几年中,他游历了整个欧洲和北非,把巴黎作为大本营,展示自己的作品,与当地的评论家和艺术家交流,他也一定和这些人谈论过加州的艺术状况。[22]

图 8 萨姆·弗朗西斯,《在蓝的周边》,1957—1962 年,布面油画和丙烯。275.1×487.1 厘米。© 2014 萨姆·弗朗西斯基金会,加州 / 社会艺术家(ARS)。纽约。摄影:塔特,伦敦 / 艺术史源,纽约
Fig.8　Sam Francis, *Around the Blues,* 1957—1962. Oil paint and acrylic paint on canvas, 275.1×487.1cm. © 2014 Sam Francis Foundation, California / Artists Rights Society（ARS）, New York. Photo: Tate, London / Art Resource, NY

that highlighted the art from the West Coast, such as *Eight American Artists* organized by the Seattle Museum of Art, which was shown in France under the title, *Peinture de l'ouest, sculpture de l'est des* États-Unis in 1958. Yet, the strongest factor in Parisians' acquaintance with the artistic scene of the West coast was certainly the West Coast artists themselves, many of whom spent time in Europe. Tobey, for instance, travelled extensively in Europe and spent long periods in Paris, where he befriended artists and critics such as Tapié and the painter Georges Mathieu, with whom he had a long standing correspondence.[18] In 1960 Tobey actually moved to Europe permanently and settled in Switzerland. In contrast, Pollock never traveled to Europe and thus remained, for Europeans, nothing but a signature on canvas. In contrast, Tobey was part of the European art scene and Europeans could relate to him in a personal and concrete way. Callahan and Graves also spent time in Europe, traveling, working, exhibiting, mingling, and telling their European acquaintances about their activities in Seattle.[19]

Likewise, knowledge about the San Francisco art scene would have come to Europeans from the numerous artists who moved from California to Paris in the 1950s. Sam Francis, who moved to Paris in 1950 and stayed in Europe until 1961, was obviously the most famous Californian of Paris （Fig.8）,[20] but he was also part of a larger group of artists who came to Paris after the dismissal of Douglas McAgy, the CSFA director who had championed innovative approaches and hired Clyfford Still and Rothko to teach at the school. Among the other influential Californians in Paris were Lawrence Calcagno and Claire Falkenstein. Falkenstein, who taught at CSFA, moved to France in 1950, where she lived until 1963. In Paris, she befriended Francis and Tapié, and quickly became an active member of the Parisian art scene.[21] Calcagno, a student at the CSFA, likewise moved to Paris in 1950. He spent the following years traveling through Europe and North Africa, keeping Paris as the base where he showed his work and socialized with French critics and artists, whom he must have told about the art scene back home.[22]

However, when it comes to the visibility of West Coast artworks in postwar Paris, the most important figure was undoubtedly John Franklin Koenig. Born in Seattle, Koenig was familiar with the Northwest School of Art, particularly the work of Graves and Tobey. In 1948, he moved to France to further his French study at the Sorbonne. In Paris he met Jean-Robert Arnaud, the owner of a bookstore, with whom he first opened Galerie Arnaud and then founded the international art magazine *Cimaise*. Thanks to the gallery and the journal, Koenig played a very influential role on the Parisian art scene.[23] He not only exhibited （West Coast） Ameri-

西岸的艺术家在战后巴黎变得越来越重要，但此时最有知名度的西海岸艺术家当属约翰·富兰克林·科尼格（John Franklin Koenig）。他出生在西雅图，十分熟悉以格雷夫斯和托比为代表的美国西北派作品。1948年，他去往法国，随后在索邦大学继续学习法语。在巴黎他认识了一家书店的老板让-罗伯特·阿尔诺（Jean-Robert Arnaud），二人首先一起办了阿尔诺画廊，随后共同创办国际性艺术杂志 Cimaise。凭借着画廊和杂志的成功，科尼格一跃成为巴黎艺坛举足轻重的人物。[23] 他不但举办美国艺术的展览，还通过在自己杂志上的宣传和评论来提升这些作品的知名度。1954年到1955年，他连续写出了几篇介绍太平洋画派的文章，其中就包括在费尔肯斯坦工作室内塔皮和弗朗西斯共同参与的一次讨论。[24]

巴黎人想象中的美国西海岸

如果说美国西海岸艺术家频繁出现在巴黎的画廊、杂志和咖啡馆中，可以说明巴黎人对他们作品的认可或接纳，但是这还不足以彰显出巴黎人对西海岸艺术家的热情。为了更好地了解巴黎人对美国西海岸艺术家的热情，我们需要考察一下20世纪50年代里，美国究竟给了法国人什么印象。

20世纪60年代早期，在商用喷气式飞机——这一改变了跨大西洋旅行方式的交通工具——大力发展之前，欧洲人很少能有机会能造访美国本土。因为横跨大西洋的旅行会花费相当长的时间而且耗资巨大，签证的获取和美元的兑换也十分困难。在那些能到美国的人中，又只有幸运的少数人有时间和精力前往了美国西海岸。法国人对茫茫西部只停留在模模糊糊的想象中：牛仔、狩猎、淘金者和印第安人等。[25] 对于他们来说，这才是真正的美国。美国西海岸之所以能迷住欧洲人，恰恰是因为欧洲人对其知之甚少而只能凭借着臆想。更重要的是，欧洲人认为美国西海岸和欧洲有着根本的不同。

我想巴黎人和欧洲人更偏爱那些来自美国西海岸的艺术家而不是东部艺术家的主要原因就是在他们眼里，纽约艺术家们因为太接近于欧洲而显得无趣。波洛克最知名的作品当属《母狼》（1943年，图9），1953年至1959年，这幅作品在西欧展出了20次。作品的名字涉及罗马神话传说中的莱姆斯和罗慕路斯，被欧洲评论界解读为波洛克与欧洲古老文化间的一种联系。在战后巴黎人看来，他的绘画风格似乎是超现实主义和德国表现主义的结合。波洛克另一件在战后欧洲反复展览的作品是《月亮女人》，在1956年之前被公开展览过8次。它的标题应该是与夏尔·波德莱尔（Charles Baudelaire）的一首诗有关，或者至少是波德莱尔的诗唤起的灵感，

can art in the gallery, he also promoted it in his magazine. Furthermore, between 1954 and 1955, *Cimaise* published several essays on the School of the Pacific, including a conversation that took place in Falkenstein's studio in which Tapié and Francis participated.[24]

The American West Coast in the Parisian Imagination

If the presence of West coast artists in Parisian galleries, magazines, and cafés may explain Parisians' knowledge of their works, it cannot alone account for their enthusiasm. To understand Parisian keenness for West coast artists, we need to consider what this particular region of the United States would have represented for the French in the early 1950s.

Before the development of commercial jet airliners in the early 1960s, which transformed transatlantic travels, very few Europeans had the opportunities to visit the United States. The journey was long, expensive, and required hard-to-obtain visas and US currencies. Among those who managed to go to the United States, only a happy few had the time and resources to go to the West Coast, whose remoteness fascinated them. French people would have only had very vague images of this vast Far West, which most certainly involved cowboys, trappers, gold-prospectors, and Indians.[25] For them, this was the *true* America. In many ways, the West coast of the United States fascinated the Europeans because they knew so very little about it and imagined it as being radically and fundamentally different from Europe.

This was the main reason, I believe, why Parisians and Europeans preferred West coast to East coast artists: in their eyes, the New York artists were simply too European to be interesting. This was born out by the artworks that were sent from New York to Europe and Paris. The most widely exhibited work by Pollock was the *She-Wolf* （1943; Fig.9）, which was shown twenty times in Western Europe between 1953 and 1959. The title of the work, which refers to Roman legend of Remus and Romulus, would have been read by European critics as a proof of Pollock's connection to European, old culture. Stylistically, the painting would have appeared to postwar Parisians as a combination of Surrealism and German Expressionism. Another Pollock frequently shown in postwar Europe was the *Moon-Woman* （1942）, which was on view eight times before 1956. Its title is supposed to or at least was thought to evoke a poem by the Charles Baudelaire, while the color palette and style would also have prompted comparisons with Surrealism and Expressionism. Among the drip paintings often seen in Europe was *Full Fathom Five* （1947）, which was presented

画面所展现出的超现实主义和表现主义的张力更加强烈。1950 年至 1959 年间展览多达 11 次的滴画《暴风雨》(1947)，名字明显和莎士比亚的戏剧有关，这些作品使得巴黎人认识了一个行动绘画的表现主义者。[26] 罗慕路斯、瑞摩斯、波德莱尔、莎士比亚、德国的表现主义、超现实主义……对 20 世纪 50 年代的欧洲观众来讲，波洛克的作品显得十分"欧化"。

波洛克的作品不仅太过于欧化，还参照了一些在当时认为不恰当的欧洲先例。20 世纪 50 年代的战后法国，把超现实主义看作过时且不重要的。第二次世界大战期间，很多年轻艺术家离开了超现实主义阵营，一方面因为其主要的组织者逃离法国；另一方面是因为这项运动太国际化，以至于不能在沦陷后的法国具备真正的象征性力量。他们的主要注意力转移到乔治·布拉克(Georges Braque)和亨利·马蒂斯（Henri Matisse）身上。后立体派和野兽派为年轻的艺术家提供了具有民族性的灵感源泉，帮助他们建立起一种如法语般的形式语言，以此来对抗德国的表现主义。[27] 立体主义、野兽派和印象派仍然是战后巴黎艺术家的主要参照。因此，不难解释他们对的纽约艺术家的作品冷淡反应：超现实主义的倾向被认为是过时的；表现主义中的狂暴又会因为太过德国化而遭抵制。[28]

相比之下，西海岸艺术家们则更加自由且较少受到欧洲影响，塔皮在 1953 年克莱尔·费尔肯斯坦伦敦展览的上讲道：

从西雅图到旧金山，画家托比、格拉夫、思迪莱、萨姆·弗朗西斯、莱德·马丁（Fred Martin）和雕塑家克莱尔·费尔肯斯坦代表着这个时代艺术真正的价值和

eleven times in seven different countries between 1950 and 1959. Here the title refers to Shakespeare, while the drip technique may have appeared to Parisian viewers as an expressionist version of automatic drawing.[26] Romulus and Remus, Baudelaire, Shakespeare, German Expressionism, Surrealism… to a French audience of the 1950s, Pollock's work would have seemed very European.

Not only was Pollock's work too European, it referred to the wrong European precedents. In postwar France, Surrealism was by 1950s regarded by many as passé and irrelevant. During the Second World War, young artists had moved away from Surrealism, because the movement was too international to have real symbolic power in Occupied France and because its main practitioners had fled the country. Their attention went rather to Georges Braque and Henri Matisse, who stayed behind. The post-Cubism and post-Fauvism they practiced offered young artists a national source of inspiration to create a visual language that could be read as French in contrast to the violence of German expressionism.[27] In the postwar period, Cubism, Fauvism, and Impressionism remained major references for Parisian artists. Hence their lukewarm reaction to the works of the New York artists: while the Surrealist influences would have made their works look passé, the Expressionist violence would be rejected as too German.[28]

In contrast, the works of the West coast artists seemed free from European influences, as Tapié explained in the catalogue of Claire Falkenstein's 1953 London show:

From Seattle to San Francisco, the names of TOBEY, GRAVES, STILL, SAM FRANCIS and FRED MARTIN in painting, and of CLAIRE FALKENSTEIN in sculpture, lead the contemporary venture in its most authentic and unexpected contribution as concerns our ingrained habits of vision and thought. In the U.S.A., Pacific art is the only kind of art which owes absolutely nothing to European emanations and it is, for this reason, of particular interest. Its genuine creativeness first disconcerts, then fascinates as it confuses us, compels us to think, and to modify some of our ideas about such things as dynamism, space, structures, and even the elements of mysticism. The Pacific coast is the direct and real point of contact between the most adventurous descendants of the pioneer and the highly complex civilisations of China, Japan and Indonesia. Without passing through Europe. It is an exceptionally favoured geographical situation. These then are the conditions of extreme audacity and complete freedom within which such works as this is likely to develop.[29]

Tapié thus regarded the artists from the West Coast of the United States as the most original and genuine American artists, because they were connected to and influenced by Asia. However odd it may sound today, Tapie's belief was actually shared by many Parisian critics. Reviewing Cal-

期待，改变了我们长期以来根深蒂固的审美眼光和思想。在美国，太平洋艺术是最纯粹的，没有受到任何欧洲影响的艺术，也正因为这样，使得它呈现出特别的趣味。这些天才般的创造先是让我们惊慌失措，继而让我们迷恋不已，它们使我们困惑，继而迫使我们重新思考，并改变之前的关于空间、动力、结构甚至某些神秘主义的因素的观点。美国的西海岸没有通过欧洲，而是直接去接触诸如中国，日本和印度尼西亚等高度复杂的文明先行者。这是一个得天独厚的地理优势。正是这样极端大胆和完全自由的环境使得这些作品的创作成为可能。[29]

塔皮之所以认为西海岸艺术家代表了美国正统艺术的最高水平，是因为他们受到亚洲的影响，尽管这个结论今天听起来有些奇怪。但很多巴黎艺评家与塔皮抱有同样的观点。卡卡格诺在 1955 年保罗·法切提（Paul Facchetti）工作室举办了个展。路易斯 - 保罗·法埃尔（Louis-Paul Favre）是这样向他的读者评述的："卡卡格诺的青年时光在加利福尼亚州的牧场度过，也就是美国的西海岸，这里离欧洲极其遥远……"[30] 朱利安·奥瓦德高度赞扬了卡卡格诺的风景画，认为他代表了"太平洋风格"：

不需要再次强调这种分化现象，卡卡格诺的绘画作品中特殊的结构安排可以表明这点，在这个结构中，画面被分为两部分，两边的力线横扫整个画面，使得不规则的沙漠边际线获得了稳定性。这种来自太平洋沿岸的风格，确实带给了我们一些新的东西。[31]

巴黎的艺评人不仅赞赏这种风格，而且认为其会对巴黎本土艺术家产生有益的影响。1953 年罗伯特·雷柏（Robert Lebel）在他的当代艺术研究论问题提到了受太平洋风格影响的巴黎先锋派：

此外，这个陌生的事物除了通过美洲艺术家的作品向我们展示自己，无论我们如何表述这个事件所产生的影响都不夸张。欧洲对遥远的文明一直秉持着一种迷恋，半个世纪以前，这种迷恋淋漓尽致的体现在对远古艺术和土著艺术的使用上，这一做法很快就发生了变化。欧洲再现性艺术仍然保有影响力的话，但在这些欧洲再现性艺术作品中已经有墨西哥的踪影，东方的书法和构图也已经通过托比的作品开始影响巴黎的前卫艺术家。[32]

在一个驻法美国艺术家展览的引言中，塔皮也提到太平洋风格对巴黎艺坛的影响："对于我们来说，100% 纯正的美国艺术或者说'太平洋'绘画的贡献在于它们给巴黎艺坛增添了新鲜的元素。换句话说，这种艺术来源于东方，没有经过欧洲"二次加工"；最后，我们能看到我们这个时代所有核心元素是如何融和成一种艺术特质的。"[33]

战后的法国普遍流行这样的观点：美国已经成为，

cagno's one-person exhibition at the Studio Paul Facchetti in 1955, Louis-Paul Favre explained to his readers: "Calcagno spent his youth on a ranch in California, on this extreme western border that is the West coast of America. The East is closer than distant Europe…"[30] Discussing the same exhibition Julien Alvard also praised Calcagno's landscapes for their specifically Pacific style:

Without trying to insist one more time on the phenomenon of differentiation, we can indicate the appearance of a particular arrangement in Calcagno's painting, the one which divides the canvas into two layers sweeping the space on both sides of a line of force which evokes by its fixedness the disproportionate horizons of the desert. To a style born on the Pacific coast, this exhibition brings something new.[31]

Not only did Parisian critics endorse this American Pacific style but they also saw it as a positive influence on Parisian artists. In the introduction of his 1953 study of the contemporary art scene, Robert Lebel evoked this particular Pacific influence on the Parisian avant-garde:

Besides this unknown begins to manifest itself to us by the appearance of the American continent on the field of the artistic creation. It is hereby an event the impact of which we cannot exaggerate. The fascination that Europe had always experienced for distant civilizations, and that was translated during the last half century by a particularly effective use of the archaic and native arts, could soon be updated. If the said school of Paris maintains its influence, already the Mexican claw finds itself on many representational works of Europe and the imprint of the oriental extreme calligraphy or the layout, through Mark Tobey and the school of the Pacific, is detectable on the Parisian avant-garde.[32]

Introducing an exhibition of American artists based in Paris, Tapié also considered that the influence of the Pacific style on the Parisian art scene: "The first point for us is the contribution that the presence of a 100% American or "Pacific" painting—can make on the turntable of the Paris scene. That is to say, an art which emanates possibly for the Orient without passing through Europe; and then finally to observe how certain temperaments have been able to assimilate the essential elements of our present epoch."[33]

In the context of the postwar years, the idea that the United States was or could be a meeting point between Europe and Asia, a place where a synthesis of the cultural traditions of the two continents could emerge and flourish, had a strong currency in France. The War and the American engagement on the Pacific front had indeed made Europeans strongly aware of the United States' geographic connection to Asia. In the catalogue of the 1952 Pollock exhibition, Tapié could thus write: "at the moment when the artistic future, as many other futures, is situated on a global scale—

或可以成为欧亚两块大陆的交汇点，在这里不同文化传统很有可能完成融合并且走向繁荣。战争以及美国在太平洋前线的交战，使欧洲人强烈意识到美国与亚洲的地缘联系。1952 年，塔皮在波洛克展览的宣传册上写道："此刻，艺术的未来，以及其他事物的未来，都被置于全球的视角上进行讨论——在地理位置上，东西方各主要艺术运动中所蕴藏的深层次问题在美国进行交锋，在那里，抽象的书法和叙事性质的造型实体正在强烈地相互碰撞……"[34]

在形成和传播这一新式的美国地缘政治中，托比与亚洲之间的联系发挥了相当大的作用，在对作品进行的书面阐释中也不断地重复这点。20 世纪 20 年代托比迁居西雅图之后，和当地的中国和日本社区加强了联系。1934 年，他前往上海拜访了他的中国艺术家朋友。在此次亚洲之行中，他花了一个月的时间在日本寺院体悟禅宗，回到美国后他创作了《白色书写》（图 10），对许多人来说，这件作品就是东西方传统文化交融的产物。[35]

这种融合使得托比和其他的西海岸艺术家得到了法国公众的青睐，因为 20 世纪 50 年代，法国被亚洲的艺术和文化深深吸引，从 18 世纪第一次接触亚洲开始，东方文化就成为欧洲艺术家们灵感和创新的源泉。在法国，亚洲艺术从来没有被认为是原始的；相反，从传入欧洲

America has become the real geographical crossroads of the confrontation for the deepest problems of the major artistic movements of the East and the West, in interferences where the surge of the calligraphic significance and the colorable intensity of the plastic-pictorial drama collide in a violent shock..."[34]

Tobey's connection to Asia played no small part in shaping and spreading this new geopolitical representation of the United States, all the more since it was repeated in every written account of his work. After moving to Seattle in the 1920s, Tobey had indeed come to contact with the large Chinese and Japanese communities of the region. He had befriended a Chinese artist, whom he visited in Shanghai in 1934. During his trip to Asia, he spent a month in a Zen monastery in Japan. Upon his return to the United States, Tobey developed *White Writing*, which appeared to many as a synthesis between East and West.[35]（Fig.10）

Such a synthesis made Tobey and other West Coast artists attractive to the French public because in the 1950s France was deeply fascinated by Asian art and culture. European artists and intellectuals had been engrossed in Asian art since they first encountered it in the 18th century, when it became a continuous source of inspiration and renewal for artists. In France, Asian art had never been regarded as primitive; on the contrary, from the first Chinese ceramics to 19th century Japanese prints, the works of Asian artists were regarded as extremely sophisticated. They were admired by artists, and collected by museums and collectors. Asian poetry, literature, and philosophy were also admired, translated, and studied.[36] The postwar period was marked by a renewed fascination with Asia that it is sometimes described as a neo-Japonisme.[37]

The main feature of neo-Japonisme was a strong interest in calligraphy and Zen Buddhism. Chinese Calligraphy provided Parisian artists with a poetic and controlled alternative to the Surrealist automatic drawing and the violent gesture of Expressionism. Likewise, Zen Buddhism offered them a way to achieve personal freedom and enjoy spirituality outside the rigid framework of traditional Western religions—two dimensions that were missing from Existentialism and Marxism, the two most important schools of thought in postwar Paris. The Zen practice of achieving liberation through self-knowledge also offered a welcomed alternative to psychoanalysis in the years preceding Jacques Lacan's revision of Sigmund Freud's ideas.[38]

As for the arts of the American West Coast, knowledge about Zen and calligraphy was spread in Paris through the numerous Chinese and Japanese artists who were then living in Paris, and of whom Zao Wou Ki and Kumi Sugai were the most prominent.[39] The influence of these Asian artists on

图 10　马克·托比，《西北漂流》，1958 年，木板和纸面油彩、水粉和石膏 113.5 × 90.5cm. © 2014 马克·托比的遗产 / 社会艺术家（ARS），纽约。摄影：塔特，伦敦 / 艺术史源，纽约

Fig. 10　Mark Tobey, *Northwest Drift,* 1958. Tempera and gouache on paper on board, 113.5×90.5cm. © 2014 Estate of Mark Tobey/Artists Rights Society（ARS），New York. Photo: Tate, London/Art Resource, NY

的第一件中国瓷器到 19 世纪的日本版画，亚洲艺术家的作品都被认为是充满着深刻的哲思与审美情趣，这些作品受到了艺术家的赞赏，被欧洲博物馆和收藏家争相收藏。亚洲的诗歌、文学、哲学也受到推崇、并被翻译和研究。[36]战后，欧洲又再次深深着迷于亚洲艺术，人们有时将这一时期称为"新日本风"（neo-Japonisme）。[37]

新日本风最主要的特点是对书法和佛教禅宗的关注和浓厚兴趣。巴黎的艺术家在中国书法中发现了如诗一般的控制能力，使他们从超现实主义的自动绘制和表现主义的恣意狂暴中解脱出来。同样地，他们在佛教禅宗中找到了获取个人内省的自由和精神独立的途径，超脱于西方传统思想的刚性框架范畴之外——尤其是在战后获得思想统治地位的存在主义与马克思主义的笼罩下。通过自我认识实现解放的禅宗实践也为早前雅克·拉康（Jacques Lacan）修订的弗洛伊德精神分析找到了受欢迎的替代。[38]

与美国西海岸相似，书法和禅宗在巴黎的传播也是依靠当时生活在巴黎的中国艺术家和日本艺术家，在这其中赵无极和菅井汲是最突出的。[39]就巴黎对于加州艺术家们的接纳而言，这些亚洲艺术家对巴黎视觉艺术所造成的影响是不可低估的。画家皮埃尔·艾尔肯斯奇(Pierre Alechinsky) 回忆起在巴黎见到亚洲艺术家时如是说：

1954 年 10 月，我有幸在巴黎的中国区见到了艺术家丁雄泉。我在他的工作室里观察他的工作状态，他时常弓腰蹲坐在作品面前，专心致志地盯着画面。我的注意力被他的画面上运动着的画笔所吸引，那些绘出的线条、笔刷扫过的速度、或加速或短暂的停歇都显得魅力十足。顷刻间，画面上出现了深浅不一的斑点和不同速度的笔触肌理。丁雄泉短暂地停顿，犹豫了一下随即在蓝色的背景中添置了使画面灵动的形象——下落的一只猫。顷刻间，曼妙的构图跃然于纸上。[40]

在这之后他发现了一本研究古代和现代书法的日本期刊《墨美》，他随即联系到了该刊的主编书法家森田子龙，开始了书信往来。后来他说："在 1955 年之前除了去日本，我没有其他的目标"[41]终于，在 1955 年 10 月，艾尔肯斯奇到了日本，在那里他专门为日本书法拍摄了记录电影。而且，他还在法国杂志Phase上发表了题为《书法之外》（1955 年 3 月）的论文，并于 1956 年在巴黎和阿姆斯特丹策划了展览《日本水墨》。

这个展览仅仅是 20 世纪 40 年代到 50 年代众多亚洲古代和现代艺术的展览之一。尽管我没有关于此类展览的确切统计数据，不过从目前收集的资料来看，很显然，战后法国博物馆举办的亚洲艺术展多于美国艺术展。而且我也会大胆的推测，亚洲的现当代艺术展览也比美国现当代艺术展览要多。在很大程度上，这是由于巴黎有两大博物馆在致力于亚洲艺术的推进（除卢浮宫外），

the Parisian visual arts cannot be underestimated when considering the reception of Californian artists. To only take one example, the painter Pierre Alechinsky came to his signature style through his contact with the Asian artists of Paris, as he recalls:

In October, 1954, I observe in Paris Walasse Ting, in his room of the Chinese district, passage Raguinot: he squats in front of his paper. I follow the movements of the brush, the speed. Very important the variations of the speed, the line, the acceleration, the braking. Immobilization. The light irremovable spot, the heavy irremovable spot. The whites, all the greys, the black. Slowness and speed. Ting hesitates, then out of the blue the solution, the fall of the cat on its legs. Last graceful figures beyond the paper.[40]

Shortly thereafter Alechinsky discovered *Bokubi*, a Japanese journal devoted to ancient and modern calligraphy. He then contacted Morita Shiryû the director of the journal, with whom he started a correspondence. As a result, he said: "Until 1955 I would have no other goal: to go to Japan."[41] In October 1955, Alechinsky flew to Japan, where he made a film documentary on Japanese Calligraphy. He also wrote an essay for the French magazine *Phase* entitled "Au-delà de l'ecriture"（March 1955）and organized an exhibition *L'encre de Chine dans la peinture japonaise*, which was went in Paris and in Amsterdam in 1956.

This exhibition was just one among the many exhibitions devoted to ancient and modern Asian art that took place in France in the 1940s and 1950s. Although I do not have exact data on these exhibitions, from what I have collected so far it is obvious that there were more museum shows devoted to Asian art than to American art in postwar France, and I would even venture to say that there were also more exhibitions of modern and contemporary Asian art than of modern and contemporary American art. In no small part this was because there were two museums devoted to Asian art in Paris—the Musée Cernuschi and the Musée Guimet—in addition to the Louvre's Asian collections.

As early as 1946 the Musée Cernuschi presented *La peinture chinoise contemporaine*, the first show exclusively devoted to contemporary Chinese art in France. In 1953, the museum inaugurated a series of one-person shows of Chinese contemporary artists, and that year the collector Guo Youshou gave his collection to the museum. It was the beginning of the museum's permanent collection, which resulted in additional donations by artists and collectors. In 1956, the Chinese artist Zhang Daquian had a solo-show at the Cernuschi museum and one at the Musée d'Art moderne, two years before Pollock.[42]

In fact in 1959, when the retrospective of Jackson Pollock came to Paris along with the show *The New American*

图11 《世纪百年中国绘画，1850—1950》，馆藏中华人民共和国绘画作品。巴黎，1959。

Fig.11 *One Hundred Years of Chinese Painting, 1850—1950.* Collection of the Museums of The People's Republic of China. Paris, 1959

图12 《杰克逊·波洛克和新美国绘画》国立现代艺术馆。巴黎，1959。

Fig.12 *Jackson Pollock et la nouvelle peinture américaine.* Musée National d'Art Moderne. Paris, 1959

它们分别是赛努奇亚洲博物馆和吉美博物馆。

　　早在 1946 年，赛努奇亚洲博物馆展出了"中国当代书画"，这是中国当代艺术在法国的第一次展览。1953 年，该博物馆策划了一系列中国现代艺术家的个人展览。收藏家郭有守把自己的收藏品捐献给该馆，此举开启了法国博物馆永久收藏中国现代艺术品的先河，并且激发了很多艺术家与收藏者的后续捐赠。1956 年，中国艺术家张大千在赛努奇博物馆举办了个人展览，并且早于波洛克两年在现代艺术博物馆举办了个展。[42]

　　事实上，当波洛克 1959 年的巡回展和新美国绘画展在巴黎展出时，一个非常重要的中国艺术展览——《世纪百年中国绘画 1850—1950》正在巴黎的"法国人思想之家"展出。比较一下两个展览的评论也很能说明问题。当中国艺术的展览获得普遍赞誉之时，美国艺术的展览得到的评价却褒贬不一。《艺术知识》杂志没有对《新美国绘画》展做出及时的评论，反而鼓励读者们去观看百年中国绘画展。与我的论证极为匹配的事实是，很多评论家表达了托比缺席美国艺术展览的遗憾。人们不禁想知道，假如托比参加了这个展览，评论家会在这个太平洋画派的鼻祖和中国艺术家之间建立怎样的联系。

Painting, an important show of Chinese Art, *Cent ans de peinture chinoise*（1850—1950）, was taking place in Paris at the Maison de la Pensée Française （Fig.11 and 12）. Comparing the reviews of the shows is extremely telling. While the Chinese show was generally praised, the American show received mixed reviews. While *Connaissances des Arts* did not review *The New American Painting,* it encouraged their readers to visit *Cent ans de peinture chinoise*. Of particular interest to my argument is the fact that many critics who reviewed the American exhibition regretted Tobey's absence from the show. One cannot help wondering what connection the critics would have drawn between the Chinese artists and the father of the Pacific School, if he had been included.

Conclusion: A Case Study of Cultural Transfers

West Coast artists appealed to the Parisian public because they appeared to have a special connection with Asia, and because their work offered a synthesis between Asia and Europe. If this was perfectly true for Mark Tobey who had

结语：文化传递的个案研究

西海岸艺术家之所以能够吸引巴黎的公众，是因为他们看上去与亚洲有着某种特殊的联系，作品中反映出一种欧亚传统文化的融和。如果这个结论对曾经在亚洲生活学习过的马克·托比完全适用的话，是否也同样可以表征其他的西海岸艺术家呢？或者这一关联仅仅是法国人的假设？弗朗西斯在巴黎时，与日本艺术家、评论者都保持着长期交流，并且由巴黎去往日本。科尼格的情况也是如此，他似乎在巴黎找到了能使他立足的亚洲基础。我认为，法国对亚洲的兴趣和托比对亚洲的牵连深深地影响了整整一代西海岸艺术家，使他们投入到想象中的亚洲与太平洋地区。另外，批评家和艺术史家乔治·杜慈特（Georges Duthuit）在这方面也扮演了一个重要的角色。

杜慈特的英语非常流利，他在1947年担任了《过渡》的主编。该杂志是在巴黎发行的英文杂志，并且成为连接旅居巴黎的美国艺术家和巴黎艺坛的媒介。杜慈特作为马蒂斯的女婿，向居住在巴黎的美国艺术家们介绍了马蒂斯的晚期作品。此外，他还鼓励他们多去欣赏勃纳尔和莫奈的晚期作品。比如橘园美术馆在当时刚刚向公众开放的《睡莲》等。通过杜慈特，这些美国艺术家把莫奈、马蒂斯和博纳尔当作榜样，认为他们受到了日本版画和中国绘画的强烈影响。1936年，杜慈特完成了一篇关于中国的神秘主义和现代绘画的文章。[42]我认为正是由于塔皮、阿尔瓦德、雷柏、杜慈特等一批热衷于亚洲文化，并坚信美国艺术是亚洲和欧洲艺术融和的产物的艺术家和评论家，美国艺术家才开始对美国和太平洋周边世界的关系发生兴趣。

上述事件似乎是一个极好的反映"文化交流"复杂性的案例，事实上，我是一个在美国大学工作的法籍艺术史教授，写一篇给中国读者的文章，这同样是一个"历史交叉"的案例。[43]无论怎样，我刚刚讲述的这个故事是反映文化交流中的动力以及文化转换间复杂性的一个极好案例。它证明我们不能仅仅通过双向的途径去了解文化传递的过程，因为它不单只涉及巴黎和纽约，还关联到上海、柏林、西雅图和旧金山等。思维的开阔性在研究中是不可或缺的，有些时候甚至需要从表面上没有直接相关的联系的两个事物入手。ARTL@S能承担这样的重任：依托不同领域内学者协同提供的展览数据基础，我们不但可以节省时间，还能够获取到与研究直接相关的数据支持。通过这些收集的数据，我们可以建立新的关联，这些关联将挑战我们既有的艺术史叙述方法，提出新的问题，推动研究的进一步深化。

lived and studied in Asia, was it equally true for other West coast artists or was it an assumed association by the French? Francis, for instance, came in contact with Japanese artists and critics while he was in Paris, and it is from Paris that he travelled to Japan. The same is true for Koenig who he seemingly discovered his Asian roots in Paris. It thus seems to me that the French interest in Asia and Tobey's involvement with Asia combined to influence the entire generation of West Coast artists to embrace their supposed Asian or Pacific association. It also appears that the critic and art historian Georges Duthuit played a very important role in that regard.

Duthuit spoke English fluently and was in charge, since 1947, of *Transition*, a Parisian journal published in English, which was as a point of contact between American artists living in Paris and the local Parisian art scene. Duthuit, who was also Matisse's son-in-law, introduced these American artists to the late work of Matisse, and inspired them to look at Bonnard and the late work of Monet, in particular the *Nymphéas* of the Musée de l'Orangerie, which were just reopening. Through Duthuit the American artists in Paris took Monet, Matisse, and Bonnard as their models, that is to say, they recognized them as artists who were strongly influenced by Japanese prints and Chinese paintings. In 1936, Duthuit had actually written a text on Chinese mystic and modern painting.[43]It is tempting to believe that it was their contact with Tapié, Alvard, Lebel, Duthuit and others French enthusiasts of Asia and believers in the American synthesis between Asia and Europe that those American artists became interested in the relationship between America and the Pacific world.

It is tempting because it would provide a perfect example of a complex *cultural transfer*, but the fact that I am a French art historian working in the United States and writing to a Chinese audience is also a case study of *Histoire croisée*.[44] In any case, the story I just outlined stands as a perfect example of the dynamism of cultural exchanges and the complexity of cultural transfers. It demonstrates that one cannot study cultural exchanges in a bilateral way, because it is never just about Paris and New York. It is also about Paris and Shanghai and Berlin, and about New York and Seattle and San Francisco. It is thus essential to think broadly and make wide, sometimes unconventional connections. And this is where ARTL@S can play an important role: by working on a collaborative database of exhibitions with other scholars working on different projects, we can get access to their data—data that we did not collect not only for lack of time but also because it did seem relevant to our research. Yet, in all this collective data there might be new connections to be made that will challenge our narratives, raise new questions, and bring research forward.

Notes:

1 Catherine Dossin. "Mapping the Reception of American Art in Postwar Western Europe". *ARTL@S Bulletin: For a Spatial History of Art and Literature* 1, No. 1 2012 (Fall) : 33-39. Also accessible at http://docs.lib.purdue.edu/artlas/vol1/iss1/3/

2 More information at http://www.artlas.ens.fr/?lang=en

3 For more information on Rothko's reception in Europe, see Catherine Dossin. "Mark Rothko, the Long Unsung Hero of American Art" in *Mark Rothko. Obrazy z National Gallery of Art w Waszyngtonie*, ed. Marek Bartelik Warsaw: National Museum of Warsaw, 2013. 101-102.

4 This recognition was particularly important, since that year all the international prizes had gone to Italian artists and thus regarded as invalid by the international community. Tobey is sometimes listed as the winner of the Grand Prize for Painting, which is not exact. For detailed information on the Venice Biennale prizes, see Enzo di Martino. *Storia della Biennale die Venezia, 1895—2003*. Venice: Papiro Arte, 2003. 129.

5 The exhibition of Peggy Guggenheim's collection was a success, as people were eager to see works by Brancusi, Miro, etc. However, reviewers hardly commented on the new American painting. See for instance Egon Vietta. "Panorama der europäischen Moderne: Die XXIV Biennale in Venedig". *Die Zeit* June 15, 1948, http://www.zeit.de/1948/29/panorama-der-europaeischen-moderne. Or Douglas Cooper, "24th Biennial Exhibition, Venice". *The Burlington Magazine* , 1948 (10) . Adrian Duran who examined the Italian reviews of the Biennale came to the same conclusion: Adrian R. Duran."Abstract Expressionism's Italian Reception: Questions of Influence". In : Joan Marter. *Abstract Expressionism: The International Context* : New Brunswick, New Jersey, and London: Rutgers University Press, 2007. 142-143

6 The critic of the Swiss newspaper, *Die Weltwoche*, who reviewed the exhibition, discussed the abstract and surrealist works of Mondrian, Pevsner, Arp, Ernst, Miro, etc. in great details but only mention in passing the youngsters of the show to which they belonged: "Im letzten Saal dieser Ausstellung, wird man mit dem Experiment "Moderne Kunst" (oder einem ihrer Experimente) konfrontiert: mit der neuen peinture automatique, in der eine Reihe jüngerer und junger Künstler in Europa und Amerika die Sprache ihrer Generation zu finder suchen." "Ausstellungen," *Die Weltwoche* (Zürich) , April 27 1951.

7 The guest book of the gallery suggests that the exhibition was well-attended. The guestbook is, however, not a completely reliable as it was common to sign guestbook with famous names as a joke or self-fulfilling wish. A practice that Julie Verlaine, who studied the Parisian galleries in those years, discussed in general and in relation to this exhibition. Julie Verlaine. "La tradition de l'avant-garde. Les galeries d'art contemporain à Paris, de la Libération à la fin des années 1960". Doctorat d'histoire, Université Paris I, 2008.

8 Pierre Descargues. "Paris Pollock". *Lettres Françaises*, March 20, 1952.

9 Alfred Pacquement "La première exposition de Jackson Pollock à Paris, Studio Paul Facchetti, mars 1952". In : Pontus Hulten, ed. *Paris-New York*. Paris: Centre Georges Pompidou, 1977. 536-541

10 For a complete bibliography, see Catherine Olivier, Martine Stoecklin. *Mark Tobey, Chronologie, Expositions, Bibliographie*. Paris: Université de Paris X, 1972.

11 Francoise Choay. "Jackson Pollock". *L'Œil*, 1958. July-August: 42

12 Francoise Choay. "Jackson Pollock". *L'Œil*, 1958. July-August: 44

13 J. Lusinchi."Cinquante ans de peinture aux Etats-Unis," *Cimaise*. 1955.

14 Alexander Watt. "Paris Letter: Mark Tobey". *Art in America* 49, No. 4 ,1961. 114

15 Rothko ranked 15, equally placed with Asger Jorn, Balthus, Alberto Burri, Georges Mathieu, and Maurice Estève. De Kooning ranked 17, equally placed with Alberto Giacometti, Jean-Paul Riopelle, Roberto Matta and Raymond Legueult.

16 Recently many books and dissertations have been devoted to these West coast histories. See for instance Thomas Albright. *Art in the San Francisco Bay Area, 1945—1980: An Illustrated History*. Berkeley: University of California Press, 1986; Susan Landauer. *The San Francisco School of Abstract Expressionism*. Berkeley: University of California Press, 1996; Deloris Tarzan Ament, *Iridescent Light: The Emergence of Northwest Art*. Seattle: University of Washington Press, 2002; Sheryl Conkelton, Laura Landau. *Northwest Mythologies: The Interactions of Mark Tobey, Morris Graves, Kenneth Callahan, and Guy Anderson*. Seattle: University of Washington Press, 2003.

17 Kenneth Callahan. "Pacific Northwest". *Art News.* 1946(July): 22; Dorothy Seiberling. "Mystic Painters of the Pacific Northwest" *Life Magazine*, September 28 1953. 84-98

18 Mark Tobey's archives, which are housed at the University of Washington in Seattle.

19 On Graves and Callahan, see Ray Kass. *Morris Graves, Vision of the Inner Eye*. New York: Braziller, in association with the Phillips Collection, Washington, D.C., 1983; Michael R. Johnson. *Kenneth Callahan: Universal Voyage*. Seattle: The University of Washington Press ,1973.

20 On Francis's time in Paris, see Sam Francis. et all. *Sam Francis, les années parisiennes, 1950—1961* Paris: Galerie Nationale du Jeu de Paume, 1995.

21 On Falkenstein see, for instance, Susan M. Anderson, Michael Duncan, et al.*Claire Falkenstein*. Los Angeles: Falkenstein

Foundation, 2012.

22 For more information on Calcagno, see Suzan Campbell. *Journey Without End: the Life and Art of Lawrence Calcagno*. Albuquerque: Albuquerque Museum, 2000.

23 The presence of West Coast artists in Paris also made it so that, when French critics and artists visited the United States, they made a point to visit those regions and we can safely assume had letters of introduction to people in this region. Visiting the United States in 1959, Michel Ragon for instance, commented extensively on the art scene in California and Seattle, even though New York occupied the greatest part of his report. See Michel Ragon. "L'Art actuel aux Etats-Unis". *Cimaise*, 1959 Spring, 6-35.

24 Kenneth Sawyer. "L'expressionisme abstrait: la phase Pacifique". *Cimaise*, 1954:June 3-5; Julien Alvard, Michel Tapié, et al. "L'Ecole du Pacifique". June *Cimaise*, 1954 6-9: Paul Wescher. "Ecole du Pacifique". *Cimaise*, 1955：April: 3-5.

25 In 1943, the young Claude Levi-Strauss wrote an essay on "The art of the Northwest coast at the American Museum of Natural History," in which he discussed the work of the indigenous populations and their connection to Asia. At the time, Levi-Strauss was not yet famous but in the early 1950s he became a very important scholar whose influence extended far beyond the realm of anthropology. Claude Lévi-Strauss. "The art of the Northwest coast at the American Museum of Natural History". *Gazette Des Beaux-arts*, No. 24, 1943. 175-182. He will publish *Les Structures élémentaires de la parenté* in 1949 and *Tristes tropiques* in 1955.

26 Data on Pollock's works exhibited in Europe was compiled using *catalogue raisonné* (Francis V. O'Connor, Eugene V. Thaw, eds. *Jackson Pollock: A Catalogue Raisonne of Paintings, Drawings and Other Works*. New Haven: Yale University Press, 1978) and exhibition catalogues.

27 Even though German expressionism had been condemned as degenerate and anti-German by the Nazi regime, it continued to represent German art in the eyes of the French people. On the arts in France during the War, see Sarah Wilson. "Les peintres de tradition française". In：Pontus Hulten, ed. *Paris-Paris, 1937—1957 - Création en France*. Paris: Centre Georges Pompidou, 1981, 106-15. Michèle C. Cone. "'Abstract' Art as a Veil: Tricolor Painting in Vichy France, 1940—1944" . *The Art Bulletin*, 1992 June：191-204.

28 Even if the German expressionists had been condemned by the Nazi as degenerated, in the French imaginary Germany was associated with Romanticism and Expressionism, that is to say deeply emotional, excessive and even violent styles. In contrast, French art was thought to be clear, measured, and rational.

29 Michel Tapié, "The Formal Universe of Claire Falkenstein" (London: Institute of Contemporary Art, 1953) .

30 Louis-Paul Favre. "Les Paysages de Calcagno" *Combat*, June 27, 1955.

31 Julien Alvard. "Calcagno" *Cimaise* 2, No. 8 1955（July）: 17

32 Robert Lebel. "Confrontations". In: Robert *Premier bilan de l'art* actuel. Paris: Le Soleil noir, 1953. 16

33 Michel Tapié. *Peintres américains en France*. Paris: Galerie Craven, 1953

34 Michel Tapié. "Jackson Pollock avec nous". *Jackson Pollock*. Paris: Paul Facchetti, 1952.

35 See in particular Janet Flanner. "Tobey, mystic errant" *L'Oeil*, 1955（June）: 26-31.

36 On Mark Tobey, see William Chapin Seitz, *Mark Tobey*. New York: Museum of Modern Art, 1962）; Michael Russell Freeman. "'The eye burns gold, burns crimson, and fades to ash': Mark Tobey as a Critical Anomaly". Ph.D. Indiana University at Bloomington, 2000.

37 To give a few examples: Paul Claudel's poems written while he was in China before the War were republished in the early 1950s, widely read, and greatly admired. Henri Michaux's 1933 book *Un Barbare en Asie* was republished in 1947 and 1967 which confirms the appeal of the region among the younger generation.

38 For more information on this Neo-Japonisme see EunJung Grace An. "PAR-ASIAN Technology: French Cinematic, Literary and Artistic Encounters with East Asia since 1945". Ph.D. , Cornell University, 2004; Anik Micheline Fournier."Building Nation and Self Through the Other:Two Exhibitions of Chinese Painting in Paris, 1933/1977". Ph.D., McGill University, 2004.

39 The writings of Daisetsu Teitaro Suzuki, whose essays on Zen were translated in French during the War and republished in the early 1950s, also played an important role, along with the writings of French scholars.

40 Pierre Alechinsky. *Roue libre*. Genève: Skira, 1971.116.

41 Pierre Alechinsky. *Baluchon et ricochets*.Paris: Gallimard, 1994. 99.

42 Eric Lefebvre. "Chinese Painting in Paris: The Legacy of 20th Century Master Artists". *Arts of Asia* 41, 2011（4）: 82-89.

43 Georges Duthuit, *Mystique Chinoise Et Peinture Moderne*. Chroniques du jour, 1936.

44 On cultural transfers and histoire croisée, see Thomas DaCosta Kaufman. "Interpreting Cultural Transfer and the Consequences of Markets and Exchange: Reconsidering Fumi-e" In:Michael North *Artistic and Cultural Exchanges between Europe and Asia,1400—1900. Rethinking Markets, Workshops and Collections*. Burlington, Vermont: Ashgate, 2010. 135-161; Michael Werner ,Bénédicte Zimmermann. "Beyond Comparison: 'Histoire Croisée' and the Challenge of Reflexivity". *History & Theory* 45, No. 1 2006（February）: 30-50

Suggestions for Further Reading:

[1] Albright Thomas. *Art in the San Francisco Bay Area, 1945—1980: An Illustrated History*. Berkeley: University of California Press, 1986.

[2] Ament Deloris Tarzan. *Iridescent Light: The Emergence of Northwest Art*. Seattle: University of Washington Press, 2002.

[3] Anderson, Susan M., et al. *Claire Falkenstein*. Los Angeles: Falkenstein Foundation, 2012.

[4] Conkelton, Sheryl, et al. *Northwest Mythologies: The Interactions of Mark Tobey, Morris Graves, Kenneth Callahan, and Guy Anderson*. Seattle: University of Washington Press, 2003.

[5] Francis Sam, Françoise Bonnefoy, et al. *Sam Francis, les années parisiennes, 1950—1961*. Paris: Galerie Nationale du Jeu de Paume, 1995.

[6] Hulten Pontus, ed. *Paris-New York*. Paris: Centre Georges Pompidou, 1977.

[7] Johnson, Michael R. *Kenneth Callahan: Universal Voyage*. Seattle: The University of Washington Press, 1973.

[8] Kass Ray. *Morris Graves, Vision of the Inner Eye*. New York: Braziller, in association with the Phillips Collection, Washington, D.C., 1983.

[9] Landauer Susan. *The San Francisco School of Abstract Expressionism*. Berkeley: University of California Press, 1996.

[10] Seitz William Chapin. *Mark Tobey*. New York: Museum of Modern Art, 1962.

历史再发现：21世纪早期美国历史性艺术展览与学术活动

Rediscovering History: Exhibitions and Scholarship on Historical American Art in the Early Twenty–First Century

詹妮弗·唐纳利，嘉莉·哈斯利特，维利·蒂勒曼斯[1]　李骐芳＊译
Jennifer Donnelly, Carrie Haslett and Veerle Thielemans[1]　Translator: Li Qifang

过去10年，我们一直与泰拉美国艺术基金会（Terra Foundation for American Art）合作。该基金会是一家私人基金会，支持各类非现代美国艺术项目。因此，我们有幸遍览世界各地有关美国艺术的展览和学术项目。在接触了众多处于不同发展阶段的项目后，我们注意到，在博物馆和奖学金资助项目中，针对美国历史性艺术的研究逐渐增多。这些研究对已知的"美国艺术"的定义提出了挑战，也扩展了它的外延。什么能被称为"艺术"？什么能被认作"美国的"？谁来讲述美国艺术的故事？这些主要问题自新世纪伊始便推动着各种策展活动和研究项目。它们冲击着传统的美国优越主义观点和美国轴心的重要地位，而这两点正是以往美国艺术史的特性。美国艺术总是由世界各地的文化汇聚交融组成，随着这样一种认识不断深入人心，人们意识到美国艺术史的撰写，即便向多元文化主义敞开怀抱，也会时常遭受地理的限制。学者们发现，将关注的艺术品和艺术家局限在美国的版图内是毫无意义的，但若将视野投向美国以外，走出去，或以全球化的视角审视艺术则是有益的。

在这部书中，我们的许多同事考察了美国艺术展的历史性时刻。这篇文章选取了一个略有不同的角度，关注那些终将成为历史的发展进程中的潮流，主要对象是博物馆中的展览。在后面几节中，我们会展示一系列已见的美国本土及世界其他地区对美国艺术的介绍和讨论，旨在与读者分享这一视角并概述这些经验性的案例，以期吸引更多的学者进入这一领域，推动针对这种艺术及艺术家的研究和鉴赏，而非提供泛泛的分析。

艺术中的慈善：私人财产、公共福利

非政府性慈善活动在美国艺术赞助及文化景观变革

Through our work over the last decade with the Terra Foundation for American Art, a private foundation that supports projects on non-contemporary art of the United States, we have been privileged to a bird's-eye view of exhibitions and scholarly programs on American art around the world. Being in contact with a large number of projects in various stages of development, we have observed a growing body of work on historical American art, both in museums and within scholarship, which challenges and expands established definitions of American Art. What qualifies as "art"; what qualifies as "American"; and who tells the stor（ies） of American art: these are some of the main questions that have driven curatorial and research projects since the beginning of the new century. They challenge the traditional notion of American exceptionalism as well as the primacy of the trans-atlantic axis, which have characterized American art history in the past. With the recognition that American art has always been made up of encounters between cultures from different parts of the world comes the awareness that the writing of its history, even when embracing multiculturalism, has too often been geographically confined. Scholars have realized that the restriction to art objects and artists within the territorial boundaries of today's United States does not make sense. There is benefit to looking beyond national borders, taking the outside in, and internationalizing one's perspective.

While in this volume most of our colleagues examine historical moments in the display of American art, this paper takes a slightly different path by looking at trends in progress, developments still in the process of becoming history, primarily in museum exhibitions. In what follows, we offer a series of observations on the presentation and discussion of the art of the United States nationally and internationally, not to provide extensive analysis or to explain their genesis, but rather to share this broad view and sketch out a body

＊　李骐芳　中国艺术研究院助理研究员（Li Qifang Research Assistant Professor，Chinese National Academy of Arts）

中扮演着至关重要的角色。在世界其他地区，情况可能并不是这样，政府往往成为资助文化机构的"领头羊"。在美国，像泰拉美国艺术基金会这样的私人基金会为文化事业提供重要的资金支持。美国私人基金会是个人或团体（如家庭）以慈善为目的建立的非盈利组织。这意味着它或向其他机构提供资助，或自己承办慈善活动。依据其宗旨将不少于年收入 5% 的资金捐赠社会，而剩余收入也要留作捐赠储备，这是它们必须遵守的法规之一。若捐赠比例不达标，基金会将面临税务处罚。宗旨是私人基金会的核心，它是一份具有法律效益的意图声明，并且这一意图必须满足某一社会需求或解决某一公共问题。

20 世纪初，当大多数人还沉迷于欧洲艺术时，已有不少人致力于推动美国视觉艺术发展。他们坚信这一艺术的价值，利用私人财产资助其发展、提升。² 直到 1958 年，美国才拥有第一座展示本国艺术的由联邦政府资助的国立博物馆，即位于首都华盛顿的史密森尼美国艺术博物馆（Smithsonian American Art Museum）（这座博物馆本身是一英国人建立的某机构的一部分）。但是，早在大约 30 年前，雕塑家，也是家族继承人身份的格特鲁德·范德比尔特·惠特尼（Gertrude Vanderbilt Whitney）已在纽约创建了自己的美国艺术博物馆。这还要归功于大都会美术馆拒绝了她多达 500 件 20 世纪初期美国艺术作品的捐献，这些作品全部为惠特尼私人藏品。惠特尼美国艺术博物馆就此成为世界上最著名的展示美国艺术的机构，它不仅创办了重要的美国艺术双年展，还新建了一座大楼，在 2015 年向公众开放。1930 年，就在惠特尼博物馆开馆后一年，由家资丰厚的银行家托马斯·科克伦（Thomas Cochran）创立的阿迪生美国艺术画廊（Addison Gallery of American Art）在马萨诸塞州落成。³ 这些案例表明若没有私人资助如基金会的参与，这些发展和成就是无法实现的。

美国私人基金会涉足范围之广，从以下数据即可看出。至今，全美私人基金会资产已超过 6280 亿美元。这一巨大的资产赋予基金会相当大的公共力量，使其能参与或扩展政府的行政活动，改变社会福利分配。有时，基金会也能非常规地参与商业或政治冒险。⁴

为更具体地说明它们是如何运作的，我们不妨援引几个影响力较大的基金会及其优先资助条款为例。美国历史最悠久的基金会之一是由安德鲁·卡内基（Andrew Carnegie）创立的。卡内基发迹于 19 世纪晚期的钢铁行业，之后便成为慈善活动的积极倡导者。1883—1929 年，卡内基基金会（Carnegie Foundation）资建了 2500 座图书馆，从而为普通民众提供了史无前例的文化教育机会。另一拥有较长历史的组织是亨利·卢斯基金会（Henry Luce Foundation）。出版巨头卢

of empirical evidence that, we hope, will pique interest in this field and encourage this art and these artists to be more widely studied and appreciated.

Philanthropy in the Arts: Private Wealth, Public Good

Non-governmental philanthropy has played a crucial role in supporting the arts and effecting change in the cultural landscape of the United States. This is not necessarily the case in other parts of the world, where governmental agencies take the lead in providing funding for cultural institutions. In the United States private foundations, such as the Terra Foundation for American Art, provide significant funding support for cultural endeavors. In the United States, a private foundation is a nonprofit organization set up by an individual, or a group of individuals （for example, a family） for philanthropic purposes; this means that it either donates its funds to other organizations, or uses them for its own charitable purposes. One of the laws governing private foundations in the US is that they must give away, in accordance with their mission, at least 5% of their annual earnings, with the remaining income staying within the foundation's endowment. If the required amount is not distributed, the foundation faces tax penalties. At the core of a private foundation lies its mission, a legally approved statement of intent that must attempt to meet a societal need or address a public purpose.

The early part of the twentieth century is rich with accounts of individuals using their private wealth to promote their belief in the worthiness of the visual arts of the United States in an era that primarily prized the art of Europe.[2] It was not until 1958 that the country could claim a national federally funded museum devoted to American art the Smithsonian American Art Museum in Washington D.C. （itself part of an institution established by a private individual from England）. However, some three decades earlier, the sculptor and heiress Gertrude Vanderbilt Whitney created her own museum of American art in New York City when the Metropolitan Museum of Art refused her offer of some 500 works of early twentieth-century American art from her personal collection. The Whitney Museum of American Art has gone on to become one of the world's most prominent institutions devoted to American art, with an important biennale and a new building opened in 2015. In 1930, the year after the Whitney's opening, the Addison Gallery of American Art was established in Massachusetts by another individual, the wealthy banker Thomas Cochran.[3] These examples demonstrate how private funders, like foundations, have made things happen when they would not otherwise have occurred.

To give a sense of the extent of private foundations in the United States, there is in the country today over $628 billion in

斯的父母曾在中国任教会教员，为纪念他们，卢斯于1936年设立了这家基金会。基金会的捐赠宗旨之一即促进美国与东亚、东南亚国家之间的文化、人才交流，近期的资助倡议包括中国与东南亚地区濒危语言研究、进一步扩大旧金山亚洲基金会中美关系部教育交流项目、保持与富布莱特计划的常年合作，在中国推动西方艺术史研究以及在香港、杭州和纽约开展一系列西方艺术及艺术史高级研讨会。[5] 较之以上两家，建立较晚的另一著名基金会是由微软创始人比尔·盖茨及夫人梅琳达（Melinda）于1994年创立的。这家基金会除其他项目外尤其重视资助疟疾预防、控制、消灭及向世界各地提供疫苗等活动。

泰拉基金是由芝加哥商人丹尼尔·泰拉（Daniel Terra）于1978年创建的，旨在推动美国历史性艺术的研究和鉴赏（图1）。由于各种原因，1950年之前的美国艺术无论在国内还是在国外并未长期受到高校或博物馆的关注。20世纪50年代美国设计师形成了自己独特的风格，例如抽象表现主义，纽约更无可争辩地成为全球艺术中心。泰拉先生创立基金会的初衷之一即提高美国艺术历史的吸引力，让更多人享受到美国艺术的愉悦。[6] 泰拉基金会实现这一宗旨的方法、手段在其35年的运作过程中不断发展。基金会收藏美国绘画、稿件和雕塑，并且在很长时间内有两座博物馆同时展览藏品或举办短期展览（芝加哥泰拉美国艺术博物馆，1987—2004年；法国吉维尼美国艺术博物馆，1992—2009）。大约20年后，基金会决定改变策略，与其集中运作传统博物馆等场所，不如赞助展览，以奖金资助的形式推动世界学术研究发展并利用其藏品及学术专家资源。这种方式可以惠及更多民众。

foundational assets. These large private assets lend foundations considerable public power, enabling them to alter the distribution of public goods, working outside or alongside governmental parameters. Foundations can also take risks not routinely expected in the commercial or state sectors.[4]

To illustrate more concretely how this functions, let us cite a few examples of influential foundations and their funding priorities. One of America's oldest foundations was established by Andrew Carnegie, a businessman who made a fortune in the steel industry in the late nineteenth century and became an outspoken advocate for philanthropy. Between 1883 and 1929, the Carnegie Foundation gave grants to build 2,500 libraries, thereby providing unprecedented educational and cultural opportunities for the general public. The Henry Luce Foundation is another long-established organization, founded in 1936 by publishing magnate Luce in honor of his parents, who had been missionary educators in China. One area of its giving fosters cultural and intellectual exchange between the US and the countries of East and Southeast Asia; recent initiatives in this area include grants for research on endangered languages in China and mainland Southeast Asia, expansion of an education and exchange program on U.S.-China relations at the Asia Foundation in San Francisco, a multi-year collaboration with the Fulbright program aimed at encouraging development of Western Art History in China, and a series of Advanced Workshops in Western Art and Art History held in Hong Kong, Hangzhou, and New York.[5] Another prominent foundation, relatively younger than the previous two, was established in 1994 by Microsoft co-founder Bill Gates and his wife, Melinda. This organization, among other things, funds efforts to prevent, control, and eliminate the disease malaria, and helps provide vaccinations throughout the world.

图1　丹尼尔·泰拉与塞缪尔 F.B. 摩尔斯的《卢浮宫大画廊》，图片来源：泰拉美国艺术基金会。
Fig.1　Daniel J. Terra with Samuel F. B. Morse's *Gallery of the Louvre*, Photo: Terra Foundation for American Art.

虽然这些案例只是私人基金会举办的众多活动种类中的一小部分，但是它们都遵循着一个共同原则，即服务公共需求。梳理出美国文化支持这一重要框架后，我们再来审视近期的美国艺术展览和学术项目。

挑战设想：近期美国艺术展览及学术潮流

现今，美国艺术研究及展览领域发生的最根本变化与美国艺术的定义相关，即什么艺术有资格成为"美国"艺术。在本书中，芭芭拉·哈斯克尔（Barbara Haskell）深入探讨了这一话题。至20世纪70年代，美国艺术主要指特定的一些艺术家的作品，包括定居英属北美殖民地的艺术家、1776年美国独立后出生在这里的艺术家，或是从其他国家移民至此且成为美国公民的艺术家。考虑到美国领土逐渐扩张，早期对美国土著、非洲裔美国人和其他非英裔美国居民的歧视态度，以及许多没有获得或无法获得美国国籍的移民等因素，这一定义是非常保守且极值得商榷的。现今，许多展览，尤其是近期的展览接续并进一步推动前辈策展人的工作，发掘那些历史上被忽视的、未受认可的或被边缘化的艺术家的故事。[7]例如，2013年由旧金山州立大学艺术博物馆举办的《水墨时刻》（The Moment for Ink），展出了水墨画传统深厚的国家如中国、韩国、日本等国几代艺术家的作品。这些艺术家自19世纪70年代移民美国或在美国长期居住。他们中许多人在美国，通常是在西海岸地区生活、任教、或举办展览达数十年之久。这些艺术家是美国艺术创作史的重要贡献者，然而一般而言，其地位尚未得到承认。历史上，中国移民直至1943年才被允许加入美国国籍，日本移民至1952年才可获得美国国籍。但上述艺术家早期的边缘地位与这一政令无关。

甚至在那段时期之后移民美国的艺术家通常也被排除在外，尽管他们很早便来到这个国家且影响深远。事实上，直到最近他们与美国艺术史的广泛联系及其影响才被详细考察。参展《水墨时刻》的艺术家包括三郎长谷川（Saburo Hasegawa）（图2a），他是旧金山地区（图2b）杰出的艺术教师，也是抽象表现主义艺术家弗兰茨·克莱恩（Franz Kline）的主要影响者；刘业昭（James Liu），国立杭州艺专毕业，后定居台湾。1964年旅居旧金山，并在那里任教、举办个人画展。2003年，于美国病逝；侯北人，生于中国大陆（1917年），1956年自香港迁居美国，1957年起在加利福尼亚帕罗奥图市亚太艺术联合会任教。虽然侯北人自称迁居美国后，其作品"变得更西方"，但是它仍然反映着中国传统，这实际已涉

The Terra Foundation for American Art was established in 1978 by Chicago businessman Daniel Terra in order to promote the study and appreciation of historical American Art（Fig.1）. For a variety of reasons, American art made before the 1950—the era during which American artists developed distinctive styles such as Abstract Expressionism, and New York City became an undisputed global center for the arts—has not always received sustained attention in universities or museums, whether outside or inside the United States. One of Mr. Terra's primary purposes in establishing his foundation was to help encourage greater interest in, and greater enjoyment of, historical American art.[6] The ways in which the Terra Foundation fulfills its mission have evolved over its 35 years of operation. The foundation holds a collection of American paintings, works on paper, and sculpture, and for a good part of its history operated two museums that displayed objects from the collection and mounted temporary exhibitions（the Terra Museum of American Art in Chicago, from 1987 to 2004, and the Musée d'art américain in Giverny, France, from 1992 to 2009）. After some two decades, the foundation made a decision to alter its approach: rather than concentrate on operating traditional museum venues, it would support exhibitions and promote scholarship worldwide through grants and use of its collection and intellectual expertise, thus serving a much larger public.

While these examples give only a small sampling of the wide range of projects undertaken by private foundations, they do illustrate one common aim: serving a public need. Bearing in mind this vital structure of cultural support in the United States, we now proceed to our observations on recent exhibitions and scholarly projects on American art.

Challenging Assumptions: Recent Trends in Exhibitions and Scholarship on American Art

The most radical changes that have taken place in the way American art is being studied and exhibited today have to do with defining what art qualifies as 'American,' a question explored in greater depth in this volume by Barbara Haskell. Until the 1970s, what was considered American art tended to include production primarily by those who had lived in the British American colonies, were born in the US after its founding as an independent nation in 1776, or who moved to the country from elsewhere and became US citizens. This is a very conservative and highly problematic definition given the country's gradual annexation of territory, early negative attitudes towards Native Americans, African Americans, and other non-Anglo residents, as well

121

图2　弗兰茨·克莱恩《无题》，约1951年，印度墨笔、纸本，27.7×21.7厘米，旧金山美术博物馆。乔治·霍珀·菲奇捐赠于罗伯特·弗林·约翰逊任阿申巴赫图形艺术基金会总策展人25周年纪念会，2000.48.1。并三郎长谷川《上善若水》，1954年，纸本、墨笔。三郎长谷川遗作。

Fig.2　Franz Kline, *Untitled*, c. 1951, india ink on paper, 27.7×21.7cm. Fine Arts Museums of San Francisco. Gift of George Hopper Fitch in honor of the 25th Anniversary of Robert Flynn Johnson as Curator-in-charge of the Achenbach Foundation for Graphic Arts, 2000.48.1
AND
Saburo Hasegawa, *Supreme Goodness is Like Water,* 1954, ink on paper. The Estate of Saburo Hasegawa.

及地域与文化交流的影响了。[8]正如《水墨时刻》的组织者反复强调的那样，亚洲移民或移民艺术家至今受到的认可远不及约瑟夫·阿尔伯斯（Josef Albers）和威伦·德·库宁（Willem de Kooning）等欧洲艺术家，后者在美国艺术史上的地位早已得到普遍认可。因此，联合策展人马克·迪安·约翰逊等学者的工作已使越来越多的人意识到这些工作、生活在美国，而出生于亚洲的艺术家对美国艺术的贡献，他们不再被当作与世隔绝地或在"边缘地带"进行创作，而被认作广大美国艺术圈或艺术界毋庸置疑的成员。

　　这种策展思路与修正主义艺术史观是一致的。20世纪70年代后期，修正主义艺术史观由琳达·诺克林等学者发展起来，他们声称女艺术家应当拥有一部属于自己的新艺术史，由此带动了许多其他领域的研究，尤其是在社会、政治活动领域，他们的研究有时则被贴上少数群体研究或身份认同研究的标签。对美国艺术史而言，针对非洲裔美国艺术家遭受忽视和排斥的考察和研究是最有意义的成果之一。凯莉·琼斯（Kellie Jones）的工作体现在其展览《该这个了！艺术与黑人洛杉矶》中（哈默艺术博物馆，洛杉矶，2011—2012年），而理查德·鲍威尔凭借其里程碑式的著作《黑人艺术：一部文化史》（伦敦：泰晤士与哈德逊出版公司，

as the many immigrants who did not, or could not, become citizens. Today, a number of recent exhibitions are furthering efforts by earlier curators to bring to light the stories of historically overlooked, unclaimed, or marginalized artists.[7] For example, the exhibition *The Moment for Ink* organized by San Francisco State University Art Museum in 2013, showcased several generations of artists from countries with a rich tradition of ink painting, namely China, Korea, and Japan, who from the 1870s onwards immigrated to the US, or lived there for extended periods. These artists, many of whom lived, taught, and exhibited for decades within the US, often on the West Coast, were vital contributors to the story of art-making within the US; yet, they have not generally been recognized as such. Their previously marginal place in this history was not helped by the fact that American citizenship was not possible for Chinese immigrants before 1943, or for Japanese immigrants before 1952.

　　Even artists who immigrated after those dates have also not generally been included in the established histories, despite their long presence and influence in the country. Indeed only very recently has their widespread interconnectedness with and impact on the larger story of American art been closely examined. Artists in this exhibition included Saburo Hasegawa (Fig.2a, a major influence on Abstract

2002）大胆地揭示了这段忽视与排斥的历史。美国策展人及学者愈发敏锐地意识到什么是所谓的"表现"。美国黑人艺术的研究者通常是非洲裔美国人这一事实证明拥有表现话语权的重要性。

对在艺术馆中展览美国土著物品而言，近期的发展动向是让土著民参与策展活动。自20世纪早期起，美国土著社区外的人士就认为印第安物品当被视作艺术。[9] 近期的一些展览则着力为美国土著民提供一个自我解说的机会。[10] 2012年由碧波地埃塞克斯博物馆举办的《变形：美国土著艺术的演变》展览就是以此为主旨。策展过程中，策展人与印第安艺术史研究生、土著及非土著历史学家组成的顾问及作者团队通力合作。该展览旨在"为观众提供一个不同的观看视角，理解并欣赏美国土著艺术"，具体做法是"将物品像艺术品一样展示"并"提出这样一个观点即美国土著艺术总是当代的，它能通过改变和重新解释经验领域不断自我变化、更新"。[11] 策展人考察了反映不同信仰的作品，驳斥了所有美国土著民都具有单一世界观的普遍观点，否定了印第安艺术是静止的、明显属于过去的这一观念，并强调个人的概念以对抗美国土著民只有单一的、整体声音这一错觉。

另一值得注意的趋势是不断重新思考什么物品应当成为艺术博物馆的研究对象，什么物品应在博物馆内展览——换言之，这些博物馆愿意将什么视作"艺术"。这方面的案例是2012年《空间-光-结构：玛格丽特·德·帕塔珠宝》展，该展览以一位设计师的作品为核心，这位设计师"在美国珠宝观念转变上起了关键作用，她使珠宝从装饰性工艺品变为非常高级的、相当复杂的可佩戴的雕塑"。[12] 德·帕塔曾与拉兹罗·莫荷里-纳吉（László Moholy-Nagy）在芝加哥包豪斯合作研究过。深受纳吉影响，她力图实现包豪斯的理想，即通过创造与独一无二的手工制品（图3）品质相同的流水线产品使好设计走进千家万户。德·帕塔认为其珠宝作品更应被视为"动态的物件"，而不是装饰品。"动态的物件——其内部元素能影响人们的空间、运动观念。"同样，展览组织者—— 一个是设计机构（纽约艺术与设计博物馆）；另一个是历史、科学和美术机构（加利福尼亚奥克兰博物馆）——着力扩展美术的范畴，这方面的努力反映在其策展方式及第248页的文献材料计划目录和专题论文上，专题论文是由诸如伦敦维多利亚和阿尔伯特博物馆前研究主管等学者撰写的。

有助于培养艺术细微感知力的其他展览类型还包括发掘无师自通型艺术家的作品。他们往往在地方传统艺术门类中崭露头角，并且/或者以与传统工艺相关的材料或形式呈现出来。一个例子就是2009年尤利西斯·戴维

Expressionist Franz Kline and a prominent art teacher in the San Francisco area （Fig.2b）; and James Liu, who trained in Hangzhou, lived in Taiwan, and in 1964 moved to San Francisco, where he taught and then exhibited until his death in 2003. And then there is Chinese-born Paul Hau （born 1917）, who came to the United States from Hong Kong in 1956 and has taught at the Pacific Art League in Palo Alto, California, since 1957. Although Hau claimed that after his move to the United States, his work "became more Western," it still reflected the traditions of his home country, which speaks to the influence of place and cultural dialogue.[8] As organizers of *The Moment for Ink* reiterate, immigrant or relocated artists from Asia have until now received far less recognition than European counterparts such as Josef Albers and Willem de Kooning, whose roles in the American art story are universally acknowledged. The efforts of scholars such as co-curator Mark Dean Johnson have thus led to an increasingly integrated view of the contributions to American art by such Asian-born artists who have lived and worked there, considering them not as artists working in isolation, or "on the margins", but as undeniable members of the larger American artistic community and network.

This approach to staging exhibitions is in line with revisionist art history as developed in the late 1970s by scholars such as Linda Nochlin, who claimed a new history for women artists, and has inspired research in many other areas, often in combination social-political action and sometimes labeled minorities or identity studies. For American art history, the work being done on the omission of African American artists from the canon is among the most significant. The work of Kellie Jones, with her exhibition *Now Dig This! Art and Black Los Angeles, 1960–1980* （Hammer Museum, Los Angeles, 2011–2012）, and of Richard Powell, with his landmark book *Black Art: A Cultural History* （London: Thames and Hudson, Ltd., 2002）, make ambitious attempts to address this history of oversights and exclusions. Curators and scholars in the US have become acutely aware of what is called "representation." The fact that very often the study of African American art is undertaken by African Americans themselves testifies to the importance of who has the representational voice.

For the display of Native American materials in art museums, it is a relatively recent development to include curatorial voices that actually come from these cultures. While those outside the Native American community have argued for Native American objects to be considered as art since the early twentieth century,[9] these recent exhibitions strive to provide an opportunity for Native Americans to speak for themselves.[10] Such was the case in the 2012 exhibi-

图 3 玛格丽特·德·帕塔《胸针》，约 1946—1950 年，约作于 1946—1958 年（1985 年由尤金·别洛斯基监督组装完成），银质、孔雀石、碧玉，7.7×7.7 厘米。蒙特利尔美术馆，莉莉安与大卫·斯图尔特收藏。图片来源：蒙特利尔美术馆。

Fig.3 Margaret De Patta, *Brooch*, c. 1946—1950, produced about 1946—1958 （Assembled about 1985 under the supervision of Eugene Bielawski）, silver, malachite, jasper, 7.7×7.7cm. The Montreal Museum of Fine Arts, Liliane and David M. Stewart Collection. Photo: The Montreal Museum of Fine Arts.

斯（Ulysses Davis）（1914—1990 年）的展览。尤利西斯是佐治亚州萨凡纳的一位理发师兼木雕家，他利用造船木材创作了数量惊人的雕塑。其原料有的是朋友捐赠的，有的是他自己从木材厂购买的；工具有短柄斧和"理发工具，如理发剪等"。[13] 在突出展示 20 世纪自学型艺术家（另外，殖民时代自学型艺术家早已得到普遍认可）的作品时，展览——由佐治亚州亚特兰大高等艺术博物馆和金-蒂斯坦尔乡村基金会联合举办——为重新考量主流艺术院校、机构、市场以外的艺术家提供了充分理由。

设计展或自学型艺术家个展在美国博物馆中当然不是一个全新的潮流。例如，早在 1932 年纽约现代艺术博物馆就开设了建筑与设计部，它是世界上第一个此类策展部门，并在设立初期就举办自学型或"边缘"艺术家作品展。（例如，1932—1933 年《美国民间艺术：美国普通人的艺术，1750—1900》）1953 年、1961 年新墨西哥州和纽约先后成立了完全致力于民间艺术的博物馆。近 10 年来挑战传统观点的展览不断涌现，它们质疑以往引起学者关注的视觉表达类型的观点。但这种现象反映了对艺术层次或等级再思考的新渴望。引人关注的是将这一博物馆学发展趋势与特定学术发展联系起来，特别是与物质文化和视觉文化研究的兴盛联系起来，如此物质的范畴便扩大了，从广告到数字媒体，从非正式文献到家具都可算作物质。

tion *Shapeshifting: Transformations in Native American Art*, organized by the Peabody-Essex Museum. Curators worked with Native American graduate students in art history, as well as a team of advisors and writers that included Native American as well as non-Native American historians. The exhibition aimed "to offer audiences a different way of looking at, understanding, and appreciating Native American art", which it did by "present[ing] the objects as works of art" and "put[ting] forth the idea that Native American art has always been contemporary, constantly refreshing itself through modifying and reinterpreting spheres of experience."[11] Curators examined works that expressed diverse beliefs, contradicting a common perception that all Native Americans share one worldview, countering the notion that Native American art is static and predominantly part of the past, and highlighting the concept of individuality to address the misconception that Native Americans have one, monolithic voice.

Another notable trend is the continuing reconsideration of what objects should be studied by, and displayed within, art museums—or in other words, what these museums are willing to consider as "art." An example of this interest was the 2012 exhibition *Space-Light-Structure: The Jewelry of Margaret De Patta*, which highlighted the work of a designer, who "played a pivotal role in changing the perception of jewelry in America from that of an ornamental, craft-fair object to a highly sophisticated object of wearable sculpture."[12] Heavily influenced by her study at the Chicago Bauhaus with László Moholy-Nagy, De Patta （1903–1964） strove to fulfill the institution's ideal of democratizing good design by creating production line pieces equal in quality to her one-of-a-kind, handmade works （Fig.3）. She claimed to see her jewelry not as ornament, but rather as "a dynamic object—one in which the elements of the piece could influence the perception of space and movement." Similarly, the exhibition organizers—one an institution of design （Museum of Arts and Design, New York）, the other of history, science, and fine arts （Oakland Museum of California）—display a commitment to expanding the category of fine arts, both in the curatorial approach and with the 248-page catalogue drawing on archival material and featuring essays by scholars such as the then-head of research at the Victoria and Albert Museum in London.

Other types of exhibitions that help nuance perceived hierarchies among the arts are those exploring the work by self-taught artists, emerging from local traditions, and/or executed in materials or forms traditionally associated with craft. An example was the 2009 exhibition on Ulysses Davis （1914–1990）, a barber and woodcarver from Savannah, Georgia, who created an astounding number of sculptures using "shipyard lumber, pieces donated by his friends, or wood

近期议题反映出的最后一个趋势是，与美国艺术相关的展览和会议是由当地策展人联合当地专家从特定的历史视角研究考察某一主题。例如，柏林新国家画廊（Neue Nationalgalerie）正在筹备 2014 年画家马森·哈特利（Marsden Hartley）的展览，其中对他在德国期间的创作格外关注（图 4）。虽然马森是 20 世纪最杰出的美国现代主义艺术家之一，但他在德国度过了许多年，那段时间正是其成长阶段。在德国，他根本不出名，而这场展览是一百年来他在欧洲的第一次个展——换言之，这是他有生以来第一次在欧洲举办个展。展览由德国策展人筹办，主要展出 1913 年至 1915 年画家在柏林的作品，他们认为哈特利是在那段时间发展出了一种截然不同的全新的画风，并指出"一战"是他这段时期作品的中心。展览图录的 8 位作者中有 6 位是德国人，他们都提到哈特利与德国的联系，这一点美国博物馆尚未深入探讨过。因为各策展人在地域和文化上较接近，他们能够集中精力分析艺术家作品中的元素，尤其是与地域和文化相关的内容：他在德国的生活，他根据早先未见的文献材料为主题进行绘画创作，他与被称为蓝骑士的德国艺术团体的联系；分析德国留存的唯一一幅哈特利的绘画；哈特利军事符号的象征研究；以及哈特利作品中的性别表现与柏林的同性恋文化。

2011 年，"文化流动性与跨文化对抗：以温诺德·赖斯（Winold Reiss）为跨国研究范式"会议在柏林自

图 4　马森·哈特利，《绘画 No.50》，1914—1915 年，布面、油画，119.4×119.4 厘米。泰拉美国艺术基金会，丹尼尔·泰拉收藏，1999.61。

Fig.4　Marsden Hartley, *Painting No. 50*, 1914—1915, oil on canvas, 119.4×119.4cm. Terra Foundation for American Art, Daniel J. Terra Collection, 1999.61.

he bought at lumberyards" and tools such as hatchets and those of the "barbering trade, such as the blade of his hair clippers."[13] In highlighting the work of a self-taught artist of the twentieth century （self-taught artists of the Colonial era, on the other hand, have long been acknowledged）, the exhibition—organized by the High Museum of Art in Atlanta, Georgia, in conjunction with the King-Tisdell Cottage Foundation—made a case for reconsideration of artists outside of the dominant institutions of art schools and markets.

Exhibitions of design or of self-taught artists are certainly not an entirely new trend within American museums. For example, as early as 1932 the Museum of Modern Art in New York opened a department of architecture and design, the world's first such curatorial department, and mounted exhibitions of self-taught or "outsider" artists from its earliest years （for example, *American Folk Art: The Art of the Common Man in America, 1750—1900,* from 1932 to 1933）.）. Entire museums dedicated to folk art were founded in New Mexico in 1953 and in New York in 1961. However, the increased presence in the last ten years or so of exhibitions that question persistent notions regarding the types of visual expression that warrant intellectual attention speaks to a renewed desire for reconsidering hierarchies within the arts.. It is tempting to link this museological trend to certain academic developments, in particular emergence of material culture and visual culture studies, which consider expanded ranges of material from advertisements to digital media, from printed ephemera to furniture.

A final trend observed in recent proposals are exhibitions and conferences that, while related to American art, are organized by local curators who approach the subject with their local expertise and from their specific historical perspective. For instance, the Neue Nationalgalerie in Berlin is mounting a show on the painter Marsden Hartley in 2014, with particular attention on his time in Germany （Fig.4）. Although the artist, one of the most significant American modernists of the twentieth century, spent several formative years in Germany, he is completely unknown there, and this exhibition is the first solo show of his work in Europe in one hundred years—in other words, since the artist's lifetime. Organized by German curators, the show concentrates specifically on the works he painted while in Berlin between 1913 and 1915, arguing that Hartley developed a completely distinct style of painting during that time, and pointing out the centrality of the First World War in this period of his work. Six of the eight catalogue authors are German, and all address Hartley in relationship to Germany, an aspect that has not yet been examined in depth by American museums. Due to their geographical and cultural familiarity, the curators are able to focus on elements of the artist's work

由大学召开。类似地，会议以德国出生的画家、设计师和教师温诺德·赖斯（1886—1953 年）为焦点，温诺德于 1913 年移民美国。与会者来自世界各国，但会议却是由德国学者筹备、主持的，这再次用事实证明，超越国界审视艺术能获得创造性的见解。会议"考虑到温诺德将欧洲艺术背景带入美国情境中"，有意识地将"德国元素"融入"他对美国族群和种族冲突复杂的展现中，并往往见于细微之处。"[14] 类似的情况也出现在德国自由大学跨学科研讨会"美国艺术故事"（2007 年 5 月）上，研讨会重新考察了美国艺术史的阐释范本，它也是欧洲在该领域的里程碑式的会议。但是，外来性并不一定会激发新的见解——德国文化历史学家温弗里德·弗拉克（Winfried Fluck）的论证极具说服力，他认为，域外对美国文化的看法和观点并不一定全然是批判性的、严肃的——它确实推动了自我反思和文化交流，这点对学术发展是有重要贡献的。

当时，在非美国人中间，当与其各自国家的历史比较时，美国艺术史似乎能引发他们浓厚的兴趣。[15] 全球性典范在理解、研究美国艺术史这件事上显然是卓有成效的，无论是在美国本土还是海外，并且相关的比较研究避免人们落入美国优越主义观点的陷阱。相关的理论框架，例如后殖民主义或泛太平洋视角，也促进了这类研究，由此引出本文讨论的最后一个趋势，即对域外美国艺术的关系的广泛的全球视野。所以，有越来越多的美国艺术展选择国际话题也就毫不稀奇了。这种现象意味着它们拥有全球化的视角并试图以平等的姿态展现不同文化及其相互影响，而不是认为一个比另一个高级。

从美国的角度出发，跨国性话题颠覆了美国优越主义的观点，该主义认为美国高其他国家一等，或在某种程度上与他国不同，尤其是在殖民体系内。越来越多的境内美国艺术展力图展现美国不可避免地与世界相联系，并且相互影响着。这一全球联系在 2010 年《联结：纽约 1900—1945：遭遇现代都市》展览中极其引人注目。该展汇聚了拉美和加勒比海地区艺术家的作品，这群艺术家于 20 世纪初旅居纽约城，其中也有同时期住在纽约的美国艺术家的作品（图 5）。展览为研究拉美和加勒比海地区艺术家开拓了新思路，即考察他们与同代美国艺术家之间的相互影响。其不可磨灭的贡献是一部学术性双语图录。该展览也明确显示出另一趋势，上文未提及但有相关性，即对全球艺术网络和图谱的兴趣，这一趋势近来表现得愈发明显，特别是在西欧地区。

另一尚在筹备阶段的国际性展览是基于美国地形地貌的，从加拿大到南美，沿南北轴线延伸。该展由美国、

particular to the geographical and cultural context: his stay in Berlin, drawing on previously unseen archival material his relations to the German group known as the Blue Rider; analysis of the only Hartley painting that remained in Germany; the iconography of Hartley's military symbols; and gender aspects of Hartley's work in relation to the emerging homosexual culture in Berlin.

Similarly, the conference *Cultural Mobility and Transcultural Confrontations: Winold Reiss as a Paradigm of Transnational Studies*, held in 2011 at the Freie Universität Berlin, focused on German-born painter, designer, and teacher Winold Reiss（1886–1953）, who immigrated to the United States in 1913. It featured international participants, but was conceived and hosted by German scholars, thus offering another example of how looking at art from beyond the borders of one nation can yield productive insights. The conference "considered the European artistic background he brought to the American scene," specifically weaving a "German element" into "the fabric of his complex engagement with American ethnicity and with racial conflicts."[14] Also at the Freie Universität, the interdisciplinary symposium "Narratives about American Art"（May 2007）, which reconsidered interpretative models of American art history, was a landmark in Europe for its approach to the field. While foreignness does not *a priori* yield new insight—and German cultural historian Winfried Fluck has persuasively argued that it is an illusion to think that voices from abroad necessarily come with critical outside perspectives on American culture—it does invite self-reflection and dialogue, which in itself makes significant contribution to the scholarship.

Amongst non-Americans, then, American art history when examined in relation to one's own history seems to elicit great interest.[15] The transnational model clearly seems productive in continued efforts to understand the history of American art, both within the United States and abroad, and such comparative studies help avoid the trap of an exceptionalist discourse. Related frameworks, such as the postcolonial or the transpacific, further contribute to such efforts, which brings us to the final trend to be discussed here, a widely global view of relationships of American art outside its borders. It is therefore not surprising that a rising number of exhibitions on American art treat transnational topics, meaning that they take a fairly global perspective and strive to present different cultures as equal, not one above the other, as well as mutually influential.

From the perspective of the United States, transnational topics work to up-end the concept of American exceptionalism, which situates the country as superior to, or somehow different from, other countries, especially within a colonial framework. Exhibitions on American art mounted within the

图5 黛博拉·卡伦,《联结纽约：现代都市中的拉美/美国艺术家》,
纽约：巴里奥博物馆, 2009年。

Fig.5 Deborah Cullen. *Nexus New York: Latin/American Artists in the Modern Metropolis*. New York: Museo del Barrio, 2009.

加拿大和巴西（泰拉基金会、安大略艺术馆和圣保罗州立艺术馆）联合举办，它是第一个在泛美环境下考察地图演变的展览。纵观这一个世纪，地图是国家形成与文化身份发展过程中厘清国土概念的主要媒介。策展人的最初发现之一是三个合办国对"地形"的定义是不同的。围绕主题，展览将划出一条从火地岛至北极的轴线。将这些视觉传统汇聚一处能促使人们前所未有地将错综复杂的地理环境和不同民族、国家、地区的社会政治历史以及南北美的移民社群通同考察。

更进一步的展览焦点是美国与亚洲、非洲间的艺术交流。2013年，一个关注美国雕塑家野口勇（Isamu Noguchi）（1904—1988年）（图6a）与中国水墨画家齐白石（1864—1957年）交往的展览于纽约开展。两位艺术家1930年曾在北京会面（图6b）。虽然野口游历广泛，但人们对他在中国的那段时光及其创造性研究所知甚少。该展览反映了多才多艺的中国画家的作品是如何影响到年轻学子的艺术发展的。这也是第一个为野口的《北京图卷》而设的博物馆展览，该作品是他与齐白石学画时创作的。展览图录以不同国籍和专业领域的学者论述为重点，不仅有研究美国艺术和中国艺术的美国学者参与其中，还收录了一位研究齐白石的中国专家郎绍君教授的文章，郎教授任教于北

country increasingly strive to show the US as inextricably tied to the world and that influences are mutual. This global interconnectedness was very much in evidence at the 2010 exhibition *Nexus: New York 1900–1945: Encounters in the Modern Metropolis*, which brought together works by artists from Latin America and the Caribbean who traveled to and resided in New York City during the early twentieth century, as well as works by American artists residing in New York at the same time （Fig.5）. The exhibition broke new ground in the study of the Latin American and Caribbean artists, examining their influence on their American contemporaries and vice versa. Its lasting contribution was a scholarly, bilingual catalogue. This exhibition also points up another trend, not mentioned earlier but linked, namely an interest in global artistic networks and mapping, of which more and more is being seen, especially from Western Europe.

Another transnational exhibition project in development is based upon landscapes of the Americas, running along a North-South axis from Canada to South America. Co-organized by institutions from the United States, Canada, and Brazil （Terra Foundation, Art Gallery of Ontario, and Pinacoteca do Estado de São Paulo）, it is the first exhibition to examine landscape painting in a pan-American context, looking at the century-long period during which this was the primary medium for articulating conceptions of land in the formation of the nation-state and the development of cultural identity. One of the curators' initial discoveries was the differing definition of the term "landscape" held by the three organizing countries. Thematically organized, the exhibition will draw on a vertical axis from Tierra del Fuego to the Arctic. Bringing these visual traditions together into dialogue will allow for an unprecedented consideration of the intertwined geographies and socio-political histories of the peoples, nations, regions, and diaspora of North and South America.

A further group of exhibitions focus on American artistic exchanges with Asia and Africa. An exhibition on view in New York in 2013 examined the artistic encounter of American sculptor Isamu Noguchi （1904–1988）（Fig.6a） and Chinese ink painter Qi Baishi （1864–1957） in Beijing in 1930 （Fig.6b）. While Noguchi traveled extensively, little had been known about his time in China and his creative studies there. The exhibition studied how the work of the versatile Chinese painter impacted the young student's artistic development. It was also the first museum show devoted to Noguchi's *Peking Scroll* drawings, which he created while working with Qi. The catalogue features scholars with a variety of nationalities and specialties, including not only American scholars of both American and Chinese art, but also a Chinese expert on Qi, Professor Lang Shaojun, of the

图6 野口勇，《北京图卷》（男人与男孩摔跤），1930 年，横轴、墨笔、纸本，55.5×90.8 英寸。野口博物馆。并齐白石，《螃蟹》，1861—1949 年，册页、墨笔、纸本，24.29×27.1 厘米。密歇根大学艺术博物馆。Katsuizumi Stotkichi 捐赠，1949/1.199。
Fig.6 Isamu Noguchi, Peking Drawing （man and boy in circular tumble）, 1930, horizontal hanging scroll, ink on paper, 55.5×90.8 inches. The Noguchi Museum

AND

Qi Baishi, *Crabs*, 1861—1949, album leaf, ink on paper, 24.29cm×27.1cm. University of Michigan Museum of Art. Gift of Katsuizumi Stotkichi, 1949/1.199.

京中国艺术研究院和天津美术学院，他的参与为展览主题提供了更丰富、全面、深入的资料。

另一个关注影响美国艺术的域外文化的展览将焦点对准非洲大陆，即展览《物与像：曼·雷，非洲艺术与现代主义者镜头》（2009 年）。该展探讨了在美国和欧洲等地，这位艺术家在搜集和理解非洲物品中扮演的角色，以及非洲物品的图像与艺术的融合问题。展览中，许多照片和非洲面具实物和戴着面具的人像并置展出，以此吸引人们沉思摄影表达的复杂本质。

20 世纪 90 年代后期，在欧洲，跨大西洋关系就已经开始成为一个值得关注的展览和学术主题。在柏林，德国历史博物馆举办的展览《反之亦然》（1996 年）通过考察吸引美国艺术家的教育中心、分析艺术家们受海外经历影响而成的作品探讨了德国与美国之间的艺术交流。相关的学术研究体现在 "慕尼黑的美国艺术家：艺术迁移与文化交流过程" 研讨会（2007 年）。会议聚焦慕尼黑与美国美术院校的文化共鸣现象。在英国，英美艺术关系成为国际会议的热门话题，如 "英语口音：与英国艺术互动，1776—1855 前后"（泰特美术馆，1998 年）及 "英美人：英美艺术交流" 两场会议完全围绕美英两国艺术联系进行（约克大学，2009 年）。在法国，一些展览也探讨了本国艺术与美国艺术的复杂交流过程，如 1992 年至 2009 年吉维尼小镇的前美国艺术博物馆举办的展览，以及展览《卢浮宫的美国艺术家》（卢浮宫博物馆，2006 年）。

在学术界，史密森尼美国艺术博物馆召开的一系列开创性会议力图解决美国艺术的全球关联这一话题，

Art Research Institute in Beijing and Tianjin Academy of Fine Arts, thus providing a richer, fuller, and more complex story of the subject at hand.

Another exhibition focusing on influences on American art, this time with the continent of Africa, is *Object & Image: Man Ray, African Art, & the Modernist Lens* （2009）, which explored this artist's role in the perception and collecting of African objects, as well as the incorporation of images of African objects into art, in both the US and Europe. Many photographs were juxtaposed with the actual African masks and figures featured in them, encouraging contemplation of the complex nature of photographic representation.

Outside of the United States, transatlantic relationships became a significant theme of exhibitions and scholarship in the Europe starting in the late 1990s. In Berlin, the exhibition *Vice Versa* at the Deutsches Historisches Museum （1996） explored artistic transfers between Germany and the United States by examining the educational centers to which American artists were drawn and the work that resulted from their experiences abroad. A similar example from the academic world was the symposium "American Artists in Munich: Artistic Migration and Cultural Exchange Processes" （2007）, which focused on the cultural resonance of Munich and the Academy of Fine Arts in the United States. In the United Kingdom, Anglo-American artistic relations were broached in the international conferences "English Accents: Interactions with British Art, c. 1776–1855" （Tate Gallery, 1998） and "Anglo-American: Artistic Exchange between Britain and the USA," which was devoted exclusively to the links between American and British

如"全球视野下的艺术"（2006 年）、"漫长而纷乱的关系"：美国艺术的东西交流"（2009）、"学术研讨会：美国与拉美地区艺术交流"（2011）和"美国艺术与非洲及非洲移民的对话"（2013）。2014 年，瑞典索德脱恩大学将举办研讨会从美国波普艺术在欧洲的发展状况出发，以瑞典首都为切入点评估其传播。瑞典是美国与苏联间的中立国，会议将以它为起点，重新评价东西方跨国策略。（"流转中的艺术：波普时代的策展实践与跨国策略"）

以上所举案例代表了近期非美国当代艺术项目的流行趋势。这些新方法、作品、声音及场所从一个侧面反映出各个人文领域对重新认识自我、更新自我和重新设想自我的迫切追求，在这一过程中，它们又再次发现和创造了历史。

art （University of York, 2009）. In France, the complex artistic contact between its art world and that of the United States was explored in exhibitions at the former Musée d'art américain in Giverny from 1992 until 2009, as well as in the exhibition *Les artistes américains et le Louvre* （Musée du Louvre, 2006）.

Within scholarship, a groundbreaking series of conferences at the Smithsonian American Art Museum sought to address the global links of American Art: "Art in a Global Context" （2006）, "'A Long and Tumultuous Relationship': East-West Interchanges in American Art" （2009）, "Encuentros: Artistic Exchange between the U.S. and Latin America" （2011）, and "American Art in Dialogue with Africa and its Diaspora" （2013）. In Sweden, Södertörn University will host a conference in 2014 that departs from the appearance of American Pop Art in Europe and assesses its spread from the perspective of the capital city of Sweden, a neutral country between the US and the Soviet Union, taking it as a point of departure to reassess East-West transnational strategies （"Art in Transfer. Curatorial Practices and Transnational Strategies in the Era of Pop"）.

The examples mentioned here typify a popular range of current projects on non-contemporary American art. The new approaches, objects, voices, and venues suggest the potential vitality of any field of humanistic inquiry to reinvent, re-new, and re-imagine itself and in the process, both rediscover and create history.

Notes:

1　Adapted from a presentation at the conference "American Art in Exhibition: Presentations of American Art at Home and Abroad" at the World Art History Institute, Academy of Arts & Design, Tsinghua University, Beijing, November 12-16, 2013, and the article by Veerle Thielemans. "Looking at American Art from the Outside In". *American Art* 22, No. 3 2008 （Fall）: 2-10.

2　American art had not been entirely neglected at the institutional level: the Pennsylvania Academy of Fine Arts, founded 1805, and New York's National Academy of Design, founded 1825, both showed contemporary American art, and in 1924 the Metropolitan opened an "American Wing" including both fine and decorative arts.

3　Also worth noting is that the Museum of Modern Art, conceived by three philanthropist women around the same time as Ms Whitney's museum, despite its mission to promote modern art—which at the time was largely coming out of Europe—nonetheless organized the ambitious traveling exhibition *Three Centuries of American Art*, which attempted to chronicle the history of art in the US from 1609, the date of the first English settlement in the country.

4　Rob Reich, "Forum: What are Foundations For?". *Boston Review* online, March 1, 2013. See http://www.bostonreview.net/forum/foundations-philanthropy-democracy（accessed: Oct.1,2013）.

5　The Advanced Workshop in Western Art and Art History: American Art and Modernism held in New York in 2013 was co-supported by the Henry Luce Foundation, the Terra Foundation for American Art, the Asian Cultural Council, and the Wu Zuoren Foundation.

6　One component of this shift in implementing the mission was the foundation's presence in Europe. Despite the importance of transatlantic links in the history of American art, Europe has a relative lack of resources that support research on this topic. Having assessed this "societal need," the foundation began to seek ways to address perceived lacks: visiting professorships were launched in Paris, London, and Berlin, to fill gaps in teaching on American art topics at universities in Europe; a reference-research library was created at its Paris Center（opened in 2009）since no specialized European research libraries existed; grant programs were established to support conferences and other scholarly convenings that foster networks amongst scholars across institutional and national borders; travel grants facilitated research trips to the United States for non-American scholars; and publication grants were made available to address challenges imposed by the language barrier by non-American scholars seeking recognition in the United States, high translation costs, and limited publishing market.

7　For example, the groundbreaking exhibition *Two Centuries of Black American Art: 1750—1950*, curated by David Driskell in 1976; *Shores of a Dream: Yasuo Kuniyoshi's Early work in America*, organized by Tom Wolf and Jane Myers at the Amon Carter Museum in 1996; or *Love Forever: Yayoi Kusama in New York, 1958—1968*, on the Japanese artist's decade in New York, mounted at the Los Angeles County Museum of Art in 1998.

8　*The Moment for Ink*（San Francisco: San Francisco State University in association with the Chinese Culture Center of San Francisco, the Asian Art Museum of San Francisco, and the Silicon Valley Asian Art Center, 2013）.

9　For more on these issues, see Joseph Traugott. *The Art of New Mexico: How the West is One*. Santa Fe:Museum of New Mexico Press, 2007, and Elizabeth Hutchinson. *The Indian Craze: Primitivism, Modernism, and Transculturation in American Art, 1890–1915*. Duke University Press, 2009.

10　Although based on a permanent collection and therefore different from the temporary exhibitions mentioned here, the Smithsonian Museum of the American Indian in Washington DC is worth noting for its reliance on Native guides in the design and conception of its exhibitions for its opening in 2004.

11　Cited from exhibition materials. See http://www.pem.org/exhibitions/135-shapeshifting_transformations_in_native_american_art（accessed on: Apr.19，2014）.

12　Cited from exhibition materials. See http://www.modernsilver.com/spacelightstructure/spacelightstructure.htm（accessed on: Apr.19，2014）

13　Cited from exhibition materials. See Susan Mitchell Crawley. The Treasure of Ulysses Davis.Atlanta: The High Museum of Art, 2008.

14　Cited from conference web site. See http://www.jfki.fu-berlin.de/en/v/winold-reiss/goals_trajectory/index.html（accessed on: Apr. 19，2014）.

15　See for example the work of French scholars such as Laurence Bertrand-Dorléac, Eric de Chassey, Catherine Fraixe, Fabrice Flahuttez, Serge Guilbaut, Richard Leeman, Jean-Marc Poinsot, and Hervé Vanel, who pay particular attention to the description of connections between American and European art of the 1940s and 1950s.

Exhibitions Cited:

[1]　*Isamu Noguchi and Qi Baishi: Beijing 1930* was shown at the University of Michigan Museum of Art（May 18 – September 1, 2013）, The Noguchi Museum（September 25, 2013 – January 26, 2014）and the Frye Art Museum（February 22 – May 25, 2014）.

[2]　*Les artistes américains et le Louvre* was shown at the Louvre（June 14 – September 18, 2006）.

[3]　*Man Ray, African Art and the Modernist Lens* was shown at The Phillips Collection（October 10, 2009 – January 10, 2010）, the University of Virginia Art Museum（August 7 – October 10, 2010）and the University of British Columbia, Museum of Anthropology（October 30, 2010–January 23, 2011）.

[4]　*Marsden Hartley: The German Paintings 1913—1915* will be shown at the Neue Nationalgalerie（April 5 – June 29, 2014）and the Los Angeles County Museum of Art（August 3 – November 30, 2014）

[5]　*Nexus: New York 1900–1945: Encounters in the Modern Metropolis* was shown at El Museo del Barrio（October 17 – February 28, 2010）.

[6]　*Now Dig This! Art and Black Los Angeles 1960–1980* was shown at the Hammer Museum（October 2, 2011 - January 8, 2012）and MoMA PS1（October 21, 2012 – March 11, 2013）.

[7]　*Shapeshifting: Transformations in Native American Art* was shown at the Peabody Essex Museum（January 14 – April 29, 2012）.

[8]　*Space-Light-Structure: The Jewelry of Margaret De Patta* was shown at the Oakland Museum of California（February 4 – May 13, 2012）and the Museum of Arts and Design（June 5 –

September 23, 2012）.

[9] *The Moment for Ink* was shown at San Francisco State University (February 23 – March 23, 2013）, the Chinese Culture Foundation (February 23 – May 18, 2013）, the Asian Art Museum of San Francisco (February 28 – October 27, 2013）, and the Silicon Valley Asian Art Center (February 24 – March 20, 2013）.

[10] *The Treasure of Ulysses Davis* was shown at the High Museum (December 6, 2008 – April 5, 2009）, American Folk Museum (April 21 – September 6, 2009）, Menello Museum of Art (October 17, 2009 – January 1, 2010）, and Intuit: The Center for Intuitive and Outsider Art (February 12 – May 15, 2010)

[11] *They Taught Themselves: American Self-Taught Painters between the World Wars* was shown at the Galerie St. Etienne (January 7 – Mar 14, 2009)

[12] *Vice Versa: German Painters in America, American Painters in Germany, 1813–1913* was shown at the Deutsches Historisches Museum (September 17–December 1, 1996）.

Suggestions for Further Reading:

[1] Berman Avis. *Rebels on Eighth Street: Juliana Force and the Whitney Museum of American Art*. New York: Atheneum, 1990.

[2] Bott Katharina, Gerhard Bott. *Vice Versa: Deutsche Maler in Amerika, Amerikanische Maler in Deutschland, 1813—1913*. München: Hirmer, 1996.

[3] Crawley, Susan Mitchell. *The Treasure of Ulysses Davis: Sculpture from a Savannah Barbershop*. Atlanta: High Museum of Art, 2008.

[4] Cullen Deborah. *Nexus New York: Latin/American Artists in the Modern Metropolis*. New York: Museo del Barrio, 2009.

[5] Dixon Jenny, Joseph Rosa. *Isamu Noguchi, Qi Baishi: Beijing 1930*. Long Island City, N.Y.: The Isamu Noguchi Foundation and Garden Museum, 2013.

[6] Fink, Lois Marie, et al. *Les Artistes américains & le Louvre*. Paris: Hazan, 2006.

[7] Grossman Wendy. *Man Ray, African art, and the Modernist Lens*. Washington, DC: International Arts & Artists, 2009.

[8] Hutchinson Elizabeth. *The Indian Craze: Primitivism, Modernism, and Transculturation in American Art, 1890–1915*. Durham, NC: Duke University Press, 2009.

[9] Ilse-Neuman, Ursula et al. *Space, Light, Structure: The Jewelry of Margaret De Patta*. New York, N.Y.: Museum of Arts and Design, 2012.

[10] Johnson, Mark Dean (Principle editor）. *The Moment for Ink*. San Francisco: San Francisco State University, 2013.

[11] Jones Kellie. *Now Dig This!: Art & Black Los Angeles, 1960—1980*. Los Angeles: Hammer Museum, 2011.

[12] Russell, Karen Kramer. *Shapeshifting: Transformations in Native American Art*. Salem, Mass: Peabody Essex Museum, 2012.

[13] Traugott Joseph. *The Art of New Mexico: How the West is One*. Santa Fe: Museum of New Mexico Press, 2007.

雅各布·劳伦斯,《大移民系列第 49 号》, 1941 年, 板上蛋彩, 18×12 英寸 (45.72×30.48 厘米), 纽约现代艺术博物馆, 纽约。
Jacob Lawrence, *The Migration Series*, Panel no. 49, 1941, Casein tempera on hardboard, 18×12in. (45.72×30.48cm) . Museum of Modern Art, New York.